Postmodern Genres

Oklahoma Project for Discourse and Theory

OKLAHOMA PROJECT FOR DISCOURSE AND THEORY

SERIES EDITORS

Robert Con Davis, University of Oklahoma
Ronald Schleifer, University of Oklahoma

ADVISORY BOARD

Postmodern Genres

Edited by Marjorie Perloff

University of Oklahoma Press : Norman and London

Other Books by Marjorie Perloff:

Rhyme and Meaning in the Poetry of Yeats (Hawthorne, N.Y., 1970)
Frank O'Hara: Poet Among Painters (Austin, Texas, 1979)
Poetics of Indeterminacy: Rimbaud to Cage (Princeton, N.J., 1981)
The Dance of the Intellect: Studies in the Poetry of the Pound Tradition
 (Cambridge, England, 1985)
The Futurist Moment: Avant-Garde, Avant Guerre, and the Language of Rupture
 (Chicago, 1987)

CIP info. to come

Library of Congress Catalog Card Number: 89-40220

ISBN: 0-8061-2231-5

The paper in this book meets the guidelines for permanence and durability of
the Committee on Production Guidelines for Book Longevity of the Council
on Library Resources, Inc.∞

Postmodern Genres is Volume 5 of the Oklahoma Project for Discourse and
Theory.

Contents

Series Editors' Foreword

. . . animals are divided into: (a) belonging to the Emperor, (b) embalmed, (c) tame, (d) sucking pigs, (e) sirens, (f) fabulous, (g) stray dogs, (h) included in the present classification, (i) frenzied, (j) innumerable, (k) drawn with a very fine camelhair brush, (l) *et cetera*, (m) having just broken the water pitcher, (n) that from a long way off look like flies.

—Jorge Luis Borges

The famous parody of taxonomy of Borges has for many readers become an exemplary postmodern fragment, a moment that speaks of and enacts the very possibility of postmodern discourse in culture— including the possibility of contemporary and "postmodern" classifications, generic and otherwise. This is the "dispersal" that Jean-François Lyotard claims characterizes the postmodern narrative; the "pure sign system" that "cannot be embedded in a chain of finalities" which Arthur Kroker and David Cook describe as the "scene" of postmodern discourse; and the very *"inflation of discourse"* which Charles Newman perceives within contemporary and "postmodern" art. Moreover, the passage most clearly embodies a postmodern discourse when its most famous reader, Michel Foucault, is provoked to laugh with such force as to shatter "all the familiar landmarks of my thought—*our* thought, the thought that bears the stamp of our age and our geography— breaking up all the ordered surfaces and all the planes with which we are accustomed to tame the wild profusion of existing things, and continuing long afterwards to disturb and threaten with collapse our age-old distinction between the Same and the Other." For many theorists of postmodern culture, in fact, it is precisely this entire scene with Foucault in it—the archaeologist of knowledge as laughing reader of Borges—that most fully suggests the *"violation, disruption, dislocation, decentering, contradiction"* which, as Marjorie Perloff says, comprise and accompany postmodern texts.

The essays of Perloff's *Postmodern Genres* generally argue, in fact, that

the most fundamental questions about postmodern culture—
epistemological, ontological, political, and aesthetic—are derived
from considerations of classification and genre. The underlying ratio-
nale for genre—with its assumption that rational demarcation and
taxonomy are possible—falls within the larger category of post-
Enlightenment culture. But if a specifically Western project of
understanding, a strategy for engaging or even *having* a world to begin
with, genre's manifestations are not hugely generalizable. Rather,
genre—*our* postmodern sense of genre—is, as Perloff argues, "always
culture-specific and, to a high degree, historically determined"—
sometimes belonging to the Emperor and sometimes simply a stray
dog. In this, there is no unity of genre, but only the historical
determinations of "genres." As Jacques Derrida says in "The Law of
Genre," "every text participates in one or several genres, . . . yet such
participation never amounts to belonging." And if genres are in this
way shaped by specific cultural contexts, as Ralph Cohen states,
quoting Maria Corti, it further follows that "every genre . . . be
directed toward a certain type of public, sometimes even to a specific
class."

 The contributors to this collection, in fact, have precisely this
awareness of postmodern genre as situated within the problematics and
the discourses of postmodern culture. Thus, the critics in this book
frame art and aesthetics within cultural studies in order to redirect
"textual analyses," as Cohen explains, "from studying behavior to
studying the grounds of behavior; from the overt desire to manipulate
behavior to studying . . . the processes of manipulation." And this
situated sense of genre promulgates not only a general cultural
approach to aesthetics. The study of postmodern genres, further, as
Joan Retallack adds, begins with history and ideology and the
assumption of the failure of the "Enlightenment promise of redemp-
tive rationalist method," the passing, in other words, of the post-
Enlightenment cultural "mastery" and its underlying values that
Borges parodies. In place of that edifice is the fluid nature and
instability of postmodern culture, inflationary, dispersed, without
finalities—the constant tendency of postmodern genres, as Perloff
explains, toward nonrationalistic and wholesale "appropriation of other
genres, both high and popular . . . [in] a both/and situation rather than
one of either/or."

 Even the collection containing these essays about genre, as Cohen

notes emphatically, must itself be such a problematic genre, itself participating in all of the same indeterminacies of postmodern culture. In fact, there is a great deal of self-consciousness in this collection's pages about the radically multifarious nature of addressing such a topic—and of discussing the dimensions of postmodern culture. In this regard, the first essay here, for example, is Cohen's "professional critical essay" (in Perloff's words), a highly rational treatise on the possibility of circumscribing postmodern genres. The collection's last essay, at another extreme, is Retallack's essayistic/postmodern interweaving of "dialogue, aphorism, and comic citation" configured, Perloff says, in "all manner of play." Between these essays, and at various levels of verbal "play," are postmodern probings of opera, metafiction, poetry, performance art, and L-A-N-G-U-A-G-E poetry.

This collection, in fact, actively eschews, as Perloff points out, a traditional pattern of "coverage" or regularity in its approach. Thus, while many of this collection's essays are "well formed" in the traditional sense, as well as insightful scholarship, they often avoid the "professional" perspectives and academic assumptions more in harmony with premodern and modern culture.

In fact, much like earlier volumes in the Oklahoma Project for Discourse and Theory, Perloff's collection finds the interest of theory and criticism precisely in the discursive strategies, verbal and nonverbal, created by violent cultural disruption, that which Foucault locates when he laughs about the "otherness" that resists cultural assimilation. It is a point where dislocations of rational classification and thought open "between the Same and the Other" to enact postmodern attempts to construct new discourses, including that of "genre," which articulate the violations, disruptions, dislocations, of a larger cultural "order." In other words, like the other volumes of the Oklahoma Project for Discourse and Theory, *Postmodern Genres* engages culture through discourses not confinable within the traditional disciplines of "professional" life. In this way, this volume challenges the boundaries of the literary, musical, graphic, plastic, and performance arts, and in so doing, it attempts to articulate a contemporary discourse which engages culture in its performative and ideological dimensions.

ROBERT CON DAVIS
RONALD SCHLEIFER

Norman, Oklahoma

Postmodern Genres

1
Introduction

Marjorie Perloff
Stanford University

Postmodern genre—it sounds like a contradiction in terms. Modernist discourse, we know, was preoccupied with the question of the renewal or adaptation of the traditional genres. *Surgery for the Novel—or a Bomb*, as D. H. Lawrence called one of his manifestos, the possibilities of the "Vorticist" epic (Ezra Pound), the presence or absence of *hamartia* in Paul Claudel's "tragedies"—these were subjects of commanding interest to Modernist writers. But postmodernism, especially in its post-structuralist manifestation, has tended to dismiss genre as a more or less anachronistic and irrelevant concept. Thus Maurice Blanchot writes in *Le Livre à venir* (1959):

> The book alone is important, as it is, far from genres, outside rubrics—prose, poetry, the novel, the first-person account—under which it refuses to be arranged and to which it denies the power to fix its place and to determine its form. A book no longer belongs to a genre; every book arises from literature alone, as if the latter possessed in advance, in its generality, the secrets and the formulas that alone allow book reality to be given to that which is written. Everything happens as if, genres having dissipated, literature alone was affirmed, alone shone in the mysterious light that it spreads and that every literary creation sends back to it while multiplying it—as if there were an "essence" of literature. (Cited by Rosmarin 7–8)[1]

Blanchot's emphasis on literary "essence" looks ahead to Barthes' famous formulation, in "From Work to Text" (1971), that "What constitutes the Text is . . . its subversive force in respect to the old classifications . . . the Text is that which goes to the limit of the rules of enunciation" (157). The point is made even more emphatically by Derrida in "The Law of Genre" (1980):

> I submit for your consideration the following hypothesis: a genre cannot belong to no genre, it cannot be without or less a genre. Every text participates in one or several genres, there is no genreless text; there is always a genre and genres, yet such participation never amounts to belonging. And not because of an abundant overflowing or a free, anarchic, and unclassifiable productivity, but because of the *trait* of participation itself. (65)

Which is to say that no text called, say, *tragedy* has traits that will identify all the texts within that class. Moreover, as soon as a given text is identified as *belonging to* a specific genre, that genre is no longer the same: participation inevitably means difference. The "law of genre," accordingly, can only be seen as a form of interdiction and punishment: " 'Do,' 'Do not' says 'genre' . . . as soon as genre announces itself, one must respect a norm, one must not cross a line of demarcation, one must not risk impurity, anomaly, or monstrosity" (56–57). And Derrida presents us with the example of Blanchot's *La Folie du jour*, arguing that its supposed generic designation—the *récit*—cannot contain its textual indeterminacies.

But of course Blanchot's inclusive term *book* (which "no longer belongs to a genre") is itself also a genre—and one that is not without its own generic aporias. The Mallarméan concept of *le livre* as the repository of what Blanchot calls the "mysterious light" of "literary creation" is itself historically bound, the embodiment of a late Romantic desire to escape from an increasingly technologized world, the world of newspapers, film, and photography, and, by Blanchot's time, of radio and television—all those non-book (and increasingly non-print) media that are ready to appropriate the book's place as literary sites. Indeed, however "irrelevant" generic taxonomies may seem in the face of the postmodern *interdisciplinarity* of the arts (see Barthes 155), however pointless it may seem to classify and label texts that refuse to fit into the established categories, practically speaking, it is virtually impossible to read a given new "text" without bringing to it a particular set of generic expectations. For how, in the first place, does one decide what to read or hear or look at? Can an interview affirm the "mysterious light" of literature? Can a lecture? A greeting card? A Congressional hearing? A telephone conversation? A message on the telephone answering machine?

It is the paradox of postmodern genre that the more radical the dissolution of traditional generic boundaries, the more important the concept of genericity becomes. Let me give a concrete example. In Spring

1987, Jack Miles, the book editor of the *Los Angeles Times*, announced that henceforth the *Times* would stop publishing reviews of poetry books, the rationale being that (a) so many such books are published that the editors cannot decide which ones are worth reviewing, and (b) nobody reads poetry anyway (although everyone seems to be writing it) and so the *Times* readership would be better served by the publication of even a single poem per week rather than by the review of X's new books of poems. Despite protests from local poets and their friends, within a few weeks Jonathan Yardley, writing his weekly column for *The Washington Post Book World*, applauded Jack Miles' courage and declared that, if truth were told, the *Post* would also like to get out of the poetry-reviewing business, there evidently being, according to Yardley, no critical consensus on who the leading poets, the poets worth reviewing, might be. Morever, Yardley concurred, the Book Review public just doesn't read poetry, so why review it?

One can dismiss these editorial decisions and comments as hopelessly Philistine—an insult to all of us who care about poetry. Or, more fruitfully, one can try to understand what is really involved. And here genre comes into play. By *poem*, Miles and Yardley mean essentially the short neo-Romantic lyric poem, an autonomous "framed" object, a set of which can be collected in a book. The reviewer, in turn, reads, or, more accurately scans, a number of such books, trying to find a particular trend or set of themes or pattern of self-revelation that gives the book in question its distinctive flavor.

But suppose I were to argue that there is more real "poetry" in one of Jonathan Borofsky's wall panels or in Laurie Anderson's performance pieces or in John Cage's "Irish Circus on *Finnegans Wake*" called *Roaratorio* than in X's or Y's most recent book of poems. If this were a correct assumption (and it means, of course, that I would be applying different generic markers to "poetry" than is Jonathan Yardley, that, for example, I would stress the sound features of poetry rather than such issues as subjectivity, sensitivity, or authenticity of feeling), then it would be quite untrue to say that in the late twentieth-century "no one cares about poetry." For Borofsky's installations, like Anderson's and Cage's performances, draw huge crowds.

What debates about such issues as "Does poetry speak to anyone today?" or "Who is our leading American poet?" suggest is that, even as we pronounce on the "irrelevance" of genre in a time of postmodern openness, inclusiveness, and flexibility, we are all the while applying

generic markers to the subjects of our discussion. When, for example, Jasper Johns exhibited, in 1958, his first paintings of alphabets and number series, of American flags and ordinary coat hangers, the public reaction was not "This is bad painting," but "That's *not* painting," as if to say that, since Johns' canvasses violated the formal, structural, and emotive norms of Abstract Expressionism, then in its heyday, they couldn't "belong" to the species called *painting*. In the same way, exemplars of what Linda Hutcheon calls *historiographic metafiction* are often dismissed as not sufficiently fictive, on the one hand, or not historically accurate enough on the other.

The case of theory is especially interesting in this regard. Allan Bloom's recent best-seller, *The Closing of the American Mind* (1987) articulates the malaise of a whole group of "well-educated" readers who cannot understand why "great works" (primary texts) are increasingly subordinated to the secondary discourse of arcane and mandarin theorists.[2] Criticism, after all, is supposed to serve literature, isn't it? How shocking, then, to have our students read Barthes' *S/Z* rather than the Balzac novella (*Sarrasine*) it purports to "analyze"!

Here again, it is a question of genre. For if we classify *S/Z* as anatomy, or, more accurately, as a kind of feverish Surrealist autobiographical fiction that obsessively revolves around the question, "What is a narrative and how can we ever hope to reconstruct what has happened and what it means?", a text, in any case, that tells us a good deal more about Barthes than about Balzac, then *S/Z* can enter the contemporary literature classroom and submit to close reading along with related fictions and poetic texts. But in that case, we won't assign *S/Z* as a paradigmatic critical text which students can "apply" to Joyce or Kafka. Again, it is our generic expectation that makes the difference.

Indeed, the real issue confronting us is not whether genre X is weighty enough or respectable enough to make its way into the literature class-room but rather, as Ralph Cohen, argues, *why* certain genres and conventions dominate at particular moments in history. "Classifica-tions," as Cohen has put it in an earlier essay, "are empirical, not logical. They are historical assumptions constructed by authors, audiences, and critics in order to serve communicative and aesthetic purposes" (210). As "open systems" that can be understood only "in relation to other genres" (Cohen 207), generic classes are inevitably fluid.

Moreover, new, or seemingly new genres regularly compete with the old, the validity and stability of a given genre tending to be guaranteed, as Maria Corti has suggested, not by the most original and profound works of a given period, but by the minor authors who perpetuate the already canonical (132). Thus it is our minor authors today who carry on, quite unselfconsciously, the tradition of the realist novel, even as minor painters perpetuate the genre of landscape painting and minor composers perpetuate the symphony. At the same time, as David Antin forcefully argues in his "The Stranger at the Door," other works, perhaps previously considered outside the High Art realm, begin to surface, challenging us, not so much to "open up" the canon of acceptable genres, as today's conventional wisdom would have it, as to rethink the "literary" or "aesthetic" field.

ii

In assembling the essays in this collection, no attempt has been made to "cover" the available postmodern genres: there is, for instance, no discussion of architecture or film, of dance or science fiction, to mention just four important areas that might profitably have been discussed. Partly, this neglect is the result of my decision to let the contributors follow their own bent, but it is also the case that the question of genre in postmodernism precludes precisely such comprehensiveness of coverage.

Nevertheless (and to my own surprise), the reader will find a marked area of conceptual agreement in what are otherwise a very diverse group of essays, a continuity of argument that reinforces my conviction that genre, far from being a normative category, is always culture-specific and, to a high degree, historically determined. Rather than summarizing the content of each essay in what would be a very un-postmodernist move, let me simply point to some interesting areas of agreement.

Whether writing about the historiographic metafiction of J. M. Coetzee or Christa Wolf (Linda Hutcheon), the *palimtexts* of George Oppen and Ron Silliman (Michael Davidson), the Gertrude Stein "illustrations" of Tom Phillips and Jiri Kolar (Renée Hubert), the performance art of Laurie Anderson (Jessica Prinz), the installations of Jonathan Borofsky (Henry Sayre), the narrative photographs of Cindy Sherman (Frederick Garber), or, in the case of my own essay, the textual/aural relationships in John Cage's *Roaratorio*, our contributors repeatedly use terms like *violation, disruption, dislocation, decentering, contradiction, con-*

frontation, *multiplicity*, and *indeterminacy*. Postmodern texts are regularly seen as *problematizing* prior forms, as installing one mode only to contest it, as exploiting the space between, say, "novel" and "history" (Hutcheon), between representation and invention (Garber), between original text and commentary (Hubert), between the verbal and the visual (Hubert, Sayre, Prinz, Perloff). In this context, *purity*, *autonomy*, and *objecthood* are the enemy (Sayre's rejection of Clement Greenberg's "purist" Modernism is implicit in most of the other essays as well), the pleasure of the text being regularly seen as one of *transgression* and *contamination*, of what Derrida calls the play of representations.

The short poems of George Oppen, for example, which are usually framed by the white space of the page in a given collection of Oppen's verse, take on an entirely different aura, so Davidson argues, when they are read as part of the Oppen archive, part of the manuscript page with its ancillary diary notes, its quotations from other writers, the sheer materiality of its writing and of the way that writing is assembled. However much a poet may want his or her lyrics to be presented in the pristine white space of the conventional page (or the equally pristine white space of the conventional art gallery), we now take pleasure in reading (and seeing) works, so to speak, archeologically. Both Cindy Sherman and Laurie Anderson (so Garber and Prinz respectively argue) oppose the self (usually construed as absent) and other; the psychological person is replaced by the linguistic one, even as nostalgia is displayed for the former. Or again, the scrambled series of what look like dictionary definitions that constitute George Brecht's "GLOSS FOR AN UNKNOWN LANGUAGE" is seen by David Antin as having marked affinities with Wittgenstein's *Tractatus* on the one hand and the genre we call science fiction on the other. Postmodern genre is thus characterized by its appropriation of other genres, both high and popular, by its longing for a both/and situation rather than one of either/or.

This is why *opera* may well be, as Herbert Lindenberger argues, all but impervious to the incursions of postmodernism. The institutional constraints of the opera house, with its emphasis on extravagance and brilliant decor, make opera "the last remaining refuge of the high style," the genre most difficult to "contaminate," even though postmodern directors repeatedly make the effort to do so. It is true, of course, that from the 1920s on and especially in recent years, opera has been subjected to its own share of transgression, as works like the Robert Wilson-Philip Glass *Einstein on the Beach* testify. But Lindenberger's

point is that when opera takes this route, it inevitably gives up its institutional base, thus becoming as it were, a somewhat suspect member of the family.

If disruption and transgression are intrinsic to postmodern genre, one would think that the critical or theoretical essay itself would have undergone a decisive swerve away from its Modernist predecessors. But in fact, as Ralph Cohen puts it with reference to Fredric Jameson and Brian McHale's essays of radical statement, "Alterations of views about dominant features do not [necessarily] result in changes of genre." Indeed, like opera, the professional critical essay—for example, the essay you are reading right now—has, perhaps regretfully, perhaps necessarily, made little attempt to challenge its institutional constraints. Recently, however, in such collections as Charles Bernstein's *Content's Dream* (1986) and Steve McCaffery's *North of Intention* (1987), the *essay* has shown signs of real difference—a difference exemplified in this volume by Joan Retallack's "Post-Scriptum-High-Modern." Part prose poem (and Retallack is a poet), part meditation on philosophical transforms, part analysis of the shifting forms of metanarrative as supplied by Lyotard, Baudrillard, Kristeva, Huyssens, and others, Retallack interweaves dialogue, aphorism, and comic citation—at one point she rewrites a passage from James' *Portrait of a Lady* in the syntax and vocabulary of Beckett—into her larger argument, submitting her own phrasing, as well as that of the many texts she quotes, to all manner of play.

It is therefore all the more surprising that, whereas most of the other essays (see especially Hutcheon and Hubert) are at pains to distinguish the Postmodern from the Modern, Retallack's essay is closest to Ralph Cohen's "Do Postmodern Genres Exist?", in its insistence on their essential continuity. Even an enigmatic and fragmented text like "nimr" by the Language poet P. Inman is finally, Retallack suggests, to be seen "as a fascinating post-script to a long century of modernist experimentation," a delicate shift in figure/ground ratio that reconfigurates the relationship of "text" to "world." Post-Scriptum, as she puts it, High (Hi) Modern. Or is this formulation too one that we must recognize as being generically conditioned?

NOTES

1. Rosmarin comments on this passage: "Is not Blanchot's 'literature' itself a vast genre, one whose 'generality' is paradoxically hidden by its very vastness? And is his 'book' the natural or self-evident 'particular' that it seems?" (8). See further the section titled "Resisting Genre" (8–10).

2. Bloom typically writes, "There are endless debates about methods—among Freudian criticism, Marxist criticism, New Criticism, Structuralism and Deconstructionism . . . all of which have in common the premise that what Plato or Dante had to say about reality is unimportant. These schools of criticism make the writers plants in a garden planned by a modern scholar, while their own garden-planning vocation is denied them. The writers ought to plant, or even bury, the scholar" (375).

WORKS CITED

Barthes, Roland. *Image—Music—Text*, Essays Selected and Translated by Stephen Heath. New York: Hill and Wang, 1977.

Blanchot, Maurice. *Le Livre à venir.* Paris: Gallimard, 1959.

Bloom, Allan. *The Closing of the American Mind.* New York: Simon and Schuster, 1987.

Cohen, Ralph. "History and Genre." *New Literary History*, 17 (Winter 1986): 203–218.

Corti, Maria. *An Introduction to Literary Semiotics.* Translated by Margherita Bogat and Allen Mandelbaum. Bloomington and London: Indiana University Press, 1978.

Derrida, Jacques. "The Law of Genre." *Glyph* 7 (Spring 1980); rpt. *Critical Inquiry*, 7 (Autumn 1980): 55–81.

Rosmarin, Adena. *The Power of Genre.* Minneapolis: University of Minnesota Press, 1985.

2

Do Postmodern Genres Exist?

Ralph Cohen
University of Virginia

Critics and theorists who write about postmodern texts often refer to "genres" as a term inappropriate for characterizing postmodernist writing. The process of suppression results from the claim that postmodern writing blurs genres, transgresses them, or unfixes boundaries that conceal domination or authority, and that "genre" is an anachronistic term and concept. When critics offer examples of postmodern novels, for example, they cite omniscient authors who are parodied or undermined. They point to self-conscious addresses to the reader in *If on a Winter's Night* and note the self-conscious foregrounding of literary artifice that undermines the generic assumption that a novel is referential or that it is a construction that bears a real relation to society.

These critics assume that a genre theory of the novel is committed to backgrounding literary artifice, to demanding coherence, unity and linear continuity. But though such an assumption may apply to some generic theories, there are others that are perfectly compatible with multiple discourses, with narratives of discontinuity, with transgressed boundaries. To mention the multiple discourses that Bakhtin defines as characteristic of the novel is to note only one of the modernist theorists who accept multiple discourses and discontinuous structures. Not only are there genre theories based on these premises but there are texts like *Tristram Shandy* and *Joseph Andrews* that exhibit what are now referred to as postmodern features. Ihab Hassan, one of the leaders of postmodernist theorizing, remarks that we now perceive "postmodern features in *Tristram Shandy* precisely because our eyes have learned to recognize postmodern features" (xvi).

Ihab Hassan is correct in noting that what we call "postmodern" writing is espied in an earlier time, but eighteenth-century genres exhibited some of the same features. We rename these features in terms of our critical language, but *Tristram Shandy*'s marbled pages were

11

transgressions then as now as were the foregrounding of literary artifice, the nonlinear narration, the insertion into the narrative of sermons, letters and stories. The basis for a genre theory of mixed forms or shared generic features is as old as Aristotle's comparison of tragedy and epic. Rosalie Colie has pointed out that numerous Renaissance writers self-consciously worked with mixtures of generic features, "self-conscious, carefully worked mixtures, which counterpoint against one another the separate genres Petrarca was trying to reestablish" (19). And such mixtures were not isolated cases but rather a way of thinking, of assuming that genres, mixed or unmixed, were the appropriate carriers of ancient knowledge. In fact the mixtures found in Homer's works were considered by some critics as the source of all poetic kinds. Colie points out that "there were many more kinds [genres] than were recognized in official literary philosophy; and it is by these competing notions of kind that the richness and variety of Renaissance letters were assured" (8). [1]

Postmodern critics and theorists are often unaware of the various generic theories that have been created, and when they attack genre assumptions, they select these most often from modernist critics. Jonathan Culler, for example, in his 1975 essay, "Towards a Theory of Non-Genre Literature" took as his modernist model the assumption that genre was a set of expectations between reader and text. This was a modernist assumption that could have been derived from Northrop Frye's *Anatomy of Criticism* (1957). By the mid-1970s there were several modernist formulations of a "set of expectations." But this phrase is always part of a comprehensive statement or theory. For example, for Hans Robert Jauss the "set of expectations" form one part of his system of the aesthetics of reception and influence.

> The analysis of the literary experience of the reader avoids the threatening pitfalls of psychology if it describes the reception and influence of a work within the objectifiable *system of expectations* that arises for each work in the historical moment of its appearance, from a pre-understanding of the genre, from the form and themes of already familiar works, and from the opposition between poetic and practical language. (22) [My italics][2]

And the relation of expectations to a particular public as addressee was formulated by Maria Corti: "every genre seems to be directed toward a certain type of public, sometimes even to a specific class, *whose expectations* are directed toward that genre as long as social conditions warrant" (118). [My italics]

Culler formulates the concept of expectations as follows: "genre, one might say, is a set of expectations, a set of instructions about the type of coherence one is to look for and the ways in which sequences are to be read" (255). This is a reader based definition, one that can accommodate to many variations within a genre. But it does not take account of how this generic claim actually fits into a genre theory. These theories attend to the historical moment of a work's appearance or to the social conditions that provide a warrant to a particular public for a specific genre.

When a theory of expectations is divorced from its theoretical frame it can be treated as an unstated "contractual" relation of author to reader although the formulation of such a contract is a legal image, not an actual situation. Culler argues that postmodern novels void the contract because they alter conventions and become "unreadable." But this argument presupposes some hypothesis about how conventions begin, how they become commonplace and how they are altered or abandoned. Postmodern genres, as many critics point out, have features that are inherited from modernist genres. Since genres are interrelated, there seems always a basis for some readability. And at the end of the essay Culler seems to concede that even abstruse postmodern novels come to be read because of a basic human capacity for ordering disorder. There is, he writes, an "astonishing human capacity to recuperate the deviant, to invest new conventions and functions so as to overcome that which resists our efforts" (259).[3] In fact Joyce's *Finnegans Wake*, a text often used as an example of postmodern writing, is treated by Frye as an encyclopedic form and ironic epic. The text requires no abandonment of a genre system: on the contrary, it can fit quite readily within it.

Postmodern critics have sought to do without a genre theory. Terms like "text" and "écriture" deliberately avoid generic classifications. And the reasons for this are efforts to abolish the hierarchies that genres introduce, to avoid the assumed fixity of genres and the social as well as literary authority such limits exert, to reject the social and subjective elements in classification. But these reasons apply to a genre theory that Austin Warren calls "classical" and that argues for the "purity" of genres. As he points out, modern genre theory is descriptive: "It doesn't limit the number of possible kinds and doesn't prescribe rules to authors. It supposes that traditional kinds may be 'mixed' and produce a new kind (like tragi-comedy)" (245). Modernist genre theories minimize classification and maximize clarification and interpretation. Such genre theories are part of semiotic theories of communication that relate genres

to culture. Indeed, modernist critics who resort to genre theory—
Todorov, Jameson, Fowler, Bakhtin, Gilbert and Gubar[4]—undertake to
explain and analyze the relation between trivial or ignored genres and
canonized genres. And this is a procedure that seems most applicable to a
postmodern inquiry.

The initiation or use of one genre is determined by its relation to
others. If writing were always identical, there would be no kinds and no
need for generic distinctions about whole works. And if each piece of
writing were different from all others there would be no basis for
theorizing or even for communication. But since one piece of writing
tends to be based on other pieces—some theorists refer to genres as
families of texts with close or distant relatives—a genre offers the most
extensive procedure for dealing with this phenomenon. It not only
inquires into the reasons for intertextuality; it inquires into the signifi-
cance of the combinatory procedures that result from it. The generic
concept of combinatory writing makes possible the study of continuities
and changes within a genre as well as the recurrence of generic features
and their historical implications. But this particular genre theory is one
among many. Theorists who propose genre theories no less than those
who oppose them need, therefore, to explore the aims which govern any
genre theory. Whether the purpose of a genre system (however con-
structed) be evaluative, as it was for Aristotle or Dryden or Irving
Babbitt, or educative as it was for Renaissance theorists, or evolutionary
as it was for Brunetière, or a system of communication as it is for Maria
Corti or an ideological structure as it is for Fredric Jameson or a basis for
understanding literary transitions and history as it was for the Russian
formalists, genre theorizing is itself a genre. It can be an essay, literary
criticism, literary theory, literary history, etc. And writing in genres is
demonstrated by a text itself.

When Derrida asks of what genre is genre, he draws attention to the
fact that his own essay belongs with essayistic genres like literary theory
or philosophical discourse. This is not the place to discuss the issues
involved in the naming of genres, but to point out that every text is a
member of one or more genres. What needs to be studied are the
constituents of a text and what kinds of effects these have or can have
upon readers. It is these constituents in a mixed or combinatory form
that make some theorists refer to genres as "blurred." In this respect,
many critics who find postmodern writing non-generic because it is
combinatory or reader oriented or discontinuous seem to be unfamiliar

with the available generic theories upon which they can draw.

Clifford Geertz's essay, "Blurred Genres," is a noteworthy example of assuming that the blurring or mixing of genres is indicative of a new way of thinking. Although his essay is directed at studies of social thought, it also refers to literary examples. He describes the phenomenon of blurring as follows:

> . . . scientific discussions looking like belles lettres *morceaux* (Lewis Thomas, Loren Eiseley), baroque fantasies presented as deadpan empirical observations (Borges, Barthelme), histories that consist of equations and tables or law court testimony (Fogel and Engerman, Le Roi Ladurie), documentaries that read like true confessions (Mailer), parables posing as ethnographies (Castenada), theoretical treatises set out as travelogues (Lévi-Strauss), . . . Nabokov's *Pale Fire*, that impossible object made of poetry and fiction, footnotes and images from the clinic, seems very much of the time; one waits only for quantum theory in verse or biography in algebra. (165–66)

Geertz finds interactions and intertextuality in and out of "literary" texts. I add to his examples by noting that genres such as ballads, lyrics, proverbs, short stories, etc., become part of other texts—of novels, of tragedies, of comedies. He notes that parts of a genre such as autobiography, can be mixed with a scientific disquisition (James Watson's *The Double Helix*). One can add that a theoretical essay (Annette Kolodny's "Dancing Through the Minefield: Some Observations on the Theory, Practice, and Politics of a Feminist Literary Criticism") can also contain autobiographical discourses. For Geertz, this procedure represents a refiguration of social theory; he sees it as indicative of a change in social inquiry from one concerned with *what knowledge is* to "what it is we want to know" (178). He assumes that "modernist" inquiry studied the dynamics of collective life in order to alter it "in desired directions" (178). Postmodern inquiry studies the anatomization of thought, not the manipulation of behavior. In *The Double Helix*, however, the purpose of mixing laboratory politics with scientific inquiry serves to undermine the "objectivity" of scientific procedures and the assumption of a unified scientific community. And Kolodny's essay, in its combinatory procedures, describes her actual indoctrination by male critics in order to support her argument urging the need for an adequate feminist criticism. It is an attack on the "objectivity" of literary criticism, on the need for an overt acknowledgement of the authority implied in such criticism, on the need for recognition of gender as an overlooked or repressed aspect of academic instruction.

In these works, the combination of autobiography, laboratory or classroom practice and politics is related to social and political attitudes. Combinations present not merely the procedures of scientific or literary inquiry, but serve to illustrate the procedures by which they conceal antagonisms, prejudices and disunity. This generic analysis redirects textual analyses: from studying behavior to studying the grounds of behavior; from the overt desire to manipulate behavior to studying the nature of this desire, the actual processes of manipulation.

The texts that I have been describing still fall within accustomed genres: the history of a scientific discovery or the theoretical essay about literary study. Nevertheless they do transgress the modernist generic bounds by introducing subjective elements and insisting on the ideological bases governing inquiries. Still, the very concept of transgression presupposes an acknowledgment of boundaries or limits. Such transgressions, as some theorists of postmodernism recognize, presuppose genres, presuppose that postmodern practices have not homogenized writing; rather they continue to introduce distinctions even though these differ from modernist practices. Certain models of modernist literature—Dos Passos's *U.S.A.*, Pound's *Cantos*, Faulkner's *Absalom, Absalom!*—are cited repeatedly as combinations of multiple discourses found in modernist genres. Thus the issue is not a matter of multiple subjects or discontinuous narration, but of the shift in the kinds of "transgressions" and in the implications of the revised combinations. And Bakhtin, Jameson and other modernist genre theorists do provide insights into the social basis of generic structures.

What alternatives exist if one rejects the study of genres in analyzing postmodern texts? One can discuss themes, one can discuss periods, one can discuss rhetorical strategies. None of these, however, are incompatible with generic study. If we conceive of postmodernism as a style, it must be defined or described by being shown to be different from the modernist style. And yet any such change will inevitably call upon similarities or continuing features. If we conceive of postmodernism as a period, such description will have to include genres like tragedy or new mass culture genres like TV sitcoms and the detective or spy story and film. A period study will have to include genres like Shakespeare's plays and Milton's *Paradise Lost* from earlier periods that are kept alive by the curricula of academic institutions and stage or TV productions. A period study, therefore, unless it degenerizes all previous texts within a given chronological segment, will inevitably have to retain the language of

genres as a part of the period.

It is one of the ironies of postmodern criticism that critics who are rightly cognizant of the constraints imposed by boundaries, who seek to reveal what boundaries conceal about "the nexus between knowledge and power," often do so within boundaries they seem not to recognize. In the introduction to an anthology of theoretical essays entitled *Criticism Without Boundaries*, the editor sees boundaries in terms of disciplinary demarcations. But the anthology of essays is itself a genre, a genre that has been practiced by modernist no less than by postmodernist critics. The essays themselves are collected into a fictitious unity, and they are written, each of them, in the linear tradition of the modernist essay with intersections of sociological, educative and Marxist discourses. What this generic combination implies, since the essays were given or intended as lectures, is the disregard of the difference between oral delivery and the written text in an anthology, between the relation of an audience to a speaker in contrast to a reader reading an essay. We have generic continuity of a modernist genre that aims, as Robert Stallman's anthology did, to undermine earlier critical positions. An awareness of this enterprise as generic would have introduced an aspect of cultural continuity requiring explanation. After all, this postmodern enterprise displays a readiness of critics to operate within the academy, using modernist generic conventions to undermine modernism and its values. This generic procedure operates within familiar categories and constituents including the insistence on the need to defamiliarize them and to politicize them.

One can point out that the journal and the anthology as genres present options of beginning with any selection, of providing multiple thematic approaches or variations of one approach. The texts within an anthology call attention to shared features of essays or poems or stories no less than to differences and they thus permit distinctions to be made regarding individual examples. But these combinatory texts, when they deny their generic identity, serve to repress the difference between what they say and what they are. What lurks in the denial of generic combinations while employing them is the fear that boundaries are conservative, that to admit that bounds or limits are inevitable is to submit to them. But as I have pointed out, there need be no such confinement. "Postmodernist" writing without boundaries is as much a fiction as postmodernist writing fixed by them.

The combinatory nature of genres moves in our time to mixtures of

media and to mixtures resulting from the electronic world in which we live. Films,[5] TV genres, university educational programs, our very explanations of identity and discourses all indicate combinations of one kind or another. The precise nature of these combinations differ, but what genre critics and theorists can now study are the interactions within combinations and how these differ from earlier combinations, whether in epic, tragedy, novel, lyric, etc.

This generic procedure, this combinatory genre theory no less than that of the postmodern "novel" or surfiction, has significant antecedents in the writings of the early eighteenth century. Marjorie Perloff has suggested that this might be the case with postmodern poetics: "Postmodern poetics, it may yet turn out, has more in common with the performative, playful mode of eighteenth-century ironists than with Shelleyan apocalypse" (176). Here the recognition of the anthology as a genre reveals a substantial clue for grasping what might be called generic history, the discontinuous recurrence or the continuity of certain genres or features of genres.

To pursue one example of this that is pertinent to postmodern genres, I wish to consider some of the innovative genres that occur at the beginning of the eighteenth century. One of the characteristic features of that species of writing which came to be called the novel reveals a narrator who quite consciously addresses the reader and suggests how the text should be read. The obvious example, *Tristram Shandy*, resists narrative closure, linear narration, includes genres such as the sermon, letter, and story, produces interventions of musical and other non-verbal genres. Certainly with regard to the postmodern palimpsest assumption that each new text is written over an older one,[6] one need only consult a satire like Swift's *A Tale of a Tub*. And Henry Fielding's *Joseph Andrews* announces itself as "Written in Imitation of Cervantes, Author of Don Quixote." I am not suggesting that Fielding is Borges or that *Joseph Andrews* is equatable with "Pierre Menard, Author of the *Quixote*" or that "imitation" as used in the eighteenth century is anything but resisted and discarded by postmodern critics. What I am arguing is that Fielding's self-conscious addresses to the reader, that his use of inset stories and thus of multiple narrators who result in making the primary characters become secondary while some of the trivial characters become, for the inset story, the primary narrators, that these practices are analogous to some in postmodern genres. When the inset story of Leonard and Paul is interrupted and left uncompleted in *Joseph Andrews* we have a further

instance of the discontinuity characteristic of postmodern writing. A generic history will not merely point to these recurrences, but suggest that these are tied to social and cultural no less than literary phenomena. Thus these procedures are not merely engaged in rejecting inherited hierarchial genres, but, by parodying them, they offer a consciousness of certain limited eighteenth-century alternatives.

Since I am proposing a historical linkage between eighteenth-century and postmodern genres, I wish to relate the innovative periodical essay to the postmodern presence of the critical and theoretical essay. My purpose in drawing attention to the prevalence of innovative early eighteenth-century genres and those in our time is to indicate shared features. These reveal relations between generic constituents and societal changes. The eighteenth-century genres that appeared in periodical papers—letters, stories, critical and political essays, etc.—were addressed primarily to a female audience deprived of a university education. They sought to educate a new audience and in so doing helped create in readers a consciousness that some transgressions were an acceptable and even desirable practice. If, as Douwe Fokkema claims, postmodernism is "the most 'democratic' of literary codes" (48), the generic developments of the earlier time sought to provide generic changes that would make it possible to legitimate a bourgeois society. However different a postindustrial society is from one moving into a bourgeois economy, genre theory may indicate that we are dealing with beginnings and endings. If an analysis of eighteenth-century generic instances and intersections reveals that these served to elevate folk genres (or popular genres ignored by critics) then it seems reasonable to inquire what shifts are involved in modern and postmodern critical acts that elevate formerly ignored genres like slave narratives or popular romances so that they merit academic research and critical analyses. In both situations we find the retention of some older genres, whether the sermon or comedy. In both periods there develop popular genres that serve readers not yet a coherent part of a bourgeois class or of a postmodern non-elite audience. The limits imposed by postmodern writing surely narrows its audience, an audience that responds more fully to rock music of the sixties, to TV sitcoms and to other genres current in the modernist period.

Critics and theorists disagree about how to explain the phenomenon of postmodernism; some even believe that such explanations are unnecessary. But it is especially important to observe that by rejecting generic procedures, such critics deprive themselves of explanatory tools. In order

to demonstrate the characteristics of postmodern writing, critics need to distinguish these from those found in modernism. Postmodern critics resist the usefulness that generic critics find in discussing entities. But writings of different kinds do begin and stop. Constituent parts require that they be considered both within the text and in connections with other texts that begin and stop differently. Some generic procedures are essential to any such effort. Derrida, in discussing the genre of a text by Maurice Blanchot, declares that it reveals the madness of genre: "in literature, satirically practicing all genres, imbibing them but never allowing herself to be saturated with a catalogue of genres, she, madness, has started spinning Peterson's genre-disc like a demented sun. And she does not only do so *in* literature, for in concealing the boundaries that sunder mode and genre, she has also inundated and divided the borders between literature and its others" (228).

But this very attack upon genre falls within the genres of satire, parody and literary theory. To note that genres are necessary in order to be rejected is to remain within the discourse of genres. That a short work can have reference to or be the basis of all other genres is to parody the claim that Homer's epics included them all (however ironic one treats or parodies this claim).

Derrida's parodic essay does, of course, have an ending regardless of its "openness." And it is this writing against genre while being in it that Linda Hutcheon identifies with parody: "The collective weight of parodic *practice* suggests a redefinition of parody as repetition with critical distance that allows ironic signaling of difference at the heart of similarity" (185).[7] This definition applies to parody as a constituent of a text as well as a genre of its own. And it is as a genre that parody displays itself in the playful/serious text that Derrida has written.

I have emphasized the constituents of generic text, the combinatorial parts that together produce effects upon readers. But it is necessary, also, to stress the notion of an entity, of the consequences of particular kinds of combinations, mixtures, multiple discourses, intertextuality. The language that critics—modern and postmodern—use in discussing texts implies images of the human body as a system, as a biological organism (gender), as a machine. They refer to voice, to sight, to hearing, to smelling, moving, etc. Overtly or implicitly the image of the body of the reader (sometimes of the narrator) is present in the transaction with a text. In drama, of course, the actor's body is a constituent of the drama whereas in postmodern fiction the body can be a theme as it is in

Sukenick's "The Death of the Novel." But there is another sense in which the image of the text as a member of a genre is appropriate. Just as a human body has physically descriptive limits, so, too, does any text. The body is dependent on oxygen, on drawing into itself and excreting from itself substances that make it possible to endure as a physical entity, so texts depend upon the language of generic forms in order to be considered as verbal entities. These make it possible to distinguish texts that at any one time are considered unknown or even unknowable genres from those that are known. How does the unknown genre become knowable? That the concept of a genre changes because its members change is self-evident. What is not self-evident is how the constituents of a text begin to undermine the usefulness of a genre so that critics offer replacements.

Two examples should be mentioned here. One is M. H. Abrams's positing of "the Greater Romantic Lyric" as a genre. His procedure is to argue that no known genre describes the texts to which he refers. The new genre is a combination of parts from the loco-descriptive poem, the Romantic meditative lyric, the conversation poem. For Abrams, the new genre "displaced what neoclassical critics had called 'the greater ode' . . . as the favored form for the long lyric poem" (528). Abrams sought to fill a gap in our understanding of Romantic literary invention. He thus proceeded generically in locating the origins of the new genre for which numerous examples existed but remained unnamed or misdescribed.

The second example of generic imitation occurs in Rosalind Krauss's essay "Sculpture in the Expanded Field." Her argument is that critics have expanded the genre "sculpture" to include earthworks, "narrow corridors with TV monitors at the ends; large photographs documenting country hikes" (277), and other structures so that the category has become "almost infinitely malleable" (277). The reasons for such inclusion she attributes to the desire to make the new familiar by assuming that the new forms evolved from past forms. In this respect genre serves to avoid discontinuity by expanding the members of the category. Krauss argues that the genre is a "historically bounded category" with its "own internal logic, its own set of rules, which, though they can be applied to a variety of situations, are not themselves open to very much change" (279). But if the reliance on the internal logic of sculpture is a problematic use of "logic," her subsequent explanation is much more persuasive. It is that the genre "sculpture" must be understood in relation to the genres of landscape and architecture (and not-landscape

and not-architecture): "within the situation of postmodernism, practice is not defined in relation to a given medium—sculpture—but rather in relation to the logical operations on a set of cultural terms, for which any medium—photography, books, lines on walls, mirrors or sculpture itself—might be used" (288). For Krauss, the remapping of genres is the result of forces reshaping history contemporaneous with the new genres. And the durability of these genres, established by ruptures in concepts of history, would seem to be contemporaneous with the history that initiated it.

For Fredric Jameson, the history that initiates postmodern views of sculpture is not a matter of the rational logic of a genre, but what he calls "cultural logic." Postmodernism is a historical period concept characteristic of the late stage of capitalism.

In his projection of a "new systematic cultural norm," Jameson names as the constituents of postmodernism he plans to discuss "a new depthlessness," "a consequent weakening of historicity," "a whole new type of emotional ground tone," "the deep constitutive relationships of all this to a whole new technology, which is itself a figure for a whole new economic system."[8] I cannot rehearse here Jameson's remarkable study of sophisticated and complex features that change as a result of economic changes, his distaste for the dominant cultural norm he finds in postmodernism, his desire to replace Hutcheon's key term "parody" with "pastiche," a term that makes "parody" blank, "a statue with blind eyeballs."

The very same concept of a cultural "dominant" is developed by Brian McHale except that the latter finds critics discovering various "dominants" demonstrating the reciprocal linkages between modernism and postmodernism: "Clearly, then, there are *many* dominants, and different dominants may be distinguished depending upon the level, scope, and focus of the analysis. Furthermore, one and the same text will, we can infer, yield different dominants depending upon what aspect of it we are analyzing . . . In short, different dominants emerge depending upon which questions we ask of the text, and the position from which we interrogate it" (6).[9]

The writings of Jameson and McHale fall into established genres of critical theory and literary criticism. Alterations of views about dominant features do not result in changes of genre. It thus appears that Jameson's Marxist interventions and McHale's formalist interventions still aim at reader persuasion. Thus we can note that the ideology in the

linear essay can be seen as resisting postmodernist emptiness of form or aligning some aspects of modernist ideology while others involve an attack upon it. The two texts thus render paradoxical the arguments they make.

The writings of the critics and theorists who argue for "postmodern" as a turning away from modernism find themselves, with few exceptions, continuing to write in the essay genres that were characteristic of modernism. Whatever thematic discourses of generic interpretations they introduce into their essays, they combine them with the traits of modernist essays. Even an essay that seeks to free itself from the modernist genre does include some modernist devices. Thus an essay by Ihab Hassan entitled "POSTmodernISM: A Paracritical Bibliography" undertakes the creation of the essay as encyclopedic genre, as a verbal object typographically innovative, deliberately disjunctive, rejecting linear development, including parts that are normally excluded from the text itself (a bibliography), blank lines for the reader to fill in as he wishes and to become an author, participating in the writing of the essay: "I offer . . . some rubrics and spaces. Let the readers fill them in with their own spaces or grimaces. We value what we choose" (35).

Yet even as he experiments with the transformation of the essay, Hassan expresses reservations about postmodernism's transformatory characteristics. Is it, he asks, "somewhat more inward with destiny? Though my sympathies are in the present, I cannot believe this to be entirely so" (45). This essay was published in 1971; in *The Postmodern Turn* published in 1987, he writes of postmodernism with considerable uneasiness about its usefulness as a category: "Though postmodernism may persist, like modernism itself, a fiercely contested category, at once signifier and signified, altering itself in the very process of signification, the effort to speak it can not be wholly vain" (xii).

Critics are divided about the constituents of postmodernism and about its relation to modernism. But most essays confine themselves to constituents of texts rather than to texts as examples of genres. Matei Calinescu writes that as long as we compare and contrast postmodernity with modernity, "modernity survives, at least as the name of a cultural family resemblance in which, for better or for worse, we continue to recognize ourselves" (312). Even Linda Hutcheon, in her comprehensive attempt to theorize about postmodernism, points out that postmodernism's relation to modernism is typically contradictory. "It makes neither a simple and radical break with it nor a straightforward continuity with

it: it is both and neither" (23).

Now this description occurs in an essay developed in a linear manner, including, however, some of the discourses of postmodernism in fiction and the other arts as well as discourses from Marxist and other critics, and, in conclusion, arriving at pluralism, at pragmatism, at an understanding of signifying processes (at epistemology) and even (perhaps in a parodic demonstration of postmodernist contradictions) at a version of humanistic aims: "To move from the desire and expectation of sure and single meaning to a recognition of the value of differences and even contradictions might be a tentative first step towards accepting responsibility for both art and theory *as signifying processes*. In other words, maybe we could begin to study the implications of both our making and our making sense of our culture" (26).

The critical and theoretical essay—and my essay is another example of this—is a genre that has come to be practiced more frequently in the late modernist and postmodernist periods than at any time previously in English literary history. To recognize it as a kind of writing, as a genre, is to demonstrate some of the functions it has for us. The essay is not merely a part of anthologies; it is a genre of its own and critics have traced its changes from Montaigne to the present. The academic essay serves postmodernism by exemplifying how a genre can embrace discourses that attack genres, how a genre can be the site of contrary ideologies.

Roland Barthes' view of the essay, as quoted by Réda Bensmäia, is that it is a question " 'with intellectual things . . . of combining . . . *at the same time* theory, critical combat, and pleasure.' " And Barthes' experimentation with the essay as a unique form offers "the possibility of a 'plural' text made up of multiple networks 'that interact without any one of them being able to dominate the others' . . . it has no beginning; it is reversible; we gain access to it by several entrances, none of which can be authoritatively declared to be the main one' " (99).

This is a postmodern view of the essay and it does not refer to the essays I have quoted, but it does draw attention to the fact that the theoretical essay is a historical kind. If this is a postmodern definition, then the multiple networks argument is itself a dominant for postmodern essays. Treating the essay as genre is a recognition that discourses cannot be an adequate substitute for the works that encompass them. The rejection of genre falsifies the situation in which entrances are many and exits are many. For it conceals the fact that in different kinds of postmodernist writing, in novels, dramas, essays, entrances and exits are not the same.

Do postmodern genres exist? This question can now be seen in the context I have set for it. If one wishes to trace the relation between modernism and postmodernism, if one wishes to understand the diverse ways of distinguishing postmodern fiction from postmodern surfiction and from the romance and spy story as fictions equally contemporary but not postmodern, then genre study is the most adequate procedure to accomplish this aim.

Do postmodern genres exist? If we wish to understand the proliferation of academic anthologies, journals, collections of critical essays, then we need names for such omnibus volumes and genre theory provides them. If we wish to study these kinds of writing with reference to the social environment of which they are a part, then genre study helps us relate institutions and economics to the production of texts. If we seek to understand the historical recurrence of certain kinds of writing, the rejection or abandonment of other kinds, genre theory provides the most adequate procedure for this inquiry. If we wish to analyze an individual text, genre theory provides a knowledge of its constituents and how they combine. Not only do these actions recognize the value of a genre theory in analyzing modernist writing, but they demonstrate that postmodern theorists, critics, authors and readers inevitably use the language of genre theory even as they seek to deny its usefulness.

NOTES

1. On page 29 of *The Resources of Kind*, Colie writes: "I would like to present genre-theory as a means of accounting for connections between topic and treatment within the literary system, but also to see the connection of the literary kinds with *kinds* of knowledge and experience; to present the kinds as a major part of the *genus universum* which is part of all literary students' heritage."

2. An earlier version of some sections of this essay was published in 1970 in *New Literary History*.

3. A point similar to Culler's on the unreadableness of some postmodern genres is made by Charles Caramello. Referring to essays by Edmond Jabes, Ihab Hassan, Campbell Tatham and Raymond Federman, he writes: "What they *are* is impossible to ascertain. 'Impossible to classify these books,' Rosemarie Waldrop writes of Jabes's *Le Livre des Questions*. 'They have the texture of poetry, but are mostly prose.' "

4. Discussions of this aspect of genre theory can be found in the essays of Jurij Tynjanov and Roman Jakobson in *Readings in Russian Poetics: Formalist and Structuralist Views*; M. Bakhtin, *Problems of Dostoevsky's Poetics, The Dialogic Imagination*, and *Speech*

Genres and Other Late Essays; T. Todorov, *The Fantastic*; Alastair Fowler, *Kinds of Literature*; Fredric Jameson, *The Political Unconscious*; Sandra M. Gilbert and Susan Gubar, *The Madwoman in the Attic*.

5. See Rick Altman, *The American Film Musical*, Christian Metz, *The Imaginary Signifier*, and S. J. Solomon, *The Film Idea*, among others.

6. Charles Caramello quotes Julia Kristeva in *Performance in Postmodern Culture*: "every text takes shape as a mosaic of citations, every text is the absorption and transformation of other texts. The notion of intertextuality comes to take the place of the notion of intersubjectivity" (224).

7. The entire issue is devoted to the subject "Modernity and Modernism, Postmodernity and Postmodernism."

8. See also an earlier version "Postmodernism and Consumer Society."

9. The concept of the "dominant" is applied by T. Todorov to a theory of genres in *The Fantastic*.

WORKS CITED

Abrams, M. H. "Structure and Style in the Greater Romantic Lyric." *From Sensibility to Romanticism*. Ed. F. W. Hilles and H. Bloom. New York: Oxford UP, 1965.

Altman, Rick. *The American Film Musical*. Bloomington: Indiana UP, 1987.

Bakhtin, Mikhail. *The Dialogic Imagination*. Trans. Caryl Emerson and M. Holquist. Austin: U Texas P, 1981.

————. *Problems of Dostoevsky's Poetics*. Ed. and trans. Caryl Emerson. Minneapolis: U of Minnesota P, 1984.

————. *Speech Genres and Other Late Essays*. Ed. Caryl Emerson and M. Holquist. Trans. V. W. McGee. Austin: U of Texas P, 1986.

Barthes, Roland. *The Barthes Effect: The Essay as Reflective Text*. Trans. Pat Fedkiew. Minneapolis: U Minnesota P, 1987.

Buttigieg, J. A., ed. *Criticism without Boundaries*. Notre Dame: Notre Dame P, 1987.

Calinescu, Matei. *Five Faces of Modernity*. Durham: Duke UP, 1987.

Caramello, Charles. "On Styles of Postmodern Writing." *Performance in Postmodern Culture*. Ed. M. Benamou and C. Caramello. Madison: U Wisconsin P, 1977.

Colie, Rosalie. *The Resources of Kind*. Berkeley: U California P, 1973.

Corti, Maria. *An Introduction to Literary Semiotics*. Trans. M. Bogat and A. Mandelbaum. Bloomington: Indiana UP, 1978.

Culler, Jonathan. "Towards a Theory of Non-Genre Literature." *Surfiction*. Ed. Raymond Federman. Chicago: Swallow Press, 1975; 2d ed. 1981.

Derrida, Jacques. "The Law of Genre." *Glyph* 7. Baltimore: Johns Hopkins UP, 1980.

Fokkema, Douwe W. *Literary History, Modernism and Postmodernism*. Amsterdam and Philadelphia: John Benjamins, 1984.

Fowler, Alastair. *Kinds of Literature*. Cambridge, Mass.: Harvard UP, 1982.

Geertz, Clifford. "Blurred Genres: The Refiguration of Social Thought." *The American Scholar* 49 (Spring 1980).

Gilbert, Sandra M. and Susan Gubar. *The Madwoman in the Attic: The Woman Writer and the Nineteenth-Century Literary Imagination*. New Haven: Yale UP, 1979.

Hassan, Ihab. *The Postmodern Turn*. Columbus: Ohio State UP, 1987.

Hutcheon, Linda. "The Politics of Postmodernism: Parody and History." *Cultural Critique* 5 (Winter 1986–87): 179–207.

————. "Beginning to Theorize Postmodernism." *Textual Practice* 1.1 (Spring 1987): 23.

Jakobson, Roman. "The Dominant." *Readings in Russian Poetics: Formalist and Structuralist Views.* Ed. L. Matejka and K. Pomorska. Cambridge: MIT P, 1971.

Jameson, Fredric. *The Political Unconscious.* Ithaca: Cornell UP, 1981.

———. "Postmodernism and Consumer Society," *The Anti-Aesthetic Essays on Postmodern Culture.* Ed. Hal Foster. Port Townsend, WA: Bay P, 1983.

———. "Postmodernism, or The Cultural Logic of Late Capitalism." *New Left Review* 146 (July/August 1984).

Jauss, Hans Robert. "Literary History as a Challenge to Literary Theory." *Toward an Aesthetic of Reception.* Trans. T. Bahti. Minneapolis: U Minnesota P, 1982.

———. "Literary History as a Challenge to Literary Theory." *New Literary History* 2.1 (Autumn 1970): 7–37.

Kolodny, Annette. "Dancing Through the Minefield: Some Observations on the Theory, Practice, and Politics of a Feminist Literary Criticism." *Feminist Studies* 9 (1980).

Krauss, Rosalind E. "Sculpture in the Expanded Field." *The Originality of the Avant-Garde and Other Modernist Myths.* Cambridge: Harvard UP, 1985, pp. 277–90.

McHale, Brian. *Postmodernist Fiction.* New York and London: Methuen, 1987.

Metz, Christian. *The Imaginary Signifier.* Bloomington: Indiana UP, 1982.

Perloff, Marjorie. "Postmodernism and the Impasse of Lyric." *The Dance of the Intellect.* Cambridge: Cambridge UP, 1985.

Rose, B. G., ed. *TV Genres.* Westport, CT: Greenwood P, 1985.

Solomon, S. J. *The Film Idea.* New York: Harcourt Brace Jovanovich, 1972.

Stallman, Robert W., ed. *Critiques and Essays in Criticism 1920–1948.* New York: Ronald Press, 1949.

Sukenick, Ronald. *The Death of the Novel and Other Stories.* New York: Dial Press, 1969.

Todorov, Tzvetan. *The Fantastic.* Trans. R. Howard. Cleveland: Case Western Reserve U, 1973.

Tynjanov, Jurij. "On Literary Evolution." *Readings in Russian Poetics: Formalist and Structuralist Views.* Ed. L. Matejka and K. Pomorska. Cambridge: MIT Press, 1971.

Warren, Austin. "Literary Genres." R. Wellek and A. Warren. *Theory of Literature.* New York: Harcourt Brace, 1949.

Watson, James. *The Double Helix.* New York: Signet Books, 1969.

3

From Opera to Postmodernity:
On Genre, Style, Institutions

Herbert Lindenberger
Stanford University

Among the performance art-forms flourishing today, none would seem more distant from a postmodernist sensibility than opera. One need merely visualize the well-groomed crowd in any of the world's major opera houses as it scurries through the lobby to reach the auditorium before the lights go out precisely at their appointed time. (Lateness is generally punished with a mandatory stay in the lobby throughout the first act—though sometimes with the performance thrown in on closed-circuit TV to remind the stragglers what they might be seeing in the flesh had they been less dilatory.) Those in the darkened auditorium accept a role of silence and passivity (programs these days caution the audience to switch off its digital-watch alarms) as they witness the active goings-on just the other side of the proscenium.

This proscenium, which became a part of theater architecture at more or less the time opera was invented nearly four centuries ago, has, especially since the mid-nineteenth century, worked in effect to separate audience from singers, to assure that the stage illusion remain inviolate. It hardly matters if the singers are obese or are unable to act with the verisimilitude that audiences have come to expect in the non-musical theater. Indeed, the programs in the spectators' hands (not to speak of those supertitles projected with increasing frequency these days above the proscenium) seek to guarantee a correspondence between the doings onstage and the text that is being enacted. "When Padre Guardiano answers her call for help, Alvaro curses his fate, but Guardiano and the dying Leonora beg him to find salvation in religion," one reads at the end of a typical program synopsis (*Forza*). Whatever these fateful words may mean, we are expected to take their relationship to the stage action on faith.

28

The correspondence we accept between this action and some given narrative itself corresponds to the unity we are expected to experience between the music and the actual words it is setting. Ever since opera's beginnings, composers and theorists have justified opera as a medium by means of its ability to wed music and text. Although most often they have made words the dominant partner, even those composers who have favored music over words—for example Berlioz or Wagner in his later phase—would not have questioned the underlying unity that had traditionally defined opera. To insure that their audiences experience this unity properly, opera companies go to great lengths to encourage them to come to the performance well prepared. Thus, local opera guilds sponsor demonstration lectures on how to listen to key passages, and company-sponsored shops sell recordings of a particular season's repertory so that operagoers may prepare themselves, libretto in hand and earphones on head, in the privacy of their dens.

The passivity that one notes in opera audiences is encouraged as well in the settings within which performances take place. As an edifice the opera house has characteristically cultivated grandeur both by its size and its trappings. Moreover, many of the world's great opera houses are placed as centrally and conspicuously as cathedrals were in earlier days. The imperial or the royal box (even in countries that have overthrown hereditary government since the time their opera houses were constructed) serves as a visual reminder that opera has traditionally been nurtured and flaunted by those who held power. (In a country such as ours, which has never known royalty, the so-called Diamond Horseshoe of boxes at the old Metropolitan in New York kept the audience aware of the patronizing power exercised by the local financial oligarchy.)

As an art-form intimately connected with the reigning establishment, it is no wonder that opera projects an image of something considerably larger than life. As I once put it in another context, opera is the last remaining refuge of the high style (15). As such it establishes a relationship with its consumers much like that of an earlier high-style genre, epic poetry. Like literary epic, opera cultivates heroic and often extravagant actions that nobody would take to be (nor even desire to view as) typical of everyday life. The traditional critical vocabulary that we associate with epic, for example terms such as *awe, admiration,* and *wonder,* more adequately describes the emotions that operagoers expect to experience than does the terminology associated with the more modest literary genres.

The extravagance that marks the style and content of opera, not to speak of the physical characteristics of the opera house, is matched by an economic extravagance demanded of operatic productions, whose costs are passed on to the spectators and benefactors (whether the latter come from the private or the public sector depends on the institutional arrangements for the arts in a particular country). Impresarios have complained of singers' financial demands since the seventeenth century. Even without these demands, total production costs (and also often ticket prices) have generally proved higher for opera than for the other live performing arts at any give time. In view of the extravagance that the form demands (and that is in turn demanded of those seeking entrance into the opera house), it is no wonder that opera finds little room for minimalism or for any of the other currents which might question its essential aesthetic.

Thus far I have suggested what might seem an essentially timeless image of opera as a form whose changes over the years have been less significant than its continuities. Although certain issues have been central to opera since its early days—for example, debates on the relation of music to text—the image I have presented of opera as a deliberately and selfconsciously elevated form of art is one that developed only during the last century. One need only compare this image to, say, the carnivalesque world of the eighteenth-century Italian opera house to note the most striking differences. Instead of the silent contemporary audience sitting in darkness and devoting all its attention to the stage illusion before it, the Italian audience two centuries ago would have walked in and out at will and paid at best sporadic attention to the singers onstage. Since theater lighting was dependent on candles, lights could not easily be switched on and off; indeed, the darkened auditorium was not introduced until the time of Wagner, who exploited a new technology to achieve a highly illusionistic theatrical effect. The same Italian opera houses that today function as palaces of high art in their early days were more like social clubs, for the boxes were owned by families who came to the opera to carouse, to play cards, and occasionally—if the famed castrato onstage was about to embark on some bravura passage—to pay brief attention to the music itself. In view of the noise and the confusion, the sustained theatrical illusion we have come to know during the last century was impossible. Whatever awe or admiration the audience experienced was occasioned by the vocal prowess of individual singers and not, as in more recent times, by the massive combination of

forces—large orchestra, dance, scenery, lighting—that unite with the singers to produce that larger-than-life effect we have come to associate with opera.

If the admiration that a singer excited was particularly strong, the opera could be interrupted with a demand for an encore; by the same token, a performance that for one reason or another did not please could be interrupted by a vehement display of hissing that itself rivalled the stage action in its theatricality. Musical scores made no pretense to record what would actually take place in real performance, for singers, somewhat analogous to actors in the commedia dell'arte, were expected to add their own elaborations to the vocal lines in the text. Even those members of the audience who paid more attention to the singing than to the cardgames could dispense with the extensive preparation—pre-opera lectures, record listening, program notes—that our contemporary audience needs or demands. At most, they might have bought a libretto to follow during the performance (baroque vocal style did not make for comprehensible diction even in one's own tongue). From a musical point of view operas presented no special difficulties to their audiences. The works one heard were all new or nearly new, much as the films one attends today are. The dramatic and musical conventions governing new operas were so familiar to everybody that the audience preparation we demand today would have seemed both unnecessary and ridiculous.

I have presented two contrasting images of opera, not, as some readers might suspect, to portray an ancestor of postmodern aesthetics in the boisterous and non-illusionistic world of eighteenth-century Italian opera, but to show how a genre is rooted in particular institutional frameworks at different historical moments. The earlier form satisfied social and aesthetic needs quite distinct from those we have come to associate with opera during the last century. Moreover, what we call an operatic text—whether in the form of libretto or full score—has little meaning outside the institutional framework in which it is performed. Thus, whenever an eighteenth-century *opera seria* is revived today in the major houses, it would be experienced by its audience far differently than in its own time. Not only are earlier performance practices difficult to reproduce, but the later audience's demand for a sustained theatrical illusion encourages extensive cuts and the addition of massive scenic effects that would have seemed quite foreign to the earlier aesthetic. (It is little wonder that these revivals in the major houses are still relatively rare—and then largely to serve as vehicles for virtuoso singers.)

From an institutional point of view the opera house that has emerged during the past century has much in common with another institution that developed at the same time, namely the art museum.[1] Both the opera house and the museum are heirs to that nineteenth-century historical mentality that sought to reconstitute what was thought to be every aesthetically significant period of time and then offer it to the public in a readily consumable form. The museum presents as many historical periods as a particular collection and current taste will allow: thus, any visitor to a major collection can expect to find rooms devoted to seventeenth-century Dutch landscape, *Quattrocento* Florentine painting, and the French impressionists, not to speak of Egyptian, Greek, and Roman art (though ancient cultures, as well as twentieth-century art, may sometimes be housed in separate collections within the same city). In recent years museums have sought to accommodate artifacts from more distant cultures, for example oceanic and pre-Columbian art, or previously non-canonical areas such as French academic painting of the nineteenth century and American art before abstract expressionism.

Although its historical range is far more circumscribed in time and place than the museum, the modern opera house during any given season seeks a repertory representing what it takes to be the major moments of operatic history; thus, a typical season would mount productions of a so-called "bel canto" opera of the early nineteenth century, a French and a Russian opera of the late nineteenth century, a sprinkling of works to display each of those composers—above all, Mozart, Verdi, Wagner, Puccini, and Strauss—deemed sufficiently towering in stature to have defined the genre for today's audiences. In recent years, managements have made forays into pre-Mozart opera and have re-canonized such once-famed opera composers as Monteverdi, Handel, and Gluck, though no single work during this extended period, which encompasses virtually half the history of the genre, has yet achieved a secure hold in the contemporary repertory; similarly, certain areas new to the art museum, for example oceanic sculpture and Near Eastern textiles, have yet to attract the imagination of most museum visitors.

Both the museum and the opera house depend on extensive educational programs to mediate their offerings to the public. Just as opera mediates by way of recordings, televised broadcasts, and guide-books, as well as the lectures and program-notes that a particular house organizes for its clinetele, so the museum educates its public with art-books, docent lectures, curator's notes on the walls, and descriptive catalogues

prepared for special shows. Both the opera house and the museum have become the domain for specialists attached to the style of a particular historical period.[2] Opera identifies singers, conductors, and sometimes even stage directors especially suited to and trained for, say, the style of bel canto, Wagnerian music-drama, Italian *verismo*. Similarly, the most prestigious museums boast curators in specialties such as French nineteenth-century painting, Egyptian art, and pre-Columbian pottery. Whether or not they receive their funding directly from public sources, both the museum and the opera house are objects of civic and often national pride, and the buildings that house them (as well as the sites at which they are constructed) are expected to demonstrate that they are worthy of this pride. Both, in fact, speak for what passes as the official culture of their time and place.

In view of their role in defining and expressing this official culture, it is scarcely any wonder that both the museum and the opera house maintained a skeptical, sometimes overtly hostile attitude to the more radical movements that took place within art and music during the early part of this century. To the extent that modernism has questioned the validity of earlier canons, it questions the very idea of an operatic repertory or of a museum devoted to preserving the artifacts of earlier periods. It is significant that a Metropolitan Opera impresario, when asked some years ago why he rarely produced new works, replied proudly that an opera house is essentially a museum devoted to the past. Yet the analogy this impresario sought to make no longer seems as convincing as it once did, for the opera house and the museum have come to differ in one essential respect: whereas the former has never made its peace with modernity, the latter, at least since the middle years of this century, has managed to accommodate even those strains of contemporary art that defy the very idea of a museum. To be sure, the art of our century has often had recourse to special museums of modern art to display itself. Yet these modern museums have themselves absorbed the historicist principles as well as the whole institutional framework behind the traditional art museum. For example, just as the latter is organized around specific historical periods that visitors pass through in more or less chronological order, so the typical museum of modern art directs its clinetele through the many periods and schools—for example, cubism (analytic and synthetic), futurism, expressionism, surrealism, pop—that have blazed forth (if only briefly) in the course of this century. It is characteristic of modern museums, indeed of many traditional museums as well, that

they include examples of the latest postmodern style—be it minimalism, conceptualism, neo-expressionism—not only in special shows but also in special rooms (often placed so that visitors will reach them in the proper chronological place at the end of their itinerary) that quickly transform this new style into a permanent historical category.

One asks why the art museum's capacity in recent years to transform the new into a historical category has not been shared by opera. Whatever answers one may come up with, one must first acknowledge the fact that even modernist operas from the early part of this century do not have the secure place in the repertory that comparable works in the visual arts have in the museum. The "regular" operatic repertory common to houses throughout Europe and North America extends barely 140 years from, say, *Le nozze di Figaro* (1786) to *Turandot* (1926). Among the twentieth-century works that have achieved this status, most of them by Strauss and Puccini, all except Strauss's early *Salome* and *Elektra*, together with Debussy's *Pelléas et Mélisande*, were deemed musically conservative in their own time. By regular repertory I refer to works that opera administrations can count on to draw audiences and that record companies need not hesitate to produce even if rival recordings are already available. Beyond this repertory there exists what could be called a peripheral repertory of modern works that are presented sporadically. Among musically "difficult" works, the two Alban Berg operas, several Janacek operas, Schoenberg's *Moses und Aron*, and Stravinsky's *Rake's Progress* now belong to the peripheral repertory in North America. Yet even this peripheral repertory contains far fewer "advanced" works than it does works that, however "distinguished" one may deem them, are unashamedly conservative in musical and often also in theatrical style: one thinks here of the later Strauss, of Benjamin Britten, of Francis Poulenc's *Dialogues des Carmélites*. (What counts as regular and peripheral repertory often differs according to location: *Wozzeck*, for instance, has achieved regular status in many German houses, and several Britten operas enjoy this status in the United Kingdom.) One can also speak of a peripheral repertory of works that are not only musically conservative, but also conspicuously undistinguished—works such as Douglas Moore's *Ballad of Baby Doe* or the various Gian Carlo Menotti operas that managements exhume in the hope that they can sell their audiences on contemporary opera, which in such instances means simply operas that were composed in long-dead idioms during the audience's own time.

Even though one can speak of a sizable peripheral repertory of twen-

tieth-century works, one might also note that an uncommonly large number waited many years before they gained entrance into the opera house. Although during much of its first half century *Porgy and Bess* appeared in occasional theatrical productions outside the opera house, only in recent years has it come to seem worthy of the official operatic stage. Even conservative composers such as Britten and Menotti felt forced to produce their own operas at festivals that they themselves created so that these works might gain sufficient familiarity to eventually reach the opera house. Among the more musically advanced scores, some could be heard for years only in concert performances under the sponsorship of societies dedicated to contemporary music; many such scores owe their survival to the fact that some influential conductor could prove them performable.

It is true that opera houses, despite their general unfriendliness to new work, occasionally commission operas for special occasions, usually of a festive sort. Thus, the Metropolitan commissioned Samuel Barber's *Antony and Cleopatra* for the opening of its new quarters in 1966, and San Francisco commissioned Andrew Imbrie's *Angle of Repose* for the city's (and country's) bicentennial ten years later; despite the festiveness (and expense) with which they come into the world, the act of commissioning is often perceived as a kiss of death, and such works rarely if ever enter even the peripheral repertory. New works are of course more common in European, especially German, opera houses than they are in North America, if only because the former can count on government subvention;[3] yet the ten- or twenty-year survival rate of these new works is not, I suspect, significantly greater than that of the relatively fewer new works performed on this side of the Atlantic. A large proportion of the new works performed here are done outside the major opera centers by smaller companies, in say, Minneapolis or St. Louis that seek to draw in big-city reviewers and to demonstrate that their town hopefully does not belong to a cultural hinterland.[4] Costs of these companies can be kept low by a deliberate reining in of resources, for example the use of relatively unknown (and thus inexpensive) singers, of a small orchestra, and with little of the spectacle that audiences have traditionally associated with grand opera. Perhaps most important, these companies are usually not saddled with the huge opera houses (much larger than their European equivalents) to which the more established companies are tied, and, as a result, they can perform in smaller theaters—sometimes converted old movie houses—that do not demand either the vocal power

of major singers or the attendance figures of a large house.

In view of the obscurity to which most operatic writing in our century has been doomed, it is a wonder how many composers and librettists of the most varying talents and styles have continued to work in the medium. Here the comparison between opera house and art museum may once more be instructive. Whereas even the most popular older operas are financial burdens that depend on extreme munificence (whether from governmental or private sources), modernist visual artifacts, at least since the middle of this century, have been successful financial commodities whose ownership, whether by affluent individuals, corporations, or by the museums to which they are often donated, confers a prestige commensurate with their perceived monetary values. About the only big money to be made in opera goes to a few top singers whose voices rarely show off well in (or are even necessary to) contemporary musical styles; by contrast, since the middle of the century a range of people within the art world—private gallery owners, collectors (who often view themselves as investors), and sometimes even the artists themselves—have been able to profit handsomely from the latest art. Moreover, whereas the opera house must cope with the wrath of subscribers forced to pay for an evening's performance of a new work that they usually dread attending, the museum can display its more provocative new acquisitions in special rooms that its visitors may, if they so desire, skip without feeling they have wasted their time or money.

Considerably more is at stake in the composition and production of an opera than in the making and display of visual artifacts. Whereas the productivity of opera composers has declined from several works a year in the early nineteenth century to not many more per lifetime in our own century, visual artists by and large have continued the productivity that marked their predecessors in earlier centuries. From the consumer's point of view, new operas demand much greater exposure (whether by recordings or by live performers) than visual artifacts before they can be assimilated; visual artifacts, moreover, can be looked at relatively quickly, and once the consumers have assimilated a particular style (or assimilated the work of an artist with a pronouncedly individual style), they can absorb stylistically similar artifacts with relative ease. Even if one were thoroughly at ease with *Moses und Aron* or *The Rake's Progress*, a new opera in an equivalent style by Schoenberg or Stravinsky—even if there were one—would demand considerable exposure and preparation on the listener's part; by contrast, one can visit a museum with, say, a

previously unfamiliar Rothko or Pollock and deal with it in relatively short order. It is surely harder for consumers of opera than of visual artifacts to justify (whether to themselves or others) the effort that must be expended in mastering a new work—especially since they can tell themselves (quite correctly) that the opera will likely soon be forgotten (audiences before the mid-nineteenth century of course rarely expected the operas they attended to last beyond a single season). Moreover, whereas opera functions principally as "entertainment" (even if also of a most prestigious sort), the new visual artifact can claim to meet a functional need—for example, filling an otherwise blank domestic or corporate wall or monumentalizing some public space.

The historicizing mission that both the opera house and the art museum have undertaken has resulted, in recent years, in the reassessment and revival of past periods that had long been neglected or had fallen into disrepute. Just as the museum has transferred its French nineteenth-century academic paintings from the basement and found room as well for non-Western artifacts that had earlier seemed too primitive to warrant precious exhibition space, so the opera house has restored the bel canto repertory (with the result that specialist singers who can negotiate the florid passages undertake rigorous training to meet the new demand) and has moved backward in time before Mozart to produce (if only as part of the peripheral repertory) the occasional Handel or Vivaldi work or, even further backward, to opera's beginnings to restore (with a good bit of guess-work about what its proper instrumentation should be) a Monteverdi or a Cavalli. The great difference between the two institutions is that the art museum, unlike the opera house, has proved able to convince its consumers that the latest style belongs to a historical period that it behooves them to know as intimately as any earlier style—while the opera house invites groans and protests when it asks the equivalent from its audiences.

The difference between the two institutions does not derive simply from the fact that visual artifacts, as I have suggested, breed familiarity more readily than auditory ones. Non-operatic "serious" music during this century has had as difficult a time establishing itself with audiences as opera. What distinguishes opera in this respect from, say, symphonic music is that opera does not seem to fare well in small packages. (The formality and sublimity of style that non-comic opera has traditionally cultivated themselves discourage brevity.) Although symphony orchestras perform new works with a regularity not shared by opera companies,

the typical new symphonic work is a twenty-minute piece that an audience is generally willing to tolerate as a means of paying its duty to high culture—but with the condition that this piece merely supplement such familiar fare as, say, a Beethoven concerto or a Strauss tone poem. (Composers, in fact, consciously cultivate brevity of style in order to get themselves heard.) Similarly, ballet companies have been able to offer their more experimental products in small packages that can be grouped in a program with more classical pieces; thus, the New York City Ballet can stage Jerome Robbins's distinctly postmodern *Moves: A Ballet in Silence*—a less-than-half-hour work without musical accompaniment and with its dancers practicing abstract movements in informal dress— together with, say, a group of Balanchine pieces that, however abstract *their* movements, are danced in costumes and accompanied by reassuringly familiar music. A considerable number of musical experiments in our time have not even taken place in either the symphonic or operatic medium but in diverse (and usually small) combinations of instruments and/or singers that, if they get performed at all, have had to depend on specialized organizations, with equally specialized (and usually small) audiences such as Schoenberg's Gesellschaft für musikalische Privataufführungen in Vienna around 1920 or the Monday evening concerts inspired by Stravinsky and Robert Craft in Los Angeles during the 1950's.

If short operas had not experienced the difficulty they have had in getting heard, many hard-to-digest works would have been able—like short instrumental pieces and ballets—to make themselves familiar to audiences in our time. Yet operas of less than a full evening's length have rarely succeeded in entering the regular repertory. There is of course no shortage of fine one-act operas going back to the early eighteenth century in Italy when short comic operas such as Pergolesi's *La serva padrona* were composed to serve as intermission diversions between the acts of *opere serie*. Yet in our own century a natural place for these works has not been found. Impresarios nowadays can justify making a full evening out of Strauss's *Salome* or *Elektra* since each of these, despite encompassing only a single act, offers close to two hours of music—more, in fact, than such an opera as *La Bohème*, whose brevity is masked by its three intermissions. Despite the odds against less-than-full-length operas, composers of our century have produced them in considerable numbers, often because the experimental modes in which they were working could best be realized in brief, tense works such as Schoenberg's *Erwartung* and *Die*

glückliche Hand or Stravinsky's *Oedipus Rex*. Although opera houses have often put together evenings of such works in varying combinations, none has secured much of a place for itself in the repertory—nor have such less rigorously experimental works as Ravel's two one-act operas or the multitude of short operas by composers the likes of Hindemith and Bartok.

As with poetry and the non-musical theater, that modernist impulse toward achieving intensity by means of suggestiveness rather than explicitness manifests itself in works—often of a quite ambitious sort— of considerably more brevity than one finds in earlier centuries. From this point of view such operas as *Erwartung* and Poulenc's *La Voix humaine*—each with only a single character and without chorus or ballet or the scenic resources associated with grand opera—are paradigmatic modernist works. Yet this impulse toward brevity (and austerity) also conflicts with the desire of the opera audience for a sustained illusion, for a prescribed period in which it can submit itself passively to the over-powering auditory and visual forces that emanate from the stage. It is significant that the only short operas that remain part of the regular repertory are Mascagni's *Cavalleria rusticana* and Leoncavallo's *I pagliacci*, which, though by different composers, are in musically similar styles and on a similar theme—namely the consequences of illicit love among the southern Italian poor—that the audience can experience twice over, sometimes even with the same tenor and baritone appearing in each. (Despite many recent attempts to vary this double bill by substituting another short opera [as often as not a member of Pucccini's *Trittico*] for either Mascagni's or Leoncavallo's, these two works have proved difficult to separate—as one notes from the fact that in recent years they have been rechristened with a single name, *Cav/Pag*.)

The opera audience's essential passivity and its perceived need for illusion have manifested themselves not only in a bias toward full-length works, but also in the fact that those modernist works that have entered even the peripheral repertory have posed only moderate challenges toward operatic form. As opera developed over the years, and especially during the nineteenth century, it defined itself as an institution through a particular mix and range of personnel—an orchestra of a certain amplitude; a group of singers who, despite differences in period styles, carefully distinguish themselves both from speaking actors and from singers in such popular forms as operetta and folksong; and, despite their relative unimportance in certain operatic period styles, chorus and

dancers. To the extent that modernism in the various arts has challenged and questioned the materials and means by which a particular art-form has traditionally realized itself, one would expect that modernist operas would call for an orchestra with new types of instruments, or perhaps for no orchestra at all; or with singers who pursue a technique wholly different from that with which opera singers have ordinarily been trained. As it turns out, challenges of this sort, even if occasionally posed, have not entrenched themselves in the way that, say, collage and various types of mixed media have entered the mainstream of the visual arts.

Indeed, those modernist operas that have more or less entered the repertory have each tended to challenge only a single aspect of that institution we call opera. Whatever we may call modernist in *Ariadne auf Naxos* lies less in its use of opera personnel—though Strauss has here reduced the gigantic orchestra of his earlier operas to Mozartian proportions—than in its theatrical idea, namely the use of a play within a play and, even more conspicuously modernist, its self-conscious juxtaposition of tragic and comic conventions; even when Strauss parodies earlier operatic styles, the audience has come to experience these parodies in an unselfconscious way very much as it hears Mozart's parodies of *opere serie* in his Italian comic operas.

Similarly, from a musical point of view the Brecht/Weill *Mahagonny* and *Porgy and Bess* challenge the institution principally through their use of jazz techniques, which, when they were composed during the 1930's, must have seemed to subvert operatic claims to represent high as against popular art. An audience today would no longer hear this challenge, for in the intervening half century a profusion of new and often louder musical styles has reshaped our conception of what constitutes popular culture. Indeed, now that these two operas have entered at least the peripheral repertory, we come to experience their jazz rhythms in much the same way that we experience such earlier popular forms as the oriental marches in Mozart or the tunes blasted out onstage by a Verdi *banda*. (The political irreverence of *Mahagonny* is scarcely more shocking today than that of *Le nozze di Figaro*; moreover, sung irreverence is ordinarily less explosive than its spoken equivalent.)

For many years it was assumed that *Moses und Aron* was too forbidding a work to enjoy the success it has turned out to have in those opera houses enterprising enough to stage it. Yet except for its use of serial composition (an attribute it shares with Berg's *Lulu*, which has established itself

even more widely than Schoenberg's opera), *Moses und Aron* challenges its audience with only one conspicuously "unoperatic" feature—the assignment of the Moses role (and of some choral passages) not to a conventional singing voice but to what the composer called *Sprechstimme*, a mode between speech and song that he had concocted years before in his more radically experimental piece *Pierrot Lunaire*. Once an audience reconciles itself to the opera's use of *Sprechstimme* and its lack of tonality, it can discover amply traditional operatic elements in the score—for example, the extravagantly florid singing of Aron, sufficiently massive orchestral and choral forces to overwhelm it in the manner of late nineteenth century opera, and, in the Dance around the Gold Calf, an orientalist purple patch with the lurid appeal of the Bacchanal in *Samson et Dalila* or the Dance of the Seven Veils in *Salome*.

In view of the resistance that opera, in comparison with other art forms, has shown to change, one may ask how opera has responded to that attitude which we have come to call postmodernism in the various arts. Postmodern opera, if such a style has developed at all, should in fact threaten the very foundation upon which opera as an institution has rested during the last century and more. To the extent that opera has defined itself as a bastion of high art, it would presumably resist the attempt of postmodernists to break down the traditional distinction between "high" and "low" cultural artifacts. To the extent that opera has been committed to the union of word and music, it would resist a postmodernist attempt not only to rupture this union, but also to question any sort of unity that the work might claim. To the extent that it seeks to overwhelm its audience into a passive state, it would not, like much postmodernist art, encourage its audiences to participate actively in its creation, or analysis, or questioning, or even rejection.[5]

Yet despite these resistances, a postmodern intrusion into the opera house has in fact been taking place, and it has manifested itself principally in two forms—first, in new modes of interpreting the operatic canon and, second, in some new approaches to operatic form. The first, and thus far the more pervasive of these intrusions has been the development, primarily during the last twenty years, of what can be called directorial opera, namely the reinterpretation of canonical works in often iconoclastic ways. I refer here to the controversial restagings of classic operas by directors such as the late Jean Pierre Ponnelle, Götz Friedrich, and Patrice Chéreau, who seek to rethink and control the visual elements of a performance to a far greater degree than opera directors before them did.

(Some, like Ponnelle, not only direct the stage action, but also design their own scenery and costumes.) However iconoclastic a postmodernist operatic interpretation may be, it allows opera to maintain itself as an institution, for it preserves the traditional canon and ordinarily leaves a work's original music and text intact; indeed, since the reinterpretation normally takes place purely in visual terms, audience members who feel offended by what the director is doing to a beloved opera may simply close their eyes and listen to a quite familiar score emanating from the singers and orchestra.

But of course audiences who have purchased tickets for this, the most expensive of the performing arts, are rarely willing to close their eyes; they are much more likely, in fact, to use the opportunity of an iconoclastic production to express their outrage that what they take to be a sacred art-work has been subjected to a form of sacrilege. Nowadays the vehement expression of outrage that we associate with the reception of modernist experiments in the other arts early in this century is most likely to take place in opera—and in particular in postmodern interpretations of canonical operas. This outrage against what is perceived as violating some timeless image of a great work emanates not only from audiences threatening to cancel their subscriptions, but also from performers, for example the famed soprano who cancelled just before the opening of a Ponnelle production of *Cavalleria rusticana* in San Francisco after she was asked to appear pregnant and submit herself to obscene gestures; from opera house staff, sometimes even from the impresario who had hired the director without quite realizing what he was getting into; from the local newspaper critics, who write in the hope that their denunciations will insure more traditional productions in the future; from scholars, for example the theater historian who recently attacked contemporary directorial opera in a book aptly (though also naively) entitled *Misdirection*.[6]

The most common accusation made against director-dominated opera is that directors take a cavalier, sometimes even defiant attitude toward the opera's libretto: not only does the stage action often contradict or ignore the words uttered by the singers, but it also belies the stage directions that the librettist and/or composer wrote into the score. For example, Ponnelle aroused considerable furor with *Der fliegende Holländer*, in which the whole action is turned into a dream of the helmsman, with the latter doubling (and sung by the same tenor) as the rejected lover Erik. Since even the boldest of directorial opera productions tend to

retain the traditional vocal and orchestral score, the imposition of a visual action at odds with the text creates a rupture that not only undermines the claims that opera has traditionally made to unify music and text but also challenges opera's pretentions (at least since Wagner's time) to create an organic art-work all of whose parts function harmoniously with one another. (One wonders whether the recent craze for supertitles represents a conspiracy between opera managements and the public to provide a check against the contemporary directorial imagination; it is significant, for instance, that Ponnelle refused to allow his productions to sport supertitles.)

But directorial reinterpretation often goes far beyond simply conflating characters and changing stage directions and plots. Contemporary audiences may expect to find such verbal signals as graffiti painted on flats or Brechtian projections directing them how to interpret the action they witness on stage. Visual objects associated with popular culture are displayed as a means of challenging operatic claims to represent a "higher" form of culture. Historical settings stipulated in the score are often discarded in favor of new settings intended to demythify the opera. (Changes in historical milieu have been common since at least mid-century in the non-musical theater, especially in the production of Shakespeare, whom audiences—perhaps because they are often reminded by directors that Elizabethans played Romans in Elizabethan guise—are increasingly willing to accept in, say, Victorian or even punk dress.) Thus, Friedrich's *Aida* used stage sets of sheet metal suggesting a technological culture as a means of commenting on Verdi's image of Egypt. Chéreau's *Ring des Nibelungen*, commissioned by Wagner's descendants for the Bayreuth centennial in 1976, relocated its characters from their mythical ancient realm into the nineteenth-century world of the composer, with the Rhine maidens transformed into prostitutes and prancing about a hydro-electric dam. (Despite the family sponsorship, the Chéreau production's power to outrage was reflected in many critical reviews as well as in the refusal of Wagner's aged daughter-in-law to meet the director.)

Outside the institutional constraints of the opera house, directorial opera can take even freer forms. Film enables visual effects different from those possible on the stage, and, perhaps even more important, film can remain impervious to the complaints of the opera subscriber. For example, Hans-Jürgen Syberberg's filmed version of *Parsifal*, though as faithful to the music as any stage performance, cultivates a variety of

alienating effects such as the refusal fully to synchronize vocal sounds with the mouths from which they supposedly emanate to the transformation of the hero visually from male to female (though retaining his accustomed tenor voice) at the point that he resists Kundry's temptation. Similarly, a directorial reinterpretation on a non-operatic stage allows for less traditionally operatic expectations. For instance, Peter Brook's *Carmen*, designed for an intimate theater, departs radically from the musical score, which it reduces to the smallest of proportions: whole singing roles are eradicated, choral and orchestral forces minimalized, arias cut down to what are no more than suggestive fragments of their familiar selves, and, to counter the effect of the proscenium in ordinary opera, the spectators sit in a circle around the singers. It seems no accident that many admirers of the Brook *Carmen* were persons with distinctly postmodern tastes and with a disdain for opera; by the same token, many operagoers willing to close their eyes to the visual violence done by iconoclastic directors in the opera house found to their disappointment that Brook's *Carmen* did not even compensate them with their long-familiar musical score.

Although director-dominated opera has been the chief means by which a postmodernist sensibility has entered the opera house, one can suggest at least the beginning of a second threat to operatic tradition in the composition of new operas within a distinctly postmodernist mode. In view of the argument of this paper, a rigorously postmodern opera would seem a contradiction in terms; indeed, as I shall indicate, those contemporary operas that seek entrance into the opera house are forced to subdue the anti-aesthetic attitude we have come to associate with postmodernism.[7] The possibility of a postmodern opera is evident in the work of Philip Glass, most forcefully perhaps in the first piece he called an opera, *Einstein on the Beach* (1976). By attaching this label to his work, Glass challenged his audience's generic expectations in a way he could not have done by simply labelling *Einstein*, say, a "performance," "mixed media," or some other term without the historical burden inherent in the word "opera." Moreover, the Metropolitan Opera House was among the places in which *Einstein* was first performed—a fact that did not so much confirm the work's status as opera as underline the gap separating it from the other works that audiences experienced in the same setting.

Indeed, these performances did not even emanate from the Metropolitan as an institution (they were not part of the regular subscription series and, like much contemporary music, were subsidized by a foundation)

nor could they have, for they did not use either operatic voices or an opera orchestra. The small instrumental group, in fact, was the the Philip Glass Ensemble, which, in the best modernist fashion, the composer had put together over the years as a means of getting his own compositions performed. The sounds coming from this ensemble must have sounded strange in the opera house, for they were processed by an electronic synthesizer. About the only traditionally operatic elements in *Einstein* were the chorus and the dancing—but the choral text consisted of counting numbers to the changing musical rhythms or naming the notes being vocalized, while the dancing maintained a considerable distance from the classical ballet style that still dominates operatic productions. In addition, Glass and the director/designer, Robert Wilson (whose name, significantly, preceded the composer's on the program and whose collaborative role was considerably greater than that of the traditional opera librettist) challenged the traditional operatic attempt to unite words and music by making the text seem irrelevant not only to the music being heard but also to the whole Einstein theme.[8]

This text, most of which is spoken against a musical background, is in fact notable for the pop-culture elements it shares with other forms of postmodern writing—for example, appropriations from advertising ("So if you're tired of glasses, go to . . . a Phonic Center on 11 West 42nd Street near Fifth Avenue for sight with no hassle"); clichés drawn from such diverse areas of modern life as male-female relationships ("Finally she spoke. 'Do you love me, John?' she asked. 'You know I love you, darling.' ") and travel ("One of the most beautiful streets of Paris is called Les Champs Elysées' "); apparently contextless phrases that resonate with undetermined meanings ("Mr. Bojangles / If you see any of those / Baggy pants / It was huge / Chuck the hills. . .") (Wilson et al. 14–22). Although the music seems to go its own way independent of the text, it too mimics elements from everyday life, both those of an overtly musical nature such as chorales and those of a "non-musical" sort such as the rhythms of a train.

Despite the fact that the text and music provide no narrative of the kind one expects to witness in opera, the spectacle enacted onstage presents at least the semblance of narrative development, namely the transition from a nineteenth-century world to the nuclear age. But the work refuses any form of organization that one could call an operatic plot, and what we see of the title character is certainly not the "real" person Einstein, but rather the mythical image he projected onto the world with

his incessant violin playing (rendered with the repetitive rhythms central to Glass's style) and with his role as father of nuclear energy. Since Glass's style, like that of his fellow minimalist composers, eschews the narrative development characteristic of the mainstream of Western music, the relative absence of plot in the opera's verbal text constitutes what would seem a double questioning of the traditional notion that an opera, like a symphony or a non-musical play, should transport its audience toward some sort of cathartic experience.

Philip Glass's systematic deviations from operatic norms include, in addition, a challenge to the customarily passive role of the audience, as one can see from the following note on the Metropolitan program: "As *Einstein on the Beach* is performed without intermission, the audience is invited to leave and reenter the auditorium quietly, as necessary" (Wilson et al. 6). By inviting the audience to come and go at will, Glass is suggesting a return to the anti-illusionistic world of eighteenth-century *opera seria* or, to cite an analogy more likely on the composer's mind, to the world of Oriental theater. Yet with the final words of this note ("quietly, as necessary") it is evident that Glass's invitation is something less than hearty, that it amounts to little more than encouraging one's guests to use the bathroom if they happen to feel the need. Indeed, the hypnotic quality of Glass's repetitive musical style, together with the high-tech precision of Wilson's stage spectacle, may well work to keep the audience passively in its place as firmly as more traditional operas manage to do.

Could it be that Glass is not quite so iconoclastic as one might think? Certainly in subsequent years he has been willing to accommodate himself increasingly to operatic tradition, especially since he is now being commissioned to compose for opera houses. For example, in *Satyagraha*, composed for the Netherlands Opera in 1980, Glass writes for real opera singers and a real opera orchestra—though his musical style remains as identifiable as ever, and the text (passages from the *Bhagavad Gita* sung in Sanskrit) maintains a conspicuous distance from the stage spectacle, which consists of scenes from the early political life of Gandhi, who, like Einstein in the earlier opera, appears principally as a mythical image which in turn is juxtaposed with the public images of three other kindred spirits, Tolstoy, Tagore, and Martin Luther King.

If there is indeed such a style as "postmodern opera," it may well remain a compromise between the two antithetical terms encompassed by the phrase. To the extent that the term "postmodern" challenges most

everything we associate with opera from the performing personnel to the role of consuming audience, any operatic work that rigorously pursues a postmodern program must seek its audience, if it can, outside the opera house. As with other avant-garde musical forms, such a work can generally hope for at best a single performance before a small group that is already committed to its aesthetic (or, more precisely, its anti-aesthetic) program. For example, Stephen Dickman's first opera, *Real Magic in New York*, a radically minimalist work that makes *Einstein on the Beach* seem positively operatic, received its single performance in 1971 not in an opera house or even in a theater or concert hall, but in a former warehouse in downtown New York with about fifty persons in the audience. Lack of funding necessitated an unstaged performance, though slides were projected on a screen to indicate stage directions. Richard Foreman's surrealistic libretto, about a man who becomes Christ, consists largely of entrances of the hero's doctors and relatives, with people falling off chairs and clocks coming in through windows. The personnel includes singers and chorus, but no orchestra; percussive effects, emanating from a pre-recorded tape, are supplied by crackling sounds derived from the crumpling of paper. The musical style is neither tonal nor serial, but an *ad hoc* creation of the composer, who assigns each character a particular note with which he or she starts every musical phrase, which is then subjected to considerable dynamic range and rhythmic variation.

Like the vast majority of avant-garde theatrical works of its time (whether musical or non-musical), Dickman's first opera has perforce languished in obscurity. By contrast, visual art-works in, say, the minimalist or conceptualist mode of that period could hope for a continuing life in a collector's home or in a museum. Even poetry and fiction in an equivalent mode maintain a certain availability to the reader, though often only in obscure little magazines and chapbooks. With his current opera-in-progress, *Tibetan Dreams*, Dickman makes sufficient concessions to institutional concerns to hope for more of a performance life than his austere first opera achieved. Besides its chorus and solo singers, *Tibetan Dreams*, unlike its predecessor, employs an orchestra. Again, unlike its predecessor, it is designed as a full evening's performance. The theatrical resources it demands can be adjusted to either a small or large house. Its musical style, which, like Glass's, shows the influence of non-Western music, is less forbidding than that of *Real Magic in New York*; indeed, it even contains some discernible melodies—though on scales invented by the composer and somewhat foreign to the Western

musical ear—that are repeated with sufficient frequency to implant themselves in the audience's mind. At least as important, the new opera even sports a plot (based on a novel) that narrates a spiritual quest much in the tradition of the operatic quests that shape *Die Zauberflöte* and *Parsifal*, though here (with the help of his librettist Gary Glickman) with a contemporary slant that selfconsciously examines the very idea of a quest. As with Glass's operas, the presence of a compelling thematic idea may go a long way to mitigate an audience's difficulties with what it will also perceive as an unfamiliar musical style.

Indeed, Glass and, more recently, John Adams have fleshed out their thematic ideas by means of historical figures who have achieved mythical status for their audiences. Thus, in *Nixon in China*, commissioned by the Houston Grand Opera for late 1987, Adams (in collaboration with his librettist Alice Goodman) presents larger-than-life portraits of recent world leaders against an instrumental background influenced by American big bands of the 1940's. Explaining his refusal to use the classical myths common to many earlier operas, Adams says, "It seemed to me the subconscious of our culture is really more profoundly affected by myths of the great world figures, and in Nixon and in Mao I was able to identify very strong archetypes" (Rothman). But in turning to world-historical figures, Adams is not quite so distant from operatic tradition as he may think: though his heroes are drawn from a more recent past than those of earlier operas, they also belong to a long line of historical figures from Monteverdi's Nero through Handel's Julius Caesar and Mozart's Titus to Berlioz's Benvenuto Cellini, Verdi's Philip II, Musorgsky's Boris Godunov, and, for that matter, Glass's Gandhi. And in its appropriation of a recognizable popular musical style, Adams, like visual artists who draw images from popular culture, stands a chance of tapping his audience's communal memory, even if he may also test their assumption that opera belongs solely to the realm of high culture. One might add that the strong presence of the librettist in Adams's and also in Dickman's and Glass's operatic projects (even if the music often pretends to move independently of the text) attests to the continuing power of the collaborative effort between writer and composer endemic to opera since the time of Monteverdi.

Although I have argued for the relative conservatism of opera in relation to other art-forms, one should recognize that the institutional pressures and strategies determining the composition, production, and preservation of operas represent an extreme instance of pressures and

strategies characteristic, as well, of these other forms. If postmodernism has found a less problematic reception in the museum than in the opera house (to return to my earlier analogy between the two institutions), one should also note that the museum has worked assiduously in recent decades to educate—one might also say manipulate—its viewers to assent to incoming experimental styles. The museum's way of mediating between art-work and viewer is evident, for example, in an exhibition of contemporary British sculpture at the San Francisco Museum of Modern Art in 1987. Among the works in the show was a collection of objects— for example, a workman's worn glove and shoe, a rusty paint can, a rock, an empty beer bottle, the remains of an old barrel—that seem to be strewn randomly on the floor.

As though to ward off too easy a dismissal of these objects ("That's the sort of mess my five-year-old might make if he could get his hands on those worthless things!"), the museum provides at least three framing devices to direct the viewer's response: first the fact that the display is part of an officially sponsored event within the museum walls—and in this instance within a conspicuously premodern building in elegant Beaux Arts style; second, the title and medium designated on a nearby wall by the artist, Tony Cragg; and third, an explanatory statement on another wall by the show's curator justifying what he takes to be Cragg's contribution to modern art. (One could cite such additional framing devices as the show's catalogue, the regularly scheduled docent talks, and the newspaper reviews.) Just as Philip Glass entitles the apparently non- or anti-operatic *Einstein on the Beach* an "opera in four acts" on the Metropolitan program, so Cragg labels his objects *Axehead (mixed materials)*—with the result that a potentially skeptical viewer discovers that Cragg's objects are not randomly strewn at all, but assume the shape of an axehead; moreover, even if the materials are "mixed," one's recognition that the phrase "mixed materials" belongs to a verbal category parallel to, say, "oil on canvas" works to confirm its status as art.

And just as John Adams justifies his use of recent historical figures as myths to which a contemporary audience can easily respond, so the curator teaches his museum audience how to relate Cragg's objects (not only in *Axehead* but also in his other contributions to the show) to what he takes to be their own needs and concerns: "Cragg uses the remnants of our packaged and media-interpreted world and re-presents them, allowing us to reconsider them as first-order experiences so that we may better understand our relationship to the objects, images, and materials of our

world" (Beal). If the title and generic label confer aesthetic status, the curator's statement, with its romantic formula expressing disdain for the modern world, confers social relevance on Cragg's postmodernist work —while the building in which it is housed serves as a reminder of the museum's tie to official culture.

Indeed, museum visitors entering the building would note the ornate neo-Renaissance city hall directly across the street. Moreover, the museum's building is externally, at least, virtually a twin of the opera house down the same block. Before opera matinees one ordinarily sees a goodly number of operagoers making their way through the latest postmodern exhibit. To be sure, the closest they are likely to get to a postmodern experience in that particular opera house is the occasional production of a classic work by an iconoclastic director. One might note, however, that visitors to the museum might, in the spring of 1987, have watched the installation of Cragg's *Axehead* before attending an unstaged run-through of *Nixon in China*—emphatically not sponsored by the opera company next door—in a small theater in the museum's building dedicated to the performance of chamber music and, though at relatively rare intervals, of non-canonical operas.

Despite the disparity in the commitment of opera house and museum to what is radically new, the repeated viewing and hearing of works that at first elicit a puzzled and often also outraged response, together with the mediating process organized within both these institutions, can serve to transform this response into something less discomforting, sometimes, in fact, to canonize these works. Rauschenberg's grainy silk-screen enlargements of Kennedy photos, like the Warhol paintings of Marilyn Monroe, have, after a quarter century of viewing, gained a classical aura in the eyes of many viewers—much as the latter now view early Picasso and Braque collages with the same attitude they take to long-canonical paintings. (It has become the burden of scholarship in recent years to recapture the revolutionary ambiance in which each of the great modernist waves broke upon a stunned and hostile public.) Audiences who witnessed repetitions of the Chéreau *Ring* for several seasons subsequent to its premiere complained less loudly than before and not simply because the director modified some of his concepts; indeed, the repeated viewings of this production on educational television even after it was retired from the stage have routinized our response to the point that the once demythified Rhinemaidens have gradually become re-mythified. After repeated hearings of *Einstein on the Beach* we become so

habituated to what we hear that the arbitrariness we were intended to note in the relation of text and music gives way to the perception that the spoken words and the accompanying music really *do* belong together. The framing accomplished by institutions inevitably results in taming—yet it also assures a continuing life to artifacts that, whatever their power to provoke, inspire, offend, would otherwise (though quite in conformity with that postmodern attitude which marks art-works as disposable) disappear from view.

NOTES

1. For an analogous comparison, see DiMaggio's detailed study ("Cultural Entrepreneurship") of the development of the Boston Museum of Fine Arts and the Boston Symphony Orchestra during the late nineteenth and early twentieth centuries. DiMaggio uses Boston as a case study to describe such phenomena of the period as the separation of high and popular culture and the development of a cultural elite.

2. On the development of professionalism in the administration of the various arts during the last century, see Peterson.

3. For statistics on the dramatic difference in governmental support for the arts in the United States and most European countries, see the tables in Montias 299, 300, and 303. For example, whereas government support for arts organizations during the early 1970's comprised .13% of national income in Germany, it comprised only .008% of national income in the United States (303). In the United States, arts organizations are dependent on foundations and on private donors to a far greater degree than they are in European countries.

4. For some interesting remarks on how operas are commissioned by smaller companies and how they fare at the box office, see Duffy and Blassingham. One might note that nearly all the contemporary operas discussed in these articles, which seek to encourage the composition and production of new works, are musically and often also theatrically conservative. For a discussion, with telling statistics, of the paucity of contemporary operas (even of a conservative sort!) in the repertory of the major American companies, see Martorella 83–114.

5. On conscious attempts during the later nineteenth century to "strengthen boundaries between the performer and the audience, the former transported, the latter receptive and subdued," see DiMaggio ("Cultural Entrepreneurship" 312). DiMaggio describes a process of audience training applicable not only to music-listeners but also to museum-goers and, I might add, to readers of literature. Challenging this process is central to postmodernist aesthetics.

6. See Nagler. For a recent debate on the subject, see "The Future of Opera" 49–59.

7. For a discussion of how the term *anti-aesthetic* can be useful in understanding postmodernist art, see Foster (xv-xvi), who defines the term as, among other things, "signaling a practice . . . sensitive to cultural forms . . . that deny the idea of a privileged aesthetic realm" (xv). As I have argued in this paper, the opera house for at least the past century has identified itself with such a realm.

8. For a brief discussion of *Einstein on the Beach* (and also *Satyagraha*) in relation to Glass's earlier music and to that of other minimalist composers, see Martins 11–17, 79–86.

WORKS CITED

Adams, John. *Nixon in China.*

Barber, Samuel. *Antony and Cleopatra.*

Beal, Graham, curator. *A Quiet Revolution: British Sculpture Since 1965.* San Francisco Museum of Modern Art. Veterans Building, San Francisco. June–July 1987.

Berg, Alban. *Lulu.*

———. *Wozzeck.*

Berlioz, Hector. *Benvenuto Cellini.*

Blassingham, Ellen. "Marketing Opera: Is There an Audience for New Works?" *Perspectives: Creating and Producing Contemporary Opera and Musical Theater: A Series of Fifteen Monographs.* Washington, D.C.: Opera America, 1983. 127–35.

Brecht, Bertolt. *Aufstieg und Fall der Stadt Mahagonny.*

Brook, Peter, dir. *La Tragédie de Carmen.* Vivian Beaumont Theater, New York. 1983.

Chéreau, Patrice, dir. *Der Ring des Nibelungen.* Bayreuth Wagner-Festspiele, Bayreuth. Aug. 1976.

Cragg, Tony. *Axehead (mixed materials).* San Francisco Museum of Modern Art. Veterans Building, San Francisco. June–July 1987.

Debussy, Claude. *Pelléas et Mélisande.*

Dickman, Stephen. *Real Magic in New York.* Film Makers' Cinematique, New York. 1971.

———. *Tibetan Dreams.*

DiMaggio, Paul. "Cultural Entrepreneurship in Nineteenth-Century Boston." *Media, Culture and Society* 4 (1982): 33–50, 303–22.

Duffy, John. "Commissioning Operas." *Perspectives: Creating and Producing Contemporary Opera and Musical Theater: A Series of Fifteen Monographs.* Washington, D.C.: Opera America, 1983. 121–25.

La forza del destino. San Francisco Opera. War Memorial Opera House, San Francisco. Sept.–Oct. 1986.

Foster, Hal. Preface. *The Anti-Aesthetic: Essays on Postmodern Culture.* Ed. Hal Foster. Port Townsend, Washington: Bay Press, 1983, ix–xvi.

Friedrich, Götz, dir. *Aida* Berlin Komische Oper, East Berlin. 1969.

"The Future of Opera." *Daedalus* 115.4 (1986): 2-92.

Gershwin, George. *Porgy and Bess.*

Glass, Philip. *Einstein on the Beach.*

———. *Satyagraha.*

Handel, George Frederich. *Giulio Cesare.*

Imbrie, Andrew. *Angle of Repose.*

Leoncavallo, Ruggero. *I pagliacci.*

Lindenberger, Herbert. *Opera: The Extravagant Art.* Ithaca: Cornell UP, 1984.

Martins, Wim. *American Minimal Music: La Monte Young, Terry Riley, Steve Reich, Philip Glass.* Trans. J. Hautekiet. London: Kahn and Averill, 1983.

Martorella, Rosanne. *The Sociology of Opera.* South Hadley: Bergin; New York: Praeger, 1982.

Mascagni, Pietro. *Cavalleria rusticana.*

Monteverdi, Claudio. *L'incoronazione di Poppea.*

Montias, John Michael. "Public Support for the Performing Arts in Europe and in the United States." *Nonprofit Enterprise in the Arts: Studies in Mission and Constraint.* Ed. Paul J. DiMaggio. New York: Oxford UP. 287–319.

Moore, Douglas. *The Ballad of Baby Doe.*

Mozart, Wolfgang Amadeus. *La clemenza di Tito.*

———. *Le nozze di Figaro.*

———. *Die Zauberflöte.*

Musorgsky, Modest. *Boris Godunov.*

Nagler, A.M. *Misdirection: Opera Production in the Twentieth Century.* Hamden: Archon, 1981.

Nixon in China. By John Adams. San Francisco Concert Opera. Herbst Theater, Veterans Building, San Francisco. 21–22 May 1987.

Pergolesi, Giambattista. *La serva padrona.*

Peterson, Richard A. "From Impresario to Arts Administrator: Formal Accountability in Nonprofit Cultural Organizations." *Nonprofit Enterprise in the Arts: Studies in Mission and Constraint.* Ed. Paul J. DiMaggio. New York: Oxford UP, 1986. 161–83.

Ponnelle, Jean-Pierre, dir. *Cavalleria rusticana.* San Francisco Opera. War Memorial Opera House, San Francisco. Nov. 1980.

———. *Der fliegende Holländer.* San Francisco Opera. War Memorial Opera House, San Francisco. Sept.–Oct. 1975. Metropolitan Opera. Metropolitan Opera House, New York. 1979.

Poulenc, Francis. *Les Dialogues des Carmélites.*

———. *La Voix humaine.*

Puccini, Giacomo. *La bohème.*

———. *Il trittico* [comprising *Il tabarro, Suor Angelica,* and *Gianni Schicchi*].

———. *Turnandot.*

Rauschenberg, Robert. *Retroactive I.* Wadsworth Atheneum, Hartford.

Robbins, Jerome, chor. *Moves: A Ballet in Silence.* New York City Ballet. New York State Theater, New York. 2 May 1984.

Rothman, Andrea. "Trouble Is, Someone Keeps Erasing Certain Lines from the Libretto." *Wall Street Journal* 22 July 1987, western ed.: 25.

Saint-Saens, Camille. *Samson et Dalila.*

Schoenberg, Arnold. *Erwartung.*

———. *Die glückliche Hand.*

———. *Moses und Aron.*

———. *Pierrot Lunaire.*

Strauss, Richard. *Ariadne auf Naxos.*

———. *Elektra.*

———. *Salome.*

Stravinsky, Igor. *Oedipus Rex.*

———. *The Rake's Progress.*

Sybenberg, Hans-Jürgen, dir. *Parsifal.* Corinth Video, 1982.

Verdi, Giuseppe. *Don Carlos.*

Wagner, Richard. *Parsifal.*

Warhol, Andy. *Twenty-five Colored Marilyns.* Fort Worth Art Museum, Fort Worth.

Wilson, Robert, dir., and Glass, Philip, composer. *Einstein on the Beach.* Byrd Hoffman Foundation in cooperation with Metropolitan Opera. Metropolitan Opera House, New York. 21 and 28 Nov. 1976.

Wilson, Robert et al. Libretto. *Einstein on the Beach.* CBS Records, M4 38875, n.d.

4

"The Pastime of Past Time": Fiction, History, Historiographic Metafiction

Linda Hutcheon
University of Toronto

i

We theoreticians have to know the laws of the peripheral in art.
The peripheral is, in fact, the non-esthetic set.
It is connected with art, but the connection is not causal.
But to stay alive, art must have new raw materials. Infusions of the
peripheral.

Viktor Shklovsky

In the nineteenth century, at least before the rise of Ranke's "scientific history," literature and history were considered branches of the same tree of learning, a tree which sought to "interpret experience, for the purpose of guiding and elevating man" (Nye 123). Then came the separation that resulted in the distinct disciplines of literary and historical studies today, despite the fact that the realist novel and Rankean historicism share many similar beliefs about the possibility of writing factually about observable reality (Hayden White "Fictions" 25). However, it is this very separation of the literary and the historical that is now being challenged in the theory and art of what we seem to want to label as postmodernism. Recent postmodern readings of both history and realist fiction have focused more on what the two modes of writing share than on how they differ. They have both been seen to derive their force more from verisimilitude than from any objective truth; they are both identified as linguistic constructs, highly conventionalized in their narrative forms, and not at all transparent, either in terms of language or structure; and they appear to be equally intertextual, deploying the texts of the past within their own complex textuality. But these are also the implied teachings of what I would like to call postmodern "historiographic metafiction"—novels that are intensely self-reflexive but that also both re-introduce historical context into metafiction and problematize the

54

entire question of historical knowledge. Like those recent theories of both history and fiction, this kind of novel—*G.*, *Midnight's Children*, *Ragtime*, *The French Lieutenant's Woman*, *The Name of the Rose*—forces us to recall that history and fiction are themselves historical terms and their definitions and interrelations are historically determined and vary with time (see Seamon 212–16).

In the last century, as Barbara Foley has shown, historical writing and historical novel writing influenced each other mutually: Macauley's debt to Scott was an overt one, as was Dickens's to Carlyle in *A Tale of Two Cities* (Foley 170–1). Today, the new skepticism and suspicion about the writing of history that one finds in the work of Hayden White, Michel de Certeau, Paul Veyne, Lionel Gossman, Dominick LaCapra, and others are mirrored in the challenges to historiography in novels like *Shame*, *The Public Burning* or *A Maggot*: they share the same questioning stance toward their common use of conventions of narrative, of reference, of the inscribing of subjectivity, of their identity as textuality, and even of their implication in ideology.

In both fiction and history writing today, our confidence in empiricist and positivist epistemologies has been shaken—shaken, but perhaps not yet destroyed. And this is what accounts for the skepticism rather than any real denunciation; it also accounts for the defining paradoxes of postmodern discourses. Postmodernism is a contradictory cultural enterprise, one that is heavily implicated in that which it seeks to contest. It uses and abuses the very beliefs it takes to task; it installs and only then subverts the conventions of genre. Historiographic metafiction, for example, keeps distinct its formal autorepresentation from its historical context, and in so doing problematizes the very possibility of historical knowledge, because there is no reconciliation, no dialectic here—just unresolved contradiction.

The history of the discussion of the relation of art to historiography is therefore relevant to any poetics of postmodernism, for the separation is a traditional one, even if it is being reformulated in a different context today. To Aristotle (*Poetics* 1451a–b), the historian could only speak of what has happened, of the particulars of the past; the poet, on the other hand, spoke of what could or might happen and so could deal more with universals. Freed of the linear succession of history writing, the poet's plot could have different unities. This was not to say that historical events and personages could not appear in tragedy: "nothing prevents some of the things that have actually happened from being of the sort

that might probably or possibly happen" (1451b). History-writing was seen to have no such conventional restraints of probability or possibility. Nevertheless, many historians since have used the techniques of fictional representation to create imaginative versions of their historical, real worlds (see Holloway; Levine; Braudy; Henderson). The postmodern novel has done the same, and the reverse. It is part of the postmodernist stand to confront the paradoxes of fictive vs. historical representation, the particular vs. the general, and the present vs. the past. And its confrontation is itself contradictory, for it refuses to recuperate or dissolve either side of the dichotomy, yet it is willing to exploit both.

History and fiction have always been notoriously porous genres, of course. At various times both have included in their elastic boundaries such forms as the travel tale and various versions of what we now call sociology (Veyne 30). It is not surprising that there would be over-lappings of concern and even mutual influences between the two genres. In the eighteenth century, the focus of this commonality of concern tended to be the relation of ethics (not factuality) to truth in narrative. Both journalism and novels could be equally "false" in ethical terms. (Only with the passing of the Acts of Parliament that defined libel did the notion of historical "fact" enter this debate [Davis].) It is not accidental that, in one critic's words, "[f]rom the start the writers of novels seemed determined to pretend that their work is not *made*, but that it simply exists" (Josipovici 148); in fact, it was safer, in legal and ethical terms. Defoe's works made claims to veracity and actually con-vinced some readers that they were factual, but most readers today (and many then) had the pleasure of a double awareness of both fictiveness and a basis in the "real"—as do readers of contemporary historiographic metafiction.

In fact, J.M. Coetzee's recent novel, *Foe*, addresses precisely this question of the relation of "story" and "history" writing to "truth" and exclusion in the practice of Defoe. There is a direct link here to a familiar assumption of historiography: "that every history is a history of some entity which existed for a reasonable period of time, that the historian wishes to state what is literally true of it in a sense which distinguishes the historian from a teller of fictitious or mendacious stories" (Morton White 4). *Foe* reveals that storytellers can certainly silence, exclude, and absent certain past events—and people—but it also suggests that histo-rians have done the same: where are the women in the traditional histories of the eighteenth century? Coetzee offers the teasing fiction that

Defoe did not write *Robinson Crusoe* from information from the historical castaway, Alexander Selkirk, or from other travel accounts, but from information given him by a subsequently "silenced" woman, Susan Barton, who had also been a castaway on "Cruso" 's [sic] island. It had been Cruso who had suggested that she tell her story to a writer who would add "a dash of colour" to her tale. She resists because she wants the "truth" told, and Cruso admits that a writer's "trade is in books, not in truth" (40). But Susan sees the problem: "If I cannot come forward, as author, and swear to the truth of my tale, what will be the worth of it? I might as well have dreamed it in a snug bed in Chichester" (40).

Susan tells Foe (he added the "de" only later, and so lost Coetzee's irony) her tale and his response is that of a novelist. Susan replies: "You remarked it would have been better had Cruso rescued not only musket and powder and ball, but a carpenter's chest as well, and built himself a boat. I do not wish to be captious, but we lived on an island so buffeted by wind that there was not a tree did not grow twisted and bent" (55). In frustration, she begins her own tale, "The Female Castaway, Being a True Account of a Year Spent on a Desert Island. With Many Strange Circumstances Never Hitherto Related" (67), but discovers that the problems of writing history are not unlike those of writing fiction: "Are these enough strange circumstances to make a story of? How long before I am driven to invent new and stranger circumstances: the salvage of tools and muskets from Cruso's ship; the building of a boat . . . a landing by cannibals . . . ?" (67). Her final decision is, however, that "what we accept in life we cannot accept in history" (67)—that is, lies and fabrications.

The linking of "fictitious" to "mendacious" stories (and histories) is one that other historiographic metafictions also seem to be obsessed with: *Famous Last Words, Legs, Waterland* and *Shame*. In the latter, Salman Rushdie's narrator addresses openly the possible objections to his position as insider/outsider (i.e., an immigrant) writing about the events of Pakistan from England—and in English:

> *Outsider! Trespasser! You have no right to this subject!* . . . I know: nobody ever arrested me [as they did the friend of whom he has just written]. Nor are they ever likely to. *Poacher! Pirate! We reject your authority. We know you, with your foreign language wrapped around you like a flag: speaking about us in your forked tongue, what can you tell but lies?* I reply with more questions: is history to be considered the property of the participants solely? In what courts are such claims staked, what boundary commissions map out the territories? (28)

The eighteenth-century concern for lies and falsity becomes a postmodern concern for the multiplicity and dispersion of truth(s), truth(s) relative to the specificity of place and culture. Yet the paradox is still there: when Pakistan was formed, the *Indian* history had to be written out of the Pakistani past. But who did this work? History was rewritten by immigrants—in Urdu and English, the imported tongues. As the narrator of *Shame* puts it, he is forced—by history—to write in "this Angrezi . . . and so for ever alter what is written" (38).

There has also been another, long tradition, dating (as we have seen) from Aristotle, that makes fiction not only separate from, but also superior to, history, a mode of writing which can only narrate the contingent and particular. The romantic and modernist assertions of the autonomy and supremacy of art led, however, as Jane Tompkins has shown so convincingly, to a marginalization of literature, one that extremes of metafiction (like American surfiction) only exacerbate. Historiographic metafiction, in deliberate contrast to what I would call such late modernist radical metafiction, attempts to demarginalize the literary through confrontation with the historical, and it does so both thematically and formally.

For example, Christa Wolf's *No Place on Earth* is about the fictionalized meeting of two historical figures, dramatist Heinrich von Kleist and poet Karoline von Günderrode: "The claim that they met: a legend that suits us. The town of Winkel, on the Rhine, we saw it ourselves." The "we" of the narrating voice, in the present, underlines the metafictive historical reconstruction on the level of form. But on the thematic level too, life and art meet, for this is the theme of the novel, as Wolf's Kleist tries to break down the walls between "literary fantasies and the actualities of the world" (12), contesting his colleagues' separation of poets from praxis: "Of all the people here, perhaps there is none more intimately bound to the real world than I am" (82). It is he who is trying to write a romantic historical work about Robert Guiscard, Duke of Normandy. The metafictive and the historiographic also meet in the intertexts of the novel, for it is through them that Wolf fleshes out the cultural and historical context of the fictive meeting. The intertexts range from Günderrode's own letters to canonic romantic works like Hölderlin's *Hyperion*, Goethe's *Torquato Tasso* and Brentano's *Gedichte*—but, in all, the theme is the relation, or rather the conflict, between art and history, between literature and life. This novel reminds us, as did Roland Barthes much earlier, that the nineteenth century gave birth to both the realist

novel and history, two genres which share a desire to select, construct, and render self-sufficient and closed a narrative world that would be representational but still separate from changing experience and historical process. Today, history and fiction share a need, if not really a desire, to contest these very assumptions.

ii

To the truth of art, external reality is irrelevant. Art creates its own reality, within which truth and the perfection of beauty is the infinite refinement of itself. History is very different. It is an empirical search for external truths, and for the best, most complete, and most profound external truths, in a maximal corresponding relationship with the absolute reality of the past events.

David Hackett Fischer

These words are not without their ironic tone, of course, as Fischer is describing what he sees as a standard historian's preconceptions about art and history. But it is not far from a description of the basic assumptions of many kinds of formalist criticism: "literature is not a discourse that can or must be false . . . it is a discourse that, precisely, cannot be subjected to the test of truth; it is neither true nor false, to raise this question has no meaning: this is what defines its very status as 'fiction' " (Todorov 18). Historiographic metafiction suggests that truth and falsity may indeed not be the right terms in which to discuss fiction, but not for the reasons offered above. Postmodern novels like *Flaubert's Parrot, Famous Last Words* and *A Maggot* imply that there are only truths in the plural, and never one truth; and there is rarely falseness *per se,* just other truths. Fiction and history are narratives distinguished by their frames (see Smith), frames which historiographic metafiction both asserts and then crosses. It posits both the generic contracts of fiction (as self-sufficient, autonomous metafiction) and of history. The postmodern paradoxes here are complex. The interaction of the historiographic and the metafictional foregrounds the rejection of the claims of both "authentic" representation and "inauthentic" copy alike, and the very meaning of artistic originality is as challenged as is the transparency of historic referentiality.

Postmodern fiction suggests that to re-write or to re-present the past in fiction and in history is, in both cases, to open it up to the present, to prevent it from being conclusive and teleological. Such is the teaching of

novels like Susan Daitch's *L.C.*, with its double layer of historical reconstruction, both of which are presented with metafictional self-consciousness. Parts of the journal of (fictive) Lucienne Crozier, implicated yet marginalized witness of the (real) 1848 revolution in Paris, are edited and translated twice: once by Willa Rehnfield and once by her younger assistant after her death. The recent interest in archival women's history is given an interesting new twist here, for the two translations of the end of Lucienne's diary are so vastly different that the entire activity of translation, as well as research, is called into question. In the more traditional Willa's version, Lucienne dies of consumption in Algiers, abandoned by her revolutionary lover. In the version of her more radical assistant (a veteran of Berkeley in 1968, being sought by the police for a bombing), Lucienne stops writing, while also awaiting arrest for her own revolutionary activities. The only common denominator appears in the image that, in the Arab world of Algiers, Lucienne feels *like an invalid—* sequestered and marginalized.

The problematizing of the nature of historical knowledge, in novels like this or like Ian Watson's *Chekhov's Journey*, points both to the need to separate and the danger of separating fiction and history as narrative genres. This problematizing has also been in the foreground of much contemporary literary theory (on Lentricchia, de Man, and Derrida, see Parker) and philosophy of history, from Hayden White to Paul Veyne. When the latter calls history "un roman vrai" (10), he is signalling the two genres' shared conventions: selection, organization, diegesis, anecdote, temporal pacing, and emplotment (14, 15, 22, 29, 46–8). But this is not to say that history and fiction are part of the "same order of discourse" (Lindenberger 18). They are different, though they share social, cultural, and ideological contexts, as well as formal techniques. Novels (with the exception of some extreme surfictions) incorporate social and political history to some extent, and that extent will vary (Hough 113), just as historiography is often as structured, coherent, and teleological as any narrative fiction. It is not only the novel but history too that is "palpably betwixt and between" (Kermode "Novel" 235). Both historians and novelists *constitute* their subjects as possible objects of narrative representation, as Hayden White ("Historical Text" 57) has argued (for history alone, however). And they do so by the very structures and language they use to present those subjects. In Jacques Ehrmann's extreme formulation: "history and literature have no existence in and of themselves. It is we who constitute them as the object of our understand-

ing" (153).

Postmodernism deliberately confuses the notion that history's problem is verification, while fiction's is veracity (Berthoff 272). Both are signifying systems in our culture, what Doctorow once called modes of "mediating the world for the purpose of introducing meaning" ("False Documents" 24). And it is both the constructed, imposed nature of that meaning and the seemingly absolute necessity for us to make meaning that historiographic metafiction like Coover's *The Public Burning* reveals. This novel teaches that "history itself depends on conventions of narrative, language, and ideology in order to present an account of 'what really happened' " (Mazurek 29). Both history and fiction are cultural sign systems, ideological constructions whose ideology includes their appearance of being autonomous and self-contained. It is the metafictionality of these novels that underlines Doctorow's notion that "history is a kind of fiction in which we live and hope to survive, and fiction is a kind of speculative history . . . by which the available data for the composition is seen to be greater and more various in its sources than the historian supposes" (25).

Fredric Jameson has argued that historical representation is as surely in crisis as is the linear novel, and for much the same reasons:

> The most intelligent 'solution' to such a crisis does not consist in abandoning historiography altogether, as an impossible aim and an ideological category all at once, but rather—as in the modernist aesthetic itself—in reorganizing its traditional procedures on a different level. Althusser's proposal seems the wisest in this situation: as old-fashioned narrative or 'realistic' historiography becomes problematic, the historian should reformulate her vocation—not any longer to produce some vivid representation of history 'as it really happened,' but rather to produce the *concept* of history. ("Periodizing" 180)

There is only one word I would change in this: the word "modernist" seems to me to be less apt than "postmodernist," though Jameson would never agree (see "Postmodernism and Consumer Society" and "Postmodernism or The Cultural Logic"). Postmodern historiographic metafiction has done exactly what Jameson calls for here, though it is more the problematizing than just the production of a "*concept* of history" (and fiction) that results. The two genres may be textual constructs, narratives which are both nonoriginary in their reliance on past intertexts and also unavoidably ideologically laden, but they do not, in historiographic metafiction at least, "adopt equivalent representational

procedures or constitute equivalent modes of cognition" (Foley 35). However, there are (or have been) combinations of history and fiction which do attempt such equivalence.

iii

. . . the binary opposition between fiction and fact is no longer relevant: in any differential system, it is the assertion of the space *between* the entities that matters.

Paul de Man

Perhaps. But historiographic metafiction suggests the continuing relevance of such an opposition, even if it be a problematic one. It both installs and then blurs the line between fiction and history. This kind of generic blurring has been a feature of literature back to the classical epic and the Bible (see Weinstein 263), but the simultaneous assertion and crossing of boundaries is more postmodern. Umberto Eco has claimed that there are three ways to narrate the past: the romance, the swashbuckling tale, and the historical novel. He has added that it was the latter that he intended to write in *The Name of the Rose* (74–5). Historical novels, he feels, "not only identify in the past the causes of what came later, but also trace the process through which those causes began slowly to produce their effects" (76). This is why his medieval characters, like John Banville's in his *Doctor Copernicus*, are made to talk like Wittgenstein. I would say, however, that this device points to a fourth way of narrating the past: historiographic metafiction—and not historical fiction—because of the intensely self-conscious way in which all this is done.

What is the difference between postmodern fiction and what we usually think of as nineteenth-century historical fiction, though its forms persist today (see Fleishman)? It is difficult to generalize about this latter complex genre because, as theorists have pointed out, history plays a great number of distinctly different roles, at different levels of generality, in its various manifestations. There seems little agreement as to whether the historical past is always presented as individualized, particularized and past (i.e., different from the present) (see Shaw 26, 48, 148) or whether that past is offered as typical and therefore present, or at least as sharing values through time with the present (Lukács). While acknowledging the difficulties of definition (see Turner; Shaw) that the historical novel shares with most genres, we might define historical

fiction as that which is modelled on historiography to the extent that it is motivated and made operative by a notion of history as a shaping force (in the narrative and in human destiny) (see Fleishman). However, it is Georg Lukács' influential and more particular definition that theorists most frequently have to confront in their defining, and I am no exception.

Lukács felt that the historical novel could enact historical process by presenting a microcosm which generalizes and concentrates (39). The protagonist, therefore, should be a type, a synthesis of the general and particular, of "all the humanly and socially essential determinants." From this definition, it is clear that the protagonists of historiographic metafiction are anything but types: they are the ex-centrics, the marginalized, the peripheral figures of fictional history—the Coalhouse Walkers (in *Ragtime*), the Saleem Sinais (in *Midnight's Children*), the Fevvers (in *Nights at the Circus*). Even the historical personages take on different, particularized, and ultimately ex-centric status: Doctor Copernicus (in the novel of the same name), Houdini (in *Ragtime*), Richard Nixon (in *The Public Burning*). Historiographic metafiction espouses a postmodern ideology of pluralism and recognition of difference; "type" has little function here, except as something to be ironically undercut. The protagonist of a postmodern novel like Doctorow's *Book of Daniel* is overtly specific, individual, culturally and familially conditioned in his response to history, both public and private. The narrative form enacts the fact that Daniel is not a type of anything, no matter how much he may try to see himself as representing the New Left or his parents' cause.

Related to this notion of type is Lukács' belief that the historical novel was defined by the relative unimportance of its use of detail, which he saw as "only a means of achieving historical faithfulness, for making concretely clear the historical necessity of a concrete situation" (59). Therefore, accuracy or even truth of detail was irrelevant. Many readers of historical fiction would disagree, I suspect, as have writers of it (John Williams 8–11). Postmodern fiction contests this defining characteristic in two different ways. First of all, historiographic metafiction, as we have seen, plays upon the truth and lies of the historical record. In novels like *Foe, Burning Water* or *Famous Last Words*, certain known historical details are deliberately falsified in order to foreground the possible mnemonic failures of recorded history and the constant potential for both deliberate and inadvertent error. The second difference lies in the way in which postmodern fiction actually uses detail or historical data. Historical

fiction (*pace* Lukács) usually incorporates and assimilates these data in order to lend a patina of verifiability or an air of dense specificity and particularity to the fictional world. Historiographic metafiction incorporates, but rarely assimilates the data. More often the process of *attempting* to assimilate is what is foregrounded. Historiographic metafiction acknowledges the paradox of the *reality* of the past but its (only) *textualized* accessibility to us today.

Lukács's third major defining characteristic of the historical novel is its relegation of historical personages to secondary roles. Clearly, in postmodern novels like *Doctor Copernicus, Kepler, Legs* (Jack Diamond) and *Antichthon* (Giordano Bruno), this is hardly the case. In many historical novels, the real figures of the past are deployed to validate or authenticate the fictional world by their presence, as if to hide the joins between fiction and history in a formal, ontological sleight of hand. The metafictional self-reflexivity of postmodern novels prevents any such subterfuge, and poses that ontological join as a problem: how do we know the past? what do (what can) we know of it now? Sometimes the manipulation of historical personages is so blatant and in conflict with known fact that the reader is forced to ask the reason behind, for instance, John Barth's rewriting of John Smith's rescue of Pocahontas in *The Sot-Weed Factor*. It is never too difficult to see that reason, thanks to the overt metafictionality: here, it is the demystification of the heroic—and falsifying—view of history that has passed into legend. Similarly Coover does considerable violence to the history of the Rosenbergs in *The Public Burning*, but he does so to satiric ends, in the name of social critique. I do not think that he intends to construct a wilful betrayal of politically tragic events; perhaps, however, he does want to make a connection to the real world of political action through the reader—through our awareness of the need to question received versions of history.

While the debates still rage about the definition of the historical novel, in the 1960s a new variant on the history/fiction confrontation came into being: the non-fictional novel. This differed from the treatment of recent factual events recounted as history, as in William Manchester's *The Death of a President*. It was a form of documentary narrative which deliberately used techniques of fiction in an overt manner and which usually made no pretense of objectivity of presentation. In the work of Hunter S. Thompson, Tom Wolfe and Norman Mailer, the authorial structuring experience was often in the forefront as the new guarantee of "truth," as we watched the narrator's individual attempts to

perceive and impose pattern on what he saw about him. This metafictionality and provisionality in the non-fictional novel obviously link it to historiographic metafiction, but there are, as we shall see, significant differences.

It is probably not accidental that this form of the New Journalism, as it was called, was an American phenomenon. The Vietnam War had brought with it a real distrust of official "facts" as presented by the military and the media, and the ideology of the sixties had licensed a revolt against homogenized forms of experience (Hellmann 8). The result was a kind of overtly personal and provisional journalism, autobiographical in impulse and performative in impact. The famous exception was Truman Capote's *In Cold Blood*, which is a modern rewriting of the realist novel—universalist in assumptions and omniscient in narrative technique. But in works like *The Electric Kool-Aid Acid Test*, *Fear and Loathing: On the Campaign Trail '72*, and *Of a Fire on the Moon*, there was a very "sixties" kind of direct confrontation with social reality in the present (Hollowell 10). The impact of the new mixing of fiction and fact is clear on popular, if not academic, history in the years following: in *John Brown's Journey*, Albert Fried broke the rules and showed the tentative groping movement of his becoming interested in his historical topic. The book is "marked by the feeling of a historian in the act of grappling with his subject" (Weber 144), as the subtitle underlines: *Notes and Reflections on His America and Mine*.

The non-fictional novel of the sixties and seventies did not just record the contemporary hysteria of history, as Robert Scholes has claimed (37). It did not just try to embrace "the fictional element inevitable in any reporting" and then try to imagine its "way toward the truth" (37). What it did was seriously question who determined and created that truth, and it was this particular aspect of it that perhaps enabled historiographic metafiction's more paradoxical questioning. A number of critics have seen parallels in the non-fictional novel and contemporary metafiction, but they seem to disagree completely on the form that parallel takes. For one, both stress the overt, totalizing power of the imagination of the writers to create unities (Hellmann 16); for another both refuse to neutralize contingency by reducing it to unified meaning (Zavarzadeh 41). I would agree with the former as a designation of the non-fictional novel, though not of all metafiction; and the latter certainly defines a lot of contemporary self-reflexive writing more accurately than it does the New Journalism. Historiographic metafiction, of

course, fits both definitions: it installs totalizing order, only to contest
it, by its radical provisionality, intertextuality, and, often, fragmenta-
tion. In many ways, the non-fiction novel is a late modernist creation (see
Smart 3) in the sense that both its self-consciousness about its writing
process and its stress on subjectivity (or psychological realism) recall
Woolf and Joyce's experiments with limited, depth vision in narrative,
though, in the New Journalism, it is the author whose historical
presence as participant authorizes subjective response. Postmodern
novels like Rudy Wiebe's *The Scorched-Wood People* parody this stance,
however. The participant in the historical action was real, but is still
fictionalized: he is made to tell the tale of Louis Riel from a point in time
AFTER his own death, with the insights of retrospection and access to
information he could not possibly have had as participant.

<center>iv</center>

History is three-dimensional. It partakes of the nature of science, art, and
philosophy.

<div align="right">Louis Gottschalk</div>

 Historiographic metafictions raise a number of specific issues regard-
ing the interaction of historiography and fiction that deserve more
detailed study: issues surrounding the nature of identity and sub-
jectivity; the question of reference and representation; the intertextual
nature of the past; the ideological implications of writing about history;
narrative emplotting; and the status of historical documents, not to
mention "facts."
 First of all, historiographic metafictions appear to privilege two
modes of narration, both of which problematize the entire notion of
subjectivity: multiple points of view (as in Thomas's *The White Hotel*) or
an overtly controlling narrator (as in Swift's *Waterland*). In neither,
however, do we find a subject confident of his/her ability to know the
past with any certainty. This is not a transcending of history, but a
problematized inscribing of subjectivity into history. In a novel like
Midnight's Children, nothing, not even the self's physical body, survives
the instability caused by the rethinking of the past in non-
developmental, non-continuous terms. To use the (appropriate) lan-
guage of Michel Foucault, Saleem Sinai's body is exposed as "totally
imprinted by history and the process of history's destruction of the body"
(148). Postmodernism establishes, differentiates, and then disperses

stable narrative voices (and bodies) that use memory to try to make sense of the past. It both installs and then subverts traditional concepts of subjectivity; it both establishes and is capable of shattering "the unity of man's being through which it was thought that he could extend his sovereignty to the events of the past" (Foucault 153). The protagonist's psychic disintegration in *Waterland* reflects this shattering; but his strong narrative voice asserts that same selfhood, in a typically postmodern and paradoxical way. The second epigraph of Swift's novel is from *Great Expectations* (a retrospectively ironic source for a book about no expectations and about the past). *Waterland* shares with Dickens's novel a locale (the marshy fenlands) and a preoccupation with the past, but Swift reveals none of Dickens's confidence that one could learn from that past. Indeed, his history teacher protagonist knows better—from both global and personal experience. This kind of intertextuality, often parodic in its ironies, is typical of postmodern fiction. It is a way of literally incorporating the textualized past into the text of the present.

Postmodern intertextuality is a formal manifestation of both a desire to close the gap between past and present for the reader and a desire to rewrite the past in a new context. It is not a modernist desire to order the present through the past or to make the present look spare in contrast to the richness of the past (see Antin 106–14). It is not an attempt to void or avoid history. Instead, it directly confronts the past of literature—and of historiography, for it too derives from other texts (documents). It uses and abuses those intertextual echoes, inscribing their powerful allusions and then subverting that power through irony. In all, there is little of the modernist sense of a unique, symbolic, visionary "work of art"; there are only texts, already written ones. Intertexts can be both historical and aesthetic in their nature and function.

To what, though, does the very language of historiographic metafiction refer? To a world of history or one of fiction? It is commonly accepted that there is a radical disjunction between the basic assumptions underlying these two notions of reference. History's referents are presumed to be real; fiction's are not. But what postmodern novels teach is that, in both cases, they actually refer at the first level to other texts: we only know the past (which really did exist) through its textualized remains. They problematize the activity of reference by refusing either to bracket the referent (as surfiction might) or to revel in it (as non-fictional novels might). This is not an emptying of the meaning of language, as Gerald Graff seems to think (397). The text still communicates—in fact,

it does so very didactically. There is not so much "a loss of belief in a significant external reality" (403) as there is a loss of faith in our ability to (unproblematically) *know* that reality, and therefore to be able to represent it in language. Fiction and history are not different in this regard.

Historiographic metafiction also poses new questions about reference. The issue is no longer: "to what empirically real object in the past does the language of history refer?"; it is more: "to which discursive context could this language belong? to which prior textualizations must we refer?" Postmodern art is more complex and more problematic than extreme late modernist autorepresentation might suggest, with its view that there is no presence, no external truth which verifies or unifies, that there is only self-reference (Smith 8–9). Historiographic metafiction self-consciously states this, but then immediately points to the discursive nature of all reference—both literary and historiographical. The referent is always already inscribed in the discourses of our culture. This is no cause for despair; it is the text's major link with the "world," but one that acknowledges its identity as construct, rather than as simulacrum of some "real" outside. Once again, this does not deny that the past "real" existed; it only conditions our mode of knowledge of that past—we can only know it through its traces, it relics. The question of reference depends on what John Searle (330) calls a shared "pretense" and what Stanley Fish calls being party to a set of "discourse agreements which are in effect decisions as to what can be stipulated as a fact" (242). A "fact" is discourse-defined; an "event" is not.

Postmodern art is not so much ambiguous as it is doubled and contradictory, as can be seen in novels like Pynchon's *Gravity's Rainbow*, whose overassertion of reference "dissipates its own referentiality" (Bradbury 178). There is clearly a rethinking of the modernist tendency to move away from representation (Harkness 9) by both installing it materially and subverting it. In the visual arts, as in literature, there has been a rethinking of the sign/referent relation in the face of the realization of the limits of self-reflexivity's separation from social practice (Menna 10). Historiographic metafiction shows fiction to be historically conditioned and history to be discursively structured, and in the process manages to broaden the debate about the ideological implications of the Foucaldian conjunction of power and knowledge—for readers and for history itself as a discipline. As the narrator of Rushdie's *Shame* puts it: "History is natural selection. Mutant versions of the past struggle for dominance; new species of fact arise, and old saurian truths go to the

wall, blindfolded and smoking last cigarettes. Only the mutations of the strong survive. The weak, the anonymous, the defeated leave few marks History loves only those who dominate her: it is a relationship of mutual enslavement" (124).

The question of whose history survives is one that obsesses postmodern novels like Timothy Findley's *Famous Last Words*. In problematizing almost everything the historical novel once took for granted, historiographic metafiction destabilizes concepts of both history and fiction. The premise of postmodern fiction is the same as that articulated by Hayden White regarding history: "every representation of the past has specifiable ideological implications" (*Tropics* 69). But the ideology of postmodernism is paradoxical, for it depends upon and draws its power from that which it contests. It is not truly radical; nor is it truly oppositional (as Martin 44–6 claims for the novel as a genre). But this does not mean it has no critical clout. The Epiloguist of *A Maggot* may claim that what we have read is indeed "a maggot, not an attempt, either in fact or in language, to reproduce known history" (449), but that does not stop him from extended ideological analyses of eighteenth-century social, sexual, and religious history. Similarly, contemporary philosophers of history like Michel de Certeau have reminded historiographers that no research of the past is free of socio-economic, political, and cultural conditions (65). Novels like *The Public Burning* or *Ragtime* do not trivialize the historical and the factual in their "game-playing" (Robertson), but rather politicize them through their metafictional rethinking of the epistemological and ontological relations between history and fiction. Both are acknowledged as part of larger social and cultural discourses which formalist literary criticism had formerly relegated to the extrinsic and irrelevant. This said, it is also true that it is part of the postmodern ideology not to ignore cultural bias and interpretive conventions and to question authority—even its own.

All of these issues—subjectivity, intertextuality, reference, ideology—underlie the problematized relations between history and fiction in postmodernism. But many theorists today have pointed to narrative as the one concern that envelops all of these, for the process of narrativization has come to be seen as a central form of human comprehension, of imposition of meaning and formal coherence on the chaos of events (Hayden White "Narrativization" 795; Jameson *Political* 13; Mink 132). Narrative is what translates knowing into telling (Hayden White "Value" 5), and it is precisely this translation that obsesses postmodern

fiction. The conventions of narrative in both historiography and novels, then, are not constraints, but enabling conditions of possibility of sense-making (Martin). Their disruption or challenging will be bound to upset such basic structuring notions as causality and logic—as happens with Oskar's drumming in *The Tin Drum*: narrative conventions are both installed and subverted. The refusal to integrate fragments (in novels like *Z.* or *The White Hotel*) is a refusal of the closure and telos which narrative usually demands (see Kermode *Sense*). In postmodern poetry too, as Marjorie Perloff has argued, narrative is used in works like Ashbery's "They Dream Only of America" or Dorn's *Slinger*, but used in order to question "the very nature of the *order* that a systematic plot structure implies" (158).

The issue of narrativity encompasses many others that point to the postmodern view that we can only know "reality" as it is produced and sustained by cultural representations of it (Owens 21). In historiographic metafictions, these need not be directly verbal representations, for *ekphrases* (or verbal representations of visual representations) often have central representational functions. For example, in Carpentier's *Explosion in a Cathedral*, Goya's "Desastres de la guerra" series provides the works of visual art that are actually the sources of the novel's descriptions of revolutionary war. The seventh of that series, plus the "Dos de Mayo" and "Tres de Mayo," are particularly important, for their glorious associations are left aside by Carpentier, as an ironic signal of his own point of view. Of course, literary intertexts function in the narrative in a similar way. The details of Estaban and Sofía's house in Madrid come, in fact, from Torres Villaroel's *Vida*, a book which Estaban had read earlier in the novel (see Saad 120–2).

Historiographic metafictions, like both historical fiction and narrative history, cannot avoid dealing with the problem of the status of their "facts" and of the nature of their evidence, their documents. And, obviously, the related issue is that of how those documentary sources are deployed: can they be objectively, neutrally related? or does interpretation inevitably enter with narrativization? The epistemological question of how we know the past joins the ontological one of the status of the traces of that past. Needless to say, the postmodern raising of these questions offers few answers, but this provisionality does not result in some sort of historical relativism or presentism. It rejects projecting present beliefs and standards onto the past and asserts, in strong terms, the specificity and particularity of the individual past event. Neverthe-

less, it also realizes that we are epistemologically limited in our ability to know that past, since we are both spectators of and actors in the historical process. Historiographic metafiction suggests a distinction between "events" and "facts" that is one shared by many historians. Events are configured into facts by being related to "conceptual matrices within which they have to be imbedded if they are to count as facts" (Munz 15). Historiography and fiction, as we saw earlier, *constitute* their objects of attention; in other words, they decide which events will become facts. The postmodern problematization points to our unavoidable difficulties with the concreteness of events (in the archive, we can find only their textual traces to make into facts) and their accessibility (do we have a full trace or a partial one? what has been absented, discarded as non-fact material?). Dominick LaCapra has argued that all documents or artifacts used by historians are not neutral evidence for reconstructing phenomena which are assumed to have some independent existence outside them. All documents process information and the very way in which they do so is itself a historical fact that limits the documentary conception of historical knowledge (45).

I do not mean to suggest that this is a radical, new insight. In 1910, Carl Becker wrote that "the facts of history do not exist for any historian until he creates them" (525), that representations of the past are selected to signify whatever the historian intends. It is this very difference between events (which have no meaning in themselves) and facts (which are given meaning) that postmodernism foregrounds. Even documents are selected as a function of a certain problem or point of view (Ricoeur 108). Historiographic metafiction often points to this process by using the paratextual conventions of historiography (especially footnotes) to both inscribe and undermine the authority and objectivity of historical sources and explanations.

Unlike the documentary novel as defined by Barbara Foley, what I have been calling postmodern fiction does not "aspire to tell the truth" (Foley 26) as much as to question *whose* truth gets told. It does not so much associate "this truth with claims to empirical validation" as contest the ground of any claim to such validation. How can a historian (or a novelist) check any historical account against past empirical reality in order to test its validity? Facts are not given but are constructed by the kinds of questions we ask of events (Hayden White *Tropics* 43). In the words of *Waterland*'s history teacher, the past is a "thing which cannot be eradicated, which accumulates and impinges" (109). What postmodern

discourses—fictive and historiographic—ask is how we know and come to terms with such a complex "thing."

WORKS CITED

Antin, David. "Modernism and Postmodernism: Approaching the Present in American Poetry." *Boundary 2* 1.1 (Fall 1972): 98–133.

Aristotle. *Poetics*. Trans. James Hutton. London & NY: Norton, 1982.

Barthes, Roland. *Writing Degree Zero*. Trans. Annette Lavers & Colin Smith. London: Jonathan Cape, 1967.

Becker, Carl. "Detachment and the Writing of History." *Atlantic Monthly* 106 (1910): 534–6.

Berthoff, Warner. "Fiction, History, Myth: Notes toward the Discrimination of Narrative Forms." In Bloomfield 263–87.

Bloomfield, M.W., ed. *The Interpretation of Narrative: Theory and Practice*. Cambridge: Harvard UP, 1970.

Bradbury, Malcolm. *The Modern American Novel*. Oxford & NY: Oxford UP, 1983.

Braudy, Leo. *Narrative Form in History and Fiction: Hume, Fielding and Gibbon*. Princeton: Princeton UP, 1970.

Bremner, Robert H., ed. *Essays on History and Literature*. np: Ohio State UP, 1966.

Canary, Robert H. and Henry Kozicki, eds. *The Writing of History: Literary Form and Historical Understanding*. Madison: U of Wisconsin P, 1978.

Certeau, Michel de. *L'Ecriture de l'histoire*. Paris: Gallimard, 1975.

Coetzee, J.M. *Foe*. Toronto: Stoddart, 1986.

Daitch, Susan. *L.C.*, London: Virago, 1986.

Davis, Lennard. *Factual Fictions: The Origins of the English Novel*. NY: Columbia UP, 1983.

Doctorow, E.L. "False Documents." In Trenner 16–27.

Eco, Umberto. *Postscript to The Name of the Rose*. Trans. William Weaver. San Diego, NY, London: Harcourt, Brace, Jovanovich, 1983, 1984.

Ehrmann, Jacques. "The Death of Literature." Trans. A. James Arnold. In Federman 229–53.

Federman, Raymond, ed. *Surfiction: Fiction Now . . . and Tomorrow*. 2nd ed. Chicago: Swallow P, 1981.

Fish, Stanley. *Is There a Text in This Class?: The Authority of Interpretive Communities*. Cambridge & London: Harvard UP, 1980.

Fleishman, Avrom. *The English Historical Novel: Walter Scott to Virginia Woolf*. Baltimore: Johns Hopkins UP, 1971.

Fletcher, Angus, ed. *The Literature of Fact*. NY: Columbia UP, 1976.

Foley, Barbara. *Telling the Truth: The Theory and Practice of Documentary Fiction*. Ithaca & London: Cornell UP, 1986.

Foster, Hal, ed. *The Anti-Aesthetic: Essays on Postmodern Culture*. Port Townsend, WA: Bay P, 1983.

Foucault, Michel. *Language, Counter-Memory, Practice*. Trans. D.F. Bouchard and S. Simon. Ithaca: Cornell UP, 1977.

———. *This Is Not a Pipe*. Trans. & ed. James Harkness. Berkeley: U of California P, 1982.

Fowles, John. *A Maggot*. Toronto: Collins, 1985.

Graff, Gerald. "The Myth of the Postmodernist Breakthrough." *TriQuarterly* 26 (Winter 1973): 383–417.

Harkness, James. "Translator's Introduction." In Foucault *This Is Not a Pipe* 1–12.

Hellmann, John. *Fables of Fact: The New Journalism as New Fiction*. Urbana: U of Illinois P, 1981.

Henderson, Harry B. *Versions of the Past: The Historical Imagination in American Fiction*. NY: Oxford UP, 1974.

Holloway, John. *The Victorian Sage*. NY: Norton, 1953.

Hollowell, John. *Fact and Fiction: The New Journalism and the Nonfiction Novel*. Chapel Hill: U of North Carolina P, 1977.

Hook, Sidney, ed. *Philosophy and History: A Symposium*. NY: NYUP, 1963.

Hough, Graham. *An Essay on Criticism*. NY: Norton, 1966.

Jameson, Fredric. *The Political Unconscious: Narrative as a Socially Symbolic Act*. Ithaca: Cornell UP, 1981.

———. "Postmodernism and Consumer Society." In Foster 111–25.

———. "Postmodernism, or The Cultural Logic of Late Capitalism." *New Left Review* 146 (July/August 1984): 53–92.

———. "Periodizing the 60s." In Sayres *et al* 178–209.

Josipovici, Gabriel. *The World and the Book: A Study of Modern Fiction*. London: Macmillan, 1971.

Kermode, Frank. "Novel, History and Type." *Novel* 1 (1968): 231–8.

———. *The Sense of an Ending*. NY: Oxford UP, 1970.

LaCapra, Dominick. "On Grubbing in My Personal Archives: An Historiographical Exposé of Sorts (Or How I Learned to Stop Worrying and Love Transference)." *Boundary 2* 2.3 (1985): 43–67.

Levine, George. *The Boundaries of Fiction: Carlyle, Macaulay, Newman*. Princeton: Princeton UP, 1968.

Lindenberger, Herbert. "Toward a New History in Literary Study." *Profession 84* (1984): 16–23.

Lukács, Georg. *The Historical Novel*. Trans. Hannah & Stanley Mitchell. London: Merlin, 1962.

Martin, Wallace. *Recent Theories of Narrative*. Ithaca: Cornell UP, 1986.

Mazurek, Raymond A. "Metafiction, the Historical Novel, and Coover's *The Public Burning*." *Critique* 23.3 (1982): 29–42.

Menna, Filiberto. "Gli anni Settanta." *Il Verri* 1–2, 7th series (marzo/giugno 1984): 9–14.

Mink, Louis O. "Narrative Form as a Cognitive Instrument." In Canary & Kozicki 129–49.

Munz, Peter. *The Shapes of Time*. Middletown, Conn.: Wesleyan UP, 1977.

Nye, Russel B. "History and Literature: Branches of the Same Tree." In Bremner 123–59

Owens, Craig. "Representation, Appropriation & Power." *Art in America*. 70.5 (May 1982): 9–21.

Parker, Andrew. " 'Taking Sides' (On History): Derrida Re-Marx." *Diacritics* 11 (1981): 57–73.

Perloff, Marjorie. *The Dance of the Intellect: Studies in the Poetry of the Pound Tradition*. Cambridge: Cambridge UP, 1985

Ricoeur, Paul. *Time and Narrative*. Volume 1. Trans. Kathleen McLaughlin & David Pellauer. Chicago & London: U of Chicago P, 1984.

Robertson. Mary F. "Hystery, Herstory, History: 'Imagining the Real' in Thomas's *The White Hotel.*" *Contemporary Literature* 25.4 (Winter 1984): 452–77.

Rushdie, Salman. *Shame*. London: Picador, 1984.

Saad, Gabriel. "L'Histoire et la révolution dans *Le Siècle des lumières.*" In *Quinze Etudes autour de El Siglo de las luces de Alejo Carpentier*. Paris: L'Harmattan, 1983: 113–22.

Sayres, Sohnya, Anders Stephanson, Stanley Aronowitz, Fredric Jameson, eds. *The 60s Without Apology*. Minneapolis: U of Minnesota P and *Social Text*, 1984.

Scholes, Robert. "Double Perspective on Hysteria." *Saturday Review* 24 (August 1968): 37.

Seamon, Roger G. "Narrative Practice and the Theoretical Distinction Between History and Fiction." *Genre* 16 (1983): 197–218.

Searle, John. "The Logical Status of Fictional Discourse." *New Literary History* 6 (1975): 319-32.

Shaw, Harry E. *The Forms of Historical Fiction: Sir Walter Scott and His Successors*. Ithaca & London: Cornell UP, 1983.

Smart, Robert Augustin. *The Nonfiction Novel*. Lanham, NY, London: University Press of America, 1985.

Smith, Barbara Herrnstein. *On the Margins of Discourse: The Relation of Literature to Language*. Chicago: U of Chicago P, 1978.

Swift, Graham. *Waterland*. London: Heinemann, 1983.

Todorov, Tzvetan. *Introduction to Poetics*. Trans. Richard Howard. Minneapolis: U of Minnesota P, 1981.

Tompkins, Jane. "The Reader in History: The Changing Shape of Literary Response." In Tompkins 201–33.

Tompkins, Jane, ed. *Reader-Response Criticism: From Formalism to Post-Structuralism*. Baltimore: Johns Hopkins UP, 1980.

Trenner, Richard, ed. *E.L. Doctorow: Essays and Conversations*. Princeton: Ontario Review P, 1983.

Turner, Joseph W. "The Kinds of Historical Fiction." *Genre* 12 (1979): 333–55.

Veyne, Paul. *Comment on écrit l'histoire*. Paris: Seuil, 1971.

Weber, Ronald. *The Literature of Fact: Literary Nonfiction in American Writing*. Athens, Ohio: Ohio UP, 1980.

Weinstein, Mark A. "The Creative Imagination in Fiction and History." *Genre* 9.3 (1976): 263–77.

White, Hayden. "The Fictions of Factual Representation." In Fletcher 21–44.

———. "The Historical Text as Literary Artifact." In Canary & Kozicki 41–62.

———. *Tropics of Discourse: Essays in Cultural Criticism*. Baltimore & London: Johns Hopkins UP, 1978.

———. "The Value of Narrativity in the Representation of Reality." *Critical Inquiry* 7.1 (Autumn 1980): 5–27.

———. "The Narrativization of Real Events." *Critical Inquiry* 7.4 (Summer 1981): 793–8.

White, Morton. "The Logic of Historical Narration." In Hook 3–31.

Williams, John. "Fact in Fiction: Problems for the Historical Novelist." *Denver Quarterly* 7.4 (1973): 1–12.

Wolf, Christa. *No Place on Earth*. Trans. Jan Van Heurck. NY: Farrar, Straus, Giroux, 1982.

Zavarzadeh, Mas'ud. *The Mythopoeic Reality: The Postwar American Nonfiction Novel*. Urbana: U of Illinois P, 1976.

5

Palimtexts: Postmodern Poetry and the Material Text

Michael Davidson
University of California, San Diego

```
Rembranfts's Old Woman Utting Her Nails

An old woman
As if I saw her now
For the first time, cutting her nails
In the slant light

WE HAVE A LONG TRADITION OF CONTEMPT FOR MATTER, AND HAVE
CEASED TO NOTICE THAT ITS EXISTENCE __ AND ONLY ITS EXISTENCE __
REMAINS ABSOLUTELY UNEXPLAINED

   No raod now ends   : a network of roads.
       _____

   Wespeak of people's death, except the deaths of the extremely
   old, as if they might have lived forever   of course tney could
   not have, and therefore the difference bewteen thirty years of
   life and seventy years does not in itself define thexdifferxnxe
   tragedy
         But the wives or husbands and parents and children!!
   That is, when the young die, there are the bereaved   By the time
   the old man or woman dies, no on e is bereaved? Dare we say that?

   By the time a man or woman is very old, the tragedy has already
   happened
       _____

   'Mankind' is a conversation
       _____

   It would be hard for human nature to find a better ally in this
   enterprise than love'   Symposium

   One knows what he thinks   but not what he will find

   the classic love of the finite has no relevance to our knowledge
```

Figure 1

"Piling up pieces of paper to find the words" (George Oppen)

The page [figure 1] is relatively free of pencilled marks or emendations. Brief prose remarks are spaced at intervals, sometimes separated by typed underlining. At the top of the page is a short lyric entitled "Rembrandt's Old Woman Cutting Her Nails":

An old woman
As if I saw her now
For the first time, cutting her nails
In the slant light

It is a poem whose brevity, economy of imagery and lack of editorializing embody many of the values one associates with Imagism and Objectivism. The only concession to a larger theme is the phrase beginning "As if," which introduces the absent poet, a third participant in the conversation between painter (Rembrandt) and old woman. This "As if" finds its visual correlative in the "slant light" of the last line which hints at the indirect source of sight, mediated through a painter, a period of time, an aesthetic frame, a rhetorical displacement: "As if I saw her now."

Below the poem, perhaps serving as a commentary on it, is a prose remark, typed in caps:

WE HAVE A LONG TRADITION OF CONTEMPT FOR MATTER, AND HAVE CEASED TO NOTICE THAT ITS EXISTENCE—AND ONLY *ITS* EXISTENCE—REMAINS ABSOLUTELY UNEXPLAINED

To some extent this prose extends the poet's meditation on Rembrandt's design but shifts the emphasis from the painting's subject—the old woman—to its materiality, a shift that, as subsequent lines make clear, has distinctly existential implications:

We speak of people's death, except the deaths of the extremely old, as if they might have lived forever Of course they could not have, and therefore the difference between thirty years of life and seventy years does not in itself define tragedy

But the wives or husbands and children!! That is, when the young die, there are the bereaved By the time the old man or woman dies, no one is bereaved? Dare we say that?

What began as a depiction of an old woman has now become an interrogation of the life beyond her. The author seems anxious to interrogate the painting by understanding the world he shares with it, a world in which matter "matters." And to the degree that both painter and poet engage the problem of mortality, they share the same world.

What links poet and painter, youth and age, painting and subject is care: "It would be hard for human nature to find a better ally in this enterprise than love," the poet quotes from *The Symposium*. But human care alone is not enough; the material expression of that care, as presented in painting, poem and prose is the form that care takes. "Mankind is a conversation," and one might add that the page itself, in its wandering and questioning, is the material analogue of that conversation.

This page by George Oppen,[1] one of thousands like it among his papers housed at the Archive for New Poetry at the University of California, San Diego, represents a crucial problem for any consideration of postmodern genres: that of the poem's materiality, its existence as writing. Once we have seen the "poem" in this context it becomes difficult to isolate it from its written environment. Indeed, can we speak of "poetry" at all when so much of it is embedded in other quotations, prose remarks and observations? Does Oppen's *oeuvre* end in the work we know as *The Collected Poems* or does it end on the page on which it began? I would like to answer some of these questions by thinking about the status of the manuscript page, not out of some antiquarian interest in early drafts but out of a concern for epistemological questions that lie at the heart of genre theory. For if genre implies a way of organizing knowledge, then to "think genericity" is to think thinking.

The question of genre in postmodernism has most often taken the form of a debate over "new" genres (various forms of non-narrative prose, sound poetry, procedurally derived forms) or the rediscovery of previously marginalized genres (the manifesto, the fragment, the epistle). And while this discussion has had a useful taxonomic function, it has not addressed the issue of genericity itself, the degree to which postmodernism challenges notions of categorization altogether. It could be said that the current debate extends a more pervasive romantic skepticism over formal categories, manifesting itself on the one hand by a pursuit of some idealized, Mallarméan *livre*, or on the other by a ruthless exhaustion of types through forms of appropriation, quotation and parody. It could equally be said that both positions rest on an opposition between literary and ordinary language (or in the case of Mallarmé, between poetry and journalism) which can be transcended only by exploiting the possibilities of the former.[2]

The most significant critique of genericity has occurred within the context of post-Structuralism with its emphasis on *écriture* as the recognition of difference (differance) within the linguistic sign. The writer is no

longer "one who writes something, but the one who writes" (Barthes 18), leaving in place of novels, poems and plays, the process of writing itself. Literature ceases to be defined by its "signs of literariness" but rather by its intransitivity, its refusal of all rhetorical and generic markers. I would like to retain post-Structuralism's emphasis on writing as trace, as inscription of an absence, but emphasize the material fact of that trace, an inscribing and re-inscribing that, for lack of a better term, I have called a "palimtext." By this word I mean to emphasize the intertextual—and inter-discursive—quality of postmodern writing as well as its materiality. The palimtext is neither a genre nor an object, but a writing-in-process that may make use of any number of textual sources. As its name implies the palimtext retains vestiges of prior writings out of which it emerges. Or more accurately, it is the still-visible record of its responses to those earlier writings.

We can easily see evidence of such palimtextual writing in recent writers like Susan Howe, Bob Perelman, Kathy Acker, Bruce Andrews, Michael Palmer, Ken Irby, Paul Metcalf and Clark Coolidge who make extensive use of documentary or "found language." In these poets, the material nature of the sign and its specifically social and discursive context become major features of composition. Susan Howe's *Defenestration of Prague*, for example, makes use of documentary histories of the Thirty Years War (from which her title is derived) but also of etymological glosses, philological research and wordlists embodying qualities of linguistic fragmentation and materialization that inaugurate the modern era. But we can see many of these same features in a modernist lyric poet like George Oppen, especially if we treat his manuscript page as a text in its own right. It is precisely because Oppen's work so little challenges generic boundaries that his material text becomes so important for reconsidering the authority of those boundaries.

Poetry, according to Louis Zukofsky, "is precise information on existence out of which it grows" (28). It is seldom observed, however, that this growth begins and ends on a page. Traditional textual research has provided us with a methodology for investigating such materiality, but always with an eye toward some definitive version out of which to establish a copy text. As Jerome McGann points out, textual criticism has had one end until recently: "to establish a text which . . . most nearly represents the author's original (or final) intentions" (15). That desire to recover the author in the work is part of a ". . . paradigm which

sees all human products in processive and diachronic terms" (119). Those intentions can be discovered by locating the last text upon which the author had a primary hand before it came under the influence of copy editors, compositors and house style. The textual editor must master the corrupt text, deleting any superfluous or extraneous material not directly related to the work in question. Genre becomes an ally in such mastery insofar as it provides a codified set of rhetorical and textual expectations to which the text must ultimately conform. The editor's service to the author therefore is mediated by his generic expectations.

Postmodern poets, in this context, are no different from previous generations in the way that they keep notebooks, use paper, and revise their work. But recent poets have incorporated the material fact of their writing into the poem in ways that challenge the intentionalist criteria of traditional textual criticism. At the same time that poets have foregrounded the page as a compositional field, they have tended to "think genericity" to an unprecedented degree, making the issue of formal boundaries a central fact of their poetics. Indeed, for many poets today, it has become meaningless to speak of "the poem" but rather of "the work," both in the sense of *oeuvre* and of praxis. We can see the evolution of such a poetics not just in the writings of poets but in their papers and manuscripts which, in increasing numbers, have been deposited in academic libraries. What we see in such collections is the degree to which writing is archeological, the gradual accretion and sedimentation of textual materials, no layer of which can ever be isolated from any other. George Oppen's page, to return to my initial example, is only one slice through a vast, sedimented mass that quite literally rises off the page, carrying with it the traces of prior writings. That page is part of a much larger "conversation" for which the published poem is a scant record.

One of the most important implications to be derived from studying the material text is the way that the page reinforces certain epistemological concerns of contemporary writers, notably the idea that writing is a form of knowing. Robert Creeley's remark, "One knows in writing," Charles Olson's equation of Logos and Muthos (thought and saying) and Allen Ginsberg's poetics of spontaneity are but three examples of a pervasive postmodern attempt to ground thought not in reflection but in action (Creeley 279; Olson 20). George Oppen is no exception. In a letter to Rachel Blau DuPlessis he speaks of the poem as a "process of thought" and then goes on to qualify this remark:

. . . but it is what I think. A poem which begins with an idea—a 'conceit' in
the old use of the term—doesn't learn from its own vividness and go on from
there unless both terms of the conceit or one at least is actually *there*. I mean,
had it begun from the parade, the experience of the parade and stuck to it long
enough for the thing to happen it could have got one into the experience of
being among humans—and aircraft and delivery trucks—? (Oppen, Letters
to Rachel Blau DuPlessis 121)

For Oppen the poem does not represent the mind thinking; it *is* the
thinking itself, including its marginal references, afterthoughts and
postscripts. One may begin with a "conceit," but, if one attends to the
"parade" of passing things, one will find oneself "among humans—and
aircraft and delivery trucks." Like one of his favorite philosophers,
Heidegger, Oppen understands that knowledge is gained not by
bracketing experience but by finding oneself already in the world,
engaged in human intercourse. The poet strives to reduce words to their
barest signification, prior to their subordination to various cognitive or
intellectual schemes.

The ideal of a poetry that no longer represents but participates in the
process of thought is hardly new. It is part of the romantic movement's
desire to escape forms of associationism and empiricism by a belief in the
poem's creative nature. George Oppen is seldom mentioned in such
contexts, but this is because we have tended to read his poetry through
modernist spectacles. Critics have tended to see his work as the logical
extension of certain Imagist principles involving "direct treatment of the
thing" and economy of language. It is as though we have focused only on
the first word in the title to his first book, *Discrete Series*, to the exclusion
of the second. And by doing so we have reified the processual—and I
would argue dialogical—nature of his thought in an ethos of the hard,
objective artifact. Such a reading is not surprising; many of Oppen's own
comments speak of the poem as "discrete" object among others, "a girder
among the rubble," as he liked to quote from Reznikoff. This emphasis
on the single poem is supported by his oft-stated desire to find the final
real and indestructible things of the word, "That particle of matter,
[which] when you get to it, is absolutely impenetrable, absolutely
inexplicable" (Interview 163).

My contention is that rather than being regarded as a series of single
lyric moments, George Oppen's poetry should be seen as "a lyric reaction
to the world" (Interview 164), a fact that becomes dramatically evident
once one looks at a page like the one described earlier. His poems

represent the outer surfaces of a larger "conversation" that appears partially in broken phrases, ellipses, quotations and italics throughout his work. We know, for example, that *Of Being Numerous* is constructed largely around quotations from Meister Eckhart, Kierkegaard, Whitehead, Plato, Whitman as well as friends like Rachel Blau DuPlessis, Armand Schwerner and John Crawford, all of whom enter the poem silently in the form of inverted commas. And even where such obvious quotation does not occur, as in the poems from *Discrete Series*, Oppen's paratactic logic, truncated syntax and ambiguous use of antecedents embody the shifting attentions of a mind dissatisfied with all claims to closure. Like the "Party on Shipboard," in that volume, Oppen's narrative movement is "Freely tumultuous" (*Collected* 8).

This idea of poetry as a "lyric reaction" can be understood best by comparing a poem from *Of Being Numerous* with a page from which it emerged. In the fourth section of "Route" we encounter the image of a sea anemone which serves to focus a series of observations on language:

Words cannot be wholly transparent. And that is the
 'heartlessness' of words.

Neither friends nor lovers are coeval . . .

as for a long time we have abandoned those in
 extremity and we find it unbearable that we should
 do so . . .

The sea anemone dreamed of something, filtering the sea
 water thru its body,

Nothing more real than boredom—dreamlessness, the
 experience of time, never felt by the new arrival,
 never at the doors, the thresholds, it is the native

Native in native time. . . .

The purity of the materials, not theology, but to present
 the circumstances (*Collected* 186)

As a poem, "Route" deals with the difficulties of achieving clarity, the lure of the finite and indestructible. The section quoted here appears to be a qualification of that clarity, an attempt to express the "heartlessness" of words that refuse to become transparent to the world.[3] This qualification takes the form of a meditation on boredom, a state in which the world is reduced, as Oppen says, to "dreamlessness." The reality of boredom is, as he says elsewhere, "the knowledge of what *is*" (Interview

169), a state in which things have been divested of significance and are encountered spontaneously and without reflection. It is a state in which one is naturalized in one's environment, "Native in native time." Things have lost their novelty and may now be encountered in their instrumentality, ready-to-hand. In this condition, rather than in dreams or in conscious reflection, the "purity of the materials" may be experienced.[4]

The most confusing lines of this passage are those concerning the sea anemone. It is the only concrete image of the section and so becomes all the more important in focusing exactly how Oppen understands boredom. On the one hand, the sea anemone could represent a kind of ultimate boredom in which the organism's whole existence is conceived around "filtering the sea / water thru its body." This interpretation would seem to be borne out by a brief prose remark included among Oppen's papers:

> Boredom, the sense of lack of meaning—In the cities from the sense of being submerged in the flood of people, of not being able to see out, of being a passenger—In the small cities from the sense of shallowness, the shallowness of affairs Actually, of nothing happening

Here boredom is compared to "being submerged in the flood of people," a sort of urban analogue to the anemone's condition. On the other hand, because it is capable of dreaming, the sea anemone might represent the endurance of concern and novelty against the deadening effects of routine. However the "conceit" is being used, Oppen is clearly trying to find an image of reduced nature, a biological reality that challenges the theological and metaphysical. In its published version, the image of the sea anemone cannot be interpreted allegorically; it is one of those "heartless" words that must be interrogated and as such becomes "real."

This refusal of the anemone to become symbol is all the more evident when we look at a page upon which it makes an earlier appearance. Unlike the final published version in which all lines are relatively long, the typescript page [Figure 2] contains a variety of prose and lined verse forms. The image of the sea anemone is contained in considerably shorter lines than in the later version and seems to respond to a previous prose remark:

> Impossible to use a word without finally wondering what one means by it. I would find that I mean nothing, that everything remained precisely as it was

without the word, or else that I am naming absolute implausibilities, which are moreover the worst of all nightmares

The attempt to name, to "use a word without wondering what one means by it," leads to a cycle of repetition in which the only thing to say is that "we die":

We die we die we die

All there is to say
The sea-anemeone dreamed of somethong
No reason he shoul d not

Or each one does
Filtering the sea water thru his body

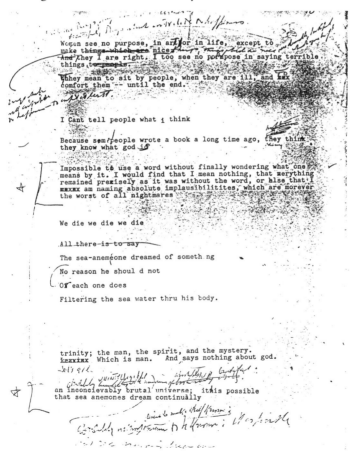

Figure 2

I have retained Oppen's typos and misspellings to indicate how, at least in his early writing of it, the sea anemone was closely identified with the individual. The pronoun "one" is hidden in the misspelled word "anemeone" and "somethong" and is explicitly developed in the penultimate two lines (deleted from the published version). These two lines also provide an alternate antecedent for "his" in the final line, uniting anemone and human subject. Oppen wants to link human mortality with that of other creatures—as if to say "each one of us is like the sea anemone, living in a perpetual state of boredom, filtering the world rather than reflecting upon it. In this state all we can say of existence is that 'we die'."

This existential fact is not alleviated by theological alternatives. In the published version, Oppen stresses "The purity of the materials, *not theology*, but to present the circumstances" (emphasis added), but in the typescript version the attack on theology is much more forceful, directly linked to Oppen's concern with language: "Because some people wrote a book a long time ago, they think they know what god is." This remark on the limitations of an authorizing Logos is extended later in a definition of the trinity as "the man, the spirit, and the mystery. / Which is man. And says nothing about god." In pencil, Oppen has added "Job's God," a remark which may very well have inspired the final remark: "an inconceivably brutal universe; it is possible that sea anemones dream continually." Clearly a logocentric world view is inadequate to the brutality of the universe, a view given secular force by the image of the anemone and salvific force by the story of Job.

What we see in the page that we do not see in the published poem is the dialogue between individual sections, each responding to and qualifying the previous. I see the sections as linked, one to the next, in a debate or argument over the efficacy of language in a "brutal universe." Language is both the vehicle and the object of Oppen's speculations as he oscillates between competing propositions. Such dialectical progress can be seen in the published version to be sure, but the page—with its spelling mistakes, its holograph emendations and variable lineation—provides a "graphic" indication of how immediate and personal that progress is. That is, the published page provides us with a series of more or less balanced (if truncated) prose statements on the theme of language; the typescript page provides us with the "graphic voice" out of which that theme emerges. The page shows Oppen grousing about difficulties of self-expression, the image of the sea-anemone serving as a satiric

version of the poet himself dreaming in his watery environment. The sea anemone, rather than serving as an icon of either boredom or conscious reflection, is a term around which all other sections constellate. It does not "serve" the poet's purpose but gets in his way, forces him to ask each question anew.

The varieties of intentions that I have described on one page are synecdochic for Oppen's archive in general. Like the individual page, the archive returns a quality of voice and physicality to work which may seem, in its published version, hermetic and isolated. In terms that I have already employed, the archive revises generic expectations, turning lines of poetry into quotations, queries and questions. As my epigraph suggests, Oppen was engaged in "Piling up pieces of paper to find the words" that would ultimately become poems. The archive is the physical remains of that "piling up" and deserves to be described as a text in its own right.

As the then curator of the Archive for New Poetry, I had a unique chance to view Oppen's papers in their pristine state, prior to being divided up into separate categories according to genre (manuscripts, notes, correspondence, daybooks, etc.). When we first opened the boxes in which the papers were sent, we were not prepared for the chaos that appeared. Where some archives come in folders or envelopes with dates or other identifying marks on them, Oppen's papers appeared as a great midden with shards of writing in every conceivable form, no one page related to the next, no recognizable order to the whole. A page containing a verse from the early 1960's would be followed by a page with scribbles from his last days. Prose and poetry were interspersed with grocery lists, phone numbers, quotations from philosophers, observations on films, tables of contents from books (his own and others). Every conceivable type of paper had been used, from cheap, high acid newsprint (seriously decaying and flaking) to letterhead bond. Writing had been performed equally by typewriter and pen, the former often heavily annotated by the latter. Occasionally, passages of particular importance had been circled by crayons or felt-tipped pencil. Each manuscript page was like a collection as a whole: a marvellously scribbled, jumbled and chaotic written field.

Although the bulk of the collection consists of individual pages like those already discussed, there are numerous larger manuscripts made up of anything from two to several hundred pages. In some cases, these manuscripts consist of a final typed draft of poems for a book, but in most

cases, the gathering is simply a heterogeneous scatter of poems, jottings and typings. The methods by which these groupings are held together deserve some comment. Oppen used a variety of fasteners—from safety pins, pieces of wire, pipestem cleaners to ring binders. The manuscript for the poem, "The Little Pin," is held together, appropriately enough, by a little pin. Another batch of pages is held together by a nail driven through the upper left hand corner into a piece of plywood. A better definition of Objectivism cannot be imagined.

Oppen's method of composition can be best glimpsed by considering what I will call his "palimpsestic" manuscripts: pages of individual poems onto which new lines or stanzas have been glued so that the revised draft seems to rise vertically off the page in a kind of thick, textual impasto. Rather than add new lines on fresh sheets of paper, he would build his poem on top of itself, adding new lines in many cases ten or twelve pages thick. One such palimpsest, containing work from *The Materials*, appropriately enough, is "built" out of a ring binder. On the front and back inside covers, Oppen has glued the entire script for a reading given at the Guggenheim Museum, including his own interlinear commentary. The binder's metal clasps hold part of a manila folder (addressed to the Oppens in Brooklyn) to which other drafts and fragments are glued. The whole pile of pages is held together by pipestem cleaners which are wrapped, at the top, around a number 2 pencil and a one inch roundhead screw.[5]

My purpose in describing the material component of Oppen's work is to suggest the degree to which writing was first and foremost a matter of something ready-to-hand, something as immediate as a coat hanger or piece of wire. The pipestem cleaners, metal clasps and glue are visible representations of those "little words" that Oppen liked so well, the basic materials of a daily intercourse. "Gone for Breakfast in Z coffee shop across the street," reads the back of one heavily scribbled folder, indicating that the recto of poetry easily became the verso of daily living. And just as he used whatever writing surface was nearby, so he drew upon the "signage" that surrounded him: newspapers, books, magazines, and of course, conversations, parts of which can be found recorded through the collection. Oppen did not keep a separate notebook for poems and another for quotations and another for prose, but, rather, joined all of them together in a continuing daybook.[6] One finds drafts of letters to friends on pages that contain the beginnings of poems. In many cases, a quotation from a newspaper would become the genesis of a poem, a poem the genesis for a prose commentary on an article in the newspaper.

This daily, unbound diary covers an extraordinary range of subjects: the youth culture of the 1960's, the Civil Rights movement, rock and roll, the poetics of Imagism, the work of John Berryman ("shameless but seductive"), Jung, the Vietnam War, the Altamont concert, Elizabeth Bishop's "The Fish" ("I had always thought 'o to be like the Chinook' was the silliest line ever written, but I see that it is not"), Charles Olson on PBS ("giving birth to the continent out of his head like Jove"), Plato, Hegel and Marx. His comments on Robert Lowell's "Skunk Hour" are worth quoting in full:

> perhaps I simply do not understand the Christian sense of "sin." I do not understand a sin by which no one was injured. If the people in the love cars were embarrassed by his peeking, then it was a sin. If not, it was merely undignified.

Or his remarks on Pound

> —and if Pound had walked into a factory a few times the absurdity of Douglas' theory of value, which Pound truculently repeats in the *Cantos* would have dawned on him—it sometimes pays to have a look. And to keep still till one has seen.

Treated palimtextually, such remarks elucidate that trinity of concerns that informs Oppen's entire life: politics, epistemology and poetics. The archive suggests that all three are inextricably united like those jerry-rigged manuscripts held together with pipestem cleaners. As he meditated on contradictions in American politics, so he drafted poems; as he drafted poems so he thought about the relationship of old age to love. The manuscripts do not suggest a man working toward the perfect lyric but of a man struggling for a vision of society in which the poem plays an instrumental role. To adapt a remark on the page mentioned earlier, Oppen "knows what he thinks but not what he will find."

John Taggart records a conversation in which Oppen claimed that ". . . he did not think of his books as collections of individual poems but as developments of a thought . . ." (259). The study of Oppen's manuscript certainly verifies this developmental aspect of his writing and suggests the need for an alternate mode of analysis that takes the entire archive—including its material form—into account.[7] Unfortunately, much modernist criticism has defined "materiality" in strictly rhetorical terms—the foregrounding of poetic devices and the defamiliarizing of language—thus validating artisinal aspects of the poem to the exclusion of the world in which it is produced. For Oppen,

materiality implies "objects" and the realms of value that objects constellate:

> There are things
> We live among 'and to see them
> Is to know ourselves'. (147)

Oppen's processual mode of writing, his incorporation of non-literary genres), his use of the page as speculative field or "conversation" are all dimensions of his Objectivism and cannot be separated from the final published poem.

What we have seen in Oppen as an explicit materialization of writing is reflected implicitly in numerous contemporary poets for whom the page has become a "field" or "score." Charles Olson's oralist poetics, for example, emphasizes the typewriter as score for the voice and the physical page as a map or graph. And Robert Creeley, speaking with Allen Ginsberg at the Vancouver Poetry Conference, comments on the importance of typewriters, pens and paper in creating the measure of his verse:

> Habits of this kind are almost always considered immaterial or secondary. And yet, for my own reality, there is obviously a great connection between what I physically do as a writer . . . and what comes then out of it (30).

Creeley goes on to qualify this remark by speaking of his dependence on the typewriter:

> I wanted to be able to [write] with a typewriter. Now, equally I never learned to type. So I mean my typing is a habit that's developed, with two fingers . . . Think again—that begins to be a qualification of how *fast* I can write. In other words, I find that the pace of my writing is concerned with the speed with which I can type (30).[8]

Such remarks could be seen as the poet's version of an action aesthetic, shared by painters and musicians of Creeley's generation, in which the physical medium becomes as much the subject as the means of production. The typographic and concrete experiments of Pound, Williams, Apollinaire, cummings, Mallarmé, the Dadaists and Futurists provided a variety of important new models for what the graphic poem might be, and the poets of "field verse" extended those modernist experiments into distinctly physiological dimensions.

The most characteristic form that field composition takes is the long, open-ended notebook poem.[9] Works like Olson's *Maximus Poems* or

Robert Duncan's *Passages* are based on historical and literary researches
that incorporate documentary evidence as well as the methodologies of
that research into the poem.[10] History, for both poets, is a matter of the
record—a written record—and their poems incorporate not only refer-
ences to American history or Renaissance theology but to specific edi-
tions, translations and volumes in which that evidence was first encoun-
tered. More importantly, Olson and Duncan make their inaugural
entries into these other sources part of the poem. Olson, for example,
corrects details about Gloucester's history in "Maximus to Gloucester,
Letter 15" that he had made in a previous "Maximus" poem (71).
Similarly, Robert Duncan in "Poem Beginning with a Line by Pindar"
provides a parenthetical comment about his edition of the Greek poet:

> (An ode? Pindar's art, the editors tell us, was not a statue but a mosaic, an
> accumulation of metaphor. But if he was archaic, not classic, a survival of
> obsolete mode, there may have been old voices in the survival that directed
> the heart. . . (69).

The fact that this remark concerns genre nicely illustrates my point: that
reference to a canonical genre—the ode—occurs in a passage that denies
the genre's authority. Duncan's "ode," at least in his editor's definition,
will be like Pindar's, "a mosaic, an accumulation of metaphor." The
open parenthesis suggests that what had begun as an afterthought
continues into the poem as a generative element in its composition.
Olson's and Duncan's self-reflection marks a desire to make the means
and materials of research part of the poem—a dance, as Olson says,
"sitting down" (39).

The idea of the poem-as-notebook coincides with poets' increasing
desire to have greater control over the means of reproduction. Robert
Duncan has insisted that his recent work be reproduced directly from his
own typescript and has produced several facsimile volumes of his holo-
graph copy. Olson's *Maximus Poems* involves typographic and notational
formats that provide an idiosyncratic "map" of the poet's vocal and visual
intentions. George Butterick chronicles the difficulties of transferring
those intentions to the printed page, and in at least one case simply
reproduces the author's holograph version of "*Migration in Fact . . .*"
with its spiralling, interlocked notation (Butterick v–xvi). Several of
Philip Whalen's actual notebooks have been reproduced in order to show
his extraordinary calligraphic hand in concert with his designs and
drawings. Pages of Robert Creeley's notebook have been reproduced in

facsimile by Bouwerie Editions. And in a more general sense, works like A. R. Ammons' "Tape for the Turn of the Year," John Ashbery's "Vermont Notebook," Paul Blackburn's *Journals*, Robert Creeley's *A Day Book*, Ed Dorn's *Yellow Lola*, Ted Enslin's *Synthesis*, Allen Ginsberg's *Planet News*, Joanne Kyger's *Desecheo Notebook*, Denise Levertov's "Entr'acte," Bernadette Mayer's *Midwinter Day*, Ron Silliman's *Tjanting*, Gary Snyder's *Mountains and Rivers Without End* and Philip Whalen's *Scenes of Life at the Capital*, to name only a few, in some way or another incorporate the idea or format of the notebook into their form. [11]

At one level the poem-as-notebook seeks to establish some kind of authenticity and immediacy. [12] The poem becomes the record of its own growth, form replicating the sudden shifts of attention in a desultory speculation. But at a more complex level such emphasis on the process rather than the product of writing dissolves boundaries between literature as artifact and literature as daily record. This could be said for a work like Bernadette Mayer's *Midwinter Day*, a poem that incorporates observations, readings and routines of a twelve-hour period of time in December of 1978. Although on the surface it appears to be a rather typical personalist lyric, balancing local details with reflective comments, it is animated by the urgency of staying within certain imposed temporal boundaries. The notebook, rather than being the source for materials used retrospectively, is the activity *of* and *for* that day. Writing and living are so closely united that incidents like shopping or doing the wash merge imperceptibly with the act of writing about them.

> You go out for cigarettes,
> As if love is not the food
> Of those of us satisfied enough to write
> To write to lend urgency pleasure, to sing,
> To celebrate, to inspire, to reveal
> You put on
> Your gotten shoes and coat in an image
> And say you will be right back
> While you're out love is stored
> In intensest house, this cave of it, . . . (116)

More traditional "domestic lyrics" would find the poet looking back upon an incident, using details to inspire reflections "on" or "about" those actions. In Mayer's work, there is no separation between incident and reflection. Time is happening "right now"; the writer is "this person";

> Today I'm the present writer
> At the present time the snow has come
> At this moment we won't starve
> At once the ferries terrify us and
> We knead red and green peppers with
> Our contrasting hands
> At a time
> Very close to the present I want to get
> A tight pair of pants and dance
> With you with things as they are (16–17)

The last lines play a nice variation on Stevens' "Man With a Blue Guitar," in which "Things as they are / Are changed upon the blue guitar" (165). By making her poem coincide with the day it records (and the notebook in which it is written) Mayer claims a kind of presence unmediated by any appeal to the transforming imagination. At the same time, because the time of writing is the present, she must suspend until the future a time when she can "dance / With you" and truly participate with "things as they are."

Although one feature of the notebook-as-poem is an anti-formalist gesture in the direction of more authentic experience it also imposes its own formal limitations upon writing. Mayer's decision to record *everything* on one day determines a strict limit on materials that will be permitted. The same could be said for the overtly procedural poetics of Ron Silliman who uses notebooks as a way of generating long, rule-determined books like *Ketjak* or *Tjanting*. In composing such works, Silliman draws from a vast body of materials, some derived from the newspaper and much derived from observation. Unlike the personalism of Mayer, however, Silliman subjects this material to formal operations which remove the incident from its experiential context. In *Tjanting*, for example, the account of a muscle pull, spilled grease and a blistered lip are subjected to radical transformation. Individual sentences are removed from their normal narrative progression and organized according to the Fibonacci number series. Each paragraph of the book expands incrementally as numbers of sentences are added according to the formulation 1,2,3,5,8,13 . . . and so forth. The opening paragraphs give some indication of how this occurs:

> Not this.
> What then?
> I started over & over. Not this.

> Last week I wrote "the muscles in my palm so sore from halving the rump
> roast I cld barely grip the pen." What then? This morning my lip is blisterd.
> Of about to within which. Again & again I began. The gray light of day
> fills the yellow room in a way wch is somber. Not this. Hot grease had spilld
> on the stove top
> Last week I wrote "the muscle at thumb's root so taut from carving that
> beef I thought it wld cramp." No so. What then? Wld I begin? This morning
> my lip is tender, disfigurd. I sat in an old chair out behind the anise. I cld
> have gone about this some other way (Silliman 11).

Not only does each paragraph increase according to the Fibonacci series,
each sentence counteracts or contrasts the previous, thus extending the
dialectic of the opening lines: "Not this./ What then?" My point in
using this example is to show how the use of materiality (the notebook-
as-source for poetry), when subjected to procedures, points to a second-
order materiality, that of language itself. And since language is the
barrier as well as the object of the poem, its radical defamiliarization
points to the conventional, rather than the natural, qualities of com-
munication. Silliman's larger point is not how poetry can accommodate
the quotidian by ever-more effective representations but how the quoti-
dian is already materialized *as* representation. And to return to my point
about Oppen, it is only when the language of passive observation ("This
morning my lip is tender") is fractured that the mood of boredom is
erased and a critical perspective becomes possible.

Genre theory has no name for this kind of writing and so falls back on
hybrid terms like "greater romantic lyric" or "prose poem." Such terms
are useful in mapping a general area of shared features, but they ignore
the specific discursive properties of each work. A palimtextual study of
poetry would look not only at the poem in relation to similar poems (the
traditional task of genre study) but to the writing each poem displaces, a
displacement that is "represented" in the manuscript as a kind of
over-writing. Far from rejecting theories of genre I see this study of
poetry as emphasizing the presentational aspect of genre, the degree to
which literary works are addressed to an audience. Northrop Frye sees
this aspect as central to generic distinctions, whether a work is intended
to be played on a stage or recited to a community or sung to the Muse.
"The basis of generic criticism in any case is rhetorical, in the sense that
the genre is determined by the conditions established between the poet
and his public" (247). Precisely, but I would go a step further and see
this relationship as being embodied in the way the poem engages the

materiality of both written and speech genres.

We can see this presentational relationship to an audience best in those areas where an audience is least invited: in the poet's papers and manuscripts. What we learn from the material fact of archive and page is the degree to which poems are a temporal process of marking and remarking, of response and contention. George Oppen's poems exist in relation to other texts and are part of his larger interrogation of the world. As Jack Spicer says, "Poems should echo and reecho against each other. They should create resonances. They cannot live alone any more than we can" (61). And it is this temporal process that is foregrounded in more recent postmodern works. These more self-consciously antigeneric texts—far from distinguishing themselves from the past—force us to look at traditional forms from new perspectives. Shakespeare's heavily annotated acting texts, Blake's illustrated books, Emily Dickinson's fascicles and Pound's ideograph-encrusted late Cantos are but four examples of a materializing tendency in every writer, a tendency that tends to get lost in the attempt to interpret and unify the text. So long as we search for "new" genres in the interstices of the old, we will be searching within the terms of normative criticism that seeks consensus among dissimilar elements. We will fail to see processes that occur at (or *in*) the margins of the material artifact, an object that can never be recovered strictly within textual terms. If that object fails to stay in one place, perhaps it is because it is the trajectory rather than the fulfillment of writing.

NOTES

1. All references to George Oppen's papers are to the George Oppen Manuscript Collection at the Mandeville Department of Special Collections, University of California, San Diego, La Jolla, California.

2. On Mallarmé and genre see Perloff, 172–181. On Romanticism and the attack on genre see Lacoue-Labarthe/Nancy and Beaujour.

3. In earlier drafts of the poem, section four directly follows those which, in the published version, now conclude section two: "I have not and never did have any motive of poetry/ But to achieve clarity."

4. Eric Mottram glosses these lines as stating that "Knowledge of boredom becomes a philosophic tool to ascertain what the facts are" (Mottram 151).

5. Many of the palimsestic manuscripts had originally been pasted to the wall of Oppen's study, suggesting that he not only wrote *on* paper but lived quite literally *within* it.

6. I have edited a selection from Oppen's "daybooks" in *Ironwood* 26 (1985), 5–31. Excerpts appear, as well, in *Conjunctions* 10 (1987).

7. Susan Howe has begun just such a project in her recent work on American women writers. See *My Emily Dickinson*. Berkeley, Ca.: North Atlantic Books, 1985; "The Captivity and Restoration of Mrs. Mary Rowlandson," *Temblor* 2 (1985): 113–121.

8. Creeley's remarks on the relationship between his characteristically short lines and his typing become even more interesting when set beside the fact that Robert Duncan, who writes in extremely long lines and open-forms, earned his living as a typist when younger.

9. Of course by referring to "field" verse and "notebook poem" I am participating directly in the genre-naming tendency I wish to call into question. The difficulty of discussing poetics without depending on classifications shows how completely genre structures our thought. I can only look forward to a time in which a "notebook poem" also refers to a notebook and not just a series of stylistic features.

10. I have discussed the fuller implications of this methodology in " 'From the Latin *speculum*': The Modern Poet as Philologist," *Contemporary Literature* 28.2 (Summer, 1987): 187–205.

11. Works referred to in this section: Philip Whalen, *The Invention of the Letter: A Beastly Morality* (N.Y.: Carp and Whitefish, n.d.); Philip Whalen, *Highgrade* (San Francisco: Coyote's Journal, 1966); Robert Creeley, *Notebook*, (N.Y.: Bouwerie Eds., 1972); A. R. Ammons, *Tape for the Turn of the Year* (Ithaca, N.Y.: Cornell University Press, 1965); John Ashbery, *The Vermont Notebook* (Los Angeles: Black Sparrow Press, 1975); Paul Blackburn, *The Journals* (Santa Barbara: Black Sparrow Press, 1975); Robert Creeley, *A Day Book* (N.Y.: Charles Scribner's, 1972); Ed Dorn, *Yellow Lola* (Santa Barbara, Ca.: Cadmus Eds., 1981); Ted Enslin, *Synthesis 1–24* (Plainfield, Vt.: North Atlantic Books, 1975); Allen Ginsberg, *Planet News: 1961–1967* (San Francisco: City Lights, 1968); Joanne Kyger, *Desecheo Notebook* (Berkeley, Ca.: Arif Press, 1971); Denise Levertov, "Staying Alive" in *To Stay Alive* (N.Y.: New Directions, 1971), 21–84; Robert Lowell, *Notebook* (N.Y.: Farrar, Strauss and Giroux, 1970); Bernadette Mayer, *Midwinter Day* (Berkeley, Ca.: Turtle Island, 1982); Ron Silliman, *Tjanting* (Berkeley, Ca.: The Figures, 1981); Gary Snyder, *Six Sections from Mountains and Rivers Without End* (San Francisco: Four Seasons Foundation, 1965); Philip Whalen, "Scenes of Life at the Capital," in *Heavy Breathing: Poems 1967–1980* (San Francisco: Four Seasons Foundation, 1983). Many of these poems or books have been subsumed into larger collections, but I have cited the original publication data in order to emphasize the form of the "book" as it first appeared.

12. Obviously the very fact of such immediacy rules out a work like Robert Lowell's *Notebook* for inclusion in the preceding list, even though it would seem an obvious variation. The sonnets of *Notebook* with their ornate rhetoric, complex rhymes and reflective mood stand at quite the opposite end of the continuum from what I have been developing here.

WORKS CITED

Barthes, Roland. "To Write: An Intransitive Verb?" *The Rustle of Language*. Trans. Richard Howard. N.Y.: Hill and Wang, 1986. 11–21.

Beaujour, Michel. "Genus Universum." *Glyph* 7 (1980): 15–31.

Butterick, George, *Editing the Maximus Poems*. Storrs, Conn.: The University of Connecticut Library, 1983.

Creeley, Robert. "An Interview with Robert Creeley." *The Poetics of the New American Poetry*. Ed. Donald Allen and Warren Tallman. N.Y.: Grove Press, 1973. 273–292.

——. "Contexts of Poetry: With Allen Ginsberg in Vancouver." *Contexts of Poetry: Interviews 1961–1971.* Ed. Donald Allen. Bolinas, Ca.: Four Seasons Foundation, 1973. 29–43.

Duncan, Robert. *The Opening of the Field.* N.Y.: Grove Press, 1960.

Frye, Northrop. *Anatomy of Criticism: Four Essays.* Princeton, N.J.: Princeton University Press, 1973.

Howe, Susan. *Defenestration of Prague.* N.Y.: Kulchur Foundation, 1983.

Lacoue-Labarthe, Philippe and Jean-Luc Nancy. "Genre." *Glyph* 7 (1980): 1–14.

Mayer, Bernadette. *Midwinter Day.* Berkeley, Ca.: Turtle Island Press, 1982.

McGann, Jerome. *A Critique of Modern Textual Criticism.* Chicago: University of Chicago Press, 1983.

Mottram, Eric. "The Political Responsibilities of the Poet: George Oppen." *George Oppen Man and Poet.* Ed. Burton Hatlen. Orono, Maine: National Poetry Foundation, Inc., 1981. 149–167.

Olson, Charles. *The Maximus Poems.* Ed. George F. Butterick. Berkeley, Ca.: University of California Press, 1983

——. *The Special View of History.* Ed. Ann Charters. Berkeley, Ca.: Oyez, 1970.

Oppen, George, *Collected Poems.* N.Y: New Directions, 1975.

——. Interview with L. S. Dembo. *Contemporary Literature.* 10.2 (Spring, 1969): 159–177.

——. "Letters to Rachel Blau-DuPlessis." *Ironwood* 24 (Fall, 1984): 119–138.

Perloff, Marjorie. "Postmodernism and the Impasse of Lyric." *The Dance of the Intellect: Studies in the poetry of the Pound tradition.*" Cambridge, England: Cambridge University Press, 1985. 172–200.

Silliman, Ron. *Tjanting.* Berkeley, Ca.: The Figures, 1981.

Spicer, Jack. *The Collected Books of Jack Spicer.* Ed. Robin Blaser. Los Angeles: Black Sparrow Press, 1975.

Stevens, Wallace. *The Collected Poems of Wallace Stevens.* N.Y.: Knopf, 1968.

Taggart, John. "Deep Jewels: Oppen's *Seascape: Needle's Eye.*" *Ironwood* 26 (Fall, 1985): 252–262.

Zukofsky, Louis. "A Statement for Poetry." *Prepositions.* N.Y.: Horizon Press, 1968. 27–31.

6

Gertrude Stein, Cubism, and the Postmodern Book

Renée Riese Hubert
University of California, Irvine

Two among Gertrude Stein's illustrated texts would seem to lend themselves particularly well to establishing contrasts between modern and postmodern book art: *A Book Concluding With As a Wife Has a Cow,* 1926, and "A Circular Play," 1922.

The first was illustrated by the cubist painter Juan Gris shortly after it was written; the second, by a team of avant-garde artists: Tom Phillipps, Albert Ayme, Arthur Aeschbacher, Jiri Kolar, and Brion Gysin in 1985. As I assume that a painter's visual response to a text can function as a critical statement, I shall consequently assess Gris's modernist interpretation of *A Book Concluding With As a Wife Has a Cow* and confront it with the postmodern treatment of "A Circular Play." My intention is not only to confront two ways of illustrating the same author, but also to establish the postmodern illustrated book as a distinct genre.

A study of *A Book Concluding With As a Wife Has a Cow* [Figure 1] must take into account a German born art dealer, Henri Kahnweiler, a Spanish painter, Juan Gris, and an American writer, Gertrude Stein, all three attracted for quite different reasons by the stimulating atmosphere of pre-World War I Paris. Kahnweiler expected each of his protégés to illustrate a volume. François Chapon, in an article entitled "Livres de Kahnweiler," stresses the unity of each one of his books as an artifact: the visual harmony created by typography and images, as well as the format which, by curtailing distances, permitted a reading rather than a viewing of both the verbal and visual elements. Kahnweiler eagerly included the art patron Stein among his poets along with Apollinaire, Leiris, Limbour, and Reverdy. We learn from his text entitled "Gertrude Stein" that he took great pains to initiate himself in her writings:

Figure 1. Juan Gris: lithograph from *A Book Concluding with As a Wife has a Cow*, (Paris: Galerie Simon, 1926). With permission of Artists' Rights Society Inc., 1987.

I shall admit frankly that I did not at once understand these articles but I was deeply impressed by them. An awareness of being confronted by something of great importance, that is what I felt . . . It was after the first war that I read other works by Gertrude Stein, either printed in periodicals or in manuscript, and it was then that I conceived the idea of publishing something by her. (xi)

For each of his books, Kahnweiler arranged the encounter between poet and painter in an endeavor to harmonize their talents; he insisted in this particular case on the analogy of Steinian and cubist experimentation.

It is not only in *The Autobiography* but also in *Portraits and Prayers* that

we find comments by Stein on the first and foremost painter to illustrate her works: "The Pictures of Juan Gris," 1924, appeared two years before *A Book Concluding*; "The Life and Death of Juan Gris," 1927, was written shortly after the painter's death. Stein alludes simultaneously to the painter, his paintings, his likes, his associations. She speaks, Gris speaks, the paintings speak. "Pictures of Juan Gris" recounts primarily her search for a method enabling her to talk about the painter. She tries out various "genres," tending toward the anecdotal, the historical, and the biographical, which she dismisses in turn while moving from one method to another. Even when she writes a tribute to the painter after his death, she subverts traditional texts composed for such occasions. In her "Life and Death of Juan Gris" emerges her struggle with the generic issues with which she has seemingly become involved.

Stein's comments do not provide in any way a verbal equivalent of, or an initiation in, the paintings, or take into account subject matter and technique; and we may even wonder whether she really does acknowledge the work of art. Her portraits function as transgeneric experiments providing bifurcations from both verbal and visual representations. The various texts on painters, invariably entitled portraits, have uncomfortably been referred to, according to individual scholarly preferences, as poetic or critical. As her writings, here and elsewhere, undercut the mimetic in all its aspects, she could hardly avoid recognizing in Gris a similar rejection of imitation: "If come come translated means translated if translated means translated if come come" (*Portraits* 46). Even before we examine *A Book Concluding* we can surmise that the Steinian text, characterized by a refusal to make its object-subject recognizable and by digressive discontinuity, would raise serious difficulties for a painter seeking to render visually some of the subject-object's salient features. By the time Juan Gris came to interpret Stein's text, he was already an experienced illustrator. His reading of *A Book Concluding* does, however, raise an issue. Did he accept the mediation of Kahnweiler or did Stein provide him with a translation? The painter in his letters shows an attitude of humility toward, and respect for, Stein, both as author and patron. He referred, without a trace of irony, to *A Book Concluding* as her book and never as ours.

Gris's iconography during a given period does not appear to undergo radical transformations as he moves from painting to graphic works, or from one set of illustrations to another. The lithograph for *Denise*, reproduced in *Cinquante ans d'édition de D. H. Kahnweiler*, presents a

still-life of apples, violin and fruit dishes (Hugues 21). The space between objects has in most instances been eliminated, for several of them share the same contours while their shapes tend to overlap. Angularity predominates in the slanting structure which multiplies its frames. Except in the choice of objects, namely the elimination of the circular shaped apples, no basic distinction can be made between this lithograph and the final one in *A Book Concluding*. Both still-lifes display a dynamic slant by which the painter undercuts any suggestion of gravity, which these still recognizable objects might convey; and both display a structure where objects encroach upon each other, all the while presenting significantly changed proportions seen from an unusual perspective, as objects lifted into the same picture plane project themselves at various angles toward the viewer.

The last plate of *A Book Concluding*, presenting a still-life with once again the same objects assembled, but this time in a somewhat different manner, generates greater intensity through spatial curtailment. But the painter has hardly departed from his accustomed pictorial order. In addition to the metaphorical and iconographic analogies so dominant in his paintings, we note a closer merging of the book and the musical instrument, as linear and undulating lines blend their contours and subdue their diverging identities. This plate, while providing a novel variation on other cubist still-lifes, happens to belong to a sequence of four lithographs, to a text, and to a book. The letters FINIS inform the viewers that they have reached the end of their textual perusals and are present at the spectacle of the work's closure. The letters also stress the slanting quality of the structure and enhance the alternating black and white color zones, where fact and fiction, reality and appearance, at first reversible, ultimately become indistinguishable.

The initial lithograph presents a female figure standing in front of a window and holding a book. It is followed by a *pierrot* standing in front of a frame and holding a musical instrument.[1] These two lithographs are placed within the first untitled section of Stein's text, composed of a series of short poems which often bear unrevealing one word titles such as "Choose," "Pink," "Today." The two remaining lithographs open and close "As a Wife Has a Cow." Their role differs from that of the first two lithographs since they function respectively as title page and endplate of a tale. Moreover, these still-lifes differ generically from the portraits; and thus we move plastically from one of Stein's favorite, if subverted, verbal genres to another. In the first two plates, both the male and female

figures, by displaying an object, assert its autonomy and identity, whereas the strong interrelation of the objects in the last two plates has transformed them, or to borrow Gertrude Stein's own word from her text on Juan Gris, has *translated* them more significantly. They have, as we already suggested, relinquished their "thingness" or quiddity in order to function as signifiers and signs. The guitar and the book assert their affinities more clearly, and the interplay of lines becomes bolder in the final plate. In the third plate, Gris shows the analogy between musical scores, printing, strings, and even the lines in the fibre of the table; they create a monument to textuality and at the same time disperse it. In the final plate, it is the movement of their curves, their common generative power that he highlights. He presents not so much a text in its decipherable fixity alone, but a page or scroll with its full potential, the page as it unrolls—the page as process. By now, the divergences between Stein and Gris may no longer seem irreconcilable. Not only does the writer appropriate the painter's favorite genres: the portrait and the still-life, but she also seeks a similar form of destabilization by abolishing the object-subject distinction and refusing the I/eye that would permit a single perspective. At least as early as *Tender Buttons*, Stein had invented the modernist portrait of the object.

Let us look more closely at the texts contained in *A Book Concluding*. The first part is composed of brief individual sections without connecting links: fragments corresponding to discrete moments of consciousness, where any element of the discourse, whether a noun, a verb, an adjective, an adverb, a number, can provide a single word title, for instance "Fifty," "Insisted," "Knives," "All." Standing in isolation, these non-descriptive and non descript words refrain from giving information either about the text they "preface" or from echoing other titles from other poems. These anti-titles, that prevent readers from getting their bearings, provide little if any stimulation. The reading once completed, the titles produce no *post-hoc* illuminating effect. Each one corresponds to a word in the text, which may just as well have set the verbal chain in motion as arrested it. Working on the level of signifiers, Stein appears to be matching poems and titles, but in reality she divorces them by splicing only signifiers so that expected similarity and relevance must inevitably abort.

Each section of the text displays certain basic strategies. It reiterates words which establish links or connections while making sparing use of terms that could build concrete structures. Her "lively words," un-

encumbered by memory, semantics, and myth subvert the reader's propensity to seek meaning and even curtail the ability to accomplish this habitual task.

"Pink"

Pink looks as pink, pink looks as pink, as pink supposes, suppose.

This text stresses the word pink only to disperse its seeming focus. Incomplete, fragmentary statements emphasize the absurdity of a search for meaning. Syntactical permissiveness also contributes to the undermining of consolidation. *Suppose:* the poem ends in an unformulated hypothesis, and unspecified invitation; the end is but a beginning. What is left is an adjective four times repeated and a tautalogical, hence nonsensical, comparison, for it compares the same to the same. Whereas the meaning of the word pink is undermined because it never refers to anything, its grammatical function shifts, for we wonder whether it is an adjective or a noun, a color, a flower, or a person? Manipulations of comparisons recur in *A Book Concluding*, as they do in many other texts by Stein. By this device, she works against conventional systems of analogy, while fostering the kind of analogy favored by cubist painters, who established correspondences among represented objects, whether or not they resembled one another in "reality." Comparisons—literary strategies that record the shift between the known and the unknown, devices intended to measure and evaluate—are divorced from their cognitive function. By means of this self-conscious way of pointing to literary convention, Stein theorizes her experiments.

For this non-anecdotal, non-narrative, non-descriptive text, Gris provided two figurative and representational lithographs that appear unusually anecdotal, narrative, and descriptive. Gris has thus introduced a complementary rather than illustrative type of reading. The visual tends to reveal whatever the verbal has deliberately omitted or undermined. But are we not suggesting that Gris has misread or, because of linguistic barriers, failed to interpret the text and therefore that his illustrations skillfully provide inappropriate embellishments and may even counter Stein's efforts at verbal experimentation?

But Gris may actually have illustrated the author rather than her work. In each of his plates, he presents books and musical instruments. In the first two lithographs, the woman and the *pierrot* hold the book or its musical counterpart, the guitar. Gris acknowledges Stein, the poet and maker of the book, as "holder" and "beholder," as artist, reader,

viewer, listener. By situating the two portraits within the text, he
abolishes the distinction between the container and the contained, so
that the book becomes in essence an omnipresence.

The second text, which, by its title, announces a central theme,
characters, and a narrative, ironically relates to fictional models. Need-
less to say, Stein does not give her readers the benefit of a love story. Her
text considers story telling, but refrains from providing a narrative. As
the text ponders such problems as stages of "écriture" and wavers
between continuity and disruption, objectivity and subjectivity, it
advances, retreats, and expands. The author's efforts toward self-
consciousness and sophistication rely largely on a non-written or sup-
pressed story. The title, beginning with "as," is revealing in so far as it
posits the metaphorization of the text, which is echoed by Gris's re-
presentation of the book. Throughout, words such as "like" or "as"
recur. A cow concomitantly chews its cud. By dint of repetition,
syntactical manipulation, use of indefinites, and model verbs, Stein
merges title, character, and time sequences.

The relation of the two still-life illustrations to the second text is
radically different from that of the two portraits to the opening piece.
Once again, Stein's techniques differ considerably from the recognizable
contours provided by the cubist illustrator, even in these stylized still-
lifes which open and close the love story. Whereas Stein deconstructs the
writing process in *As a Wife Has a Cow*, Gris points to a self-contained
world into which he introduces art and artistic endeavor by means of
recognizable signs. Considered as a sequence, Gris's four illustrations
move, at least to a certain extent, toward a progressive merger of its
various elements, ultimately echoing Stein's text as a selecting process.
Gris's book not only metaphorizes Stein's *A Book Concluding*, it even
transforms it into a monument. The portrait of the woman standing
before a window has undergone a transformation. The heavy shape of her
arms, the pyramidal outline of her skirt or lower part of her body, by
pointing toward a third dimension, suggest a statue on a pedestal, which
thus provides an inkling of the transformation that will take place in the
still-lifes.

In each plate, however, the frame is transgressed in one manner or
another. The first lithograph suggests a *mise-en-abyme* of doors, windows,
skylines, cutting across each other according to various perspectives. The
frames may be read as exteriorizations of the book, which metaphorizes
the Steinian text with its "writing," regarded for our particular purpose

as an interiorization of its process. In the final analysis, *A Book Concluding* presented for Gris not only the challenge of illustrating Stein, but an opportunity to render homage to Kahnweiler, to show his respect for an ideal patron and an enlightened dealer. The third lithograph, with its printed letters and its numerous linear designs proposing the patterns of the page, constitutes the artist's supreme concession to literature. The final place signals an appropriation by the artist, as the cubist book generously unfolds a perfectly paginated universe.

Whereas both the text and the illustration in the first book belong to the modernist period, the very nature of writing in the presumably modernist "A Circular Play" is transformed by its postmodern visualizations. Martine Saillard's edition of *Une Pièce circulaire* closely followed a "décade" at Cerisy on Stein, organized by Gérard Georges Lemaire, the translator of "A Circular Play," and Jacques Roubaud, a mathematician, a linguist specializing in transformational grammar, and one of the major French poets of his generation. In the published proceedings, he discusses Stein's theories and her grammatical practices. At about the same time, four additional works by Stein were translated into French. In his commentary in *Critique* on these major texts, Roubaud advocates a radical revision of Stein scholarship. Henceforth, she should no longer be viewed primarily as a contemporary of Apollinaire, Jacob, Hemingway, and Sherwood Anderson or as a participant in the heroic age of cubism, but as a precursor. Not coincidentally, the present Stein revival, once again involving a Parisian avant-garde, has coincided with a renewed interest in the theory of translation and a questioning of the very notion of genre. Whereas Roubaud combines the tasks of translator, critic, and poetic mediator, Denis Roche, formerly a member of the militant *Tel Quel* group, which believed that poetry or *mispoetry* could serve as an effective tool in a cultural revolution, translates, mistranslates, de-translates an extract from *Geography and Plays*. His title, "Stein opératrice," turns the American writer into the generator of Roche's text.

In "A Circular Play," also entitled "A Play in Circles," the question of genre is made explicit. Indeed, the name of the work and its genre are equated. Stein wrote 77 plays without being an avid fan of the theater or manifesting an interest in performance. In none of her plays do we encounter characters engaging in either dialogue or soliloquy; and the dramatic space remains undefined, if not irrelevant. The outward signs of theatricality remain invisible. "A Circular Play" is divided into many "miniscenes," introduced by titles and consisting of brief texts [Fig. 2].

UNE

PIÈCE

EN

CERCLE

Premier dans un cercle.
Papa est exténué maman a éternué.
Nous ne pouvons le dire autrement.
Exactement.
Passablement.
Second en cercles.
Une citroën et un troène
Une demoiselle et un missel.
Nous arrivâmes ensemble.
Puis il y eut soudain une armée.
Dans ma chambre.
Nous leur demandâmes de partir
Nous leur demandâmes très gentiment de rester.
Comment Cailloux peut-il être mort de nouveau.
Napoléon est mort.
Pas de nouveau.

Figure 2. Martine Saillard: typography from Gertrude Stein, *Une Pièce circulaire,* (Paris: Editions Traversière, 1985). With permission of Editions Traversière for figures 2 through 11.

Betsy Ryan comments on the use of titles as virtual acts or scenes. The titles provide a merger of form and content. The words "circle" and "circular" produce a system of analogies as well as themes and variations instrumental in assuring the strong interrelational aspects of the work. Circularity contributes a constantly returning presence and present. As a presence, it undergoes transformations through associations with other words; as a present, it provides for immediacy or dramatic intensification. Circle and circular, by a process of titling and re-titling, function

both literally and figuratively as the key themes and words. Time, intermittently referred to, does not provide an ordering system, but emerges through paradox without any alternations of evolution. And Time, by manifesting its presence through tensions and clashes, hence dramatically, and without requiring literary props or conventions, designates the nature of the play itself. Although the language of Stein's text may refer to fruit and growth, a seasonal order is repeatedly denied. The very representative *out of season* makes the world of the play incompatible with the natural order and highlights alienation, a central problematics of the postmodern world.

The circle suggests a spatial order, either inside the mind or outside in the arena of the performance. Closeness and distance become instrumental in positing renewed, always changing perspectives. Nevertheless, references to a spatial order do not suggest a circumscribable entity or a fixed point on which the reader's or spectator's mind is compelled to focus. When an apparently definable or recognizable radius seems to emerge, it reveals disorder and fragmentation: *A room is full of odd bits of disturbing furniture*. Stein insists on defunctionalization or, if you prefer, irrelevance. Our intermittent awarenss of space is generated by displacements never compensated by a return to "sets." Space, inextricably linked to movement, is reduced to a circle which inscribes itself in order to be superseded, retraced, or eclipsed by other lines or contours. As Ryan states: "The concept of a play as a spatial configuration is borne out by theoretical musings in the plays themselves" (86).

As manifestations of space and time are connected with an ever changing perspective, Stein's texts have always been related to cubist representations, where frontal views, profile diagrams, and textual references combine. But in "A Circular Play," the change of perspective may provoke an even greater disturbance, since the text can barely be deciphered with any continuity. As there is no beginning, end, or middle from a narrative point of view, the circle does not imply a center, and the words reported, spoken, heard, undermine any kind of potential *dramatis persona*. *They gathered to say* and *A great many say* present a change from a preceding or following *We*. There is no referential frame for a traceless "I" which surfaces only to disappear. *A great many say* suggests indeterminacy, so frequent in Gertrude Stein. The reader lapses into the interrogative mode: Who are they? where do they gather? what do they say? The text thus withholds information while generating the impulse to ask questions and overdetermining words that grammatically func-

tion as queries. *A great many say* suggests a report that is transmitted, but not orally or directly. It formulates a customary statement unrelated to dramatic discourse, which so often relies on an extensive vocabulary. Such expressions alternate with others, equally direct, banal, or interfering, words seemingly addressed by one speaker to another, such as *Guess again, You can put five persons on it*.

Stein's text, without asserting itself as a play by any recognizable signs, relates nonetheless to theatricality. *They gathered to say:* here the encounter produces or motivates the words. Rather than by conceptual means, Stein telescopes the essence of drama by formulations which record everyday, if minimal, speech. By emphasizing movement and moment, these formulations dramatize the act of writing. "A Circular Play" does not deal with exemplary open or closed structures, for assembling, dispersing, matching, or mismatching belong to the order of verbal objects rather than ideas. Statements seemingly unconnected with what has preceded thrust the reader into confrontations of a strictly verbal nature. The play is rich in surprises and elicits strong responses: *I can never forget the slaughter*. Dramatic tension results from these clashes of words which have become practically autonomous, for they are hardly weakened by syntactical structures or dissipated by transitions.

Names abound in "A Circular Play": feminine names, historical names, names born from deliberate misspellings, names without proper referentiality, but never the name of a speaker. Partaking in the multiple games of substitution, they remain even more innocent of identity than Stein's idiosyncratic portraits. *Mrs. Persons*, suggesting role playing as well as anonymity, personifies indefiniteness and further undercuts the function of identity in the play. Identity, impermanent at best, becomes unattainable in the context of change and positions the reader on the threshold between absence and presence. Not only do Stein's manipulations of drama as a generic form of writing efface the barrier between the playwright and the critic, but by dint of persistent displacements they turn words, particularly those implying circularity, into performers. Indeed, Stein has made performance and the writing process interchangeable.

"A Circular Play" is a self-conscious piece of writing, comparable to texts by Beckett, often regarded as an exemplary postmodern writer. In his shorter texts, such as *Bing*, Beckett brings about a merger of various genres, which he has gradually streamlined. By one means or another, he makes drama, fiction, and poetry coincide. Stein, like Beckett, often

metaphorizes the meanderings of the mind. She seemingly launches
definitions which she then abandons, in order to return to them later
from a different vantage point. The same is no longer the same, for it
reveals difference or even otherness, and in the context of the play it
provides still another dramatic moment. Beckett's inherent quest with
its intermittent tracings has much in common with the Steinian ramble.
Like Beckett, Stein reports an itinerary at every moment disrupted by
misfirings and lapses of memory. The circle, like Beckett's room, refers
to the inner more than the outer world; it alternatively corresponds to a
process of focusing and dispersion. Nevertheless, Stein's work by no
means centers on the ebbing of various forces, for it essentially exempli-
fies dramatic activity and vigor. Nor does it in any way belong to the age
of "The Literature of Exhaustion."

Stein focuses on the writing of a text rather than on its performability:
Conceive that a circle, Consider a circle, The idea of a circle—the circle
suggests the trace of the yet unformulated. I would argue that in addition
to its self-referential characteristics, "A Circular Play" has more politi-
cal, historical, and social implications than other texts by Stein, a factor
which may bring it closer to certain postmodern concerns. The circle
pertains to hierarchical and social systems, at least on the level of parody.
Allusions to bureaucratic systems and World War I can easily be
detected. However, such references are again subverted by various
devices: *This is a circle, Legally a circle, When the Russians speak?, can a circle
enlist? A crushed circle.* Then Stein introduces a shift to a personal note:
When did you hear from me last? Through such ruptures and discontinui-
ties, including repetitive devices, Stein's circle simultaneously draws
and obliterates itself. Far from adding up, the many allusions merely
renew an ungraspable sameness. The events of war and the writer's
struggle are telescoped into the single line of a "miniscene."

The link between Gertrude Stein's "A Circular Play" and
postmodernism is heightened not only in the translations and texts of
certain French writers, but also by staging and illustrations. Referring to
various performances of "A Circular Play," beginning in 1979 by the
Independent Theatre of Rotterdam, Ryan insists on the performers' use
of physical acts and props in order to avoid characterization and narrative
(143). Just as Stein shows the discontinuity between the line and its
context, so the ridge between text and performance emerges on the stage.
Wilson and Foreman acknowledge their debt to Stein by disengaging in
their stagings the word from its link to reality and insisting on rela-

tionships among objects, where the absence of the figure becomes crucial.[2] These performances, whether based on Stein's text or stimulated by her other writings, strive toward a radical undercutting of mimesis.

Lemaire's translation of "A Circular Play" renders rhythmic alternations between colloquial language and seemingly childlike expression. The cross-cutting of various types of discourse, the multi-leveled fragmented speech patterns surface remarkably well in the French version. Rather than translate concrete words literally, he tends to displace or replace them while preserving a rhyme scheme and conveying the semantic idiosyncrasies of Stein's associations. Lori Chamberlain in her *Afterwords: Translation as Poetics in Postmodern Writing* mentions "The narrowing of the frontier between translation and original work" in the postmodern period: "The process of writing and reading is one of continual translation" (59). In discussing *Renga*, a serial poem written by Octavio Paz, Jacques Roubaud, Edoardo Sanguinetti, and Charles Tomlinson, she stresses collective work, a term most relevant to *Une Pièce circulaire*, particularly if we consider illustration in terms of a translation into another medium.

Une Pièce circulaire features carefully spaced printing on yellow paper. The entire text, including the titles in bold lettering, submits to the rigorous ordering of the page, consisting of symmetrically expanding and retracting lines. Obviously, a visual performance is taking place.

The contrast between the illustration of *As a Wife Has a Cow* and a *Une Pièce circulaire* points to some of the striking differences between modernism and postmodernism in book art. While both illustrations typify highly experimental developments in the relationship between text and image, in the former the book is treated purely as an artform and in the latter such non esthetic considerations as the problematics of textuality play an important part. In general, postmodern illustration undercuts any form of meaningful representation by imposing alternative forms of visualization. One of the best examples is Jasper Johns' illustration of *Fizzles*, so ably discussed by both Marjorie Perloff and Jessica Prinz. Jasper Johns incorporates textuality in his lithographs as minimal signs.

No less international than the poetic team of *Renga*, the five illustrators of *Une Pièce circulaire* alternatively and repeatedly respond to Stein's text. Collective illustrations were practiced during the thirties by the surrealists, each artist expressing his individual reaction to the same text or addressing a given political issue. But in the 1985 book, the designer

Martine Saillard, the painters Arthur Aeschbacher, Albert Ayme, Jiri Kolar, Brion Gysin, and Tom Phillipps join in a visual recuperation of a dramatic game.

How can artists adapt to, and illustrate, Gertrude Stein? If the example of Juan Gris is an indication, they would do well to rely on their own previous iconography as well as on whatever approach to art they happen to favor. Not surprisingly, several of the illustrators of *Une Pièce circulaire* refer in one way or another to their previous work. Some of Phillipps's pages are almost copied from *A Humument*. Kolar recapitulated earlier collage plates in illustrating Stein. But these two artists did not attempt in their illustration, as did Gris, to erect a monument in honor of Gertrude Stein, but like the American writer, they concentrated and self-consciously reflected on a form of production without even confining their endeavors to graphics—a transgression that would never have tempted a cubist. It is generally accepted, outside commercial illustration, that the artist by selecting a text for illustration recognizes an affinity with the writer. As a preliminary to their edition of *Une Pièce circulaire*, the five artists, the translator, and the designer met to discuss Stein's text or rather the various readings it might propose. Compared to the unity of the *As a Wife Has a Cow*, conceived by the modernist book artist Henri Kahnweiler, Saillard's volume interweaves six different responses, (or seven if we include the translator and his comments). She does not present text and image as different or alternating formulations, but as emerging simultaneously. A step in the direction of writing is taken by the painter through his use of the same medium as the poet. He too relies on printing, on letters even more than on painterly forms. Through typography, Saillard has already moved the text into the space usually reserved for visual art.

On the cover page, [Fig. 3] a white apple by Jiri Kolar—hardly the first one to appear in his art—is reproduced, undoubtedly responding to a line of text:

> Ronde comme à la ronde comme ma pomme
> [Round as around my apple]

Circularity is inscribed by the archlike shape of the writing as well as by the three dimensional roundness of the apple. Its representational aspect has been undercut. Was it a "real apple" before it came into contact with the Steinian text? Presently it is disguised by a collage of strips of paper,

Figure 3. Jiri Kolar: collage from Gertrude Stein, *Une Pièce circulaire*, 1985.

carefully pasted together to form a new kind of page. It challenges the
conventional page, so often stretched on the rack of doubts in the
postmodern era. Here the new page is round, fragmented, dis-
continuous; it highlights two words: *round* and *as*, stressing an in-
terrelated order without beginning or end. Crowned with seemingly
natural looking leaves, the strips of paper endlessly repeat the same
words derived from a single line of text. These words are always the same
and always different. They always match, yet are permanently mis-
matched, as in the round dance suggested by the text. The apple is
perfectly covered; words, invariably truncated, seem to have shifted in
relation to a previous neighboring patch. Reading turns into an endless,
unterminated, and indeterminate adventure. Kolar takes an experiment
initiated by Stein one step further. The apple forces the reader to
participate in its disguised circularity by foregrounding an operative
roundness.

The various components of the paper collage constitute both a con-
tinuity and a discontinuity in relation to the verbal text. Since every one
of its constituents is made of paper, is printed, and issues from Stein's
text, the basic duality or paradox of collage is, like everything else,
subverted. The juxtapositions do not seek, in the surrealist manner, to
elicit wonder. Rather, the presence of the cut-out and pasted elements
reduces the collage to its strictly literal qualities. Kolar's collage exploits
the difference between the shape of the apple and the printed page; the
apple parasitically borrows the paper's surface and the paper returns the
compliment by borrowing the apple's dimensions:

> We came together
> Then suddenly there was an army
> In my room
> We asked them to go away
> We asked them kindly to stay

Narrative continuity proceeds by shifting from one context to another,
consequently producing primarily erosion and giving the impression
that they originally belonged to different pages. But Stein's jux-
tapositions, for instance those I have just quoted, just like Kolar's paper
strips, will always fit together, provided we keep modifying the perspec-
tive. *Come together* and *army* are by no means incompatible, and the same
holds true for *to go away* and *kindly to stay*. Paradox seems to result in
simultaneity, all the more apparent as *stay* rhymes with *away*. In the
presence of Kolar's page, Stein's text assumes the characteristics of a
collage where divergent materials have not yet arrogated a new unity.

Three other collages are included in the book. One presents a con-
frontation between a page by Kolar and a printed page of text. Stein's
words repeatedly refer to the production of the text; she alludes to
different stages, going from invisible cogitations to concrete transcrip-
tion:

> The work can you work
> And meat
> Can you meet
> And flour
> Calligraphy. Writing to a girl

The French translation intensifies references to writing and production,
for instance in the following passage:

> Stop being thundering
> I meant wondering
> He meant blundering
>
> Cessez d'être tonnant
> Je voudrais dire émerveillée
> Il voulait dire brouillon

The first quotation pastes together words according to sounds as though the latter repeated meaning. Although *meet / meat, flour / flower* are semantically disconnected, Stein ultimately makes all the words of this little act relevant to writing. This poem, like those in the food section of *Tender Buttons*, belongs to both culinary and intellectual codes. When we compare the page "written," "cut," "performed" by Kolar to that of Stein as designed by Saillard, we notice the disruption of the linear format, the transgression of margins, the refusal to follow the accustomed order. His paper consists of nothing but quotations, borrowed elements, whereby he transforms a flat, smooth, rectangular sheet into a rhythmic dance. He presents the spectacle of overlapping fragments devoid of empty space, fragments which may go on prancing well beyond our field of vision. Kolar's pasted together, mutilated words suggest wavelike motions: a ballet without benefit of performers.

In one of the remaining compositions by Kolar [Fig. 4], the viewer perceives Gertrude Stein's bust by Lipschitz lurking behind strips of

Figure 4. Jiri Kolar: collage from Gertrude Stein, *Une Pièce circulaire*, 1985.

pasted paper. Kolar's page, divided into vertical strips covered with multidirectional printing, thus provides a doubly masked spectacle, and he has rewarded our scrutiny with a double set of intertexts: Lipschitz's sculptured image of Stein and the textual collage arising from Stein's text. Kolar alternatively hides and unveils the portrait, as though to reiterate that representations, whether image or text, is no more than a mask.[3] In the final composition, entitled "Hommage à *La Mer* de Debussy," the inner circle consists of a collaged musical score suggesting the motions of waves without referring to them explicitly. The rhythmic, dancing appearance of the score, which appropriates the center of the page, translates Stein's words into pure musicality. By bringing together the literary text and either sculpture or music, Kolar establishes a dual system of juxtapositions, both pertaining to the effort and process of *écriture* as practiced by Stein.

Like Kolar, Aeschbacher takes over the text as a printed, plastic entity in order to mutilate it [Fig. 5]. He too borrows and appropriates letters and words from the Steinian text without respecting its typography and its verbal order. Unlike Kolar, he does not require the tensions, dialectical or other, attendant upon circularity, for he rephrases its paradoxes by different means. By dramatizing tears, he makes them contribute to the singularly incomplete, fragmentary aspect of the page whose legibility he undermines. On an impeccable white sheet, he displays crumpled and torn papers on which letters, eluding their habitual regularity, appear to float away. On the initial page, a distorted circularity is made manifest through repetitions of the letter—or number 0. By the chance encounter of several lines, Aeschbacher transforms the rectangular page into a wavy discontinuity, which shortens, expands, and suppresses textuality. He simultaneously produces decentralization and destabilization. The encounter of lines results in displacements and misfits. While providing the spectacle of distorted circularity, Aeschbacher substitutes a text which repeats more than any other the word *circle*, and he shifts from a sign denoting nothing — O — to a term suggesting both fullness and emptiness. In this manner, he generates another of those bi-directional and dizzying performances by which postmodern artists respond to Stein's writing. By challenging communication, Aeschbacher fabricates a subversion even more corrosive than Stein's strategy of alternatively matching and mismatching words. There is a marked progression from one Aeschbacher page to the next. In the final plate [Fig. 6], the page has been fractured. The number of lines

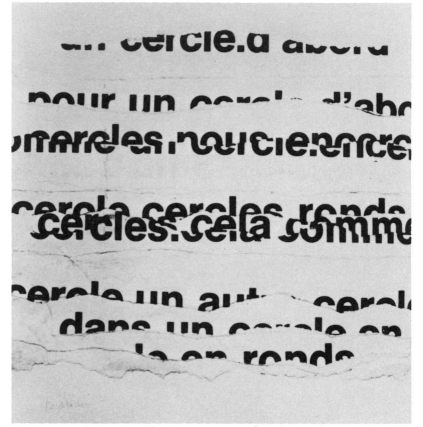

Figure 5. Arthur Aeschbacher: torn paper from Gertrude Stein, *Une Pièce circulaire*, 1985.

on the left has sharply increased, that on the right has sharply decreased, while overlappings, misfits, and displacements have become even more disconcerting. A new force seems to have invaded and pervaded the page.

On the cover page of *Une Pièce circulaire*, Martine Saillard wrote the following comment: "Afin de chercher une adéquation la plus propice possible entre le texte et sa visualisation dans le livre, 5 artistes sont intervenus à partir du texte lui-même, créant chacun selon son procédé pictural propre un nouveau tournoiement de textes possibles, en accord avec les procédés d'écriture de Stein."[4] This comment stresses the painter's responsibility to provide an adequate visualization, though by no means a form of subordination. The basic concept of the text is not one

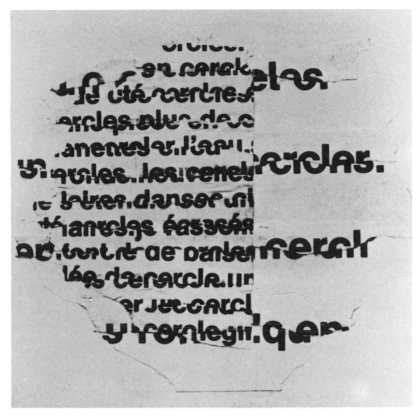

Figure 6. Arthur Aeschbacher: torn paper from Gertrude Stein, *Une Pièce circulaire*, 1985.

of authority, interpretation, or esthetic enhancement so frequently practiced in book illustration prior to the postmodern age and presently deemed inappropriate. In eluding the superannuated task of illustration, the artist engages in an activity capable of outflanking, so to speak, the domain of esthetics. Stein's play becomes an event, or a happening, (or even a textual production in the double sense of the term). Kolar and Aeschbacher reactivate the Steinian text as an unraveling construct.

If Kolar's and Aeschbacher's contributions could be abstracted from the typographical pages, they might pass muster as concrete poems, concerned with the visualization of letters, with making language concrete, with producing a new spatial order. Concrete poetry, however, is not generally intended as an aggressive cultural act; it does not lay bare

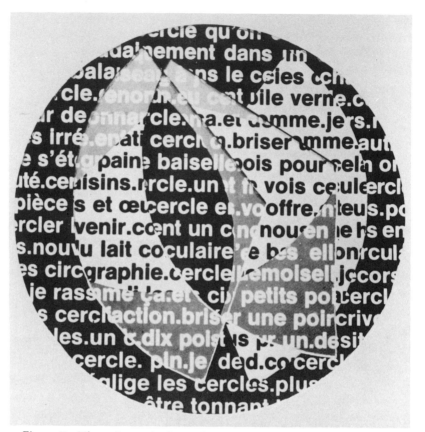

Figure 7. Albert Ayme: incisions from Gertrude Stein, *Une Pièce circulaire*, 1985.

irreconcilable tensions, but explores through reductive and analytical strategies the nature of language. Kolar's and Aeschbacher's pages echo Stein's rejection of narration and her syntactical prowesses. But they also reach out toward a newer and broader cultural domain. They begin with the destructive gestures of cutting and tearing the page, the letter, the line. Stein's pages are spread out, reshuffled, and dealt into new contexts where our mechanical habit of looking for meaning must inevitably malfunction. Stein's avant-gardism advocates, and displays enthusiasm for, the new. Saillard's book belongs to an era when shows at the Centre Pompidou as well as in various Parisian and New York galleries feature the *livre détourné*, the deviant book.[5] Artists expose burnt volumes,

volumes stapled together, volumes twisted into unexpected shapes. The deviant book withholds the tentative security provided by reading; it excludes readers, turns them into outsiders. These castrated books function as threatening performers capable of reducing us to the state of impotent spectators. *Une Pièce circulaire* does not go quite as far in its postmodern alienation, for the five artists focus merely on language and its rifts with communication.

Unlike Kolar and Aeschbacher, Ayme makes use of large, regular, legible letters. [Fig. 7] He inscribes a circle in the middle of the page, which he surrounds with blank paper covered by a printed text. Yet it is no more possible to read Ayme's text than those of the other two artists. Whereas Kolar suggests primarily unpredictable associations of words and Aeschbacher proposes the obscuring of obvious meaning, Ayme relates discontinuity to the impossibility of remaining within the same text or, in other words, he denies the unity and sameness of a single text. A page, a book is metamorphosed into a palimpsest consisting of layers, smooth on the surface but probably treacherous underneath. Simultaneity, the focusing on the present moment, the undercutting of any progression in time, these characteristics of the Steinian text seem to have preoccupied Albert Ayme. Stein's circle can be related to the shifting from a referential world to the labyrinths of the mind. Ayme's page provides an inner, boldly segmented window fraught with overlapping divisions. Although the alignment of the page is barely disturbed, although the reader could progress in a linear, horizontal direction from one zone to another, s/he cannot decipher Ayme's fractured quotations of Stein's text. This artist, in whom Lyotard has understandably shown considerable interest, has formulated many theories about his own work; he has skillfully interpreted sophisticated, self-conscious poets such as Ponge and Mallarmé. But in illustrating Stein, he has trapped his readers by making the lettering enticingly legible while at the same time inducing the text to roll out of sight through a perverse overlaying of sections. As a result, Ayme's page is no less eccentric than that of the other two artists previously discussed, and his superpositions go beyond Stein's daring associations or her gliding from one textual figment to another. No act of reading can entangle or disentangle these non-sequiturs and retrieve systems susceptible of even a momentary validation. Ayme's page is hardly the still space of a canvas; he makes visible a sliding world. Even though the painter does not present his black and white pages as so many canvases, they strongly suggest

chromatic and impasto zoning. His commentary addresses itself to the self-reflexivity of literature which he relates to his own medium and also to the more problematic question of the generic and its postmodern transgressions.

Tom Phillipps in *A Humument* and his illustrations to the *Inferno* reissues previously printed pages combining text and image in order to modify them. Thus, his contribution to *Une Pièce circulaire* is primarily based on the principle of re-adaptation. A palimpsest, a term previously applied to Albert Ayme's illustrations, consists in the erasure or displacement of a text in favor of another. It suggests, moreover, the irregular and diverse layering of linguistic strata, which mutually transform and expose one another. Phillipps, both literally and figuratively, extricates a new text from an old one. For the reader, the blocked out old text is a presence lurking behind dark colored brushed-on curtains, while the new text, a reductive narrative, repeats a tale in both words and images. This double visualization corresponds to Stein's telescoped prose passages, which often bring together distant words or expressions. Phillipps is fully aware of the implications of his project. In the introduction to the notes to the *Inferno*, he writes:

> The 139 pictures which in my translation, make up this present version of the *Inferno* attempt to provide a visual commentary to Dante's text, they form its notes or apparatus and make a bridge in time and reference . . . The plates also contain another form of commentary; a parallel text embedded in the images, a poetic gloss deriving (as does *A Humument* from W. H. Mallock's *A Human Document*, a Victorian novel, that is here plundered and "treated" anew, mined and undermined for possible insights into Dante's thought. (283)

Phillipps proclaims that he always stands on someone else's shoulders, that he "plunders" their words. He implies that he makes a habit of calling upon some traceable or untraceable text, but that while remaining within the verbal medium, he does far more than merely borrow words. Through manipulation, he can extract hundreds of words and a map from a single page of printed text. Deciphering Philipps's pages presents the reader with a cultural act, different from that of the other artists participating in *Une Pièce circulaire*. Natacha Michel, in writing about the 1979 publications of Jacques Roubaud, points to striking similarities among the painters and poets who interpret Stein. The title of Michel's article, "Les mots de seconde bouche," is as revealing as her statement:

Si le choix calligraphie, d'exégèse, de glose, point. Roubaud s'il est un moine, est un moine monteur. Ce qui règle la cueillette ce n'est pas quand Roubaud a lu, mais comment il a lu. Ce qui sélectionne c'est une sorte de sur-poème, pris au poème lui-même, de ce qui dans le poème fait le poème. (600)[6]

In *Une Pièce circulaire* [Fig. 8], Phillipps establishes a flow between extracted words without contouring as elsewhere landscapes or portraits. His texts derive from Stein's play, which appears as a dark substratum. Phillipps's constellated words, modified from page to page, perform like a theme with its variations. Far more than the other artists, Phillipps insists on the lyrical dimensions of the American poet. But if this lyricism were not counteracted by another force or if it truly dwelled on conventional poetry, then Phillipps's contribution would be a misfit in the volume.

Although there is an undeniable unity and coherence among the words that surface in the three plates by Phillipps, the spatial structure varies radically. On the first page is inscribed an oval shape, a distortion of the circle, introducing the tension between the organic and the abstract so characteristic of Phillipps's art. On the irregularly brushed over surface, obviously handpainted, the obsessively repeated word *circle* creates dissonance and estrangement. In the second page, which suggests the flatness of the surface from which a new text has been subtracted, hatchings replace brush strokes. The surface is vertically divided into sections which seem to move into each other, and in moving from dark to white zones, the text lapses into discontinuity. The geometrical page with its curtailed text is neither immobile nor does it remain outside the realm of time and its modulations. Homogeneity is subverted and organic fluctuations invade the page. Tensions increase substantially on the last page designed by Phillipps, [Fig. 9] where the circular play, in its theatricality, performs a rotation around diagonal axes. Stein's text is transformed by spatial displacement. Forces both centrifugal and centripetal disturb the seemingly natural course of the legible word. Phillipps's postmodernism thus focuses on the deep-seated problematics of textual production, where the gestural struggles so as not to succumb to parody. And we may wonder whether, contrary to the other artists, Phillipps did not conceive Stein's text as belonging to a past.

The last of the contributors, the American artist Brion Gysin, provides a link between Stein and certain postmodern manifestations in the United States. Ryan, as I stated earlier, has given an account of recent

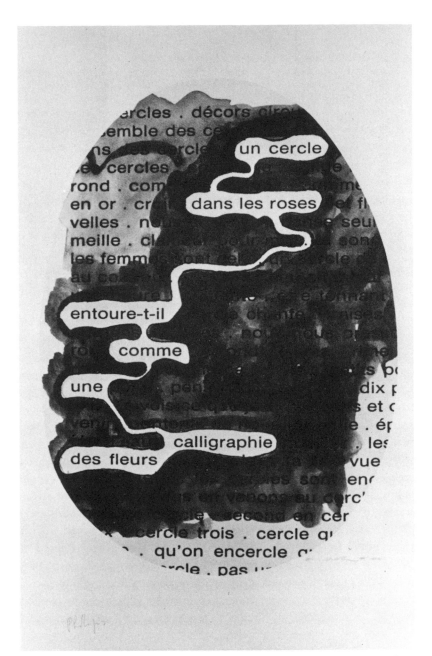

Figure 8. Tom Phillipps: blotching from Gertrude Stein, *Une Pièce circulaire*, 1985.

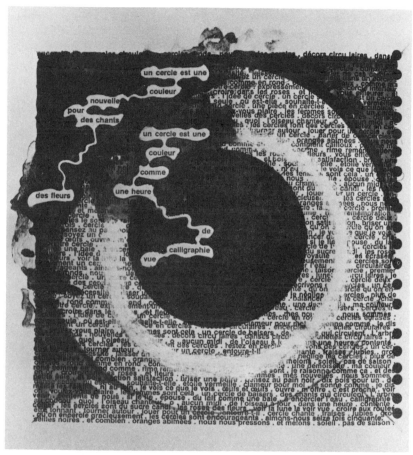

Figure 9. Tom Phillipps: blotching from Gertrude Stein, *Une Pièce circulaire*, 1985.

performances which, directly or indirectly, can relate Stein to the radical experimentations of Merce Cunningham, John Cage, Stan Brackage, Robert Wilson, and Richard Foreman. Ryan provides important information about the staging of "A Circular Play," where generic shifts, the abolishment of characters, the lifting of words into space are foregrounded as they are in the visualizations previously discussed. The performance can by no means function as the representation of a finished text; rather, it participates in its deconstruction.

Gysin, a frequent associate of William Burroughs, cannot be identified with any single genre. Performance, visual arts, and poetry both fit

and misfit his activities. Intercultural and interdisciplinary appear as
pedantic terms when applied to his experimentation. Gysin's appropria-
tion of Stein's text is by cut-outs [Fig. 10]. Like Ayme and Kolar, he
segments with scissors a printed text on which appear Stein's words.
Each one of his fragments, further bisected at the margins and set into a
square, reveals various forms of incompletion. Gysin not only doubly
cuts up Stein's text, he also cuts up the pages of the other artists [Fig.
11]. His pages assure the simultaneity of Stein's text, of his own
painterly visualizations, and also of Saillard's printing. More than any

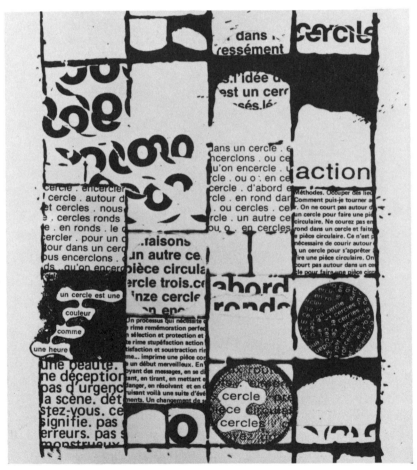

Figure 10. Brion Gysin: cut-up from Gertrude Stein, *Une Pièce circulaire*,
1985.

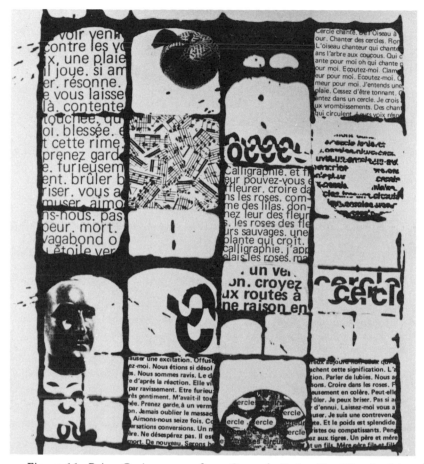

Figure 11. Brion Gysin: cut-up from Gertrude Stein, *Une Pièce circulaire*, 1985.

other artist, he abolishes the distinction between text and image, or if we take into account his claim of providing an accompaniment, he abolishes the soloist and thus comes close to decreeing the postmodern death and post-mortem of the author. His statement points to the erosion affecting text and image: "Nos tableaux sont des pages de livres qu'on pend au mur et se lisent comme un manuscrit" (48). Gysin performs a radical act in book illustration. On a page reminiscent of a chessboard, he anthologizes a series of quotations by which he completely obliterates the difference between the original text and the commentary, an endeavor entirely untraceable in the modern illustrated book, exemplified by *As a Wife Has*

a Cow. Without Gysin's contribution, *Une Pièce circulaire*, with its visualizations by painters, would have been but a sum of pages: the multiple exposition of a theatrical representation of words, of *écriture*. Kahnweiler's book features above all the harmonization of the arts as creativity; the postmodern book, far from producing such a monument, displays permutations, present within the Steinian text as well as among the different artists' pages, and constantly questions its own sporadic existence. It undermines the security that, as object or artifact, it might have provided the readers, and destroys whatever reliance they may have had in the metaphorization of space.

NOTES

1. Compare this lithograph to Gris's paintings *Harlequin with guitar*, 1917 & 1919.
2. Ryan, pp. 146–51. cf. also Grimal and Foreman; Bigsby.
3. cf. Gérald Gassiot-Talabot: "Et pourtant Kolar les enveloppe soigneusement d'un linceul de papier imprimé et les mots sur les choses proposent une étrange dialectique, une escalade sur l'identité, sur les frontières de la signification, sur le contour du verbe" (7).
4. "In order to attain the most appropriate equivalence between the text and its visualization in the book, 5 artists have intervened taking the text as a point of departure, each one creating according to his own pictorial process a whirlpool of texts, of potential meanings faithful to Stein's own writing process."
5. cf. *Livres-objets*, exposition réalisée par Caroline Corre, Bibliothèque Discothèque Faidherbe, 1985; *Le Livre dans tous ses états*, Galerie du Centre d'Action Culturelle Pablo Neruda, Corbeil, Essonnes, 1984; *Livres mis en scène*, Centre National des Arts Plastiques, 1985; Anne Moeglin-Delcroix, *Livres d'Artistes*, (Paris: Herschel, 1985).
6. "If the choice results in calligraphy, there is neither exegesis, nor glossary. If Roubaud is a monk, he is a monk who operates. What counts is not when Roubaud did some reading, but how. A 'super poem' is selected, taken from the poem itself, from what in the poem makes the poem."

WORKS CITED

Ayme, Albert. *L'Après-midi d'un Faune de Mallarmé*. Paris: n.e., 1966.
———. *Pour L'Araignée de Francis Ponge*. Paris: n.e. 1965.
Barth, John. "The Literature of Exhaustion" in Raymond Federman, *Surfiction*. Chicago: Swallow Press, 1981, 19–35.
Beckett, Samuel. *Bing*. Paris: Minuit, 1966.
Bigsby, Christopher. "Arts Theatre and the Real" in *Representation and Performance in Postmodern Performance and Fiction*. Montpellier: Delta, 1983.
Chamberlain, Lori. *Afterwords: Translation as Poetics in Postmodern Writing*. Ann Arbor: University Microfilm International, 1982.
Chapon, François. "Livres de Kahnweiler" in *Daniel-Henry Kahnweiler, marchand, éditeur, écrivain*. Paris: Centre Georges Pompidou, 1984, 45–77.
Dante's Inferno. Trans. and illus. Tom Phillipps. London: Thames and Hudson, 1985.
Foreman, Richard. "Stein." *Théâtre public*, no. 48 (Nov.–Dec. 1982), 42–48.
Gassiot-Talabot, Gérald. *Repères*. Paris: Galerie Maeght-Lelong, 1983.

Grimal, Claude. "Stein ou le chaos mode d'emploi." *Théâtre public*, no. 48 (Nov.–Dec. 1982) 10–15.

Gysin, Brion. *Ecritures dans la peinture*. Nice: Villa Arson (Avril-Juin 1984). Qtd. by Gérard-Georges Lemaire.

Hugues, Jean. *50 Ans d'Edition de D.-H. Kahnweiler*, catalogue exposition. Paris: Galerie Louise Leiris, 1959.

Kahnweiler, D. H. "Gertrude Stein," a preface to *Painted Lace and Other Pieces*. New Haven: Yale UP, 1955.

Lyotard, Jean-François. *Sur la Constitution du Temps par la couleur dans les Oeuvres Récentes d'Albert Ayme*. Paris: Edition Traversière, 1980.

Michel, Natacha. "Roubaud 78: Les Mots de seconde bouche," *Critique* (Juin-Juillet 1979), no. 385–86.

Perloff, Marjorie. "The Space of a Door" in *The Poetry of Indeterminacy*. Princeton: Princeton UP, 1971, 200–47.

Phillipps, Tom. *A Humument, a Treated Victorian Novel*. London: Thames and Hudson, 1980.

Prinz, Jessica. "Foirades/Fizzles, Beckett/Johns," *Contemporary Literature* (Summer 1980), vol. 21, no. 3, 480–511.

Roche, Denis. "Gertrude Stein opératrice" in *In'Hui, Gertrude Stein, encore*, 37–45.

Roubaud, Jacques. *Autobiographie chapitre dix*. Paris: Gallimard, 1977.

———. "Gertrude Stein, Gertrude Stein, Gertrude Stein," in *Critique*, no. 379 (Décembre 1978), 543–55.

———. "Gertrude Stein Grammaticus" *In'Hui, Gertrude Stein encore*, no. O. Amiens: Maison de la culture, Trois Cailloux, 1982), 45–57.

———. *Trente et en au cube*. Paris: Gallimard, 1973. Also Paris: Maspéro, 1978.

Roubaud, Jacques and Charles Tomlinson, Octavio Paz, and Edoardo Sanguinetti. *Renga*. Paris: Gallimard, 1971.

Ryan, Betsy Alayne. *Gertrude Stein's Theatre of the Absolute*. Ann Arbor: U. M. I. Research, 1980.

Stein, Gertrude. *A Book Concluding With As a Wife Has a Cow*, illus. with 4 lithographs by Juan Gris. Paris: Galerie Simon, 1926. Rpt. Millertown: Something Else Press, 1973.

———. *The Autobiography of Alice B. Toklas*. New York: The Literary Guild, 1933.

———. *Portraits and Prayers*. New York: Random House, 1934.

———. *Tender Buttons* in *Selected Writings*. New York: Vintage Books, 1972.

———. *Une Pièce circulaire*, traduit et postfacé par Gérard-Georges Lemaire, avec accompagnement de: Arthur Aeschbacher, Albert Ayme, Brion Gysin, Jiri Kolar, Tom Phillipps. Paris: Edition Traversière, 1985. For English edition of "A Circular Play": cf. *Last Operas and Plays*. New York: Rinehart and Co., 1949.

7

Generating the Subject: The Images of Cindy Sherman

Frederick Garber
State University of New York, Binghamton

> He wanted to see her naked and vulnerable,
> to see her in the refuse, the discarded
> plots of old dreams, the costumes and masks
> of unattainable states.
> It was as if he were drawn
> irresistably to failure.
>
> Mark Strand, *The Story of Our Lives*

That one of the earliest events in the history of photography would have some bearing on the work of Cindy Sherman should not, after all, be surprising. Sherman is one of the chief exponents of what it means to be a postmodern visual artist. But so much of what she does bears on basic generic issues like the nature of the self-portrait, and in fact on the radical nature of photography itself, that her work not only touches the timbre of the contemporary but has elemental affinities with photography's earliest gropings, the earliest questions it asks.

What I have particularly in mind is one of the first open acknowledgements that photography can be a very ironic business. On July 14, 1839, Hippolyte Bayard exhibited a set of thirty photographs made through an early experiment with light-sensitive paper. But the enthusiastic reception of the methods of Louis Daguerre left Bayard's own work in the lurch, and he responded the following year by making a photograph of himself called *Autoportrait en noyé* (*Self-Portrait as a Drowned Man*). He noted the following on the back of the print:

> The body you see is that of Monsieur Bayard . . . The Academy, the King, and all who have seen his pictures admired them, just as you do. Admiration brought him prestige, but not a sou. The Government, which gave M. Daguerre so much, said it could do nothing for M. Bayard at all, and the wretch drowned himself.[1]

126

Bayard's portrait of the artist as a drowned man is hardly convincing: the body slumps selfconsciously against a convenient wall, and the torso shows nothing of the stiff, leaden look of dead flesh. (If anything, he seems to be sleeping off an understandable binge.) But this bit of sardonic dress-up brings into serious question, and very early in the game, all of the awe that photography raises about its relations to the real world, about what it means to be both out there and within the print, about the frequently ironic status (note the self-cancelling title) of being both other *and* oneself. Bayard's play-acting establishes questions of presence and representation and selfhood, of fictions and realities that are only partly what they claim, that still haunt the medium. It is not that Hippolyte Bayard is proto-postmodernist, prescient about the shapes of our own acts and theories, but that postmodernism has ways of focusing central issues that have always been with photography.

What Cindy Sherman exemplifies is an especially telling way of making those issues apparent. She took to photography as an art student at the State University of New York at Buffalo and turned out her first important images in 1977, shortly after moving to New York City. That first phase, which lasted into 1980, consisted of a series of images called "Untitled Film Stills." All of the stills focus on a single figure, in every case Sherman herself, decked out in a variety of guises and assuming a range of characters from popular films of the 50s and 60s.[2] Though they are designedly unspecific (keeping them untitled keeps their focus radical and generic) these images take in types that have meaning for more than movie buffs. In one (#10) [Fig. 1] a figure out of any number of Italian films looks up darkly, poutingly, at an out-of-range observer, the high angle shot and the play of extreme tonalities defining not only the figure but the passions of the scene. The place is the kitchen but it might as well be kitchen-cum-bedroom, for the passion comes to focus on the broken grocery bag pointing to the darkness of her open crotch, while she picks up (what else?) a carton of eggs. In one of the best-known images (#21) Sherman takes the opposite tack, the figure this time a pallid blonde in a business suit, in the background the blurred images of some very tall buildings. The perspective is such that they tilt in toward her, which comes partly to account for the strained anxiety with which she stares out of the image at *something* (closer definition would thin the fiction) that is, again, in some sort of contact with her. From domestic sexpot to business waif and everywhere in between, the spectrum of figures plays out patterns of popular culture, its images of desire and

Figure 1.

especially its representations of women. But even this puts too simply
the intricate energies of these photographs, for they also play with the
ways in which we seek to constitute ourselves through shared public
imagery, modes of self-presentation which, wherever we touch them,
give off the feel of semblance, the sense of an artifice which is as much
willed as imposed.

The black and white film stills remain Sherman's best-known work,
though what has happened since then takes their profounder im-
plications into broader and more potent patterns. Black and white gives
way to an increasingly skilled use of color. The suggestions of narrative
inherent in the nature of the film still give way to closer attention to the
figure at the center, always "played" by Sherman herself. A series of
images with rear-screen projections, in some ways an extension of the
stills, were sometimes technically awkward but did serve to bring the
subject into higher relief, frequently up at the picture plane and now
more patently the main point of interest. Whatever their weaknesses
these images start an important shift in which the metonymical women
in the stills are turned into figures with looser connections to patterns of

pop imagery, figures for whom their own inner connections become the subject of intense brooding.

The next significant move came in 1981, when Sherman was commissioned by *Artforum* to do a series of centerfolds, for these took her established mode, now handled with greater dexterity, toward tenser emotional contexts and further suggestions of strangeness. Though these figures take on the submissive mode built into the vertical thrust of the centerfolds they are always fully clothed (contrast what Carolee Schneeman would have done with such material) and are generally pensive and anxious. In #96, a ruddy teen-ager lies prone and open on the floor, clutching a torn piece of newspaper with a lonely-hearts ad, the studied harmony between her clothes and the tile floor offering an ironic foil for her emergent unease and longing. Moving closer to life size, the images impose with their brooding occupation of space, their force a further stress on that radical question of presence which has been in Sherman's work since its inception. And it is because of precisely that question that the centerfolds continue to explore our elaborate fashionings of self, the play of text and self, text *as* self, which has obsessed most kinds of postmodernism from its own earliest stages. Then, with that kind of inevitability whose ironies seem to resonate in infinite regress, Sherman was asked, in 1983, by a Madison Avenue boutique to do a series of fashion photographs for ads for designer clothes. The images are anything but stylish, the clothes themselves perceived more as costumes than daily wear. For the first time a sort of absurd that verges on the grotesque comes into play in the images, as though to confirm the intuition coming down from Carlyle that clothes too are texts, and texts cannot be defined apart from what we are. Our compulsive self-constitutings are put forth as bluntly here as anywhere in Sherman's work, while the emphasis on high fashion brings out even more openly the implications of power that impel all such images.[3] But it is the suggestions of the eccentric that link these images most openly to the surprising changes that follow.

In the fall of 1985 Sherman showed a set of thirteen photographs at Metro Pictures, their images life size though with a life unlike any other she had inspected up to that point. The evanescent cultural surfaces seen in her previous work, with all their attendant codes, give way to substrata which have most of all to do with the permanently unsettling and unbeautiful. Sherman had been approached by *Vanity Fair* to do a series of fairy tale images, to be run with relevant texts from Grimm and

other collections. Like some of her other projects this one did not materialize in the way originally planned, but it gave her a way of focusing what had already been on her mind (Jones, 44–5). For these are no Gretels or Cinderellas but ogres and grotesques from the darkest interstices of the tales, deformed, mutilated, ugly, scary in a way that never goes away. Behind a thin curtain of erect grains a bulky, expressionless figure, with fat face and a prominent eye, stares at us from the top of the image, its head partly cropped but the completeness of its occupation of the scene never in doubt (#152). What glints out of those eyes never glinted before this show. Another figure in the series takes over the play of seduction that runs through the canon from the beginning, the play this time reflected in a harem woman with ominously gleaming teeth (#146) [Figure 2]. Sitting behind the entrance of a gauze tent she opens up sexuality not only to pop exoticism but to archetypal depths, taking on the shape of a succubus; but the breasts the figure bares and offers have nothing to do with her, for they are as false as the prosthetic buttocks another figure bares to our eyes. That other image (#155) [Figure 3] shows only some scattered body parts, giving us, it would seem, all (the little) we want. At one level we are mocked with the tits-and-ass sexuality that runs through the earlier representations, though this time we are openly told that we get no real thing but only what we think we see; yet at another level these images are shown to be grounded in a foundation of elemental myth (several reviewers of the show spoke of the collective unconscious) that takes the implicit anxieties of the earlier images into more permanent territory (Grunberg [1985], Indiana). Sherman's seeing is oxymoronic, the play of inner and outer that informs so much postmodernism taken as a play of contraries that can never quite reconcile and cannot cancel each other out. But it is also, as elsewhere, a play of representations, imagings now not only of women (some of the figures are clearly androgynous) but of ourselves at levels and conditions which are always unshakeably active, always available through the archetypal. Sherman's fascination with our imagings of ourselves came by this point to extend into longer-standing modes of figuration.

This is change within continuity, a probing that, at once, reveals and confirms. In the spring of 1987 Sherman showed a set of images at Metro Pictures which continue and restate and affirm, this time no touches of fairy tale or elemental image but of ourselves as elements, making and becoming offal. A horned mask which could have come from the

Figure 2.

Figure 3.

previous show looks most like a rotting face (#174). A pimpled, pustulated buttock recalls the previous prosthetic version, but this time it images ourselves as filthy and infected (#177). The girl in the business suit of the earlier film still has evaporated from the suit, an up-to-date, fashionable version of the outfit lying empty on a pile of junk (#168). As stagey and melodramatic as the set of mythic images, this group goes its way into other sorts of permanence, repulsed by our physicality (vomit and blood-stained panties and a plateful of worms at a banquet) and the necessary disintegration of all that could be called us, our bodies and our images of self. What we see of Sherman's image is largely fragmentary and indirect—an indistinct background figure, a partial reflection in a mirror or a pair of sunglasses, always several degrees away from anything that can be called immediate or complete. If Sherman can be said to be saying, in this and the previous show, that we never saw her whole, there is more here than a flagrant rejection of all those viewers and reviewers who saw her work as self-exposure. Deeper concerns inform these figments of detritus, for the fragility of the early fictions and the stability of the archetypes come together into scenes of permanent evanescence.

In the summer of 1987 the Whitney Museum in New York presented what was called a "survey" of Sherman's work ("retrospective" seemed hardly appropriate for a thirty-three year old artist with a career a decade along), a show which had been touring for more than a year and to which were added some of the latest Sherman images. This show gave what no other could have given up to that point, a rich and detailed sense of the development of her work, the rapid series of changes but also the consistency of vision and mode that had been with her from the beginning and appeared with even fuller passion in the most recent productions. What we have seen of the development came out with pristine clarity. More difficult and more disturbing are the stubborn, radical passions that ground this extraordinary work.

What, then, of Hippolyte Bayard and that mixed bag of mockery and poignance, his "posthumous" self-portrait? Ian Jeffrey has pointed out some of the qualities of Bayard's self-reflexive images which, like those of Fox Talbot, have as their subject the conditions and possibilities of photography (Jeffrey, 25-7). Bayard's studio pictures, as well as his photographs of architecture around Montmartre, stress the processes of deductive seeing. But the drowned man's self-portrait has even more to do with the phenomenology of photo-making as well as the complex existential status of photo and photo-maker (neither of which, Bayard

seems to argue, can be taken separately from each other). We pass quickly through the level of fiction (the drowned man cannot take his own picture) though it remains a permanent base from which to work our experience of the image. We know that what we see is life masquerading as death, that we are looking at a (then) quite fleshly Hippolyte Bayard who was, for the moment, holding his breath, that he got up from this leaning position and went to work on the image that we see. To put it another way, we are watching a play of self and persona, though the latter is in fact (even if the extent to which we can speak of "fact" is getting more difficult to define) not all that much of a persona: it is, after all, Bayard *himself* who envisions *himself* in a death that could have happened (we have to think Aristotle at this point) and, though most likely in other conditions, will happen.[4] The distinction of the photographer and his self-acted image, not very clear to begin with, becomes even less clear as our witnessing continues, though there is never any doubt that they are not exactly the same, that the moment of coincidence in which the image was taken was when they were closest together. The play of deductive seeing which so fascinated Bayard involves other sorts of deducing than—to use Ian Jeffrey's example—the ambiguous placement of objects in space that occurs in his studio images. And all these forms of deducing obviously involve us as well, for it is we who are called upon to perform the attempts at placement, not only of the objects in space but of the "posthumous" subject in its odd and really quite eerie existential space.

Which may have something to do with the eeriness of Cindy Sherman's later images, for their own ways of being are finally as much concerned with what photography happens to be as with their "personal" qualities. These matters also have much to say about her initial, intuitive turn toward the genre of the film still as both a source of images and, itself, a way of imaging. Take, again, Bayard's self-portrait, as well as Sherman's edgy, reiterated insistence that her images are in no sense autobiographical.[5] Several critics have pointed out that Sherman speaks of her characters in the third person, and her initial fascination with the work of Eleanor Antin cooled, Sherman remarking that Antin believes too much in the characters she makes.[6] We can see why Sherman said that, given her wish to distance herself from the figures in her work; but the comments on Antin are questionable for we can also ask ourselves how much Bayard believed in the image of himself as drowned. That question, as we have seen, admits of no categorical answers and neither does Sherman's work, whatever her understandable uneasiness about

Figure 4.

simplistic, diverting and ultimately gossipy identifications.

Her best known film still shows a blonde in sneakers, bobby sox, checked shirt and white blouse standing by the edge of a road, in back of her a suitcase so sloppily, hurriedly packed that an edge of clothing hangs out (#48) [Fig. 4]. In a layout familiar from classic landscape imagery—memories of Constable will do—the horizon splits the picture vertically across the middle, distant mountain and depth of sky completing their art-historical context with the predictable river but finding also a contemporary highway, its central double stripes confirming the bend of the road to the left and out of the scene. The blonde is hitch-hiking, but toward what? Toward where bobby soxers went in all sorts of popular films some twenty years before this image (it is dated 1979). And if the image is turned toward our past, the girl is turned toward her own, facing in the direction from which cars would be coming, her back to her filmic future in a play of stance and temporality which has as much to do with the nature of the film still as with any inherent story. But elements of such play turn up with regard to any still photographic image. Bayard's self-portrait, for example, works with temporality in other, related ways. The time of his drowning is false, the time of his posing is

true, just as the time of Sherman's posing is true while the time in the
photograph will be false to the extent that the image has to be considered
a feigning (and also to the extent that one can speak of true and false
times, a question implicit in both Bayard and Sherman, and in no sense
answered by either). These issues point to some of the ways in which
temporality is involved with photographic images. But there are all sorts
of other ways as well: for example, we watch Hippolyte Bayard foreseeing
his own death, long after that death has occurred; and no amount of
juggling of theories can put aside the fact that it is an image of Bayard
himself that we are watching performing that business, a point he wants
so badly for us to note that he calls the image the dead man's self-portrait.
Temporality and art and self, the play of time, text and subject, work his
photograph into a series of extraordinary complexities, few images in the
history of the art surpassing what it does. To the frame Bayard developed
Sherman adds a sense of sociocultural systems and an attendant extension
of the play of text and subject that was not possible to Bayard but which
he would have taken in stride and perfectly understood.

Take, for example, what happens with the hitch-hiking bobby-soxer.
The sox and shirt and blouse imply and implicate a definable set of
values, taking in shared modes of understanding and being which begin
with Frankie Valli and specifics of diction and diet, moving from that
level of pop sociology to all manner of more complex business. As one
instance of the latter, the impress of communal values offers not only the
sort of sustaining pressure that animals look for when they huddle, but
also the sort of impress achieved when paper is stamped with pre-existent
images. Thus, the play of pressure and impress, the kind of pressure
known by lemmings but also the various kinds known better by those
more sardonic sorts who cannot resist the movies that make them—even
though they know full well how they (themselves *and* the movies) are
made. The film still, then, comes to stand not only for communal
passions but for that play of self and semiosis, modes of temporality and
degrees of fictionality, at which Sherman's work begins.

In his essay in the Whitney catalogue of her work Peter Schjeldhal says
of the stills that "these pictures are at least tentatively about the film
frame as a sign for a fictional world," a useful way of putting one of the
basic semiotic aspects (8). Any film still is a snippet from a much larger
fictive framework. It is literally an enclosed frame in which, in the case of
Sherman's work, a central figure is caught at one point in an action. In
every film still that Sherman recalls, the figure is impersonated by an

actress, perhaps the representative of a type. Sherman's early reviewers spoke often of Monica Vitti, and it is part of the artist's point to render characters of that sort, characters with a curious existential status because we can speak of them as typical and generic (a Monica Vitti *type*) and yet as particular and specific (a *Monica Vitti* type). (Sherman's sensitivity to such apparent anomalies is one of the defining characteristics of her work, and it lifts her far above similar engagements with public semiosis.) All of this leads to what some consider to be an infinite regress of fictions. In playing out of the self-*makings* that film stills impress we play with intricate levels of *feigning*, for what we are looking at in the still is an actress playing a role and playing it in a genre which is itself hardly "true" because it is only a single piece of a much longer strip of film, a fragment of a full-length, self-enclosed fiction. Thus, the still is an image of an image, a metonymical snippet of an hour or so of feigning. In terms of Sherman's work one can complicate this even further by noting how Gina Lollobrigida plays a Gina Lollobrigida type (see #35); but that is only part of the picture that involves Cindy Sherman, because with image #35 we have to speak of a photograph of Cindy Sherman playing Gina Lollobrigida playing a Gina Lollobrigida type. To this complex of quasi-mirroring and existential states one has to add that her images of stills are designedly generic, speaking not of a single film but of a mode of making images. They are role-playings about role-playing, figments of fictionality, leaving the question of egress from this complex both open and claustrophobic.

Still, one has to consider more closely that equally curious business about our generatings of self through—under the impress of—these public packagings of the unreal. For that business causes still another kind of open-endedness, the result many more elements that do not quite jibe, more than Sherman's varied connections with codes and images and fictions can handle by themselves. Sherman is well aware that our participation in systems is an ironically creative act, maybe the only kind of creativity known to most of us; yet it is, obviously, a creativity within limits that leave the areas of choice potentially quite narrow and perhaps hardly existent. Hers is a more-than-usually ironic reading of the dream to "be" the images one sees on the screen. And it is an irony that reaches further than most such readings of codes, for it reaches toward conclusions that would involve codes and more but seem never to succeed in finally coming about. Who or what is the agent of that ironic creativity which public role-playing permits? Where, in terms of the photographic

image, is that "who" or "what" to be found? Do our viewings of these images involve other kinds of nostalgia than memories of Lollobrigida? Whatever the ways of resolving what is turning out to be a most potent oxymoron there is clearly much more at play here than matters of semiosis and the exposing of codes. We seem to be working our way back to Bayard once again. He has, in fact, been continually muttering in the background.

Bayard begins and ends with himself in a way that, whatever his ironic demurrals, is very much of his time and place. He is present in every phase, a proto-*auteur* who sets up the scene of the image, setting himself down within it as a prefigurative figment of himself and getting the image taken as well, eventually bringing it to light. Part of his point is a parody of Romantic visions of the artist as almighty creator: he has, after all, been so unsuccessful that he was compelled to drown himself (a point we might be able to guess at without the comment on the back, but find confirmed through that comment). Among his multitude of prefigurations one can include Bayard's guess at the ambiguous matter of captions. Of course this is Wertherian, Hugoesque nonsense; and yet Bayard's own work exemplifies a far less tacky version of the point because no place in the complex of events and results that centers upon this image is without his active participation, untouched by his many-faceted capacities. This means that the question of how to take him cannot easily be resolved because his ways and his arguments, that which he does and that which he mocks, are at ironic loggerheads. No genre he could have worked in would have left such matters so open. With Bayard one sees quite clearly how photography upset, and continues to upset, so many of the established principles that have created the canons of the arts. No one could come out of such events with entire satisfaction, not even Bayard himself.

Cindy Sherman contributes her own upsettings, not least to the art of photography, which can now look back on its own canonical history. What she adds raises problems and possibilities that are not quite in Bayard. His image is a self-portrait, a playing of oneself in a hypothesis. Sherman's images are of figures that come to her out of public fictions, never of herself in the special way that Bayard's is of himself. That source is the same not only for the film stills but for the fashion photographs as well, and even for the fabulous characters of the 1985 show. However much a Jungian reading would put the latter into a collective unconscious, we know those figures largely through their traditional repre-

sentations. Thus, even with the crones and the succubi there are essential, crucial differences between the figures in Sherman's work and the one which appears in Bayard's sardonic self-portrait. To play oneself, even in a hypothetical condition, is not the same as playing figures which are always-already-fictive. (The case of the *Monica Vitti* type, based on the type-casting of an Antonioni actress, is several steps closer to what Bayard actually does but is by no means precisely the same.) Sherman, unlike Bayard, appears to be enwrapped in a tightly enclosed, self-generating complex from which there is no perceptible egress, a complex whose rigid self-enclosing finds its most ironic commentary in the inherent incompleteness of the stills from which it was made.

Which goes far toward explaining several accepted readings of Sherman's work, typical of which is that in Douglas Crimp's essay "The Photographic Activity of Postmodernism." Crimp worries about questions of presence (in various meanings), performance and representation, arguing for a special kind of presence "effected through absence, through its unbridgeable distance from the original, from even the possibility of an original" (94). That, he argues, is the quality of postmodern photographic presence. Noting the importance of Benjamin's concept of the "aura" in this context (Benjamin, "Reproduction"), Crimp sees not only the depletion of the aura in the art of the 60s and 70s (referring, surely, to Pop and Minimalism) but also more recent attempts to "recuperate the auratic" in "the resurgence of expressionist painting and the triumph of photography-as-art" (96). But postmodern photography subverts this tendency, Crimp argues, by stressing the purloining of images, the unlocatability of the original, the fact that "even the self which might have generated an original is shown to be itself a copy" (98).[7] Crimp refers, inevitably, to Sherrie Levine's appropriations of Edward Weston (and one could add Barbara Kruger to the package). His remarks on Cindy Sherman follow logically from his premises. As Crimp puts it she attacks the idea of "the supposed autonomous and unitary self," showing it to be "nothing other than a discontinuous series of representations, copies, fakes . . . an imaginary construct" (99). The first and last sentences of his paragraph on Sherman are especially useful:

> Sherman's photographs are self-portraits in which she appears in disguise enacting a drama whose particulars are withheld . . . The pose of authorship is dispensed with not only through the mechanical means of making the image, but through the effacement of any continuous, essential persona or even recognizable visage in the scenes depicted.

There is no question that Crimp is correct in much of what he says about Sherman, that her images reveal a great deal about the generating of the subject through public fictions, that her work shows how the possibilities within such generation may well be so restricted that any idea of a Nietzschean-authorial-directorial figure (and therefore of the pure *auteur*) is called seriously into question. Yet that is not by any means the entire story about Sherman, even of her work up to 1980, the time of Crimp's essay, for, as Crimp puts the issues they are as unitary and totalizing, as rigid and categorical, as any of the limiting conditions Sherman ponders in her work. The result is an unconscious, mirroring complicity with authoritarian social structures, one which would lead an Hippolyte Bayard to suspect that the culture has colonized even the criticism which seeks to subvert it. Or at least this version is so colonized. Crimp shows persuasively how Sherman functions within the "directorial" mode she shares with photographers like Duane Michals and Les Krims, but that she craftily, cannily seeks to subvert the mode from within. Something very similar happens with Sherman's relation to work like that of Crimp, and the result of that partial subversion is a deeply felt ambivalence, a rejection of the categorical and an insistence on open-endedness, which get close to the essentials of the postmodern experience.

This is not the place to make a detailed response to Crimp's essay, but an outline can define the general shape it would take. How does one deal with his remark about the negation of authorship "through the mechanical means of making the image"? His point is the same as what some critics have called the "automatism" of the photographic image. That is, the actual making of the image is accomplished mechanically by the camera itself, for once the shutter is triggered a combination of technology and chemistry takes over and does the work. Joel Snyder and Neil Walsh Allen have sketched out the basics of the issue in "Photography, Vision and Representation," quoting from critics like Stanley Cavell and Rudolph Arnheim who make a case for automatism. Snyder and Allen make a strong and plausible case for the rejection of so sweeping an assertion, arguing for the element of choice, the manipulation and selectivity possible to the photographer both before and after the taking of the image. Though one turns over the *taking* of the image to machines and nature one *sets up* the taking and its aftermath so that they are by no means fortuitous but designed to derive full advantage from what is there to be taken. Sherman herself refers often to the extensive preparation,

sometimes taking several days, that goes into the making of her images. To speak exclusively, as Crimp does, of the mechanical aspects of photography is to proffer a totalization that is patently specious. And to say that Sherman "simply chooses [these guises] in the way that any of us do," as though that were all that happens (and as though the choice were "simple"), is only to enforce an unacceptable narrowness, an attempt to reduce a complex body of art to a pre-existent scheme.

Crimp's comments eventually lead us, as most comments on photography do, to the major perennial issue in the very difficult matter of photography and representation. Snyder and Allen quote Arnheim as saying that "the physical objects themselves print their image by means of the optical and chemical action of light" and therefore that photographs have "an authenticity from which painting is barred by birth" (64). Arnheim is especially useful in showing the relation of automatism and what he calls "authenticity." It has often been pointed out that the imaged object in the photograph, whatever its nature, its sobriety or fantasy, its claims for documentation or its denials of such, *has to be there* to be photographed, and that point remains valid whatever happens to the image during the process of bringing it to light. No other art form can (or indeed is willing to) make such a claim, and in making that claim photography has troubled theorists from its earliest days to our own, from Baudelaire to Arnheim and beyond. Snyder and Allen correctly point out, however, that Arnheim is wrong in saying that the objects print their image, because it is the light reflected from the image and refracted through the lens that is the agent in the process (70). To put the matter in a different way that leads further into the central issues, all that is required of the object is its presence to the light and the lens, a presence *which remains where it was* as the light goes about its business. It is only by stressing that leaving-behind that we can avoid the suggestion—the superstition—of a continuation of the object's presence; yet the matter does not end there for that point about light calls in, in its turn, another element in the matter of photography and representation. There is not only the question of the object's requisite *being-there* but the additional, related fact that the image we are viewing was made by light bouncing off an object and affecting an emulsion in such a way as to "fix" the image. Subsequent work with that light brings the image directly to us, the sequence ending at us as light reaches us. Roland Barthes was so intrigued by these points about light that he argued for a special kind of continuum between the viewer and the imaged object, and therefore for

all manner of paradoxes in the nature of the photographic image.[8] Other versions of the issue deal with the idea of the index, which theorists like Rosalind Krauss have shown to be of special moment to the nature of photography. It should be clear by this point that Crimp's comments pick out only one of several threads in an extraordinarily complex weave, and that no single thread in the text/texture of photography can handle all the contours of these issues.

That Sherman recognizes this potential insufficiency is patent from her work, some of which is involved not only in exploring public fictions but in countering what she considers to be fictions of herself, generated by all manner of viewers including some of her astutest critics. In so doing she also counters—toys with, deconstructs—all manner of public attitudes toward photography itself, especially the tendency of viewers from the earliest stages of the art to believe fully in the actuality of what the photograph shows. To "exist" in a photograph, so it has always been felt, is to be true, to be real. One has credence in the image because of the mode in which it is proffered, which means that in this view every photograph is a documentary, photography and credibility going inevitably together. The recent experiments in "Photorealism" play mockingly with this point, the term drawing on a set of assumptions about the nature of photography but also generating a subtext which counters, at every step, what the term seems to imply.

One of the profounder results of Sherman's play with public fictions is a commentary on that veristic reading of photography. Allied to the reading, and actually deriving from its preconceptions, is the view that all her images are ultimately autobiographical, that we are seeing a performance of various aspects of Sherman herself, a series of self-explorations. Impelled by the driving assumptions of photographic verity one probes beyond the dress-ups, compulsively insisting on their autobiographic import because photography, after all, is ultimately true, and the truth one sees in these, beyond all the role-playing, must be the truth of Cindy Sherman. At this point we can get a further sense of the difficult balancing act in Sherman's handling of the viewer. She is especially adept at taking the viewer on as accomplice, for her images, early and late, depend heavily on memory, not only of old films but of images from old tales and even what it looks like to dress for success—a series of given selves, the import of which we do much to fill in. But at the same time Sherman seeks to undo other givens with which we approach her images, not only our radically documentary view of the

photographic image but, what follows from that, what we think it (*and want it*) to document of the photographer herself. There is a sense in which the 1987 show at Metro Pictures, with its pervasive disintegration/fragmentation of personal being, can be seen as a rebuff to such readings of her work, and the various prosthetic devices in the 1985 show can surely be taken the same way. Yet from the beginning of her work Sherman has been undoing the most general version of such readings, undermining what seems like a permanent longing for veracity.

Still, the point I made above about the text/texture of photography holds true in several ways for Sherman's work as well, and not only because they are photographs but because of the way she handles them. No single mode of approach can take in all that she sees at once, all that she senses to be *simultaneously* existent, which generally comes to mean that we can expect an encounter of elements that do not sit comfortably together. Take Douglas Crimp's remark that "the pose of authorship is dispensed with . . .through the effacement of any continuous, essential persona or even recognizable visage in the scenes depicted." The comment about the lack of a recognizable visage is arguable, but we can put it aside for a much more difficult and ambiguous one whose implications we can pick up in one of Crimp's phrases. Isn't the phrase "essential persona" inherently self-contradictory? What can the idea of the persona—a figment, façade, fiction, a mask, role, device—have to do with anything essential, with questions of essence? "Essential" can hardly mean "necessary" in this context since the "necessary" object is lacking. It can only mean "basic" or "radical," having to do with "essentials"; and it is there the problems begin. It seems likely that Crimp, a subtle reader of images, is responding with particular sensitivity to an oxymoronic play in Sherman's handling of her work, an encounter of incompatibles that is one of its radical features and perhaps the commanding one. Take, further, the other sentence by Crimp that I quoted earlier: it says in part that Sherman's photographs are "self-portraits in which she appears in disguise." Given Crimp's expressed ideas about the subject in Sherman as "a discontinuous series of representations, copies, fakes" how can these be portraits of "self," and who is the "she" involved who is behind all these varied appearances? Who is it that is in disguise? To put it in Crimp's own words: if Sherman "simply chooses [these guises] in the way that any of us do," who is the Sherman who does the choosing? If Crimp wants to argue that there is *only* disguise, his language is actually,

doggedly, saying something quite different. Indeed, one could argue that Crimp's language reveals a stubborn residual nostalgia that he cannot quite pack away, and this may be the cause of such patent contradictions. One also could argue that such nostalgia is built into the language and cannot be avoided since we have to use language to talk about these images. (I suspect that both arguments are correct; the second certainly is.)

In either case the ambivalence of these responses is triggered by, responds to, an ambivalence built into the shape of Sherman's art and essential to its nature. One can hear its voice outright in some remarks Sherman made in the interview with Alan Jones. Responding to a question about photography and other arts, she said "a photograph is less of an *icon*. And because it's a photograph you remain aware of an event in *real time*" (Jones, 45). This points directly back to what Barthes spoke of as the sense of having-been-there that every photograph has, and it ties eventually to what Arnheim spoke of as "authenticity." Later in the interview, responding to a question about "the Vito Acconcini self, the Bruce Nauman self" in terms of "the Cindy Sherman self" she said:

> Maybe there *is* no difference. I like the way those people used their bodies. *They* didn't think of themselves as being up there on the wall. They were too concerned with the conceptual aspect of the *any body*. That's what their photographs document. They just happened to use themselves. That's the way I feel about it myself, even though I am under makeup or a wig or a costume. I wouldn't want to have done what they did, though. If I didn't have things to hide behind I'd be more aware of being up there on the wall. (45)

The relation of the last sentence to the rest of Sherman's comment is puzzling only if we refuse to acknowledge her own ambivalence about these issues. It is precisely this tonality to which Crimp and his language are responding, and it is surely a related matter that the structure of selfhood explicit in Sherman's last sentence is precisely the implicit one perceptible in some of the comments of Crimp and other critics.

And there is more. Crimp remarks, quite properly, about the lack of continuity in the persona, that status which leads him, again quite properly, to speak of fragmentation. But if there is no continuity in the look of the images there is an absolute continuity elsewhere within the circumstances of Sherman's art. Though one may reject the idea that the images we see are variations of Cindy Sherman *it is always Cindy Sherman who performs the variations*. It is she who is doing the posing, and whatever

else we have we have an unbroken set of images of her doing exactly that. This is not, however, to argue for any sort of "essentialism" in the photographic image, but indeed for quite the opposite. Whatever presence she had in those acts remains back there with the acts and cannot be carried over in that history of the work of light which so fascinated Barthes. Sherman's comments that in photography, as compared to the other arts, we are more aware of "real time," shows how her sense of the workings of the medium has the profoundest sort of relation to the images she makes out of it. More precisely, it relates to the way she works those images, the stance she takes toward them, the persistence of that posing figure which, whenever we get to it, is always-already-other, always-already the subject of transience. Photographers learned early that figures who move through the field of a long-exposure shot turn out to be barely visible, ghosts in the machine, and perhaps not visible at all, however firm their original stride. It is matters of just that sort which Sherman's work recalls.

For, though Crimp insists that absence is the defining property of post-modern photography it is surely the property of every photograph ever made, as true for Talbot and Stieglitz as for any of our contemporaries. We have seen what Hippolyte Bayard did with the complexities of this issue. We are, in fact, just catching up to him. In every photographic image there is an explicit, emphatic absence, one that is necessarily as intense (the ratio is exact) as the "lost" presence of the object struck by the light. In responding to a photographic image we are responding to a lacuna, its spaces filled with figments whose acts have been well explained by a number of recent theorists. If Sherman is obsessed by the fact of the fragmented figment she is equally obsessed by the irrevocable lacuna, that lack so intense that it cannot put away for a moment the awareness that it is an emptiness; but her stress upon the persistence of herself as performer shows that she sees the vacancy as part of a binary system which cannot help but speak, if only in negative terms, of that lost and unattainable Other whose losing has caused the lacuna. It is to an awareness of such ambiguities in the nature of photography that we must attribute what is still the most striking fact about Sherman's images, their consistent, insistent foregrounding of Sherman-as-model. Whatever the shifting faces there is always the same made-up face. Whatever the shiftiness of the issue of photographic reality and of Sherman's particular bent toward role-playing about role-playing there is a stubborn repetition (theorists of repetition could have a field-day with

Sherman's work) of the figure that speaks of shiftiness, that undoes fellow *auteurs*. That is one of the major impressions left by the Whitney survey of her work, which begins with the publicity-size, black-and-white film stills and goes through her various stages to the massive grotesques and dismemberments. The effect is quite extraordinary and maybe a bit spooky, for that sameness pursues the viewer through all the places where it is not. Were Sherman to use others as models, as she has sometimes suggested she might (e.g. Grundberg, 1987), the change would have to affect every aspect of her work.

What we have, then, is a play of absence and continuity, an odd, anomalous pairing that does not reach its fullest capacity until we add the fragmentation that most viewers have noted, an addition that puts into place an especially complex oxymoron. Despite the unshakeable up-frontness of the figure of Cindy Sherman there is, confronting the viewer, a series of scattered images that owe what coherence they have only to the fact that they form a series. But despite all the fragmentation there is an obsessive continuity that thrusts itself at the viewer in even the space of an interim show and intensifies its pitch as the immersion continues. Though it is clearly the continuity of an absent figure it is, all the same, an absolute continuity, fragmentation's requisite Other. (That it is the stubborn continuity of a necessarily *transient* figure only increases the complexity of Sherman's basic mode.) This encounter of contraries is most likely the basis of that intense underlying emotion which several critics have noticed, a deep, searching anxiety that moves very close to terror.[9] The eeriness in Bayard carries over to this body of work that is clearly so very different and yet so very much the same. What we see in this encounter is the acting out of such feelings, a postmodern morality play, for wherever one touches in that lineup of photographed images one touches at an absence whose existence is intensified by that insistent, obstinate figure which is always just out of reach. To say that Sherman can be scary has very little to do with fairy-tale ogres and most of all to do with the interplay of the elements that make up her world.

And it is precisely that interplay that has the most to say about the status of Sherman's work, its place in the histories of photography and contemporary art. Sherman's appearance in two significant collections of photographer's self-portraits shows not only the continuing refusal of some students of photography to accept her insistence that her work is in no way self-referential but, what is ultimately more important, shows also that what she does has more than occasional forebears (Billeter,

Lingwood). After Bayard there is a continuing history of photographers dressing-up, in everything from chains to near eastern exotica, as everything from volunteers to Christ (see especially Billeter, 101 ff.). Some of the same issues that were to appear in Sherman's work persist all through this history—the play of self and/as text, the business of the *auteur*—but there is no one before Sherman who carried out the play with dress-up to the degree that she does, that is, everywhere and always. This means that nowhere before her postmodern photography has there been precisely this kind of interplay between absence and continuity, with all that it entails. By taking these recurrent practices into postmodern experience Sherman does with the photographic self-portrait what has never been done before but was always potentially there, needing only the appropriate milieu to bring itself forth.

More immediately there is the question of her relation to modernist and late-modernist figures as well as the more general attacks upon Greenbergian modernism/formalism with its criteria of wholeness, coherence, identity and closure. Sherman takes part in those attacks, as all postmodernists do, and one could set her work up against that of a holistic modernist portraitist, Avedon for example, with foreseeable results. More interesting is Sherman's position vis-á-vis portraitists like Sanders and Arbus, both of whom, she says, influenced her ways of working (Grundberg, 1987). One can see the relations of Arbus's grotesques and her images of suburbia to a range of Sherman's work, while the matter of the masterly Sanders is probably a good deal more subtle, having to do with, among other things, the semiotics of role-playing. But Sherman differs from both on at least one point that makes an immense difference: the images of Sanders and Arbus are always of the figures named in the title of the image—the German industrialist, the suburban couple—while Sherman's images not only have no names but have an odd, anomalous status in which words like "fact" or "fiction" have no clear and stable claim. Whatever gaps in the nature of selfhood the images of Sanders and Arbus may show they have none of that special sort of lacunae endemic to Sherman's work, the sort that have made that work some of the most searching in our time. It is perhaps the ultimate irony that these images which draw so much on oxymoronic states not only continue history but subvert it as well. Still, given the radical qualities that pervade Sherman's images, no other way of handling the issue would be more pertinent than that.

NOTES

1. The image is printed occasionally and was shown at an exhibition of photographer's self-portraits at the Museum of Modern Art. It can be found, with the attendant comments, in Newhall, 25. It is also reproduced in Billeter and Lingwood, with useful commentary in the latter (7).

2. I shall be referring to the images by the Metro Picture numbers (preceded by #) as used in the catalogue to the Whitney show (*Cindy Sherman*). I want to thank Metro Pictures not only for permission to reprint the images but for their generous help in supplying me with printed commentary on Sherman.

3. The best study of the fashion photos is Jamey Gambrell's "Marginal Acts." See in particular her comments on the ways in which male and female stereotypes learn to view each other. Gambrell finds in Sherman's images evidence for the way women transfer the male desire to themselves through "a paradoxically narcissistic game in which the self's assimilation of the other's urge to power results in the self's loss of power" (116). For related comments see Craig Owens, "The Discourse of Others: Feminists and Postmodernism."

4. It would be appropriate at this point to recall that the image we are looking at is that of an impersonator who is long since dead. It is perhaps equally pertinent that one of the early functions of photography was to memorialize the dead.

5. In the interview with Lisbet Nilson, Sherman tries, once more among many times, to put the point as plainly as possible: "These are pictures of emotions personified, entirely of themselves with their own presence" (70). To the question whether she considers her pictures self-portraits she answers: "They may be technically, but I don't see these characters as myself. They're like characters from some movie, existing only on film or on the print" (72). With the subsequent question whether, if not self-portraits they are "in some way autobiographical," the exasperation comes through: "They're not at *all* autobiographical" (73).

6. Sherman has spoken often of her early attraction to Antin's work, but in the interview with Paul Taylor she tells of the shift in attitude (78). References to Antin turn up frequently in comments on Sherman's work, and appropriately so. Despite Sherman's demurrals the relation of her work to the performance art of Antin and others like Carolee Schneeman, as well as performance poets like David Antin, opens up a number of major issues in postmodernism. I shall be treating those relations in several subsequent studies.

7. Of course this subversion would have to include, among its victims, the neoexpressionism to which Crimp refers. Yet it is precisely along such lines that the ambiguities of the situation, and especially of Sherman's work, make their appearance, for Sherman turns up as a significant figure in an essay by Michael Brenson in *The New York Times* (January 5, 1986) entitled "Is Neo-Expressionism an Idea whose Time Has Passed?" But the ambiguities extend into Brenson's essay itself: at the beginning he lists Sherman among artists linked to the movement but later he wonders whether she "may or may not be identified with Neo-Expressionism." Brenson's hesitations seem more appropriate to what happens in Sherman's work than the formulaic categorizations to which she is so often subject.

8. His most extended comments are in *Camera Lucida* but they can be found throughout his work.

9. One way of putting this point is shown by Gary Indiana in his review of the 1985 show:

> Sherman's work has always seemed suffused with latent horror of *reduction* (to roles, to appearances); one of its tensions (and conceits) is the artist's/subject's difference from herself, played against the viewer's awareness that "they" . . . are all really "her"—the artist, a larger ironical personality hidden under the makeup, even when there is no makeup.

It is worth remarking that the implicit structure of selfhood seen in the comments of Sherman and Crimp is the same as the one seen here. It can be found in much of the criticism of Sherman's work, which clearly becomes a test case for the ambivalence that is resident in so many contemporary discussions of these issues. Take, for example, these comments from the fine essay by Lisa Phillips in the Whitney catalogue: "Her hall of mirrors, her masquerade conceals her real identity: Cindy Sherman is hidden in her self-exposure" (16).

WORKS CITED

Barthes, Roland. *Camera Lucida*. Trans. Richard Howard. New York: Hill and Wang, 1981.

Benjamin, Walter. "The Work of Art in the Age of Mechanical Reproduction." *Illuminations*. Ed. Hannah Arendt. Trans. Harry Zohn. New York: Schocken Books, 1969. 217–51.

Billeter, Erika, ed. *Self-Portrait in the Age of Photography. Photographers reflecting their own image*. Lausanne: Musée cantonal des Beaux-Arts Lausanne, 1985.

Brenson, Michael. "Is Neo-Expressionism an Idea whose Time Has Passed?" *The New York Times*. January 5, 1986.

Cindy Sherman. New York: Whitney Museum of American Art, 1987.

Crimp, Douglas. "The Photographic Activity of Postmodernism." *October* 15 (1980), 91–101.

Gambrell, Jamey. "Marginal Acts." *Art in America* 72 (March, 1984): 115–18.

Grundberg, Andy. "Cindy Sherman's Dark Fantasies Evoke a Primitive Past." *The New York Times*. October 20, 1985.

———. "The 80s Seen Through a Postmodern Lens." *The New York Times*. July 5, 1987.

Indiana, Gary. "Enigmatic Makeup." *The Village Voice*. October 20, 1985.

Jeffrey, Ian. *Photography. A Concise History*. New York: Oxford University Press, 1981.

Jones, Alan. "Friday the 13th." *NY Talk* (October, 1985), 44–5.

Krauss, Rosalind. "Notes on the Index: Part 1." *The Originality of the Avant-Garde and Other Modernist Myths*. Cambridge, Mass: The MIT Press, 1986. 210–19.

———. "Notes on the Index: Part 2." *The Originality of the Avant-Garde and Other Modernist Myths*. Cambridge, Mass: The MIT Press, 1986. 210–19.

Lingwood, James, ed. *Staging the Self. Self-Portrait Photography 1840s–1980s*. London: National Portrait Gallery, 1987.

Newhall, Beaumont. *The History of Photography*. New York: The Museum of Modern Art, 1982.

Nilson, Lisbet. "Cindy Sherman." *American Photographer* (September, 1983): 70–7.

Owens, Craig. "The Discourse of Others: Feminists and Postmodernism." *The Anti-Aesthetic. Essays on Postmodern Culture*. Ed. Hal Foster. Port Townsend, Washington: Bay Press, 1983.

Phillips, Lisa. "Cindy Sherman's Cindy Shermans." *Cindy Sherman*. New York: Whitney Museum of American Art, 1987. 13–16.

Schjeldahl, Peter. "The Oracle of Images." *Cindy Sherman*. New York: Whitney Museum of American Art, 1987. 7–11.

Snyder, Joel and Neil Walsh Allen. "Photography, Vision and Representation." *Reading into Photography. Selected Essays, 1959–80*. Ed. Thomas F. Barrow, Shelley Armitage and William E. Tydeman. Albuquerque: U of New Mexico Press, 1982. 61–91.

Taylor, Paul. "Cindy Sherman." *Flash Art* (October/November, 1985): 78–9.

8

"Always Two Things Switching": Laurie Anderson's Alterity

Jessica Prinz
The Ohio State University

Voices, slides, videos, films, musical instruments, electronic devices, oral and visual texts—these elements of Laurie Anderson's singular performance style in *United States* (1983) are, in one sense, reassuringly "Modernist." Modernism, after all, has well prepared us for this art of radical fragmentation (Cubism), for the mixing of theatrical elements in a "synthetic theater" (Futurist and Bauhaus performances),[1] for the inclusion of cacophony and noise (Bruitism, and more recently John Cage), the dreamscapes and psychic discontinuity, the games, humor, jokes and farce (Dada and Surrealism),[2] the celebration of new technology and the aesthetic of speed and suddenness (Futurism).

Yet the difference between Anderson's aesthetic and these precursors is important. *United States*, for example, is created under the control and direction of one artist—and, significantly, under the direction of a woman artist[3]—producing a new multi-media performance art that is not the result of a collaboration between "writers," "visual artists," "musicians," "dancers," "composers," all contributing elements from their own circumscribed areas of expertise. As such, the boundaries between artistic disciplines are crossed not only in the artistic product (*Parade* or *Einstein on the Beach*) but in the creative process as well.

Additionally, *United States* participates in and manifests a recent change in the relation of the artist and the audience. No longer determined to antagonize, provoke and otherwise "cancel" its relation to the audience (as in the Satie, Picabia, Duchamp, Clair performance, *Relâche*), contemporary performance artists are determined instead to engage and involve the audience. Anderson's astounding commercial success is the result of her decision to merge high art and popular culture, fine art and mass media techniques (Smith 61).

150

Anderson's popularity can also be seen as an extreme case of more widespread trends in contemporary art. As early as 1969, and in response to the emergence of pop art, Harold Rosenberg observed that "art has entered the media system" (13). More recently, Fredric Jameson has noted that "the line between high art and commercial forms seems increasingly difficult to draw" (112); he continues, "even if contemporary art has all the formal features as the older modernism, it has still shifted its position fundamentally within our culture" (124). The eclecticism which Charles Jencks defines as a distinctive feature of the postmodern style is also, he says, an attempt to "overcome the elitist claim [of modernism] not by abandoning it, but through the expansion of architectonic language in various directions—to the down-to-earth, to the traditional, and to the commercial jargon of the street" (6;8;113).

In Laurie Anderson's work, the language of art "expands in various directions" as well, including the "down-to-earth, the traditional, and the commercial jargon of the street." Indeed language is portrayed as a heteroglossia of conflicting foreign and social languages. This linguistic heteroglossia in turn contributes to the larger multiplicity of Anderson's mixed verbal, visual and musical art. The meaning of Anderson's texts arises from their visual, musical and vocal contexts, the slight intonations, pauses, sound effects that amplify, contradict or ironically deflate what is being said. "I want to be in a power series," she once remarked, "where the general term is an almost insignificant detail—a slight twitch, a repeated phrase" (Sondheim xxiv). Since so much depends on the performance itself, on the vocal delivery of texts, it is impossible to separate the "literary" from the "dramatic," the "visual" from the "aural" in this work. Anderson's textual vignettes are always presented in combination with other art forms (music, dance, photography, video and film) to shape not only an intergeneric but an interdisciplinary art.[4]

Anderson has said, "I . . . try and build [a] piece in certain visual-audio layers so that you can get conflicting bits of information, things that pull at each other" (Smith 61). The piece "Steven Weed" exemplifies the way in which "things pull at each other" within Anderson's work (Fig. 1). As in *Duets on Ice* (1974–5) or *Stereo Decoy* (1977), Anderson is here preoccupied with oppositional movements. In this case the oscillation is between the left and right motions of the head producing the gesture "No," and captured in the Janus-faced, photographic self-portrait included within *Jukebox*. "Steven Weed" expresses Anderson's

Figure 1. *Stereo Song for Steven Weed*, from "Jukebox," 1977. Reprinted by permission of Laurie Anderson.

continuing interest in dialectical motions, back and forth movements, the stereo-effect between opposites: "Most of the work that I do," she said, "is two part stereo . . . so there's always the yes/no, he/she, or whatever pairs I'm working with" (Kardon 19). The most important "stereo effect" within this piece is between two sign systems: the language of gesture ("no") and the meaning of words ("yes"). The wall-text in *Jukebox* (1977) plays out these oppositions visually, by juxtaposing a musical score, a photograph and a text, a combination of media that enacts the multiplication and differences between sign systems which the anecdote itself concerns.

As Roger Copeland says, "Anderson keeps the various media discretely independent, often pitting words and images against one another" (103). "If there is an image and a text," observes Janet Kardon, "there is also a *frisson* between depiction and a voice" (30). Anderson's hybridism sometimes erases, as in the Tape Bow transitions between sounds and words, or the blurring which occurs between text and music,[5] and sometimes preserves (in an active *"frisson"*) the boundaries between the varied artistic media which it incorporates.[6] An unresolved "dialogue" occurs between various sign systems within her work, a

sustained switching between different genres, media and disciplinary tactics.

i

The videotape of *O Superman* (1981)[7] preserves what is most effective in Anderson's performances and constitutes an interesting "artwork" in its own right. It begins with a digital pulse which is eerie itself, and over which Anderson delivers the lyrics in a cadenced rhythm halfway between speech and song. The strangeness is heightened by the image of Anderson herself, punk hair and black leather jacket, with a pillow light that emits a bright red glow from her mouth. Stylized and exaggerated motions of hands and arms play with and against the meanings of words, all the while producing huge shadows which hover over the artist in a sequence of visual messages (Fig. 2).

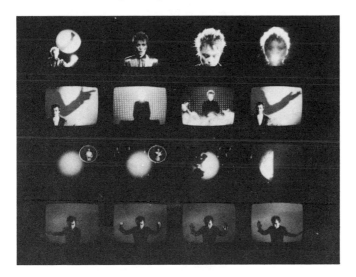

Figure 2. *O Superman*. Images from UNITED STATES by Laurie Anderson. Copyright (c) 1977, 1978, 1979, 1980, 1981, 1982, 1983, 1984 by Laurie Anderson. Reprinted by permission of Harper & Row, Publishers, Inc.

If Anderson's visual effects are uncanny, strange and bizarre, her language in this piece, as elsewhere, is perfectly familiar. ("Hello, this is your mother, are you coming home?"). New verbal combinations, musical juxtapositions and unusual visual contexts bring the most commonplace speech into the foreground; the language which has be-

come "invisible" because so familiar is heard again, as it were, for the first time.

O Superman shows that the entire spectrum of possible relations of the verbal and the visual are explored and exploited within Anderson's work. At times there is a simple translation between one sensory mode and another; the verbal text is translated into sign language, into the language of familiar gestures and into images, as one sign system repeats and echoes another.

—"Come as you are but pay as you go" is accompanied by a pointing hand;

—"This is the hand, the hand that takes," an open palm;

—"Smoking or non-smoking?" suddenly smoke fills the screen;

—"Neither snow nor rain nor gloom of night shall stay these couriers from the swift completion of their appointed rounds." A circle in the upper right corner of the screen shows Anderson looking very Chinese and translating the text into sign language;

—At the word "rounds," a disk spins around;

—"There's always justice . . ." Anderson balances her arms to suggest the scale of justice;

—"There's always force," she makes a fist;

—The recapitulation of musical themes is accompanied by the shadow-play of images from the oral text: the telephone, the cigarette, the flexed arm of "force."

More interesting, however, is the way in which these different sign systems not only translate but vary and modify each other's meanings. "You better get ready, ready to go" is a phrase ordinarily repeated by a mother to a dawdling child. But the shadow-image of the pointed hand distinctly resembles a gun, suggesting that "getting ready to go" may mean to "go" into the armed services, or even to *go*, to die and be killed. Anderson's Chinese costume indicates that her act of signing stands for translations between foreign languages as well. Finally, the spinning disk turns into a spinning earth and then a spinning white globe in which national boundaries are effaced, as they are in the opening shot of the video, in which a white globe subtly "shrinks" before the viewers' gaze. The imagery of *O Superman*, then, adds its aura of humorous literalization to the spoken text, but it also expands the text by placing it within an international or global perspective that sheds light on the ideological dilemma which the piece as a whole presents.[8]

The complex switching between media within Anderson's work is related to the continuous alterity of gender which is sustained vocally

throughout her performances. She said, "In my work I strive for a sort of stereo effect, a pairing of things up against each other and see myself as a sort of moderator between things. Sexuality is one of those things that I'm between" (Kardon 25).[9] Within Anderson's work there is a continuous alternation not only between images and texts, texts and music, but also a continuous alternation between male and female voices. Throughout her performances, Anderson either alters her own voice with electronic devices ("Say Hello"), or presents two speakers (male and female) whose voices alternate in presenting fragmented monologues ("So Happy Birthday," and "New Jersey Turnpike"). The gender oscillations present the sexes themselves in unresolved "dialectical" relations. What Owens calls Anderson's "vocal transvestism" (1985, 60), sets up a continuous binary opposition that fluctuates between male and female without resolution and without priority. In this case, all discourses (male and female, verbal and visual) become "other" (or alter) to each other in a way that undercuts and denies hegemony to any. Situating herself in this way "between" the sexes and the arts, Anderson transgresses both the "laws of genre" and gender.[10]

"The Language of the Future" (*United States*) contains many of Anderson's stock verbal strategies, including the reliance upon subtleties of vocal delivery, the alternations and contradictions of genders, and the satire on conventional modes of talk (for example, the stewardess's controlled delivery in the midst of a plane crash). It includes slang ("chitchat" "wavelength"), slapstick comedy ("Put your hands on your head. Put your hands on your knees! hey-hey"), and abrupt dissociations ("This is your Captain. Have you lost your dog?"). Like many of Anderson's other pieces, it describes eccentric characters ("Three Walking Songs"), or "normal" characters described in odd and eccentric ways. At the center of the piece is a confrontation of different and differing languages: "I realized she was speaking an entirely different language. Computerese."

Most importantly, "The Language of the Future" exploits all of the dialectical oppositions of gender and genre in Anderson's work and it extends them even further. In addition to alternations between genders, there are also continued alternations between language and sounds, and between sounds and silence (electronic beeps). The piece is, in effect, *about* the alterity it enacts. Male and female, culture and nature, text and music, the language of the self and the language of the other, the language of the future and the language of the past are all presented as

sustained dialectical opposites, like the switching of electronic or digital devices ("on and off"), sexual "currents" ("on again, off again"), and finally like the switching from life to death itself ("current runs through bodies and then it doesn't"). Given the cadenced rhythms, the anaphora, the repetitions in the conclusion, one might even argue that the piece "switches" from prose to poetry as well:

> Always two things
> switching.
> Current runs through bodies
> and then it doesn't.
> It was a language of sounds,
> of noise,
> of switching,
> of signals.
> It was the language of the rabbit,
> the caribou,
> the penguin,
> the beaver.
> A language of the past.
> Current runs through bodies
> and then it doesn't.
> On again.
> Off again.
> Always two things
> switching.
> One thing instantly replaces
> another.

Anderson has transformed a (perhaps personal) story about an imminent plane crash into a verbal artifact with wide social appeal. "The Language of the Future" concerns both social and personal experiences of "future shock," the confrontation of our society with new technologies and their languages, which parallels at the level of society the "future shock" each individual experiences when confronting the reality of his or her own death. Anderson's comic nightmare preserves a paradoxical tension between social satire and a sense of personal terror, a continuous "switching" not only between kinds of discourses, genres, and media, but also a "switching" between personal and social experience.

ii

Anderson's work includes language as one component of a multifarious art, but it also concerns language, how we think about language and use it. One way, in fact, to come to terms with the relation of Anderson's art to that of her modern predecessors is to note her ambivalent attitudes toward language and the complexity of her linguistic uses. Anderson's art includes all of the linguistic pessimism traditionally associated with modernism (Sheppard 323–326). Assaulted as vigorously as in Dadaism or in Futurism, words frequently collapse into pure noise, garbled signals, high pitched squeaks, and electronic sounds. Anderson's innovative technological devices, the tape bow violin, for instance, or the "Door and Wall Songs," actively transform spoken phrases into dissociated sound in a way that parallels the disintegrating effect of Duchamp's *Anemic Cinema* upon language. "I'm very suspicious of language," Anderson said in one interview, "it's so slippery, so slippery to seize."[11]

At the same time, a pervasive desire for communication can be traced throughout Anderson's art. While her work describes semantic and semiotic breakdowns and contains numerous parables of failed communication, as Craig Owens observes (1983, 53), it also expresses the artist's own desire to communicate. "I feel a personal responsibility to communicate," she says, "not to make art that's so coded that people can't receive it."[12] Thus much of Anderson's language is just plain, straightforward talk, everyday colloquial speech turned to the task of storytelling. "I think of the work that I do as the most ancient in the world: storytelling," she says (Jarmusch 130), and her stories are told in the vernacular languages which her audiences speak. "The key to her American vision," writes one commentator, "is language and a vocabulary rooted in ordinary everyday speech" (WGF). Neither Duchamp nor Marinetti would ever have said, as Anderson has, that "the most important thing is that people learn to talk to each other" (La Frenais 269). Nor would they have used the slangy, straightforward, even prosaic language with which she constructs her narrative vignettes.

In "Language is a Virus from Outer Space," Anderson presents a spoof on language theories, satirizing, parodying and poking fun at different views of language. In this piece, a "rock and roll riff" links a series of monologues spoken by Anderson in varied tones of voice. She playfully pokes fun at an obtuse and naive view of language: "You know I don't

believe there's such a thing as the Japanese language . . . the sounds just
synch up with their lips." The absurd and nightmarish vision of electro-
nics salesmen (who sing, "Phase Lock Loop, Neurological Bonding") is a
comic caricature of theorists, like Marshall McLuhan, who welcome the
electronic advances which will effectively short-circuit language (McLu-
han 123). Not thrilled by these possibilities offered by "Big Science and
Little Men," Anderson's answer is an emphatic "NO": "You gotta count
me out."

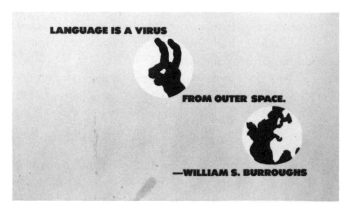

Figure 3. *Language is a Virus from Outer Space.* Image from UNITED STATES
by Laurie Anderson. Copyright (c) 1977, 1978, 1979, 1980, 1981, 1982,
1983, 1984 by Laurie Anderson. By permission of Harper & Row, Publishers,
Inc.

"Language is a Virus" also alludes to Wittgenstein in a variety of
ways. Many of the arguments in *Philosophical Investigations* (concerning
skepticism, solipsism, and forms of life) turn on the issue of whether or
not we can know someone else is in pain; the "forms of life" argument,
for instance, leads Wittgenstein to conclude, "If I see someone writhing
in pain with evident cause, I do not think: all the same his feelings are
hidden from me" (223). His picture puzzle of the rabbit-duck is pre-
sented as a huge shadow behind Anderson on the screen (Kardon 27), as
she subjects the theory to a parodic distortion, a conscious impropriety.
"And Geraldine said: You know, I think he's in some kind of *pain* . . . I
think it's a pain cry. And I said: If that's a pain cry, then language . . . is
a virus . . . from outer space." The crossing of rock and roll and language
philosophy mixes cultural codes in a way that is at once humorous and
disturbing, producing a travesty directed not only at specific theories of
language but social and cultural categories in general. Anderson's song

bears out Jencks's observation that the postmodern is organized like "a traffic accident or collision . . . more Schwitters's Merz than a cubist collage" (118).

Throughout "Language is a Virus" Anderson translates language theories into parodic and dramatic vignettes, complete with eccentric character-types, each with his or her own verbal style. This is no less true of the theory with which she is perhaps most sympathetic, Burroughs's notion of the parasitic economy of language described by him in *The Job*. "My basic theory," says Burroughs, "is that the written word was actually a virus that made the spoken word possible. The word has not been recognized as a virus because it has achieved a state of stable symbiosis with the host . . ." (12). This parasitic relation of virus/language and host/man is comically presented by Anderson as a guest/host relation in which the guest "eats all the grapes" and "takes the wallpaper samples," made even more bizarre by Anderson's use of electronic devices to lower her voice an octave: "I came home today, and I opened the door with my bare hands. . . ."

Anderson's allusions to varied theories of language exemplify the conceptualist biases of her work. [13] At the same time, her use of theory is not as analytic, say, as Joseph Kosuth's, nor would she want it to be. Indeed, in *The Visitors* she directs some of her most pointed criticism at a conceptual artist who is more intent on proving some linguistic theory than in actually communicating.

Similarly, in "Language is a Virus," Anderson mocks language theory in order to make a theoretical point. Throughout the song, she is rigorously, if humorously, exploring the effect of language upon people and their social relations. All of the vignettes in the song—and this is the crucial point—deal with the social dimension of language in some way. The McLuhanites err by willingly dispensing with language in favor of a trans-linguistic consciousness or electronic hook-up. At the other extreme from an electronically unified sociality is the isolated individual talking in a void: "So I went to the park and I sat down and I said: Boy is this fun. I'm really having fun now. . . ." This speaker empties language of meaning, making a mockery not only of individual words, like "fun," but also the social dimension of language in general. Although not attempting to generate a private language, the character is nevertheless using language privately; because of Anderson's controlled inflections and pointed repetitions, this solitary speech seems equally ludicrous in this case. We might recall that one of Wittgenstein's major themes in

Philosophical Investigations is the conventional nature of linguistic meaning, that the meaning of a word (like "pain" or "fun") does not arise from any interior feeling (although the feeling may be real enough); rather, the meaning of the word derives from its use in a given culture with conventions of language and behavior and coherent patterns of natural fact. For Wittgenstein, the emphasis is always on the relation of words to their use in a society rather than to some interior or private feeling. [14]

But the social dimension of language is also a double-edged sword: the same shared conventions and conceptual/linguistic schema which enable communication can also become "pictures which hold us captive." Indeed Burroughs's view of language overlaps with Wittgenstein's theory at precisely this point. What Wittgenstein calls a "false picture," Burroughs calls a "word-lock" and both cite the theory of the labeling function of words as a prime example of a linguistic formula or "picture" which can "lock up a whole civilization for a thousand years" (Burroughs 1974, 49; Wittgenstein BB 69). [15] Burroughs's enterprise as a whole can be viewed as an effort to assault conventional "word-locks" and culturally defined "association blocks," a project which parallels in its own way, the destabilization of linguistic and conceptual conventions within *Philosophical Investigations* (Fig. 3). [16]

But for Burroughs and for Anderson, this is not a philosophical so much as a socio-ideological activity. Burroughs says, "The word of course is one of the most powerful instruments of control . . . Now if you start cutting these up and rearranging them you are breaking down the control system" (33). The fact that Anderson's "Language is a Virus" appears in the second section of *United States*, the political section, [17] suggests her sympathy with what might be called Burroughs's project of linguistic and ideological decentralization. [18] Anderson's art, like Burroughs's, involves the use of creative techniques for allowing artists to dissociate, to manipulate, and hence gain more personal control over language, a language that would otherwise "control" them ("a virus"). Both the motive and the method of this artistic practice are closely tied to Dadaism, because there is an effort in all cases to "cut up" and dismantle prevailing socio-linguistic conventions. In Anderson's art, however, the disengagement of language is always paradoxically doubled, for she sustains an interest in everyday language even as she assaults it, and her art produces a sense of shared "forms of life" even though she satirically mocks them.

Anderson met Burroughs in 1978 (Marincola 66), and in 1981, she

performed alongside him and poet John Giorno in Los Angeles (Hicks 4). His name appears conspicuously on the screen in her performances of "Language is a Virus From Outer Space." In what is really a very poignant image, Burroughs tangos through one scene with Anderson in *Home of the Brave*. He narrates the "flipside" ("Sharkey's Night") of Anderson's "Sharkey's Day." One line included in Burroughs's narration (which does not appear in Anderson's text) goes: "Hey Kemosabe! You connect the dots . . . You pick up the pieces." It is a fitting conclusion (or introduction) to Anderson's work in general, because it calls attention to the way her work employs Burroughs's cut-up method and comes to the audience in "pieces." The cut-up method is applied across media to her texts, music, and images, all of which themselves become fragmented elements of a dynamic, multimedia collage.

In many of Anderson's most important pieces ("O Superman," "So Happy Birthday") the cut-up method is combined with a related and yet more contemporary creative procedure initiated by Burroughs: "playback." Burroughs maintains that the only way to counter the playback techniques that are used by others (personally and politically) to control us, is through "counterrecording" and "playback," a procedure of repetition, manipulation and purposeful distortion used as a tool of analysis and aggression. The camera can be used to play back images, as in Anderson's *Object/Objection/Objectivity*, or the taperecorder to play back language, as Burroughs describes in "The Invisible Generation" (160).

Burroughs's "playback" finds some striking parallels and ingenious variations in Anderson's original uses of tape and recording devices. Since the late seventies, her performances have included audio palindromes (or "word droppellers") created with the tape bow violin, a "prepared" instrument,[19] used to manipulate taped words (Goldberg 112; Kardon 17). The tape bow modulates between nonsense and sense, and then multiplies meanings as hidden sounds and new words emerge. Conventional phrases ("Say what you mean, and mean what you say") are distorted and dismantled, their sounds and their meanings complicated to suggest that they are not really as simple as they seem.

Playback is also used in Anderson's installations; in the pseudo-phone booth *Numbers Runner* (1978), listeners become speakers and then listeners again, as they are forced to confront the words that they themselves utter. The "Door Mat Love Song" plays back a familiar cliché: as a door is opened and closed by the viewer, an audio-head travels over a tape

embedded in a doormat, producing a pointed visual pun and enough verbal dissociation to ironically deflate the cliché, "You always hurt the one you love."

"I use a lot of slogans," Anderson once said, but "they are suspicious. Clichés and slogans come from a cooperative, general consensus on the world."[20] Within Anderson's art, familiar clichés function in conflicting, even contradictory ways. Although commonplace jargon, clichés, and slang allow her to communicate with her audience in a shared language, they also enable Anderson to comment critically upon the values and forms of life which that language describes and embodies. The same clichés of popular culture and mass media through which she establishes rapport with the audience are also cut up and used in playback processes, allowing her to disengage from the "cooperative, general consensus on the world," and at the very least call our attention to it.

Parody is itself a kind of playback technique, one that "reruns" or "reprocesses" another's speech with ironic and mocking distortions. It is a central stylistic strategy within *United States*, where fragments of political rhetoric ("Odd Objects"), commercial jargon ("The Visitors"), the language of cartoons ("Yankee See"), street signs ("New Jersey Turnpike"), national slogans, and popular songs are all played back and subtly mocked in new verbal and visual contexts:

> Deep in the heart of darkest America, Home of the Brave
> Ha Ha Ha . . . You've already paid for this. . . .
>
> ("Sharkey's Day")
>
> Honey you're my one and only.
> So pay me what you owe me. ("Example #22")

If Anderson pokes fun at social forms and institutions, she nevertheless directs her satire *through* the languages that people speak: the "two syllables: tops!" of TV ("Talkshow"), or the lingo of cowboy movies ("Big Science"), or the voice of the mystical prophet, Dr. J., echoed and satirized in the "prophetic" voice of her sound engineer. Just as the verbal styles of individual speakers are parodied, so are the conventional performance modes of our culture—TV, lectures, sermons. Their verbal styles are replayed and "rerun" within her work ("Talkshow," "Big Science," "Healing Horn"), as are the verbal performance modes of other cultures ("Hey Ah"). In addition, Anderson's own performance texts are parodically reprocessed in what might be called a "meta-performative" mode: "*Hey* . . . are you talking to me . . . or are you just practicing for

one of those performances of yours?" "Language is a Virus" concludes with a crescendo of music during which an alphabetical sequence of slang phrases is flashed in rapid-fire succession upon the screen, ("T Shirt U Boat V Sign W WII X Ray Y Me"), parodying the kind of "two syllables tops!" that enter commonplace writing and everyday speech. Parody is in general a "parasitic" use of language, and hence especially appropriate for an art that presents language as a "virus."

Anderson's use of language is thus paradoxically doubled: we find both the impetus to parodically deflate and systematically disintegrate language *and* the determination to celebrate the variety and complexity of ordinary speech. One of Anderson's own slogans is "Talk Normal," a phrase that reflects back on her own verbal style and the attention it pays to commonplace speech rhythms, idiosyncrasies, slang, and slippage. The conventions of everyday talk are re-presented and rerun with slight distortions, twists, deformations, so that we "wake up" not only to the very life we're living, as John Cage would say (12), but also to the language that we speak and hear.

Anderson's slogan "Talk Normal," however, is also subtly mocked, for her work vividly portrays the diversity of normative discourses. Craig Owens aptly observes that in Anderson's work, "language no longer exists; there are only languages, a multiplicity of different codes, dialects, idioms and technical jargons" (1983, 51). Despite the directness of Anderson's prose style, then, with its realistic portrayals of ordinary speech, her use of language is anything but simple and uncomplicated. In *United States* we hear a multitude of conflicting, overlapping, familiar and altogether mysterious voices: the voice, for example, of political authority ("Odd Objects"), the businessman ("The Stranger"), the movies' clichéd cowboys and college students ("Big Science"), Yuppies ("New York Social Life"), and a plethora of different "average citizens" ("So Happy Birthday," "New Jersey Turnpike"). Anderson's fragments of speech represent differing and different points of view on the world, whole sets of social beliefs, values and cultural experiences that are juxtaposed—without their differences, tensions, and conflicts with one another resolved in any way.

While Craig Owens is correct in pointing to communications technology as the source for much of the "intersubjective deafness" that we witness throughout Anderson's work,[21] many of the failures of communication outlined within her art arise from language itself, from the multiplicity of national and social languages and the differences among

them. In one comic anecdote, from "New Jersey Turnpike," a whole complex network of social experience is brought to bear on the simple word "grits":

> I know this English guy who was driving around down in the South. And he stopped for breakfast one morning somewhere in Southeast Georgia. He saw "grits" on the menu. He'd never heard of grits. So he asked the waitress, "What are grits anyway?" She said, "Grits are fifty." He said, "But what are they?" She said, "They're extra." He said, "Yes, I'll have the grits, please."

Here two different speakers and two different language systems collide, or slide past each other.[22] Like these, all of the voices in *United States* speak foreign languages ("Voices on Tape") or separate cultural languages that are foreign to one another. There is always an active tension between heterogeneous languages and verbo-semantic points of view, a continuous confrontation of different conceptual horizons.

The miscommunications that fill Anderson's work are expressed structurally by the strange manipulation of dialogue which occurs throughout *United States*. Despite the emphasis upon realistic speech patterns and styles, very few (if any) actual dialogues occur within this work. If people are portrayed primarily, even exclusively as speakers, these speakers rarely, if ever, speak to each other. Dialogues are often described but never enacted in the monologues which comprise *United States*. The alternating rhythm of conversation is maintained by the two speakers of "So Happy Birthday" or "New Jersey Turnpike," but rather than talking to each other, the actors deliver a series of fragmented monologues in varied voices. The fact that the "dialogues," say, of "New York Social Life" are presented by Anderson herself in monologue form, just adds one more level of irony to this already ironic portrayal of contemporary "talk."

Within *United States* Anderson continuously gives voice to languages that are "other" to her. That she articulates or ventriloquizes "alien" discourses, emphasizes her view of language in general as something alien, from the outside, "from outer space." According to Bakhtin, however, this confrontation with alien discourses is an essential and inescapable fact of human linguistic experience:

> It is not, after all, out of a dictionary that the speaker gets his words! . . . but rather [the word] exists in other people's mouths, in other people's contexts, serving other people's intentions: it is from there that one must take the word, and make it one's own. (294)

For Bakhtin this encounter with the discourses of others is the basis for nothing less than ideological consciousness itself (295; 345–8). An author's objective is not so much to take an ideological position (although he/she might, as he says, be biased, 314), but through heteroglossia to foreground the alternative choices involved in selecting a language or ideology of one's own.

Anderson's *O Superman*, I think, sustains just such verbo-ideological tensions in an "unresolved dialogism." In addition to being a hybrid artistic form, it is also a "semantic hybrid" in which a number of different socio-linguistic perspectives "fight it out on the territory of the utterance" (Bakhtin 360).[23] Varied socio-ideological systems are condensed into brief utterances[24]—"Smoking or non-smoking?" "Look! They're American planes, made in America," "This is the hand, the hand that takes"—which are juxtaposed without being resolved. Brief fragments of speech not only come from but also represent widely divergent social, political, and axiological systems. Anderson positions herself amidst these conflicting verbal messages, ostensibly left on her tape machine, and she attempts to locate their sources ("OK—Who is this really?") and to locate her own position in relation to them. Like the fictional situation which it describes, *O Superman* actually does "play back" diverse and contradictory ideological messages.

What we witness in *O Superman*, and in *United States* as a whole, is ideology as process: "consciousness awakens to independent ideological life," says Bakhtin, "precisely in a world of alien discourses . . . A variety of alien voices enter into the struggle for influence within an individual's consciousness (just as they struggle with one another in the surrounding social reality)" (345;8;341). Anderson's work presents precisely this intense struggle with "alien languages," languages and attitudes about language that "pull at each other" in oppositional ways.

iii

The voice is an appropriate medium for this art of unresolved dialogical relations between languages, ideologies, sexes, and media, for as Regis Durand says,

The voice goes back and forth: a go-between, an intermediary. A transmitter that makes dual, dialectical relations possible, on all levels . . . In-between, because it can only be defined as the relationship, the distance, the articula-

tion between subject and object, the object and the Other, the subject and the Other. (102)[25]

This exploration of voice, moreover, links Anderson's work to prevailing trends in contemporary literature. All of the voices in *United States* are cut off from their sources, disengaged from characters and characterization in a way that parallels major trends in contemporary fiction described by Barthes as follows:

> By bringing the whole narrative down to the sole instance of the discourse—or, if one prefers to the locutionary act—it is the very content of the person which is threatened: the psychological person . . . bears no relation to the linguistic person, the latter never defined by states of mind, intentions or traits of character but only by its (coded) place in discourse. It is this formal person that writers today are attempting to speak and such an attempt represents an important subversion. . . . ("Structural Analysis of Narratives," 113–4)

In *United States*, Anderson does not use language to generate characters or to represent people; indeed the reverse is the case, her "people" are simply voices who stand for and represent different kinds of language.

In this respect Anderson's *United States* is comparable to other examples of contemporary literature—David Antin's talk poems, Nathalie Sarraute's *The Use of Speech* or Sam Shepard's *Tongues*—in which the linguistic person replaces the psychological one,[26] in which characters stand for modes of discourse. In Antin's "Tuning," and Sarraute's *The Use of Speech*, as in Anderson's *United States*, there is an emphasis upon language barriers, an inability of speakers to communicate across national or axiological boundaries. Speech is foregrounded in the prose monologues of Sarraute, as it is in the performance modes of Anderson, Antin and Shepard. Anderson, like Shepard, combines verbal with "musical" forms and presents a variety of different social voices edged next to each other. In all of these cases, human speech predominates. Ironically, however, the mode of presentation is monologic, and serves as a fitting commentary on the limits of dialogue that is one thematic element of these very distinct works. Everyday and commonplace "talk," ordinary language, is a dominant aspect of their verbal style. If the authors all draw limits on the range of possibilities for communication and share to some extent modernism's linguistic pessimism, they nevertheless take everyday language as a basis for a literary style, a style that moves through the most prosaic of discourses to language loaded with poetic

power. All of these works "have to do with the voice . . . Voices
travelling. Voices becoming other voices" (Shepard 300). These works,
all of which toy with the relation of dialogue and monologue, all of which
skew the boundaries of the disciplines in which they appear, and all of
which employ simple and accessible words in prosaic, everyday lan-
guage, all present language as voice, as "discourse," as a "social phe-
nomenon—social throughout its entire range and in each and every of its
factors" (Bakhtin 259). "The voice is [presented as] an in-between . . .
the distance, the articulation between subject and object . . . the subject
and the Other."

Moreover, in *United States* the voice purposely confuses the self and the
Other, for the real sources of speech are always uncertain; we hear "their"
words in Anderson's mouth, "her" words in "theirs," without ever,
finally, being able to disentangle them from one another. When An-
derson's self-referencing and self-revelation seem to be the strongest, as
in "Language of the Future" or "Yankee See," she alters her voice into the
lower registers of the male speaker. The use of "actors" and electronic
devices facilitate these strategies of self-diffraction, the multiplication
and confusion of "vocal selves."[27] This diffraction and decentering of the
"self" parallels the decentering of artistic modes and categories and, as
Hal Foster maintains, both are characteristic features of postmodernism
in the arts (130).

The social dimension of Anderson's work, then, is expressed not
merely in its popularity, but also in the attention paid to the social
dimension and dynamics of language. The preoccupation with voice
itself emphasizes the "exterior deployment"[28] of language, and the art's
purposeful confusion between the voice of the self and the voice of the
other, the story of the self and the story of others further confuses and
binds the self and society.[29] In addition, the artist's use of dreams and
dream processes can be related to the confusion of self and other, the
"switching" between personal and social experience which occurs
throughout *United States*.

A dream style pervades Anderson's work as a whole. There is a
continuous distortion of physical sizes, from the miniature figure of *At
the Shrink's* to the gigantic images Anderson presents on the film screen.
A surrealistic style is further created by the continuous displacement of
ordinary functions of objects, the body used as a percussive instrument,
the violin bow used as a pointer, a neon light, a record player (Viophono-
graph), a "bow" and arrow ("It's Not the Bullet"). "Sharkey's Day"

begins "Sharkey wakes up and Sharkey says, if only I could remember these dreams, strange dreams, I know they're trying to tell me something." *United States* also "reruns" dream-texts from *Dark Dogs: American Dreams*, cut up and expressed by different voices in new and unusual contexts ("Big Science," "Lighting Out for the Territories"). Anderson's reprocessing and replaying of texts is itself related to dreaming, which reruns the familiar with bizarre and strange distortions. One sequence in *United States* reruns narratives from *Dark Dogs: American Dreams* intercut with images that link the textual style to dreaming: the word "RERUN" is superimposed over a gigantic pillow. This technique also accentuates and heightens the ambiguity concerning the sources of Anderson's texts. We never know whether the dreams were told to Anderson by other people, or if they were Anderson's dreams or Anderson's fictions. Finally, *United States* as a whole concludes with a rerun of the opening sequence "Say Hello" in which Anderson, now wearing bizarre headlight goggles (Fig. 4) adds a new line: "You can do this in your sleep."

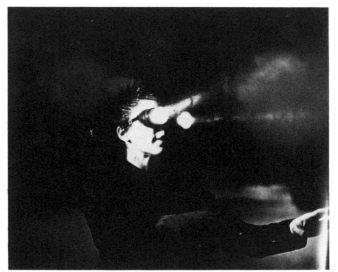

Figure 4. *Lighting Out for the Territories*. Photograph by Allan Tannenbaum. Reprinted by permission of Allan Tannenbaum.

In his essay "Painting and *Surrealism and Painting*," Marcelin Pleynet criticizes surrealism for not responding responsibly enough to Freudian theories. He quotes Freud's answer to Breton: "A collection of dreams, *without their associations and without knowledge of the circumstances* in which they took place, means absolutely nothing to me" (44). Anderson's work

is thus very much in the surrealistic tradition, especially since it presents a collection of dreams "without their associations and without knowledge of the circumstances in which they took place." We might well ask what purposes the dreams serve, since they are presented by Anderson not only without their associations but without clear human sources as well.

One might argue that *United States* presents unconscious material not as intrapsychic but interpersonal. Dream texts are wrested from individual people and diffracted and refracted by different voices. At the same time, dreams themselves are comprised of pop culture's banalities (Dairy Queen), stars (Jerry Lewis, Jane Fonda), personalities (Hitchcock), rhetoric ("democratic") and jargons ("structuralist filmmaker"). In *United States* cultural debris litters the psychic landscape. Because of the way it manipulates and confuses popular culture and personal dream, Anderson's work might be viewed in relation to the social dimension of the unconscious proposed in Lacan's theories.[30] Within Anderson's work, dreams are presented not by a singular personality but through a social fabric comprised of different speakers. With its overtly surrealistic style, *United States* as a whole becomes a kind of dream, ("you can do this in your sleep"), a shifting, violently comic *collective* dream filled with distortions and displacements, ellipses and ambiguities.

Thus Anderson's is a predominantly social art, social in much more profound ways than the obvious shift of the artist toward the audience as entertainer. Her art reflects larger cultural trends and finds parallels in those contemporary theories that are also rethinking the social dynamics of language (as "discourse," for instance, in Benveniste, Bakhtin and Kristeva)[31] and the social dimension of the unconscious as well (Lacan). Anderson's work marks a renewed commercialism in art. But it also paradoxically suggests that there is an ethical component to this postmodern style: the continuous oscillations and confusions of languages, codes, and media counter verbal, visual, or sexual hierarchies, precluding any hegemonic relation among the sexes and the arts. The heterogeneity of such a style, and its heteroglossia, does not assume a commonality of languages or values, but it does speak many languages, and therefore speaks to many people in a democratic impulse of some significance in the development of the arts. The new avant-garde is intent, as Umberto Eco says, on "reaching a vast audience . . . capturing readers' dreams." And this, he continues, "does not necessarily mean encouraging escape; it can also mean haunting them" (72).

NOTES

1. The term refers to any hybrid art form and in particular to Marinetti's "Synthetic Theater" described in his manifesto of *Futurist Synthetic Theatre*, 1915 (see Goldberg 19).

2. See Kubisch (17) and Kardon (7) for references to the "Duchampian influence" in Anderson's art. Interestingly enough, one of the more chaotic dada performances included Janco playing an invisible violin (Goldberg 40). Anderson's own miming of violin playing is predominantly a form of self-parody, yet it also shows her allegiance to Dadaist playfulness in the mixing of "artistic" forms.

3. Craig Owens and Hal Foster argue that *United States* presents a critique of phallocentrism (Owens 1983), a "decentering of the masculine subject of representation" (Foster 132). On the relation of performance to the rise of feminism, see Goldberg (113–4).

4. "*United States*," she has said, "is really an equal combination between pictures and words and sound" (Smith 61).

5. See John Rockwell's excellent discussion of Anderson as a text-sound composer.

6. Anderson's work bears out Mitchell's observation that hybridism preserves rather than erases the differences between the verbal and the visual, image and text (55).

7. I would like to thank the Video Library of Warner Bros. Studios for allowing me to borrow this tape.

8. According to Flood, *O Superman* "concludes with a matriarchal embrace as crushing as the one Athena inflicted on Laocoön" (80). It is a "viciously ironic paean to a superpower," says Owens (1981. 123). According to Goldberg, it is "an appeal for help" (1984, 87).

9. See Owens (1983) on Anderson's transvestism, which as he says, "is a matter of signs, language" (51).

10. See Derrida, "The Law of Genre." See also W.J.T. Mitchell's recent and seminal *Iconology*, which traces the history of the text-image relation and argues against the long tradition of privileging one artistic mode at the expense of another. His study reveals that artistic and sexual categories have been associated with each other by numerous theorists, primarily as a technique for justifying some hegemonic relation between the arts (109; 55).

11. From the videotaped interview with Laurie Anderson shown at the retrospective, "Laurie Anderson, Mid-Career." Frederick S. Wight Gallery, UCLA, Jan. 31–Mar. 4, 1984.

12. Quoted from the Wight Gallery Flier for "Laurie Anderson: Mid-Career." Henceforth cited as WGF.

13. See Goldberg for an excellent discussion of the relation of performance and conceptual art (1984, 170–73).

14. This view of language, and its emphasis on the conventional and cultural basis of meaning, is itself a cultural "convention" which typifies our time. See Barthes, for example, in "The Photographic Message" (27).

15. Burroughs refers to Wittgenstein in *The Job* (168). Anderson's reading of Wittgenstein is listed in the official chronology by Marincola (Kardon 63).

16. See Staten, 75.

17. Each section of *United States* has a thematic focus and a particular directional movement: Part I, Transportation (left to right motions, the arc or metronome); Part II, Politics (vertical movements suggesting social mobility and hierarchies); Part III, Money (the movement is toward the audience, parodying the extended hand); Part IV, Love (crossing axes, intersections). See Kardon (22).

18. See Burroughs (56). In one interview Anderson states that she was very influenced

by Burroughs's politics, "and also in terms of style, his absolute precision . . . he's just not sloppy . . ." (La Frenais 255–259).

19. The novelty of this manipulation of a musical instrument recalls Cage's "prepared piano." Anderson's art is indebted in many additional ways to Cage's aesthetic: the use of dissonance and noise for "musical" purposes, the confusion of artistic categories, the understated humor and ironic twists of Cage's Zen stories, the cut-up used for musical composition, and the use of performance strategies.

20. Quoted from the videotaped interview (Wight Gallery, UCLA, 1984).

21. "My work," she says, "is about what happens when you pick up the phone and try to get through" (La Frenais 264). But Anderson is really more ambivalent about technology than Owens's article suggests. In a recent interview with Charles Amirkhanian, she said, "It's true that even though I've been very very critical of technology in terms of what I say, I find that I make those criticisms through 15,000 watts of power and lots of electronics. And that says a couple of things at least, that I hate it and love it" (See Amirkhanian, 220). For an excellent discussion of Anderson and postmodern space, see Herman Rapaport's " 'Can You Say Hello?' Laurie Anderson's *United States*." Here, too, I would argue that Anderson is essentially ambivalent about postmodern travel and transit. I think her work suggests that she both loves *and* hates crossing postmodern surfaces and states; she is simultaneously critical and celebratory of "Americans on the Move."

22. Anderson's use of popular genres (musical and verbal), her comic situations, jokes and one-liners, all belie her sensitivity to language. We might recall that Bakhtin's theory arose from his study of comic writers (Rabelais, Cervantes, Dickens), and that heteroglossia, as he repeatedly emphasizes, finds its proper home in the "low" and popular genres, on the itinerant stage, in street songs and anecdotes, "in the satiric-realistic folk novella and other low parodic genres associated with jokesters" (273; 400–401). Bakhtin seems to have been unaware that heteroglossia, the mixing of voices in multi-languagedness, was the prevailing mode of modernism in Anglo-American poetry (e.g., *The Cantos*). It is important to remember that even though Bakhtin uses "heteroglossia" to distinguish between poetry and prose (mistakenly I believe), he gives priority to the novel precisely because (in his view) it is capable of greater generic complexity; it can accommodate all verbal genres, including, above all, extraliterary discourses (320–1).

23. A "semantic hybrid," as Bakhtin defines it, is one utterance that contains two speech manners or styles, two languages, two semantic and axiological belief systems" (304). "The main and sub clauses are constructed in different semantic and axiological conceptual systems " (306). The last section of *O Superman* is a "semantic hybrid," but the piece as a whole might (more loosely) be considered one as well.

24. What Bakhtin would call "ideologemes."

25. Marguerite Duras's experimentations with voice inspire Durand's discussion here, but the quotation seems fitting for Anderson's use of voice as well.

26. On the "futile talk rituals" of Antin's poetry, and the subordination of characterization to language by him, see Perloff (*The Poetics of Indeterminacy*, especially p. 332).

27. Interviewing Anderson, Michael Dare asked if she was surprised at being a pop star. She replied, "When I think of myself, I think of my role in my work. I'm a narrator, or maybe a ventriloquist. Being pop is about consolidating, about going 'I'm me; I have a certain attitude,' rather than chopping myself up. I prefer to chop myself up" (9).

28. "The writing of our day," says Foucault, "has freed itself from the necessity of 'expression': it only refers to itself, yet it is not restricted to the confines of interiority. On

the contrary, we recognize it in its exterior deployment." And he continues in a note, "the 'exterior deployment' of writing relates to Ferdinand de Saussure's emphasis on the acoustic quality of the signifier, an external phenomenon of speech . . ." (116).

29. See Kardon, 19.

30. See Eagleton, 173. For a more extensive description of Lacan's theories, see Anthony Wilden's essay, "Lacan and the Discourse of the Other" in *Speech and Language in Psychoanalysis* (especially 264–5).

31. Eagleton explains this movement from "language" to "discourse" as follows: "The shift from structuralism has been in part, to use the terms of the French linguist Emil Benveniste, a move from 'language' to 'discourse'. 'Language' is speech or writing viewed 'objectively', as a chain of signs without a subject. 'Discourse' means language grasped as *utterance*, as involving speaking and writing subjects and therefore also, at least potentially, readers or listeners" (115).

WORKS CITED

Amirkhanian, Charles. "Interview with Laurie Anderson." *The Guests Go In To Supper*. Oakland: Burning Books, 1986. 217–249.

Anderson, Laurie. *United States*. New York: Harper and Row, 1984. Unpaginated.

———. "A Laurie Anderson Story." Interview with Philip Smith. *Arts Magazine* 57 (January, 1983): 60–61.

Bakhtin, M.M. "Discourse in the Novel." *The Dialogic Imagination*. Ed. Michael Holquist. Trans. Caryl Emerson and Michael Holquist. Austin: The University of Texas Press, 1981. 259–422.

Barthes, Roland. "Introduction to the Structural Analysis of Narratives." *Image/Music/Text*. Trans. Stephen Heath. New York: Hill and Wang, 1977. 79–124.

Burroughs, William S. "The Invisible Generation." *The Job*. Burroughs and Odier. New York: Grove Press, 1974. 160–172.

Cage, John. *Silence*. Cambridge: The M.I.T. Press, 1961.

Collins, James. "Narrative." *Narrative Art: An Exhibition of Works by David Askevold, Didier Bay, Bill Beckley, Robert Cumming, Peter Hutchinson, Jean Le Gac, and Roger Welch*. Preface by James Collins. Palais des Beaux-Arts, 10 Rue Royale, Bruxelles, 26 September–3 November, 1974. Unpaginated.

Copeland, Roger. "What You See Is Not What You Hear." *Portfolio* (March–April, 1983): 102–105.

Dare, Michael. "Laurie Anderson: Dancing About Architecture." Interview. *L.A. Extra* (July, 1986): 9–10.

Derrida, Jacques. "The Law of Genre." *Glyph* 7. Baltimore: The Johns Hopkins University Press, 1980. 176–232.

Durand, Regis. "The Disposition of the Voice." *Performance in Postmodern Culture*. Ed. Michel Benamou and Charles Caramello. Madison: Center for Twentieth Century Studies, 1977. 99–110.

Eagleton, Terry. *Literary Theory*. Minneapolis: University of Minnesota Press, 1983.

Eco, Umberto. *Postscript to the Name of the Rose*. Trans. William Weaver. New York: Harcourt Brace Jovanovich, 1984.

Flood, Richard. "Laurie Anderson." *Artforum* (September 1981): 80–81.

Foster, Hal. *Recodings: Art, Spectacle, Cultural Politics*. Port Townsend: Bay Press, 1985.

Foucault, Michel. *Language, Counter-Memory, Practice*. Trans. Donald F. Bouchard and Sherry Simon. Ithaca: Cornell UP, 1977.

Goldberg, RoseLee. "Performance: The Golden Years." *The Art of Performance*. Ed. Gregory Battcock and Robert Nickas. New York: E.P. Dutton, 1984. 71–94.

————. "What Happened to Performance Art?" *Flash Art* 116 (March 1984): 28–29.

————. *Performance: Live Art 1909 to the Present.* New York: Harry N. Abrams, 1979.

Hicks, Emily. "Performance: An Information Continuum." *Art Week* 12 (October 31, 1981): 4.

Jameson, Fredric. "Postmodernism and Consumer Society." *The Anti-Aesthetic.* Ed. Hal Foster. 111–125.

Jencks, Charles A. *The Language of Post-Modern Architecture.* New York: Rizzoli, 1981. 3rd Rev. Ed.

Kardon, Janet. "Laurie Anderson: A Synesthetic Journey." *Laurie Anderson: Works from 1969 to 1983.* Ed. Janet Kardon. (Exhibition Catalogue, Oct. 15–Dec. 4). University of Pennsylvania: Institute of Contemporary Art, 1983. 6–31.

Lacan, Jacques. *Speech and Language in Psychoanalysis.* Trans. with notes and commentary by Anthony Wilden. Baltimore: The Johns Hopkins University Press, 1968.

La Frenais, Rob. "An Interview with Laurie Anderson." Ed. Laurie Anderson and Robert Nickas in New York, Dec. 1981. *The Art of Performance.* Ed. Gregory Battcock and Robert Nickas. New York: E.P. Dutton, 1984. 255–269

"Laurie Anderson." Exhibition Flier. Frederick S. Wight Art Gallery, UCLA. January 31–March 4, 1984.

Lifson, Ben. "Talking Pictures." *Laurie Anderson.* Ed. Janet Kardon. Pennsylvania: Institute of Contemporary Art, 1983. 32–47.

McLuhan, Marshall. *Understanding Media.* New York: Signet, 1964.

Marincola, Paula. "Chronology." *Laurie Anderson.* Ed. Janet Kardon. Pennsylvania: Institute of Contemporary Art, 1983. 63–83.

Melville, Stephen. "Between Art and Criticism: Mapping the Frame in *United States.*" *Theatre Journal.* 37 (March 1985): 31–43.

Mitchell, W.J.T. *Iconology: Image, Text, Ideology.* Chicago: University of Chicago Press, 1986.

Nickas, Robert. "Introduction." *The Art of Performance.* Ed. Robert Nickas and Gregory Battcock. New York: E.P. Dutton, 1984. ix–xxiii.

Owens, Craig. "Amplifications: Laurie Anderson." *Art In America* 69 (March 1981): 121–3.

————. "Sex and Language: In Between." *Laurie Anderson.* Ed. Janet Kardon. Pennsylvania: Institute of Contemporary Art, 1983. 48–55.

————. "The Discourse of Others: Feminists and Postmodernism." *The Anti-Aesthetic.* Ed. Hal Foster. Port Townsend: Bay Press, 1985. 57–82.

Perloff, Marjorie. *The Poetics of Indeterminacy: Rimbaud to Cage.* Princeton: Princeton University Press, 1981.

————. "Dirty Language and Scramble Systems." *Sulfur.* 11 (1984): 178–183.

Pleynet, Marcelin. "Painting and *Surrealism and Painting.*" Trans. Paul Rogers. *Comparative Criticism: A Yearbook.* Ed. Elinor S. Shaffer. Cambridge: Cambridge University Press, 1982. 31–53.

Rapaport, Herman. " 'Can You Say Hello?' Laurie Anderson's *United States.*" *Theatre Journal* 38 (October 1986): 339–354.

Rockwell, John. "Laurie Anderson's Music." *Laurie Anderson.* Ed. Janet Kardon. Pennsylvania: Institute of Contemporary Art, 1983. 56–62.

Rosenberg, Harold. *Artworks and Packages.* Chicago: University of Chicago Press, 1969.

Sarraute, Nathalie. *The Use of Speech.* Trans. Barbara Wright. New York: George Braziller, 1983.

Shepard, Sam. *Tongues. Seven Plays.* New York: Bantam, 1984.

Sheppard, Richard. "The Crises of Language." *Modernism: 1890–1930.* Ed. Malcolm

Bradbury and James MacFarlane. New York: Penguin Books, 1978. 323–326.

Smith, Philip. "A Laurie Anderson Story." (Interview). *Arts Magazine* 57 (January, 1983): 60–61.

Sondheim, Alan. Ed. *Individuals: Post-Movement Art in America*. New York: E. P. Dutton, 1977.

Staten, Henry. *Wittgenstein and Derrida*. Lincoln: University of Nebraska Press, 1984.

Wilden, Anthony. *Speech and Language in Psychoanalysis*. Baltimore: The Johns Hopkins University Press, 1984.

Wittgenstein, Ludwig. *Philosophical Investigations*. Trans. G.E.M. Anscombe. New York: Macmillan, 1958.

———. *The Blue and Brown Books*. New York: Harper and Row, 1958.

9

Installation and Dislocation:
The Example of Jonathan Borofsky

Henry M. Sayre
Oregon State University

Imagine an artist who one day decides to give up painting and sculpture in order to begin counting: 1, 2, 3, 4, 5, 6, 7, 8, 9, 10, 11, 12, 13, 14, 15, 16, 17, 18, 19, 20, 21. . . .The year is 1969. He writes down each number, filling first one page of graph paper, one digit in each square, then another page and another. He continues until he is tired. The next day he takes up where he left off: 827, 828, 829, 830, 832, 833, 834. . . . He continues. The next day he takes up the counting again, and the next day, and the next. For two years he does little else that could be considered "work." In relation to the counting, every other activity of his—eating, sleeping, his social life—is a form of leisure. When he "goes to work," he sits down and takes up his numbers.

Soon there are thousands of pages of numbers, which he stacks in a column that begins to grow higher and higher. The man, being an artist, recognizes this pile of paper as a kind of sculpture. He entitles it *Counting from 1 to Infinity*. It is always growing, a continuous work in progress.

Sometime, after a couple of years, he begins to get bored. His counting is going something like this—

766044, 766045, 766046, 766047, 766048, 766049, 766050, 766051, 766052, 766053, 766054, 766055, 766056, 766057, 766058, 766059, 766060, 766061, 766062, 766063, 766064, 766065, 766066, 766067.

He begins now to doodle on the page. The doodling represents a "break" from his obsessive counting. Still, the counting goes on. Not long after, he makes a small painting on canvas board of one of the doodles in his counting pages. Instead of signing the painting, he assigns it the current number from his counting sequence. It is number 843956. He begins to make many paintings, and he assigns each a number corresponding to his present position in the counting. Simultaneously, the counting itself

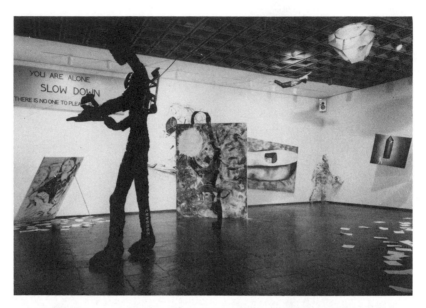

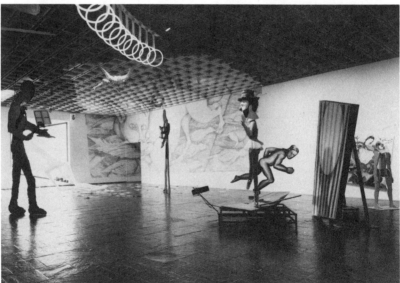

Installation by Jonathan Borofsky, Whitney Museum of American Art, New York City, December 21, 1984–March 10, 1985. Photograph © copyright by Geoffrey Clements, courtesy of Paula Cooper Gallery, New York City.

becomes even more obsessive, as if to counter his renewed interest in painting. By the end of the year he is on 2,208,287. It is 1973.

The artist's name is Jonathan Borofsky. In 1973 he is 30 years old.

i

In the *Critique of Judgment*, Kant defines a "mathematical sublime" which originates out of complete cognitive exhaustion (83). The mind, in this sublime, is reduced to nothing but counting. It is faced with no hope of ever conceptually unifying a long series of things—or their vast scattering and dissemination. It is as if for every "n" which one discovers or confronts or names, one is led on, inevitably, to "n + 1." It is the condition of recognizing that there is always simply *more*.

Such limitlessness, the vast eternity of the sibyl counting her grains of sand, measures itself against the precision, the seeming clarity of position attained in the act of counting itself. One is always at an exact place. In conversations with Mark Rosenthal during preparations for his 1984 retrospective at the Whitney Museum in New York and at the Philadelphia Museum of Art where Rosenthal curates the modern collection, Borofsky has recalled, for instance, the exact moment that he first numbered a painting:

> I leaned the painting against the wall in my apartment and remember going down and adding a number to it in the corner—it was number 843,956. That was the number I was on in the counting. At that moment something special had happened. I had taken the counting and linked it to the image. By putting the number in the corner where I would normally sign my name it implied that the next time I made a painting, I could take the number I was then on and put it in the same corner. It would be a different number, but it would still be like a signature and would be recognizably mine. (Rosenthal and Marshall 62–63)

This particular number—843,956—is implicated in each number that has come before (n - 1) and each number that will follow (n + 1); it implies *more*. Yet it remains itself, resolutely identifiable, in its place. Furthermore, this number, and any other imaginable number, in this particular spatial position—in the corner of the painting where the signature should be—is recognizably a *figure* for Borofsky. It is as if Borofsky has himself taken possession of all numbers from 1 to infinity and made them his own. The number becomes his sign. To say, as did Lucy Lippard in the title to an early article on his work, "Jonathan

Borofsky at 2,096,974," is somehow to locate him in his own time and space, like saying, "Jonathan Borofsky at age 30," or "Jonathan Borofsky at the Paula Cooper Gallery."[1]

Yet numbers, we all agree, are agents of a vast dehumanization marking modern life. We are only numbers in the computer, we complain. Even worse, as Mark Rosenthal has pointed out in his catalogue survey, "Jonathan Borofsky's Modes of Working," it was with numbers that the Nazis branded the Jews, freeing them to extinguish abstractions rather than people (Rosenthal and Marshall 21). The number depersonalizes. As "autographic" as numbers are in Borofsky's art, as much as they constitute or mark a sort of radical personal style, they are simultaneously universal and impersonal. They are "thought"-less. They are "expression"-less. Numbers are the province of the automaton, the computer, the machine—and the war criminal.

Their impersonal quality was, nevertheless, the source of Borofsky's initial interest in them. Counting, he says, "was the clearest, cleanest, most direct exercise I could do that still had a mind-to-hand-to-pencil-to-paper event occurring. . . . There was no intuition involved and everything was planned out ahead of time. All I had to do was get up the next day, pick up my pencil, see what number I was on, and continue counting from there" (Rosenthal and Marshall 33). The counting, he has said elsewhere, is "like Brancusi's *Bird in Flight* . . . just pure line for itself" (Simon 167). In an irony not lost on the artist, the word "pure" here, in the context of the Nazi's extermination of the Jews, takes on an almost obscene resonance.

Harold Bloom has suggested that the emotive basis for the sublime is "equal and opposed feelings, antithetical forces who are enemy brothers or sisters" (6). Borofsky's counting transpires above just such a cognitive abyss. In counting Kant sensed the antithetical conceptual gap that lies between numbering's precise reference and the wholly arbitrary quality of its designation, between its almost meditative purity and its totalitarian potentialities. The number, in the corner of Borofsky's painting, expresses the collision of wholly different orders of thought—or being. It can be counted on for nothing.

ii

Soon after he took up painting again, Borofsky began to record his dreams and, selectively, paint them. *Dream #1 at 1,944,821,* which

dates from 1972–73, consists of six $4' \times 5'$ panels in which the dream is narrated in cartoon style across thirty feet of wall. This is the entire text (I have used slashes to indicate a new panel):

> I'm walking the streets of some strange town with my mother. / Suddenly there are gun noises and rushes of different people. Little 14 year old "minority" (Black and Puerto Rican) gangsters are shooting at each other but also anyone else they feel like. / I hustle with mother and a huge crowd into a Super Market for protection (actually we were sort of swept in by the crowd. / But I know that two of the kids with guns are already in there (I saw them go in earlier). So I tell mother that we must get out of here through the back entrance. / In the back alley we start running—run into several gangsters— they menace us with their guns. I plead for mercy as we slowly pull back from them. A thought crosses my mind—if they are going to shoot one of us, who would I rather it be?—my mother! I saw one of the gangsters faces clearly— he was the one I was pleading with and was about 12 years old, very clean whiteish baby face, possibly of some Spanish extraction—(maybe he's me). / We get back into the Super Market for safety—almost everyone is gone. Buddy Rifkin is having a neck wound (bleeding) attended to (note: Buddy Rifkin was a "good" boy—maybe even better than me—especially in High School—*he won the election*.) I realize that the bullets might only be B.B. guns. Very little more before I woke up.[2]

The dreams are at once entirely personal and archetypal, simultaneously expressions of private anxieties and larger social paranoias with which we can all identify. "I tried to illustrate the workings of my mind," Borofsky later explained, "dreams and various psychological states. Both conscious and unconscious were exposed for the sake of making human connections with others who had similar states of mind—a sort of psychological comparing of notes" (Rosenthal and Marshall 106). In *Dream #1*, the alienation and violent aggression of the gangsters is mirrored in Borofsky's own sense of wandering alone in a "strange" city, in his complex feelings about his mother, and in his more mundane competition with Buddy Rifkin (there is another earlier dream—at 1,933,095—in which Borofsky opens the car door and says, "Mom, I lost the election"), to say nothing of his own identification with the "clean, whiteish, baby face" gangster. What Borofsky knows is that the gangsters are acting out a part of himself. "In retrospect," says Borofsky, "in most of my dreams I seem to be every character—the victim as well as the oppressor" (Rosenthal and Marshall 66).

The dream images—and the other images that he began to paint and

sculpt at this time as well—relate to the counting in a less direct and far more ambiguous way than it at first appears. It is as if the images and the counting are, like the victim and oppressor in the dreams, linked but opposing forces. The counting, that is, *goes on* with or without reference to any particular moment in Borofsky's career. There is not an image for every number. The sense of an "inventory" that the numbering creates is misleading, for there are vastly more numbers that are "indifferent" to Borofsky than numbers which "refer" directly to him or his activity. In order to work, in fact, in order to make art, Borofsky must *interrupt* the counting. In this sense the work must take place *outside* the counting, *block* it. It is tempting to think of the problem in mathematical terms. If the counting consists of a potentially infinite series of "real" numbers, then the images are like "imaginary" numbers, each one a sort of infinitely expanding decimal notation to the "real" number itself.

iii

It is hard to imagine now how it must have felt to encounter *texts*—so many of them, and so casually scrawled across paper and canvas—in Borofsky's first one-person exhibition at the Paula Cooper Gallery in March 1975. At the center of the gallery was *Counting from 1 to Infinity*, then a pile of papers over 3 feet high, a kind of mammoth, almost totemic inscription. The walls were literally covered, from top to bottom, with works, pushpinned in, more or less haphazardly arranged, a kind of visual and verbal labyrinth. "I didn't pare my output down to the ten best objects and put them under glass or frame them in preparation for a sale," Borofsky explained. "My show wasn't about that, but about bringing in all that I had been thinking about, all that I had been working through in the last year (the little scraps of paper as well as the finished paintings). The show seemed to give people a feeling of being inside my mind" (Rosenthal and Marshall 106).

Borofsky's installation violated almost every expectation generated by the gallery space, especially what Brian O'Doherty has labelled the aesthetics of "the white cube" in an important set of essays that is virtually contemporaneous with Borofsky's appearance on the scene and which expresses critically what Borofsky was beginning to realize in the gallery itself. As O'Doherty explains it, the history of modern art is essentially *framed* by its presentation in the gallery:

The ideal gallery subtracts from the artwork all cues that interfere with the

fact that it is "art." The work is isolated from everything that would detract from its own evaluation of itself. . . . A gallery is constructed along laws as rigorous as those for building a medieval church. The outside world must not come in, so windows are usually sealed off. Walls are painted white. The ceiling becomes the source of light. The wooden floor is polished so that you click along clinically or carpeted so that you pad soundlessly, resting the feet while the eyes have at the wall. The art is free, as the saying used to go, "to take on its own life." . . . Modernism's transposition of perception from life to formal values is complete. ("Part I" 24–25)

The effect of Borofsky's first show was to transpose perception back from formal values to life. At the heart of the exhibition, stacked high, was the almost purely formal activity of *Counting from 1 to Infinity*. The number in the corner of each scrap and each painting reflected back to this formal system. And yet it was as if the formal system had exploded, as if it had been exhausted by life itself. Beneath the barrage of pushpinned papers and canvases, the white wall itself had disappeared. No single work seemed to exist on its own terms, as reference and cross-reference multiplied and echoed throughout the space. (Soon Borofsky would attack the ceiling as well: in *Light Where the Painting Is and Painting Where the Light Is at 2,590,213* he attached a painting to the ceiling and the light to the wall; in Rotterdam in 1982 he left the walls of a 95' × 27' gallery bare and executed a large figure on the skylights above). The painting itself was conspicuously "bad" or unfinished. But most of all there were these *words*, these *texts*, everywhere one looked, which required one to *read* as well as see the painting. And for many, reared on modern art, the two activities contained in his work—seeing and reading—seemed so discontinuous that Borofsky's narratives constituted a kind of denial of the primacy of visual perception altogether. This was an *aggressive* show. This art seemed to be *against* the eye.

Now only artists, art historians and art critics—and a constantly diminishing number of these—have ever truly been dedicated to the idea of the primacy of the visual, but there is a long-standing and deeply entrenched "visualist" bias in Western culture. As the poet Charles Bernstein has put it in a long essay on the relation between words and pictures:

Sight is imagined to be split off from the other senses and from language, and assumed to be an autonomous realm, the *sine qua non* of truth, its own evidence—ocular proof. Evidence of the eyes is more believable than the ears, nose, hands, heart: "Show me." Because the eyes are seen as incorrigible, our metaphors of belief, like "are seen as," are often visual: "I've seen the light," "it's plain to see," "use your eyes," "seeing is believing." (124)

After the second World War, for reasons far too complex to develop here but which were related to a widespread formalist sensibility in all the arts, it was, furthermore, widely held that since the plastic arts were *primarily* a visual business, then they ought to concern themselves *only* with the visual. The ultimate expression of this position was Clement Greenberg's 1965 essay "Modernist Painting." For Greenberg, "what had to be exhibited and made explicit was that which was unique and irreducible . . . in each particular art," and painting, therefore, had to eliminate "any and every effect that might conceivably be borrowed from or by the medium of every other art." In so doing, it "would be rendered 'pure,' and in its 'purity' find the guarantee of its standards of quality as well as of its independence." For Greenberg, this meant that painting's task was to orient itself to those things which it shared with no other art—to "the flat surface, the shape of the support, the properties of pigment" (68). The work of art, in other words, was as pristine as the "white cube" which housed it. Other resources art might engage— sound, words, narrative—could only serve to undermine its primary purposes, to say nothing of its eminence.

One result of this sensibility was that titles began to cause artists a good deal of trouble. In a move which was almost surely inspired by Greenberg, Jackson Pollock quit giving titles to his paintings in 1947, designating them with numbers instead, in order to emphasize the fact that he was making "pure" or "non-objective" painting. If there was a title, it remained resolutely outside the frame, on a small unobtrusive white label, as a matter of incidental interest, rather of the same order as the artist's biography or the price of the picture, but categorically not to be confused with the painting *per se*. In fact, there was a certain wide- spread critical insistence that the more the title seemed necessary to understanding the painting, the less good the painting.

The word—and the number—invade Borofsky's work. But Borof- sky's numbers have a different impact than Pollock's. Perhaps the most radical example at Paula Cooper in the 1975 show was one work which consisted solely of the number 2,264,477 painted on paper. Unlike Jasper Johns, who had painted numbers a decade earlier in order to assert the contentless, two-dimensional flatness of the canvas—the number as a sort of pure design—this one seemed, especially in the context of the show, to contain some specific reference. The implication was that there was a dream, or a story of some kind, behind it, which had occurred at 2,264,477, perhaps too private for Borofsky to tell. As a number, it no

longer seemed abstract, but potentially *full* of content and meaning.

Similarly, Borofsky had clearly given up on investigating the "unique and irreducible" properties of painting *per se*. The integrity of the individual object was dispensed with, as each element in the installation seemed to refer to each other. Nothing seemed self-contained, just as his numbers seemed to point to some larger narrative. He had dispensed with the frame, and soon he began to draw and paint directly on the wall. Instead of "purifying" his use of pigments, he employed a deliberately crude and rapid technique. "Real communication," he told Lucy Lippard, "has nothing to do with pretty colors" ("Borofsky at 2,096,874" 63). The ideal of the image's flatness became, for him, an illusion which the experience of the three-dimensional space of the installation was designed to destroy. Sounds soon erupted into the gallery—tape recordings of street noise or pop music—and sculptures of fighters muttered barely audible epithets. Leaflets littered the floor and the public was invited to take them home or dispose of them in the trash, whichever they chose. The stories and dreams which he wrote across the walls served not merely to elucidate the image but to indicate its dependence on both the personal psychological make-up of Borofsky and more broadly cultural forces—neither of which seemed to be under the artist's control. His installations became, in short, what Joan Simon has described as "aural, visual and intellectual cacophonies" (157). Encountering one was like discovering a new sort of archeological site—pieces, traces and fragments of art proliferated, remnants of an artistic psyche's confrontation with its world. These were sites full of various "messages," and if his viewer inevitably began to piece together a story out of them, it was never "the whole story," only a conjectural or hypothetical series of gestures and events, full of logical ellipses and leaps, paradoxical situations and juxtapositions.

Perhaps the significance of Borofsky's installations can best be understood if we compare them to a more strictly literary postmodern genre such as oral or performance-oriented poetry. When the idea of the "text" is opened to performance, it begins to circulate among the plentitude of its interpretations. No longer controlled by the single authority or intentionality of its author, it becomes, rather, the nexus of a generative field of possibilities. Rather than being "self-contained," it projects a variety of possible realizations which undermine the logocentrism of the text itself. Thus the separation between the text and its voicing represents the literal gap between an inscription which situates itself outside

the temporal dimension and a performance which is firmly implicated in the contingencies of time and place. That is to say, oral poetry submits the poem to history.

Borofsky's installations perform this same "opening of the field," with a vengeance. The visual primacy of the image is submitted to the text, and conversely the text finds itself "dislocated" into a field of polysemous images. In the space of the installation, image plays off against image, text against text, each against the other, in a ceaseless whirl of combinations and recombinations. For instance, one of Borofsky's most effective images—or texts—is a clipping literally torn from the Los Angeles *Times* on Wednesday, March 15, 1978, and numbered 2,487,107. The headline reads, "Protest Fading as Seal Hunt Continues," and it is accompanied by a photo with this caption: "Undying Instinct—Mother seal has crawled atop the already skinned carcass of her pup and is barking to ward off intruders in the scene from the hunt on the ice floe off Labrador." Here Borofsky's most personal obsessions—his simultaneous identification with both victim and oppressor in his dreams—have found a broadly public expression. We are on the edge between our identification with the hunter, who we know is killing seals for us, the consumers of the world, and the hunted, whose "undying instinct" to protect her young we would like to think we share. This edge cuts between the purely personal world of Borofsky's dreams and their embodiment in a troubling public dilemma, between the "news" and "art," between, even, life and death. At his third exhibition at the Paula Cooper Gallery in March 1979, this small image was included as one of some 80-odd drawings and dreams which surrounded a door to the gallery. Across the room, on the wall, Borofsky had drawn what he calls his "Hitler" dream: "I dreamed that some Hitler-type person was not allowing everyone to rollerskate in public places. I decided to assassinate him but I was informed by my friend that Hitler had been dead a long time and if I wanted to change anything, I should go into politics. This seemed like a good idea since I was tired of making art and was wondering what to do with the last half of my life." Near this was a small white stove with a frying pan in it. Here is Borofsky talking about the dream and the stove with Joan Simon:

> I was sitting with my mother in our home in Newton, and I looked into the stove. The light was on and we both noticed the lit frying pan inside. It was like looking at a television with a still-life inside. My mother looked at me and said what I was already thinking, "Art." So I took the measurements and

made a white plywood imitation of it with a light inside and a frying pan.

As I was setting up the oven in my show a young stranger walked in and introduced himself as Todd Gast. I had just written my Hitler dream on the wall. I said "Gassed? As in ovens?" That was my connection. He said "No, it's German, it's G-A-S-T; *Gast* means 'guest' in German." So I quickly picked up my pen and wrote "gast means 'guest' in German" on the oven. Those are the kinds of connections that interest me. (166)

The circuitry of connections here, from the seal clipping to the oven to the Hitler dream, magnifies the implications of each element taken on its own. And the openness of Borofsky's work to the contingencies of the moment, its susceptibility to revision, keeps it, as it were, *unsettled*, always open to reinterpretation and transformation.

iv

This decentering or *dislocation* of the work of art's signification constitutes one distinguishing characteristic of the installation, but almost everything about its construction works to support its destabilization. The idea of the "work"—of what constitutes the work—is constantly shifting. Borofsky's realization of this was, in a way, an accident. With his studio emptied out for the 1975 exhibition at Paula Cooper, he began to paint and draw figures of all kinds—turtles, birds, sailboats, dream images—on a large 20 or 30 foot wall in his studio. The wall occupied him almost exclusively for one month. "At the end of the month," he says, "all I could think of was painting the wall white again, which I did almost immediately, but not before a friend took some slides of what had been done" (Rosenthal and Marshall 109). He filled the wall with images again, painted them over, and then filled it again. The gesture satisfied at least two important instincts. In the first place, it violated the purity and sanctity of the white wall itself (this was the era of Mayor Koch's frenzied defenses of the New York City subway system from "attack" by grafitti artists), as well as the frame, for by using an opaque projector, Borofsky was able to transfer images across corners, up onto ceilings, onto windows and doors. Secondly, the work seemed to by-pass the gallery system. Though of course it could still be shown in galleries, if a gallery chose to let Borofsky draw on its walls, it could not be sold. "When I started doing the wall paintings and drawings," he claims, "I was attacking the art system of a work having to be salable. If you wanted to buy a work you had to like it so much that you would ask me to do it on

your wall, and I would do it for the price of a painting. Obviously you had to appreciate it for itself and not for its potential resale value" (Simon 165).

Borofsky had begun, in other words, to discover and articulate the dialectic between artistic control and the work's dissemination which lies at the heart of installation as genre. Borofsky had seized back control of his work from the gallery system. Not only could the gallery no longer sell the work, Borofsky, in constructing the installation, could determine in large part the various contexts in which each of his pieces would be seen. When Courbet had the audacity to set up his own show outside the Salon of 1855, it was the first time, as Brian O'Doherty has put it, that a modern artist had the opportunity "to construct the context of his work and therefore editorialize about its value" ("Part I" 28). Installation is the ultimate manifestation of Courbet's decision. In order to install a show, Borofsky would gather together a large body of drawings and then pick and choose among them according to what seemed appropriate to the place. "I like bringing a lot of drawings with me," Borofsky says, "some recent and others from much earlier. It allows me to go and pull out an old image and bring it into context with new images. . . . Choosing and arranging images has to do with balancing inner and outer worlds; an outer image of someone working balances an inner dream image. So when you hop from one image to the next, some kind of tension is worked out" (Rosenthal and Marshall 119). More generally, the editorial gist of Borofsky's installations had something to do, it was clear from the outset, with the values we attach to art as a whole and to painting in particular. His first show in 1975 at Paula Cooper—and his many to follow both at Paula Cooper and elsewhere—spoke to the very discomfort that O'Doherty expressed a year later in his series of articles on "the white cube" in *Artforum*. "For many of us," O'Doherty wrote,

> the gallery space still gives off negative vibrations when we wander in. Esthetics are turned into a kind of social elitism—the gallery space is exclusive, isolated in plots of space; what is on display looks a bit like valuable scarce goods, jewelry or silver; esthetics are turned into commerce—the gallery space is *expensive*. What it contains is, without initiation, well-nigh incomprehensible—art is difficult. Exclusive audience, rare objects, and difficult to comprehend—there we have a snobbery social, financial and intellectual which models (and at its worst parodies) our system of limited production, our modes of assigning value, our social habits at large. Never

was space to accommodate the prejudices and enhance the self-image of the upper middle classes so efficiently codified. ("Part III" 42)

Borofsky felt that his first show at Paula Cooper, on the other hand, had not been "unlike walking into a supermarket . . . where there is just so much stuff all over, colors, and boxes of food, and prices and numbers and things hanging on the ceiling" (106). It was as if he were consciously trying to bring the gallery down out of its Parnassian vapors into the real world. The show tended not to reflect so much upon itself as to make us aware of the kinds of "environments" or "installations" that surround us in everyday life—in our living rooms, at furniture stores, at shopping malls. And the richness of Borofsky's installation—its ability to generate and sustain our interest— spoke eloquently to the impoverishment of the structures in which we normally find ourselves installed. Many people at Paula Cooper in 1975 felt as if they had wandered into Borofsky's mind, and that mind—if it seemed ungraspable, literally and figuratively exceeding our ability to possess it—still seemed infinitely preferable to the supermarket world it parodied.

Still, Borofsky chose to work within the gallery system at the same time that he defeated its almost inevitable tendency to commodify the art object. The decision owed a lot to the work of minimalist and conceptualist artists a generation older than himself who had given up "the object" in the 1960s, at least in part, in order to free art from implication in the politics of capital, especially as manifested in the Vietnam War. It was felt that the art world had itself become a kind of colonial territory, subject to the control and manipulation of the same investors who served on the museum boards, maintained large private and corporate collections, and had the greatest financial and ideological stake in the war.[3] Not making "salable" objects, or unique "collectibles," became for many a kind of guerilla action. Borofsky accepted this position, but he was quick to recognize as well its larger aesthetic implications.

In the first place, traditionally the art object—singular, sellable, framed on the gallery wall—is the *center* of our attention. We *focus* on it, as it focuses our gaze. In the history of western perspective—and hence western painting since the Renaissance—it literally organizes our visual world, codifies it, puts things in their place. But in Borofsky's work the gaze seems to ricochet around the room. In a very real way, Borofsky's installations unmask the conventions of western perspective. As in the world, things rival one another for our attention, the eye is mobile, never

fixed. Similarly, the image itself is no longer contained in one space. Free
to move from gallery to gallery, show to show, it is never singular, but
plural and fluid, appearing in one instance on a wall, in another in the
notebooks, in first one context and then another. One of Borofsky's most
ubiquitous figures is the shadow drawing of a Man with a Briefcase, a
figure for Borofsky himself carrying a constantly shifting repertoire of
one hundred or so images and dreams—some old, some new—from
exhibition to exhibition. Or like his Running Man—which seemed in
Berlin to be an image of freedom when Borofsky scrawled it on the Berlin
Wall, but which in Portland, Oregon became known as Big Foot, after
local legend of a surviving "missing link" alive in the woods of the Pacific
Northwest—the image seems to inevitably *escape* containment. Un-
settled, ambiguous, indeterminate, it is like the dream, and like the
dream it is always "interrupted." Words intrude into its world. Sounds
draw our attention away, leaflets clutter the floor, gallery-goers are
invited to play pingpong in the middle of the exhibition. Borofsky has
done these things in order to disrupt, *diffuse* our attention.

 And the image itself very often disintegrates before our eyes: soon after
Borofsky began to use the opaque projector he discovered that he could
draw attention to the three-dimensional architectural space of the site in
which he projected the image by drawing the two-dimensional figure
across two or more three-dimensional planes. At the University of
California at Irvine in 1977, he projected an image of a blimp across three
surfaces, through two separate rooms and the s-shaped gap between
them:

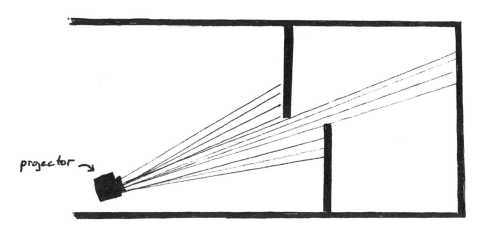

In this architectural view of the space, it is apparent that if the viewer stands in the place of the projector the image appears whole. But by moving even a little right or left, let alone through the two galleries, the image fragments, dissolves. By this means, Borofsky draws our attention away from the art object *per se* to the *context* in which we are viewing it. Site rivals image for our attention. The gallery space, and our position in it, is never neutral.

"For me," Borofsky says, "[installation] has to do with an awarness of space, and making other people conscious of the entire space they are in, not just the space that the object occupies on the wall" (Rosenthal and Marshall 105). The installation, then, for Borofsky, is not a tableau, for the tableau is simply a three-dimensional painting, a framed space which excludes the viewer. As Brian O'Doherty has put it: "With tableau . . . the illusionistic space within the traditional picture is actualized in the box of the gallery. . . . With the tableau, the gallery "impersonates" other spaces" ("Part II" 31). The installation is not involved in questions of representation, but in questions of situation. When The Running Man appeared on the Berlin Wall during a group show in 1982 at Martin-Gropius-Bau in Berlin, Borofsky was announcing that the work *takes place* in a space larger than the gallery itself, in a cultural space which it cannot afford to ignore.

v

To take place is both to appropriate space and to happen, to take time. Duration is always at issue in the installation. We are always aware that what we see is temporary—"here today, gone tomorrow." To visit an installation is to have a unique experience (as opposed to experiencing a unique thing—say, the *Mona Lisa*—an act that is infinitely repeatable). The work exists, then, sooner or later, not in fact (it has been painted over, dismantled), but in mind. It becomes, literally, an act of imagination. But, as with the dream, our memory of it is necessarily fragmentary and distorted. We recreate it, embroider upon it, interpret it, fashion it after our own designs. In short, we mythologize the event. It becomes part of the story of our lives.

Of course, we do not have to depend exclusively on our memory. A certain evidence—"ocular proof"—survives the installation itself. Photographs proliferate, sometimes videos or films, and documentary catalogues are published (such as the Rosenthal and Marshall "retrospective"

catalogue, which contains photographs of all the major Borofsky installations). In a 1980 symposium on "Space and Time Concepts in Environmental Art" at the Pleiades Gallery in New York, Harold Rosenberg commented that in the case of both large scale environmental works, such as Christo's *Running Fence* or Robert Smithson's *Spiral Jetty*, and works, like Borofsky's, that are "limited in time" and possess a purposeful "transitory nature," the gallery is, in fact, "replaced by media": "That is, the works don't really take place in the social mind. They take place in the media first. Very few people, I'm sure, in this room have seen Christo's *Running Fence* or his *Packaged Cliff* [Wrapped Coast] in Australia. But we've all seen [the photographs]" (197). This essay, in fact, has been written with a first-hand knowledge of only four Borofsky installations. And I trust my memory of those installations even less than the documentation of them provided for me in the Rosenthal and Marshall catalogue. In a very real sense, installation wills this "secondhand" quality, not in order to invest the original moment or event with *a priori* status—*not*, that is, in order to mystify it (though, perhaps inevitably, it does that too)—but in order to authenticate and valorize the very experience of the secondhand itself. There is a moment, that is, when the memory of the event, its traces and artifacts, can be experienced, as it were, first-hand, without nostalgia. It is a moment which demands *reconstruction*, not of the event itself, but of its place in the web of subsequent events. The preoccupation of installation as a genre is in fact *space*. In an aesthetic position which can be traced back at least as far as Mallarmé, it defines space as the emptiness required for deposting information, and it recognizes that the work not only fills space but that space must be itself be generated by the work in order to be filled again. Space marks the incompleteness of all signs, and space is itself, paradoxically, a sign of the fluid and mobile wandering of all signification. The installation is, then, a form—to my mind, the preeminent form —of the *intertext*. It devolves from previous acts—the acts of its audience as well as its "author"—and it is an ongoing process of accumulation and dissemination. It is not an object, so much as *"an activity of production"* (157). It is the result of "a serial movement of disconnections, overlappings, variations . . . the activity of associations, contiguities, carryings-over" (158). No longer an object of consumption, it is a "score" which "asks of the reader a practical collaboration . . . [to] *set it going*" (163). It transpires in a "space where no language has hold over any other, where languages circulate" (164).

I have been quoting here from Roland Barthes' famous essay "From Work to Text." Barthes begins that essay by contemplating a new kind of *interdisciplinary* activity (he is thinking of developments in linguistics, anthropology, and psychoanalysis, among others) which begins "when the solidarity of the old disciplines breaks down . . . in the interests of a new object and a new language, neither of which has a place in the field of the sciences that were to be brought peacefully together" (155). Installation is such interdisciplinary work, and Barthes knew that such activity was taking place in the arts as well as the sciences. It constitutes, he wrote in 1973, "the distinctive sign of the avant-garde." He saw, in "the *circulation* of the 'arts' " a movement in which painting "opens the way to 'literature,' for it seems to have postulated a new object ahead of itself, the Text, which decisively invalidates the separation of the 'arts' "("Masson's Semiography" 153). This new work of art, Barthes continues, "is no longer consecrated by a narrow ownership (that of its immediate creator), it journeys in a cultural space which is open, without limits, without partitions, without hierarchies" (154). The work of Jonathan Borofsky is deployed precisely across this terrain. It is like a genre composed of all possible genres—or *conceivably* composed of all possible genres—built upon the conventions of other genres but refusing ever to consolidate itself into something permanent, recognizable, locatable. It is defined, finally, by its resistance to definition, by its refusal to determine "once and for all" what and where it is. Like Borofsky's counting, it *goes on*.

NOTES

1. Borofsky, incidentally, was not the first to be obsessed with counting. In the mid-1960s the French artist Roman Opalka began counting himself. Two sheets of Opalka's numbers in ink, dating from 1965, are in the collection of Louisiana, the museum of contemporary art in Humelbaek, Denmark. They are *1,252,561 – 1,2555,562* and *1,255,563 – 1,258,489*. Each sheet measures approximately 36 × 23 cm., averaging 18–19 numbers per line, and 150 lines to a page. At some point Borofsky became aware of Opalka's work. One of Borofsky's dreams—at 2,481,178—goes "I dreamed Opalka ate three hot dogs and four Cokes and wasn't feeling too good." Many of Borofsky's most important dreams —including this one—are collected in his *Dreams 1973-81*.

2. The text here follows a different order than that reproduced in the Rosenthal and Marshall catalogue as plate 5 where the second and third panels are reversed. When Borofsky originally showed the work, at an exhibition at the Paula Cooper Gallery in 1975, the panels appeared in the order I have quoted them (compare to plate 5 installation views of the Paula Cooper show reproduced in Rosenthal and Marshall as plates 64 and 65).

3. For a discussion of Borofsky's connection to this and related ways of thinking see Mark Rosenthal, "The Ascendency of Subject Matter and a 1960s Sensibility." The best summary of this tendency as a whole in minimalist and conceptual art is probably Lucy Lippard's *Six Years: The Dematerialization of the Art Object from 1966 to 1972.*

WORKS CITED

Barthes, Roland. "From Work to Text." *Image / Music / Text.* Trans. Stephen Heath. New York: Hill and Wang, 1977. 155–64.

———. "Masson's Semiography." *The Responsibility of Forms: Critical Essays on Music, Art, Representation.* Trans. Richard Howard. New York: Hill and Wang, 1985. 153–56.

Bernstein, Charles. "Words and Pictures." *Content's Dream: Essays 1975–1984.* Los Angeles: Sun & Moon Press, 1986. 114–161.

Bloom, Harold. "Introduction." *Poets of Sensibility and the Sublime.* New York: Chelsea House, 1986. 1–9.

Borofsky, Jonathan. *Dreams 1973–81.* Catalogue of an exhibition at the Institute of Contemporary Arts, London, and the Kunsthalle, Basel. London: Institute of Contemporary Arts, 1981.

Greenberg, Clement. "Modernist Painting." *The New Art.* Ed. Gregory Battcock. Rev. ed. New York: Dutton, 1973. 66–77.

Kant, Immanuel. *Critique of Judgment.* Trans. J. H. Bernard. New York: Hafner, 1966.

Lippard, Lucy. "Jonathan Borofsky at 2,096,974." *Artforum* 13 (November 1974): 62–63.

———. *Six Years: The Dematerialization of the Art Object from 1966 to 1972.* New York: Praeger, 1973.

O'Doherty, Brian. "Inside the White Cube, Part I: Notes on the Gallery Space." *Artforum* 14 (March 1976): 24–30.

———. "Inside the White Cube, Part II: The Eye and the Spectator." *Artforum* 14 (April 1976): 26–34.

———. "Inside the White Cube, Part III: Context as Content." *Artforum* 15 (November 1976): 38–44.

Rosenberg, Harold. "Time and Space Concepts in Environmental Art." *Art in the Land: A Critical Anthology of Environmental Art.* Ed. Alan Sonfist. New York: Dutton, 1983. 191–216.

Rosenthal, Mark. "The Ascendency of Subject Matter and a 1960s Sensibility." *Arts Magazine* 56 (June 1982): 92–94.

Rosenthal, Mark, and Richard Marshall. *Jonathan Borofsky.* Catalogue to an exhibition organized by the Philadelphia Museum of Art in association with the Whitney Museum of American Art. Philadelphia: Philadelphia Museum of Art, 1984.

Simon, Joan. "An Interview with Jonathan Borofsky." *Art in America* 69 (November 1981): 157–167.

10

Music for Words Perhaps:
Reading/Hearing/Seeing John Cage's *Roaratorio*:

Marjorie Perloff
Stanford University

> One does not then make just any experiment but does what must be done. . .
> One does something else.
>
> —John Cage, *Silence*

> . . . the creator of the new composition in the arts is an outlaw until he is a
> classic, there is hardly a moment in between and it is really too bad very much
> too bad naturally for the creator but also very much too bad for the enjoyer,
> they all really would enjoy the created so much better just after it has been
> made than when it is already a classic. . . .
>
> —Gertrude Stein, "Composition as Explanation"

The institutionalization—or what we might call, following Gertrude
Stein, the "classicization"—of the early twentieth century avant-garde
has cast a curious shadow on the reception of our own artistic ex-
periments. Cubism, Futurism, Expressionism, Dada—the more we
know about these movements, the move we anatomize, codify, and
"museumfy" their trajectories, the more we wrap them all up in bright-
ly-colored Constructivist paper and put them in a package called *the*
avant-garde, the less receptive we may become to the artistic creations of
our own "outlaws," our own advance guard. Indeed, so striking are the
artistic ruptures of the early twentieth century—say, the dissolution of
the distinction between foreground and background that characterizes
Cubist collage (Picasso, *Violin and Fruit, 1913*; figure 1) or the abstract
materiality of the Tatlin "counterrelief" (figure 2), or the linguistic and
typographical deformations of Pound's *Cantos* (figure 3)—that, from our
vantage point at the end of the twentieth century, we often assume that
art can go no further, that "the new" has always already taken place.
"The American postmodernist avant-garde," says the German critic
Andreas Huyssens, ". . . is not only the end game of avant-gardism. It

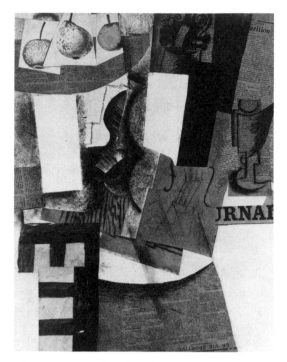

Figure 1. Pablo Picasso, *Still Life with Violin and Fruit*, 1913. Collage and charcoal on paper, 25⅜″ × 19 ½″. Philadelphia Museum of Art, A. E. Gallatin Collection

also represents the fragmentation and decline of the avant-garde as a genuinely critical adversary culture" (170). And in his essay "Against Pluralism," Hal Foster concurs: "More and more, art is directed by a cyclical mechanism akin to that which governs fashion, and the result is an ever-stylish neo-pop whose dimension is the popular past. An arrière-avant garde, such art functions in terms of returns and references rather than the utopian and anarchic transgressions of the avant garde" (REC 23).

The "end game of avant-gardism," the "arrière-avant garde"—the pessimism of such formulations (formulations that are especially prominent in recent Marxist theory) is at least in part attributable to what I shall call here the myth of repetition, that is to say, the fallacy that the literary, visual, and musical arts of our own time can do no more than to repeat the experiments of the early century. To put it another way, form

Figure 2. Valdimir Tatlin, *Corner Relief*, 1915. Reconstructed from photographs by Martyn Chalk, 1979. Iron, zinc, aluminum, wood, paint. Annely Juda Fine Arts, London.

is held to follow form. An early avant-garde sculpture, say, Brancusi's *Princess X* of 1916 (figure 4) can breed only another abstract sculpture, say Barbara Hepworth's *Pelagos* of 1946 (figure 5), the latter work reducing the witty erotic play of the former to the more purely formalist relationship of external surface to internal skeleton. Repetition, it would seem, goes hand in hand with reduction.

This, in a nutshell, is the conclusion reached by Peter Bürger in his widely discussed *Theory of the Avant-Garde*, whose first edition appeared in Germany in 1974.[1] Briefly, Bürger's thesis is that Dada, which he posits as "the most radical movement within the European avant garde," was a movement that neither developed a particular style, nor did it criticize, as do most new art movements, the schools that preceded it. Rather, Dada's role was to criticize art itself as a bourgeois institution, a capitalist mode of production and dissemination. Whereas medieval and Renaissance art, so the argument goes, was subject to "collective performance" and "collective reception," the bourgeois art of the post-Enlightenment was largely produced by isolated individuals for other

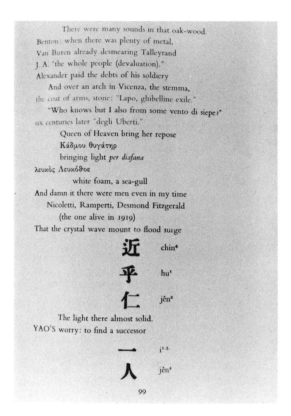

Figure 3. From Ezra Pound, *Cantos*. Copyright (c) by Ezra Pound.
Used by permission of the New Directions Publishing Corp.

isolated individuals. Divorced from the "praxis of life," it became
increasingly autonomous and elitist, culminating in the aestheticism of
the late nineteenth century.

It is this autonomy, this institutionalization of Capitalist art as
"unassociated with the life praxis of men" (note Bürger's own sexist bias
here), that the avant-garde of the 1910s and 20s challenged. When, for
example—and this is Bürger's Exhibit A—Marcel Duchamp signs a
mass-produced object (in this case an ordinary urinal) and sends it to an
art exhibit bearing the title *Fountain by R. Mutt* (figure 6), "he negates
the category of individual production," thus mocking "all claims to
individual creativity" (51–52). And Bürger concludes:

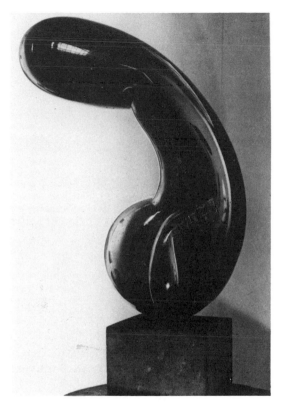

Figure 4. Constantin Brancusi, *Princess X*, 1916. Polished bronze, 23″.
Musée National d'Art Moderne, Paris. Centre Georges Pompidou, Paris.

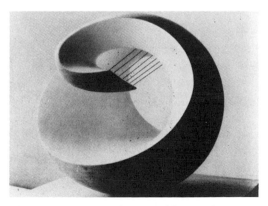

Figure 5. Barbara Hepworth, *Pelagos*, 1946. Wood with strings, 16″. The
Tate Gallery, London.

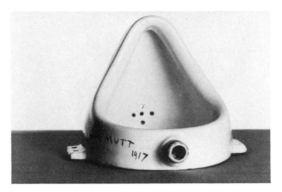

Figure 6. Marcel Duchamp, *Fountain*, 1951. (Second version after lost original of 1917). Readymade, Urinal, 18 × 15 × 12". Sidney and Harriet Janis Collection, New York

> Duchamp's provocation not only unmasks the art market where the signature means more than the quality of the work; it radically questions the very principle of art in bourgeois society according to which the individual is considered the creator of the work of art. Duchamp's Ready-Mades are not works of art but manifestations. Not from the form-content totality of the individual object Duchamp signs can one infer the meaning, but only from the contrast between mass-produced object on the one hand, and signature and art exhibit on the other. (52)

This analysis, which has been widely accepted,[2] raises more questions than it answers. First, it implies that Duchamp might have made the same point by turning any mass-produced object into a *readymade*, that the object chosen has no intrinsic meaning or value. But to turn a urinal upside down and call it *Fountain* immediately produces a host of connotations, as does the "signature" *R. Mutt*, with its play on "Armut" (poverty), "Mutti" (Mama), "Mut" (German for "courage") or "mutt" (dog).

 Secondly, the shape of this "fountain" is equivocal: on the one hand, its now-classic abstract form relates it to any number of Modernist sculptures; on the other, the relation of hole to whole, of straight line to curve, is itself sexually playful and hence semantically charged. What, after all, is the relation of the male artist (Duchamp / R. Mutt) to this seemingly female receptacle called "fountain"?

 Again, Duchamp's signature on this or on any of his readymades (e.g. *Bicycle Wheel*, figure 7; the bird cage filled with sugar cubes called "Why

Figure 7. Marcel Duchamp, *Bicycle Wheel*, 1951 (Third version after lost original of 1913). Assemblage: Metal wheel, 25 ½″ diameter, mounted on painted wood stool, 23 ¾″ high; overall, 50 ½″ high. The Sidney and Harris Janis Collection, gift to The Museum of Modern Art, New York.

Figure 8. Marcel Duchamp, *Why Not Sneeze, Rose Sélavy?* 1964 (Replica of 1921 original). Painted metal birdcage containing 151 white marble blocks, thermometer, and piece of cuttlebone; cage, 4⅞ × 8¾ × 6⅜". Collection, the Museum of Modern Art, New York. Gift of Gallerie Schwarz

not sneeze, Rose Sélavy?," figure 8) is not, as Bürger argues, a simple case of "contrast between mass-produced object . . . and art exhibit." For if Duchamp had really wanted to have no status as "individual" artist, if his aim had been to put into question the very status of art as bourgeois institution, why sign the work to begin with? As soon as the urinal or bicycle wheel are perceived as "Duchamps," we are right back in the art arena in which the individual artist has authorized the work. And indeed, today "a Duchamp" has just as much status in the art market as does the "master painting" whose value it ostensibly negates.

Bürger might counter this last objection by arguing that, despite Duchamp's original agonistic purpose, his *readymades* soon became appropriated by the capitalist art market and that thus, our social system being what it is, "the avant garde" was bound to fail. The problem, in

other words, is less one of artistic intention than of audience appropriation: unwittingly, the avant-garde, in Hal Foster's words, "helped to recycle the social discards of industrial capitalism back into its productive system" (REC 35); indeed, it could not avoid this fate since, as Roland Barthes put it in an early essay, "Le mot même d'avant-garde, dans son étymologie, ne designe rien d'autre qu'une portion un peu exubérante, un peu excentrique de l'armée bourgeoise" (80).[3]

Given this critique of the avant-garde itself, the so-called "neo-avant-garde" is doomed from the start. Attempts to isolate a core group of neo-avant-gardists have not been very successful, whether the rationale, as in the case of Nicholas Zurbrugg, is to separate an avant-garde postmodernism (e.g. Henri Chopin's audiopoems, Laurie Anderson's performance art) from its "mainstream" postmodern counterpart, as exemplified, for Zurbrugg, by Samuel Beckett; or whether, as in the case of Mikolos Szabolcsi, whose essay on the subject was commissioned for the scholarly two-volume compendium published by the ICLA in 1985 under the title *Les Avant-gardes littéraires au xxième siècle*, the "neo-avant-garde" is more or less equated with the counterculture of the sixties, which is to say, with the "hippie" protest against the Vietnam War, with Zen, drugs, pop art, and *arte povera*. If Zurbrugg's dilemma is that, try as he may, "mainstream" Beckett emerges as distinctly more "avant-garde" than Henri Chopin, Szabolcsi's is that he is forced to posit an "end" to the neo-avant garde that coincides with the "end" of sixties radicalism.[4]

Peter Bürger's own account of the neo-avant garde is even more reductive. Dada, he argues, represents a moment of crisis that cannot be repeated: "Once the signed bottle drier has been accepted as an object that deserves a place in a museum, the provocation no longer provokes; it turns into its opposite. If an artist today signs a stove pipe and exhibits it, that artist certainly does not denounce the art market but adapts to it" (52). And, accordingly, "Neo avant-garde, which stages for the second time the avant-gardiste break with tradition, becomes a manifestation that is void of sense and that permits the positing of any meaning whatever" (61).

But this is to assume that our own artists have no choice but to restage what Burger calls the "avant-gardist break," that at best they can sign stove pipes and exhibit them in museums. This thesis, namely that contemporary art is merely a recycled Modernism, that it can do no more than to spin its wheels, returning again and again to the "scene of

provocation" of the early century but devoid of that scene's intrinsically political motive, is argued with great moral earnestness in a recent essay for *October* by Benjamin Buchloch called "The Primary Colors for the Second Time: A Paradigm Repetition of the Neo-Avant-Garde."

Like Bürger, Buchloch poses the question as to whether today's "neo-avant-garde" can repeat the early twentieth-century's avant-garde impulse "to integrate art within social praxis" (42). Buchloch's exemplars are Rodchenko and Yves Klein, specifically, Rodchenko's 1921 production of three monochromatic paintings, red, yellow, and blue respectively, to Yves Klein's "scandalous" 1957 exhibition, at a commercial gallery in Milan, of eleven almost identical blue monochrome paintings. Rodchenko's project, Buchloch argues (44), was "the demystification of aesthetic production, in this case the pictorial convention of assigning meaning to color." Its aim was "to lay the foundations for a new culture of the collective rather than continuing one for the specialized, bourgeois elite."

By contrast, Klein not only "convinced [the] art world with his claim to have invented monochrome painting," but took pleasure and pride in the fact that, as he put it, "Each [buyer] selected out of the . . . pictures that one that was his, and each paid the asking price. The prices were all different of course" (50). Thus, whereas Rodchenko's monochromism signified that in the New Socialist Society, everybody had the means to make art, in the late Capitalist universe inhabited by Klein, a seemingly identical monochromism is "converted into an area of specialization for the production of luxurious fetishes for privileged audiences." "The neo-avant-garde paradigm of repetition," Buchloch concludes (52), is, then, not repetition at all, for "the very same strategies that had developed within modernism's project of enlightenment now serve the transformation of the bourgeois public sphere into the public sphere of the corporate state, with its appropriate forms of distribution (total commodification) and cultural experience (the spectacle)."

My uneasiness with this argument is not that it misconstrues the relation of Klein's monochromatic paintings to Rodchenko's, but that it assumes yet again that the contemporary counterpart of an X must be another X, in this case, that the postmodernist counterpart of a Rodchenko painting must be another painting. Yves Klein, says Buchloch, is "in many ways the quintessential neo-avant-garde artist" (45), a designation that relies on the very paradigm of repetition Buchloch claims to reject. For how can art that is avant-garde, which is to say ahead

of its time, unprecedented, against the grain, be "quintessentially neo" something that has already happened?

"You can't," John Cage tells the French philosopher Daniel Charles, "repeat anything exactly—even yourself." And he cites René Char's aphorism, "Each act is virgin, even the repeated one" (FB 48). In what sense can this be true of the supposedly recycled and commodified avant-garde of our time? In his brilliant essay, "Contemporary Art and the Plight of the Public" (1962), Leo Steinberg puts it this way:

> [The] rapid domestication of the outrageous is the most characteristic feature of our artistic life, and the time lapse between shock received and thanks returned gets progressively shorter. At the present rate of taste adaptation, it takes about seven years for a young artist with a streak of wildness in him to turn from *enfant terrible* into elder statesman—not so much because he changes, but because the challenge he throws to the public is so quickly met.
>
> So then the shock value of any violently new contemporary style is quickly exhausted. Before long, the new looks familiar, then normal and handsome, finally authoritative. All is well, you may say. Our initial misjudgment has been corrected; if we, or our fathers, were wrong about Cubism a half-century ago, that's all changed now.
>
> Yes, but one thing has not changed: the relation of any art—while it is new—to its own moment; or to put it the other way around: every moment during the past hundred years has had an outrageous art of its own, so that every generation from Courbet down, has had a crack at the discomfort to be had from modern art. And in this sense it is quite wrong to say that the bewilderment people feel over a new style is of no great account since it doesn't last long. Indeed it does last; it has been with us for a century. (5–6)

This, it seems to me, is the basic paradox that governs the reception of avant-garde artworks today. To illustrate the point, Steinberg records his own reaction, and that of the public, to the first New York show in 1958 of the then young and almost unknown painter Jasper Johns. Here, at the moment when Abstract Expressionism, with its emphasis on suggestive forms, gorgeously complex coloring, and subtle structuration, had become the order of the day (Jackson Pollock, *Blue Poles*, figure 9; Mark Rothko, *Number 10*, 1950, figure 10), was a series of paintings in oil or encaustic that were variations on four main themes: "Numbers, running in regular order, row after row all the way down the picture, either in color or white on white:" (*Gray Numbers*, figure 11), "Letters, arranged in the same way" (*Alphabets*,), "The American Flag—not a

picture of it, windblown or heroic, but stiffened, rigid, the pattern itself" (figure 12), and finally, "Targets, some tricolored, others all white or all green, sometimes with little boxes on top into which the artist had put plaster casts of anatomical parts, recognizably human" (figure 13). There was also a wire coat hanger, hung on a knob that projected from a dappled gray field (figure 14), and a canvas which had a smaller stretched canvas stuck to it, and which was called *Canvas* (figure 15).

Figure 9. Jackson Pollock, *Number 1, 1948*, 1948. Oil on canvas. 68" × 8' 8". Collection, The Museum of Modern Art, New York. Purchase.

How did the art audience assimilate such startling material? Not, assuredly by expressing outrage; in the wake of Cubism and Constructivism, Dada and Surrealism, the critic by no means wants to display his or her unsophistication vis-à-vis the new. But the alternative to outrage is by no means understanding. "The first critical reflex at the appearance of something new," Steinberg notes, "is usually an attempt to conserve psychic energy by assuring oneself that nothing really new has occurred." *Art News*, for example, labelled Johns's *Target with Four Faces* (figure 13), "neo-Dada," and this label opened the floodgates as critic

Figure 10. Mark Rothko, *Number 10*, 1950. Oil on canvas. 7′ ⅚₈″ × 57 ⅛″. Collection, The Museum of Modern Art, New York. Gift of Philip Johnson.

after critic proceeded to comment on just how and to what extent John's painting was Dada. Thus Tom Hess argued that Johns uses Dada cliche, "not to attack nor amuse, but to emulate Jackson Pollock and 'paint the subconscious' . . . through an art of Absolute Banality"; Hilton Kramer called Johns "a kind of Grandma Moses version of Dada," in that "Dada sought to repudiate and criticize bourgeois values, whereas Johns, like Rauschenberg, aims to please and confirm the decadent periphery of bourgeois taste" (OC 23); and John Canaday, writing for the *New York Times Magazine*, dismissed the whole show with the profound conclusion that "old-time Dada could—and did, as it intended—provoke to fury. The imitators today only tease and titillate" (OC 24).

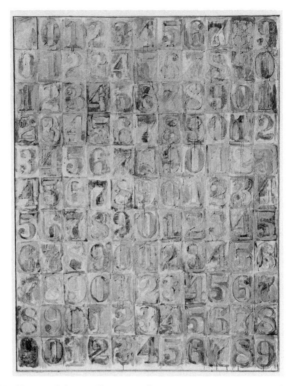

Figure 11. Jasper Johns, *Gray Numbers*, 1958. Encaustic and collage on canvas, 170.2 × 125.8 cm. Collection Kimiko and John Powers, Colorado.

Dismissal by labelling and neutralization: it is the fate of the avant-garde today even as it was half a century ago. Consider the case of the John Cage—Merce Cunningham musical-verbal-dance piece *Roaratorio. An Irish Circus on Finnegans Wake*, performed at the Brooklyn Academy of Music in October 1986. Jill Johnston, reviewing the performance for *Art in America* (January 1987), is by no means hostile to the work, but her bemused condescension is typical of the critical establishment vis-à-vis Cage's (and, to some extent, Cunningham's) work. In what follows, I shall assess her criticism of the Cage "score" rather than of the remarkable Cunningham choreography, since *Roaratorio* was not originally conceived or produced as a dance piece.

In the course of her essay, Johnston (and this is typical of commentary on Cage's work)[5] makes a series of misleading, if not simply incorrect statements:

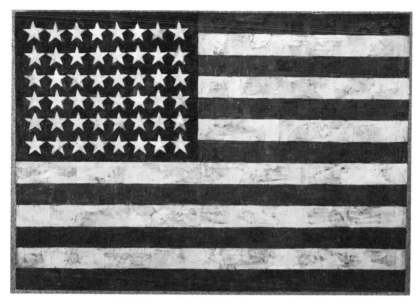

Figure 12. Jasper Johns. *Flag*, 1955. Encaustic, oil, and collage on canvas, 42 ¼ x 60 ⅝". Collection, The Museum of Modern Art, New York. Gift of Philip Johnson in honor of Alfred H. Barr, Jr.

(1) Cage chose to "write through," that is make a series of "mesostics" (a *mesostic* is an acrostic column down the center of the text rather than at the left margin) through *Finnegans Wake*, a novel he considered "the most important book of the century" although "like so many other enthusiasts, he never read it" (103).

Here Johnston is referring to Cage's "Conversation on *Roaratorio*" with Klaus Schoening, held on the occasion of the original IRCAM radio production in Paris in 1979 and reprinted in the book version of Cage's text published in Germany by Atheneum in 1982. What Cage actually says is that he first read parts of *Finnegans Wake* in *transition* where they appeared in the mid-thirties, that he bought it immediately when it was published in 1939, and that at that time "like so many other people I never read it." But, as his remarks to Schoening about the novel's themes, its use of Vico's historical cycles, its structure, make clear, Cage knows Joyce's book inside out. More important, even a cursory examination of the text itself reveals that Cage's choices for the "writings

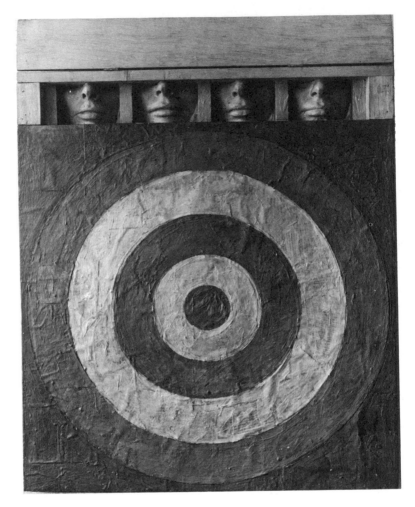

Figure 13. Jasper Johns, *Target with Four Faces*, 1955. Encaustic on newspaper over canvas, 26 × 26″ surmounted by four tinted plaster faces in wood box with hinged front; overall dimensions with box open, 33⅛ × 26 × 3″. Collection, The Museum of Modern Art, New York. Gift of Mr. and Mrs. Robert C. Scull.

through" could only have been made by someone who was thoroughly familiar with the *Wake*. Ironically, then, it is the critic (Jill Johnston) who hasn't read *Roaratorio* carefully, not Cage who hasn't read his Joyce. (2) "In producing his 'mesostics'," Johnston explains, Cage reduces Joyce's 626-page novel to 41 pages, "by organizing the text around the

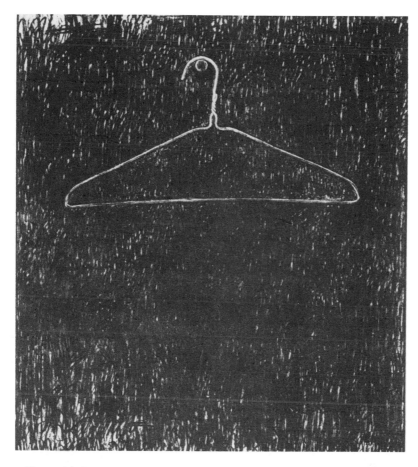

Figure 14. Jasper Johns, *Coat Hanger*, 1958. Crayon on paper. 62.3 × 54.9 cm. Collection Mr. and Mrs. William Easton.

two words: JAMES JOYCE. Beginning on Joyce's first page [figure 16], he selected the first word with a *J* in it that didn't have an *A*, because the *A* would belong to the next line for JAMES, and so on through the entire book, making a path or vertical line down the center of his own text consisting of the 10 letters of Joyce's name, and utilizing his time-honored chance operations to determine how many of Joyce's words surrounding the mesostic word proper would be included on each line. Not very many. So that Cage's text looks visually like a Minimalist

Figure 15. Jasper Johns, *The Canvas*, 1956. Encaustic and collage on wood and canvas. Collection, the artist.

concrete poem, or like a Cummings or an Apollinaire, especially as Cage lower-cased everything but Joyce's name and eliminated all punctuation."

Again, *wrong*. Note that the first word in *Finnegans Wake* that has a *j* in it, "nathandJoe" (see figure 16) also contains not only one but two *a*'s (the second letter of JAMES). The actual rule is that the second letter of the mesostic word (here "A") cannot follow the first letter (here *J*) in the chosen word. A further rule, and this produced the extreme condensa-

riverrun, past Eve and Adam's, from swerve of shore to bend
of bay, brings us by a commodius vicus of recirculation back to
Howth Castle and Environs.

Sir Tristram, violer d'amores, fr'over the short sea, had passen-
core rearrived from North Armorica on this side the scraggy
isthmus of Europe Minor to wielderfight his penisolate war: nor
had topsawyer's rocks by the stream Oconee exaggerated themselse
to Laurens County's gorgios while they went doublin their mumper
all the time: nor avoice from afire bellowsed mishe mishe to
tauftauf thuartpeatrick: not yet, though venissoon after, had a
kidscad buttended a bland old isaac: not yet, though all's fair in
vanessy, were sosie sesthers wroth with twone nathandjoe. Rot a
peck of pa's malt had Jhem or Shen brewed by arclight and rory
end to the regginbrow was to be seen ringsome on the aquaface.

The fall (bababadalgharaghtakamminarronnkonnbronntonner-
ronntuonnthunntrovarrhounawnskawntoohoohoordenenthur-
nuk!) of a once wallstrait oldparr is retaled early in bed and later
on life down through all christian minstrelsy. The great fall of the
offwall entailed at such short notice the pftjschute of Finnegan,
erse solid man, that the humptyhillhead of humself prumptly sends
an unquiring one well to the west in quest of his tumptytumtoes:
and their upturnpikepointandplace is at the knock out in the park
where oranges have been laid to rust upon the green since dev-
linsfirst loved livvy.

Figure 16. Page 1 of James Joyce, *Finnegans Wake*, as reproduced in John
Cage, *Roaratorio. An Irish Circus on Finnegans Wake*. Sound and Text. Ed. Klaus
Schoening. Koeningstein: Atheneum Verlag, 1982. Reproduced by permission
of John Cage and the publisher.

tion of the finished text, is "Do not permit for a single appearance of a
given letter the repetition of a particular syllable" (R 173). This means,
of course, that the sounds will be extremely varied, despite the recur-
rence of *J*'s in two out of every ten mesostic words. But what is most
misleading in Jill Johnston's account is the assertion that the words
surrounding the mesostic word proper in any given line are chosen by
chance operations. Cage himself explicitly says: "other adjacent words

from the original text (before and/or after the middle word, the word including a letter of the row) may be used according to taste, limited, say, to forty-three characters to the left and forty-three to the right."

What does "according to taste" mean here? Commentary on Cage is usually so preoccupied with his use of self-imposed rules and chance operations that it slights the role that the poet-composer's extraordinary art plays. Consider, for example, the layout of the opening page of *Roaratorio*, bearing in mind that this is a text to be recited rather than scanned silently:

I

<div align="center">

wroth with twone nathandJoe
Ä
Malt
jhEm
Shen

pftJschute
sOlid man
that the humptYhillhead of humself
is at the knoCk out
in thE park

Jiccup
the fAther
Most
hEaven
Skysign

Judges
Or
deuteronomY
watsCh
futurE

pentschanJeuchy
chAp
Mighty
cEment
and edificeS

the Jebel and the
crOpherb
flYday
and she allCasually
ansars hElpers

</div>

Figure 17. John Cage, *Roaratorio*, page 1

Notice here that although the choice, say, of the first word, "nathand-joe" is generated by rule (choose the first word in *Finnegans Wake* containing a *J* not followed by an *A*), the inclusion of "wroth with twoone" is purely Cage's decision. Suppose, then, that we follow the mesostic rule but use different adjacencies. Here is my own version:

> nathandJoe
> rot A peck
> Malt had
> jhEm or
> Shen
>
> the pftJschute
> erse sOlid
> humptYhillhead
> knoCk
> thE park
>
> of false Jiccup
> the fAther of fornicationists
> Most high
> hEaven
> the Skysign
>
> Judges had
> numbers Or
> deuteronomY (one
> for to watsCh
> futurE

In my version, the variety of pitches and long vowels that constitutes the "signature" of the original disappears as does the rhythmical mock-Irish chant of "wroth with twoone nathandJoe." More important: the duality of Joyce's "twoone" (two-in-one), which literally refers to the alternate Biblical fathers, Wise Nathan and Chaste Joseph, but here in Cage's stanza also modifies "jHem / Shen," that is, the twin sons, Shem and Shaun, of the novel's hero, H. C. Earwicker—this duality motif is lost in my version. Furthermore, Cage's "writing through" also creates its own meanings, as in "Judges / Or / deuteronomY" (Joyce's text reads, "before joshuan judges had given us numbers or Helviticus committed deuteronomy"), meanings that are not rule-bound (see my version) but freely constructed.

Accordingly, Johnston's implication that the structure of *Roaratorio* is merely random is simply not true. Nor does Cage "eliminate all punctuation," as she claims. On the contrary, the excised punctuation reappears in scattered form as part of the visual design of a given page (see figure 18).

Figure 18. John Cage, *Roaratorio*, page 3

(3) Whereas Joyce wanted *Finnegans Wake* to be "difficult" but not incomprehensible, Cage, claims Johnston, "doesn't wish to be understood at all. . . . His own interest, as he has boldly put it, has been to open up 'the possibility of doing many things *with* the book . . . rather than trying to find out what the book is *about.*' In other words, it's been a wonderful object for him to colonize and exploit, not to understand" (104). Indeed, notes Johnston, there is an inherent "contradiction" between Cage's "avowed inclusiveness (Here Comes Everyone, or let all the sounds in . . .) and his very hierarchical and obsessively structured designs" (104).

Johnston's distinction between "understanding" (by which she presumably means explication of Joyce's allusions, symbols, and plot lines) and "colonisation" (the annexation of that which belongs to someone else), between "inclusiveness" and what she takes to be "hierarchy," strikes me as dubious, for the technique of "citational graft," as Jacques Derrida has called it,[6] (GL 185) is itself one of our primary modes of understanding a given text. To cite someone else's words, to put them between quotation marks, thus cutting them free and grafting them elsewhere is to create what Cage himself would call a "both / and" situation, the cited passage retaining its original meanings even as its new context generates others. As such, the art of citation is not a simple matter of "colonisation," even as the use of generative structural devices (in this case, the mesostic) does not necessarily signify the imposition of hierarchy. On the contrary, the mesostic production of Cage's *Roaratorio* challenges precisely the Platonic doctrine that thought is prior to language and language, in its turn, prior to writing. For the name *JAMES JOYCE*, significant as it is on the page, is not *heard* at all when the poem is read aloud, and conversely the sounded *e* in "JhEm" or "hEaven" is a false externalization of the silent *e* of *JAMES*. Thus the hierarchy of thought, speech, and writing collapses. For is Cage's written text to be regarded as the secondary representation of his speaking and chanting? Or is the recital just one version of the primary written text?

Johnston's curious misapprehensions about the *Roaratorio* suggest that even the work of a venerable "avant-gardist" like Cage is far from being understood by establishment critics, much less commodified or appropriated by the bourgeois art audience whose preconceptions it implicitly challenges. Indeed, a closer look at this difficult *sprechstück*, as Cage and Schoening call it, may help to pinpoint the difference between "their" (i.e. early twentieth-century) avant-garde and ours.

ii

How was the "Irish Circus" called *Roaratorio* conceived and produced? If we think of Cage's composition as essentially a conceptual art work, we must take into account, not only the written text and the taped performance of the spoken / sung one, but also the accompanying documents in the Atheneum edition: graphs, diaries (Cage's and Klaus Schoening's) written in the course of the production; the listings of the sounds in Chapter 1 of *Finnegans Wake* (see figure 19) and their classification into different categories (figure 20); the comparable listing of place names in the *Wake*, reduced to manageable size by chance operations, and the listing of the musical pieces performed by Joe Heaney and the other musicians; the conversations between Cage and Schoening, Heinrich Vormweg's presentation speech upon the award to Cage of the Karl-Sczuka Prize for *Roaratorio* in 1979 together with Cage's acceptance speech; and, finally, Cage's important set of directions for the actual putting together of text and sound tracks.

A point of entry into this complicated network of texts and events occurs in the following remarks made by Cage as recalled in Schoening's diary:

> "A fugue is a . . . complicated genre; but it can be broken up by a single sound, say from a fire engine" (from *Silence*).
> Paraphrase: *Roaratorio* is a more complicated genre; it cannot be broken up by a single sound, say from a fire engine. (19)

A genre, then, that cannot be broken up. And further: a genre designed "to suggest the complexity of *Finnegans Wake* (75). Asked by Schoening if the use of Anthony Burgess's abridged version of the *Wake* would not have made his task easier, Cage responds: "No, no. The short *Finnegans Wake* . . . tries to give you the gist or story of it. But the story of it is exactly what it isn't" (75). The aim, in other words, is never to follow "a single line," but to produce simultaneous layers of sound and meaning that correspond to the complexity of the parent text.

How to structure this complexity? Just as the *Wake* is a cycle, beginning in the middle of one sentence and ending in the middle of another that can be combined with the first, a cycle based on Vico's theory of history and the circle of Indian Karma, so *Roaratorio* divides its one-hour time frame into cyclical recurrences of the mesostic *JAMES JOYCE* but submits those cycles to the "citational graft" of simultaneous sound sequences heard on the accompanying tracks, the aim being to

produce, not so much a cycle as a *circus*. What "circus" means, says Cage, is that "there is not one center but that life itself is a plurality of centers" (107). Or again, whereas an *oratorio*, as Cage defines it, "is like a church-opera, in which the people don't act, they simply stand there and sing," a *roaratorio* reflects the condition in which "the world has become a church—in which you don't sing, you roar" (89). The singing, that is to say, continues but the addition of the letters *r* and *a* suggests that it is the world outside the church that has become holy. Joyce himself, as Cage is delighted to note, uses the coinage *roaratorio* in the *Wake*, when he refers to "the subjects of King Saint Finnerty the Festive . . . with their priggish mouths all open for the larger appraisiation of this longawaited Messiagh of roaratorios" (41).

Given, in any case, the generic parameters of *circus* and *roaratorio*, the stage is set for the work's real thrust, which is to invent a new language field. *Finnegans Wake* is, of course, a source book for punning, neologism, and every form of phonemic and morphemic play. Add a single letter, *a*, to "laughter," Cage points out, and you get Joyce's "laughtear," a coinage that especially appeals to Cage because "the opposites which we try to keep apart in our lives" are "[brought] back together where they belong." "And that's why," he adds, "this book seems to me like a whole world, rather than part of a world, it is this *bringing together of the opposites*" (78). Thus, "if Joyce mentioned a part of Dublin which was north of the Liffey, he then followed it by mentioning something south of the Liffey. So that it's like "laughtears" again, but in terms of geography" (79).

Further, the *ears* embedded in *laughte(a)rs*, as Cage and Schoening note, can yield any number of other morphemes and words central to the *Wake*—for instance, *Earwicker* and his "suckmouth *ear*," "*ear*ish with his eyes shut," "*ears* to *ear*," or *aur*al eyeness," "*ear*opean," and "*ear*(th)-quake" (79–80). It is, that is to say, the *textuality* of the *Wake* rather than its larger "plot" or its "themes" and characters that inspires the *Roaratorio*. "For me," says Cage, "each instant in *Finnegans Wake* is more interesting than trying to find out what the whole book is about. To just go into any one word . . . and then move out from it is as though you'd become a pebble tossed into this ocean" (79). Thus the insertion of the mesostic capital letter into a word discovers a "Yes" in "eYes," a "mE" in "mElos," an "Own" in tOwn," a "yeA" in "yeArs"—even a "Ms" in "girlycuMs." These transforms—and they are everywhere in *Roaratorio*—are heightened by their removal from the grammatical sentence and the redistribution of punctuation as part of the visual page design.

LISTE MIT GERÄUSCHEN AUS *FINNEGANS WAKE* (KAPITEL I)
Die Zahlen geben Seite und Zeile im Original von James Joyce an.

LISTING THROUGH *FINNEGANS WAKE* (CHAPTER I)
The numbers show the page and line from the original edition by James Joyce.

03.04 *violer d'amores*
 .09 *avoice from afire bellowsed mishe mishe*
 .15–17 *(bababadalgharaghtakamminarronnkonn-*
 bronntonnerronntuonnthunntrovarrhoun-
 awnskawntoohoohoordenenthurnuk!)
 christian minstrelsy
04.02–03 *Brékkek Kékkek Kékkek Kékkek! Kóax Kóax*
 Kóax! Ualu Ualu Ualu! Quaouauh!
 .07 *apeal*
 .08 *a toll, a toll*
 .10–11 *with what strawng voice of false jiccup!*
05.03 *larrons o'toolers clittering up*
 .03–04 *tombles a'buckets clottering down*
 .09 *Hohohoho*
 .11 *Hahahaha*
 .15 *thunder of his arafatas*
 .16 *that shebby choruysh of unkalified*
 muzzlenimiissilehims
 .31 *fargobawlers*
 .32–33 *megaphoggs*
06.06 *all the uproor from all the aufroofs*
 .11 *lute*
 .16–17 *duodisimally profusive plethora of*
 ululation
 .18–19 *And the all gianed in with the shout-*
 most shoviality
 .21 *Some in kinkin corass, more, kankan keening*
 .22 *Belling him up*
 .24–25 *E'erawhere in this whorl would ye hear sich a din again?*
 .25–26 *With their deepbrow fundigs and the dusty fidelios*
 .28 *Tee the tootal of the fluid hang the twoddle of the*
 fuddled, O!
 .29 *Hurrah*
 .36 *baywinds' oboboes shall wail him*

Figure 19. John Cage, *Listing Through Finnegans Wake (Chapter I)*

CATEGORIES AND NUMBER OF ALL SOUNDS USED IN *ROA-RATORIO*
(Hand-written facsimile: Poster (9))

A. LISTING THROUGH FINNEGANS WAKE:

	Part I	Part II
Thunderclaps	6	4
Thunder rumbles and earthquake sounds	29	27
Laughing and Crying (Laughtears)	64	100
Loud voice sounds (shouts, etc.)	31	22
Farts	5	5
Musical instruments (short)	66	96
Bells, clocks, chimes	28	42
Guns, explosions	32	36
Wails	7	11
Animals and particular birds	56	113
Music (instrumental and singing)	57	145
Water	34	24
Birds (in general)	16	18
Singing	64	72
	495	715
		495
B. PLACES		1210
		1083
Grand Total		2293

Figure 20. John Cage. *Categories and Number of All Sounds Used in Roaratorio.*

But Cage's text also assaults the composition of the sentence itself. One function of the mesostic "writing through," as he performs it, is to call into question the *grammaticalness* of the parent text. "Thoreau," remarks Cage, "said that when he heard a sentence, he heard feet marching. And I think that sentences still clearly exist in *Finnegans Wake*. Whereas in ancient Chinese language the sentence—as we know it— doesn't to my mind exist, because you're uncertain in the ancient Japanese or Chinese language . . . whether a noun is a noun, or whether it's a verb or whether it's an adjective. So that you don't know the relationship of the words. And a single poem can move as a single word in Joyce . . . a single poem can move in many different directions to appeal to the understanding" (85).

Making it New, in this context, means "mak[ing] it less like sentences." Compare the following extracts:

Joyce: The great fall of the offwall entailed at such short notice the pftjschute of Finnegan, erse solid man, that the humptyhillhead of humself prumptly sends an unquiring one well to the west in quest of his tumptytumtoes: and their upturnpikepointandplace is at the knock out in the park where oranges have been laid to rust upon the green since devlinfirst loved livvy.

Cage: pftJschute
 sOlid man
 that the humptYhillhead of humself
 is at the knoCk out
 in thE park

Despite all its punning, compounding, rhyming, phonemic play, and onomatopoeia, Joyce's sentence relies on grammatical logic: the Humpty-Dumptyan fall off the wall brought about the "pftjschute" of Finnegan, that once-solid man, his head coming to rest at the Hill of Howth, his upturned toes at Castle Knock in Phoenix Park, where the invading Orangemen ("oranges") have been laid to rest ("rust") upon the Green ever since the first Dubliner ("devlinfirst") loved the river (Anna) Liffey. Joyce's text calls for such translation, even if no translation can exhaust its possible meanings.

Cage's stanza rejects even this much logic and linearization transforming narrative into image-field. The "knOck out / in thE park" becomes, first and foremost, a crash of spirants and stops—/p/, /f/, /t/, /th/, /s/,

KATEGORIE *TIERGERÄUSCHE*
entwickelt aus der (gegenüberliegenden) *Liste mit Geräuschen.*

CATEGORY *ANIMAL SOUNDS*
developed from *Listing through Finnegans Wake.*

Animal sounds.

4.02	frogs	✓
10.33	dogs whining (or a dog)	✓
40.05	horse neighing . bl. 282	✓
53.18	deer Hirsch , Wild bl. 137	✓
.19	cows (with bells on) bl. 123	✓
54.07	dogs bl. 7	✓
60.03	horse urinating	✶
61.02	turtle doves cooing G.97	✓
95.36	laughing jackass (kookaburra G.18	✓
98.17	birds chirping	✓
99.01	ducks quacking	✓
111.07	chickens scratching the earth	✓
117.07	bird's cry	✓
124.25	chickens playing	✓
131.19	birds in a nest	✓
133.01	bees	✓
136.35	sparrows singing	✓
141.36	grackles (a kind of bird) done	
144.24	horses trotting (or a horse) bl. 189	✓
150.25	lion's roar	✓
153.36	jackasses laughing and braying	✓
170.35	pigs grunting G.12	✓

Figure 21. John Cage. *Category Animal Sounds.*

/sh/, /d/, /k/—so to speak "knocking out" the nasals and liquids and drumming the long and short vocalic /u/ of "PftJschute," "humpt-," and "humself" and the /ah/ of "sOlid" and knoCk" into the listener's consciousness.

But this is not to say the stanza denies the words any meaning; rather "pftJschute" now stands as a kind of appositive to "sOlid man," a "humptYhillhead of humself," whom the very next stanza further identifies as "Jiccup / the fAther." Indeed, Cage's mesostic technique becomes a way of insisting, contra Aristotle, that there is no such thing as a syllable without meaning, no such thing as an article or function word that acts only as a joint (*arthron*) between significant members like nouns and verbs.[7] And it is in this sense that *Roaratorio* is, in Cage's words, "a sacrilegious homage" to Joyce, an homage that resembles *laughtears* (83).

So far, I have been speaking only of the verbal elements in *Roaratorio*. The "plot" is of course also "thickened" by the "musical" soundings of the piece, the intricate layering of drumbeat and thunderclap, water flow and birdsong, Irish dance tune and frog croak, that weaves in and out of the composition even as the voice, first heard as a solo, continues its recitation.[8] "I wanted," Cage tells Schoening, "to make a music that was free of melody and free of harmony and free of counterpoint: free of musical theory. I wanted it not to be music in the sense of music. . . . I wanted the music to turn itself toward *Finnegans Wake*. And away from music itself. So I used this text as a ruler with its lines and pages. Then I could list the sounds in *Finnegans Wake* and identify them according to page and line, and then I could put them on the tape in the hour where they at the moment belong" (89).

Let me try to clarify how this process actually worked. The first step was to make a tape recording of the recital of the text, "using speech, song, chant, or *sprechstimme*, or a mixture or combination of these" (173). This provided "a ruler in the form of a typed or printed text and in the form of a recited text, both of them measurable in terms of space (page and line) and time (minute and second), by means of which the proper position . . . of sounds [might] be determined." Thus the word "Jiccup," in the third stanza is measured spatially as 4:11 (page 4, line 11), and temporally as 14 seconds into the hour.

The next step was to make a list of places mentioned in the *Wake* as those places are identified in Louis Mink's *A Finnegans Wake Gazetteer*, and a list of the pages and line where the mention is made for each. Since

there are so many places cited, Cage then decided to limit the total number to 626, the number of pages in his copy of the *Wake*, and these 626 places were selected by chance operations and tabulated. Next Cage commissioned as many people as necessary to go to the place in question and make a recording of between 30 seconds and five or ten minutes. The recording was to be made simply by "accept[ing] the sounds which are in the place you go to" (119); Cage himself travelled around Ireland with friends recording sounds of, say, dogs barking or chickens cackling or the wind blowing as the church bells ring. These sounds are then arranged along a ruler, again made by measuring the page and line where the place name appears in the *Wake* and transferring the ruler from space to time.

The place names thus generate one set of sound tracks. A second one was made by listing all the sound references in the book (see figure 19), reducing them by chance operations, and establishing families of sounds, as in figure 20. These sounds are again transferred from their spatial position to a temporal one: for example, the reference to "the song of sparrownotes on his stave of wires" means that we hear sparrows singing at the corresponding point in time on the hour-long tape (see figure 21). But note—and this is very important—that at the point where we hear the sparrow song, the spoken mesostic text, which does not, of course, include all the sounds listed, is by no means referring to it. For Cage such an obvious correspondence between speech and sound would be much too uninteresting.

Finally, a whole program of "relevant musics" was recorded on yet another multitrack tape. Joe Heaney, "the king of Irish singers," was enlisted to perform and he urged Cage to include four Irish instruments—"the flute, the fiddle, the bodhran, which is a drum, and the Uillean pipes," the latter to be played by the Dublin musician Seamus Ennis (92–93). Thus, while Joe Heaney sings such familiar Irish songs as "Dark is the colour of my true love's hair" and "Little red fox," Seamus Ennis plays "The boys of blue hill" or the "Derry hornpipe" on his pipes, even as variations on jigs, reels, and Irish drum songs alternate with mazurkas and polkas.[9]

Place-related sounds, sound-references in the *Wake*, and actual musical sounds—these are finally superimposed on one another by a series of mathematical operations, the collection of sixteen multitrack tapes being reduced to a single one. "The material," says Cage, "is then a plurality of forms"; it has "what Joyce called 'soundsense' " (103). Whereas the language of normal communciation—say, this lecture—

remains linear, what Cage calls "purposeless" conversation, say, the conversation between two people who have lived together for a long time and talk baby talk or say things like "Ooh! Ooh!" to one another, contains, so Cage believes "more amusing sounds." As an Irish Circus, *Roaratorio* encompasses them all.

At one point in the interview, Schoening asks Cage whether it doesn't matter that the sound track often drowns out the reciter's voice so that the words cannot be understood. To which Cage responds, "But this is our experience in life every day. Wherever we are a larger amount of what we have to experience is being destroyed every instant. If for instance . . . you go to a museum where you would think that you have . . . peace and quiet as you are looking at the Mona Lisa someone passes in front of you or bumps into you from behind" (101–3). Accordingly, the layering of sounds in *Roaratorio* is meant to resemble, not "white noise," as one of Cage's composer friends suggests, but what Cage calls "black noise," which is to say, a "sphere of sounds coming together." But, in keeping with the circus format of the whole, these sounds never coalesce or merge; they retain their individual identities, thus forcing the listener to be unusually attentive.

What kind of art work (or is it an art work?) do we have in *Roaratorio?* Let me try to tease out the implications of what Cage is doing, implications that tell us a good deal about the difference between our avant-garde and that of the early century.

Let us consider first Cage's deconstruction of the Wagnerian *Gesamtkunstwerk*. Whereas what Peter Bürger calls "*the* avant-garde" produced works that were primarily verbal (say, *Finnegans Wake*) or visual (an Arp sculpture, a Malevich painting) or musical (a Schoenberg piano piece) or, when intermedia, works that combined poetry *and* painting or poetry *and* musical sound, the Cage of *Roaratorio* makes no attempt to combine the verbal and the visual or the verbal and the musical, his aim being, on the contrary, to produce a system of differences, in which each sign or set of signs can retain its own identity. Thus the generating mesostic *JAMES JOYCE*, upon which much of the *writing* depends is never fully present on the aural level, the two *e*'s being silent, and all but the letters *j* and *m* having more than one phonemic value. Conversely, the *sprechstimme*, chanting, singing, and whispering used by Cage in the actual performance of the text are never fully present in the written version. Again, the musical sounds heard—say, an Irish jig tune—do not "accompany" the words, and the words are not in fact "set to music." On the

contrary, word, melody, natural sound, animal cry, waterfall, or thunderclap remain independent of one another even though the sounds chosen by mathematical calculation exist somewhere in Joyce's text. As such, the text all but eliminates the mimesis of emotion that occurs in, say, a Hugh Ball Dada sound poem, it being pure chance, in *Roaratorio*, whether the hoot of an owl coincides with a reference to the "dEprofundity / of multmathematical immateralitieS" (R 58) or with the account of how "girlsfuss over him pellmale their *Jeune premier* / mussing his frizzy hAir" (60).

This brings me to a second point. The idea of the book, so central to Mallarmé and the Symbolists, central too to the Joyce of *Finnegans Wake*, an idea that, as Gregory Ulmer notes, depends on the notion that a totality of the signified preexists the totality of the signifier (16), is challenged by the new electronic media of our time, that call into question its inherent linearity, its sequential page format, its movement from some beginning—even the beginning of a cycle—to the end point of the late page. It goes without saying that a work like *Roaratorio* is an homage, not only to Joyce, but to the technology of multitrack tape recorders and computers. The work "speaks" at every turn of the placement, in Connemara or Carnsore Point, in Agincourt or Swabia, of someone's recorder that produced a short segment of sound, even as the poet's own voice is superimposed or supraimposed upon that segment. Without the "new technology," *Roaratorio* could not exist: this is surely one of the most important things *Roaratorio* "says."

Again, it is technology, at least in part, that makes possible the collage-mode of *Roaratorio* and of other postmodern works like it. I spoke earlier of Cage's "citational graft," of the displacing of "found" elements from one context to another. Collage was, of course, one of the central modes of Modernism, [10] but here the *collaging* is much more flexible, any conceivable extant message or material being potentially absorbable into the larger decentered text. Accordingly, what has been called by the poet Charles Bernstein (239) the "transom theory of communication" (me>you)" gives way to "black noise" in which traditional "intentionality" is irrelevant in the face of a more communal, what Cage calls a more "eucharistic" form of sound poetry.

Eucharistic, as well, in its denial of autonomy to the art object. The layering of voices (reciter, musical compositions, place-associated noises, noises generated from *Finnegans Wake*) defies logocentrism more thoroughly than do the great avant-garde experiments of the Futurists

and Cubists, of Dada and Surrealism. Even Duchamp's urinal-turned-fountain, after all, is a single, recognizable object that can be distanced from the viewer and commented upon. But *Roaratorio* functions as what I have already called, following Derrida, a "system of differences and traces," each element functioning as sign only by referring to another element. The distance between art work and audience thus breaks down; we cannot step back and interpret the text as totality; we can only make a so-to-speak horizontal investigation of the possible meanings simultaneously available in the words themselves. Indeed, the signs are always characterized by their duality—they mean something different within the frame of *Roaratorio* from what they mean in their parent text. The sound of the bodhran, for example, signifies differently when it is heard simultaneously with Cage's voice or with the barking of dogs in *Roaratorio* than if it were heard by itself. The materiality of the signifer, that is to say, thus takes precedence over that which is signified.

It should be evident by now that a work like *Roaratorio* has little in common with the "neo-avant-garde" works contemplated by Bürger or Buchloch: the "pieces of pipe" to be sent to museums so as to "shock," the "blue" paintings of Yves Klein, and so on. "Writing through" *Finnegans Wake*, it turns out, is very different from *rewriting* Joyce's great Modernist novel. But the "system of differences and traces" that characterizes *Roaratorio* remains something of a mystery to us. Its mathematically-generated structure—the use of the *Wake* as "ruler," the parallelisms of the spatial and the temporal, the recording of sounds from all the *Wake* places and their coordination with the sounds described by Joyce—is at least as difficult for us to perceive as was Pound's use of Greek meters and Chinese ideograms in the supposedly chaotic *Cantos*.

Accordingly, we will, for some time to come, read "Letters to the Editor" like the following from one William Goldstein, published in the *Los Angeles Times* for 22 March 1987, in response to a piece by Donna Perlmutter, describing Cage's role in the New Music America Festival:

> REAR GARDE
> To call John Cage a composer is an insult to the great masters of the past, as well as to those who are trying to create music that touches the nobler parts of our being.
> . . . by definition a composer is one who organizes and "controls" his material. Cage sets out with the idea of trying to "create" chaos and disorder .
> . . and attempts to "create" works which are not only bereft of any relationship to the human condition, but which are entirely out of sync with the

universe. After all, the universe has order, the universe has structure; the universe even has rhythm and harmony, and, oh yes—if you listen carefully—*even melody*.

When was the last time that any of us could apply adjectives such as beautiful, sublime, graceful, or inspiring to works of the avant-garde? (91)

When, indeed? Is it true that, as Hal Foster claims, "Shock, scandal, estrangement: these are no longer tactics against conventional thought—they *are* conventional thought" (REC 26)? Or is the concept of "shock, scandal, estrangement" itself part of the myth of repetition that we must explode?

NOTES

1. When the first edition of Bürger's book appeared in 1964, it prompted such discussion in Germany that its publisher, Suhrkamp Verlag, issued a book of responses that was more than twice the size of Bürger's own book. In the second edition (1980), Burger takes up some of the issues raised.

2. In his Foreword to the English edition (1984), Jochen Schulte-Sasse writes: "In its accurate and historically reflected definition of the avant-garde, Peter Bürger's *Theory* can hardly be overestimated" (xlvi). Cf. the Introduction to Chapter VII, "Perspectives sociologogiques," in *Les Avant-gardes littéraires*, II, 1034–36.

3. It is only fair to note that the later Barthes would probably not have subscribed to this early (1954) "radical" statement. Indeed, the irony is that Barthes was to become himself one of our notable avant-garde writers, his experiments with media and genre breaking genuinely new ground.

4. The relationship of the "aesthetic" avant-garde to political radicalism is extremely problematic and requires an essay of its own. Suffice it to say here that in the last few decades the two have gone in almost opposite directions. So-called "radical" literature has frequently adopted a mode of nineteenth-century realism, of straightforward polemic that seems, both artistically and philosophically, retrograde. Clearly, one of the major differences between the early twentieth century avant-garde and ours is that theirs tried to fuse aesthetic and political radicalism. But even this fusion was far from complete, the radical mix of art and politics espoused by, say, the Russian Futurists soon earning the scorn of the Leninist and Trotskyite revolutionaries.

5. See, for example, Bernheimer, *Los Angeles Times:* 7.

6. See Derrida, *Glyph*: 185; *Marges*, 381. Cf. Ulmer, 58–59.

7. I am indebted here to Gregory L. Ulmer's excellent discussion of Derrida in *Applied Grammatology*, Chapters 1 and 2 passim, esp. pp. 26–27, 58–59. See also Ulmer's "The Ojbect of Post-Criticism," in Hal Foster (ed.), *The Anti-Aesthetic*, pp. 83–110, and esp. the discussion of Cage's relationship to Derrida's theory on p. 101–107.

8. When this essay was presented as a lecture, I stopped at this point and played some passsages from the tape of *Roaratorio*. Since the present format makes it impossible to include examples of the sound and since there is no conventional score to be followed, the reader must bear with me here.

9. See pp. 144–45 for a complete listing of the participating musicians, the musical pieces played by each one, and their time of entry.

10. See my chapter, "The Invention of Collage," in *The Futurist Moment*, pp. 44–79.

WORKS CITED

Barthes, Roland. *Essais critiques*. Paris: Editions du Seuil, 1964.

Bernheimer, Martin. "A Musicircus Kicks Off Festival Honors for Cage," *Los Angeles Times* 7 September 1987, pp. 4, 7.

Buchloch, Benjamin. "The Primary Colors for the Second Time: A Paradigm Repetition of the Neo-Avant-Garde." *October*, 37 (Summer 1986): 41–52.

Bürger, Peter. *Theory of the Avant-Garde*. Trans. Michael Shaw. Foreword by Jochen Schulte-Sasse. Minneapolis: University of Minnesota Press, 1984.

Cage, John. *For the Birds. John Cage in Conversation with Daniel Charles*. Boston and London: Marion Boyars, 1981. Cited in the text as FB.

———. *Roaratorio. An Irish Circus on Finnegans Wake*. Sound and Text. Ed. Klaus Schoening. Koenigstein: Atheneum Verlag, 1982.

———. *Silence*. Middletown, Ct.: Wesleyan University Press, 1961.

Derrida, Jacques. *Margins of Philosophy*. Trans. and ed. Alan Bass. Chicago: University of Chicago Press, 1972.

———. "Signature Event Context." *Glyph*, 1: *Johns Hopkins Textual Studies* (Baltimore, 1977).

Foster, Hal. *Recodings: Art, Spectacle, Cultural Politics*. Port Townsend, Washington: Bay Press, 1985. Cited in the text as REC.

———. (ED). *The Anti-Aesthetic. Essays on Postmodern Culture*. Port Townsend, Washington: Bay Press. Cited in the text as AA.

Huyssens, Andreas. *After the Great Divide: Modernism, Mass Culture, Postmodernism*. Bloomington: Indiana University Press, 1986.

Johnston, Jill. "Jigs, Japes, and Joyce." *Art in America*. 75 (January 1987): 102–05.

Joyce, James. *Finnegans Wake*. New York: The Viking Press, 1975.

Perloff, Marjorie. *The Futurist Moment: Avant-Garde, Avant Guerre and the Language of Rupture*. Chicago: University of Chicago Press, 1986.

Stein, Gertrude. "Composition as Explanation." *Selected Writings of Gertrude Stein*. Ed. Carl Van Vechten. New York: Vintage Books, 1962. 511–24.

Steinberg, Leo. *Other Criteria: Confrontations with Twentieth-Century Art*. New York: Oxford, 1972. Cited in the text as OC.

Szabolski, Miklos. "La neo-avant-garde: 1960—." *Les Avant-Gardes Littéraires*, ed. Jean Weisgerber. Vol. 1: 573–596.

Ulmer, Gregory L. *Applied Grammatology. Post(e)-Pedagogy from Jacques Derrida to Joseph Beuys*. Baltimore and London: The Johns Hopkins University Press, 1985.

Weisgerber, Jean. (Ed.) *Les Avant Gardes littéraires au xxieme siècle*. 2 Vols. (Volume 4 and 5 of *A Comparative History of Literatures in European Languages* Sponsored by the International Comparative Literature Association). Budapest: Akadémiai Kiado, 1984.

Zurbrugg, Nicholas. "Beyond Beckett: Reckless Writing and the Concept of the Avant-Garde within Post-Modern Literature," *Yearbook of Comparative and General Literature*, 30 (1981), 37–56.

11

The Stranger at the Door

David Antin
University of California, San Diego

In 1965 in the second issue of the magazine *some/thing* that I edited with Jerome Rothenberg, we published the following text:

<div align="center">

Excerpts from
GLOSS FOR AN UNKNOWN LANGUAGE

Tablet 3

</div>

Line	Character	
17	9	Image formed by a moving object for the duration of one breath.
31	7	An object formed by the intersection of an imaginary sphere with objects of the reference language. (Here used to describe a plano-convex section of flesh/earth).
31	8	Used by an observer standing at the edge of a body of water to denote an area of water surface in front of the observer and an area of earth of equal size and shape behind the observer, considered as one surface.

<div align="center">

Tablet 10

</div>

Line	Character	
6	4	Everything within the bounds of an imaginary cube having its center congruent with that of the observer, and an edge of length equal to the observer's height.
23	9	A verb apparently denoting the motion of a static object (The meaning is not clear.)

<div align="center">

Tablet 13

</div>

Line	Character	
19	3	A unit of time derived from the duration of dream events.
45	2	The independent action of two or more persons, considered as a single action.

It was the longest of a series of texts by the sculptor George Brecht, some of which had originally been printed on individual cards and collected in

a cardboard box designed by George Maciunas and issued in a limited series under the title of *Water Yam* by Fluxus in 1963. In the magazine they appeared under the title

GEORGE BRECHT
Dances, Events & Other Poems

between the Table of Contents and a chapter of what the Contributor's Notes referred to as Rochelle Owen's "encyclopedic novel-in-progress," *Elga*'s *Incantation*. The title was as I remember supplied by my co-editor, because Brecht was out of the country and had simply left us a pile of manuscript copy. Together with the layout, in which the smaller pieces, for purposes of economy and clarity, were printed two or three to a page with their margins staggered to maintain their separate identities, the title tended to suggest somewhat equivocally that these texts were all to be considered poems. Equivocally, because the title itself—*Dances, Events and Other Poems*—in its use of the word "other" suggests that these "dances" and "events" are also "poems" and raises the question of in what sense these texts might be poems while also being dances and events. At the same time the texts themselves raised questions about how and to what extent they were dances or events.

Taking as examples the pieces THREE YELLOW EVENTS and THREE DANCES:

THREE YELLOW EVENTS
I ● yellow
 ● yellow
 ● yellow

II ● yellow
 ● loud

III ● red

THREE DANCES
1.
Saliva

2.
Pause
Urination.
Pause.

3.
Perspiration.

it seems probable that in the Fluxus box both of these texts would have been regarded as scenarios or instructions for performances somehow to be realized by a performer/dancer. A Judson dancer might have realized the instruction "Saliva" by spitting, begun the second movement ("Pause") with a rest, then urinated in a bottle and rested (Pause) again, and concluded with a set of violent exercises leading to "Perspiration." He could have interpreted the second with a series of lamps that flashed "Yellow" and "Red" or might better have unrolled bolts of colored cloth or paper or painted them and realized the noise with a tape of hammering or a pneumatic drill or simply yelled after the fourth yellow. This would all have been well within the context of the game of interpretation between a scenarist-inventor (composer poet, artist, choreographer) and a realizer (musician, actor, installer, dancer), a performance genre that had been established in the contemporary art community since the late 1950's and is abundantly illustrated in the Fluxus oriented anthology published by LaMonte Young and Jackson MacLow.

MacLow's own 1964 publication, *The Pronouns: A Collection of 40 Dances*, is probably the most brilliant and extensive example of the "dance-instruction poem" which MacLow explains in the following way:

> The poet creates a situation wherein she or he invites other persons & the world in general to be co-creators.[1]

and in his "Some Remarks to the Dancers" specifies precisely how he means this:

> In realizing any particular dance, the individual dancer or group of dancers has a very large degree of freedom of interpretation. However, although they are to interpret the successive lines of each of these poems—which-are-also-dance-instructions as they see fit, dancers are required to find some definite interpretation of the meaning of every line of the dance-poem they choose to realize. (67)

These remarks are both definitive and explicit; and, though perhaps somewhat more explicit than some other practitioners of the instruction genre might have liked, together with Peter Moore's photographs of various danced realizations of *The Pronouns*, they indicate how well established this genre was for the early 1960's art world.

But appearing in *something* was a bit different. Even if there was some overlap—we published George Brecht, Jackson MacLow, Carolee Schneemann in this issue under the cover of a Robert Morris lead piece—our magazine was directed more to the contemporary poetry

world, which was a somewhat different audience. Since a genre is a theater of operations that is defined by the audience that comes to it and the memories of previous performances they have attended there, as well as by the nature of the site—because what tends to determine our understanding of the nature of a site is our memories of the performances we have seen there and our dreams of the performances we might some time put there—we could have expected to see quite different generic significances attributed to these texts. And in fact, by publishing them the way we did, we were promoting these differences to get a poetry-reading audience to see these verbal pieces as poems.

But Brecht's texts were not poems in the same way as MacLow's, who considered himself a poet, called his texts poems, performed them at poetry readings as well as in concert settings, and published them in literary magazines. Moreover, however strange they might have been verbally to a conservative poetry audience that required poems to consist of more or less grammatically well-formed and semantically perspicuous utterances that expressed the psychological state (usually intense) of some plausible speaker (James Wright, for example), most of MacLow's poems should have satisfied another of the requirements of this Romantic poetics. They were very musical—in that they were marked by arbitrary phonological and intonational play, though more in the manner of Gertrude Stein than William Butler Yeats. Still, to an audience for whom Gertrude Stein was a poet, and so for the only people we took seriously, Jackson MacLow was clearly a poet. But George Brecht was another matter. It is a considerable distance from MacLow's *8th DANCE: MAKING SOMETHING NARROW AND YELLOW* (on the pronoun "We")

We make some glass boil,
& we have political material get in,
& we make some drinks,
crying,
seeing danger,
& making payments,
& all the time we seem to put examples up.

Then we do something consciously
& we name things.

Afterwards we quietly chalk a strange tall bottle.

We question each other

while we do something down on the floor,
attacking each other at times,
but never stopping our questioning,
and always reasoning regularly.

We number some things or some people
& we page some of the people,
& either we harbor poison between cotton or we go from
 breathing to a common form
while we skirt a rod,
and then again we harbor poison between cotton or we go
 from breathing to a common form
while we're doing waiting,
like someone awaking yesterday when the skin's a little
 feeble;
but each of us has an instrument,
& we go under
as anyone would who awakened yesterday when the skin's
 a little feeble;
afterwards we're being red enough;
we walk,
we rail,
and once more harboring poison between cotton or going
 from breathing to a common form,
we're finally doing waiting. (21–22)

to George Brecht's

TWO SIGNS

- SILENCE
- NO VACANCY

or the untitled

<center>*</center>

Three of them were the same size, and two were not.

But for us this distance was not so great as to obscure their family relationship within the great genre of poetry, which for us was a superordinate genre—the language art, not the microgenre synonymous with verse and based primarily on a distinction however tenuous from prose. From the very beginning as editors of *some/thing*, we were completely uninterested in the verse/prose distinction promoted by the neoclassical essayists following the lead of Eliot and Auden.

Our first issue began with a selection of Aztec definitions collected by
the Franciscan friar, Bernardino de Sahagun a few decades after the
Conquest.[2] In his preface Rothenberg introduced these texts, which he
called *Found Poems from the Florentine Codex*, with a short account of the
collapse of the great Indian civilization and the fragmentation of "that
archaic system, fixed in ritual and myth" that "had been wrenched from
them." The survivors, Rothenberg suggests, had a "need to preserve the
potency of the real by a regular overturning of primary beliefs," a task to
which they were stimulated by Sahagun's project of compiling a record
before they vanished of The Things of New Spain. To this accounting
they brought a vast assemblage of their gods, their days, their signs and
omens, their sacrifices, their songs, their defeats, and in the midst of this
collection they appear to have compiled a list of definitions of terms for
the simple things of their lives—rocks, birds, plants, trees, implements,
topographical features.

The Precipice

It is deep—a difficult, a dangerous place, a deathly place. It is dark, it is
light. It is an abyss.

A Mushroom

It is round, large, like a severed head.

Here according to Rothenberg "we can draw close to them, can hear in
these 'definitions' the sound of a poetry, a measure-by-placement-&-
displacement, not far from our own," different from their songs and
hymns collected by Sahagun and others, which "has its own goodness" as
"part of the fixed world before the upheaval." But only these definitions
participated fully in a freedom that was, in our view at that time, more
important than whether they were intended as poems or not. "For
surely," the preface concludes, "it should be clear by now that poetry is
less literature than a process of thought & feeling & the arrangement of
that into affective utterances. The conditions these definitions meet are
the conditions of poetry." I would probably, even then, have put this a
bit differently, but I am still convinced, as I am sure Rothenberg is, that
these Aztec definitions meet the conditions of poetry, or perhaps more
precisely that it is not worth while to define a set of conditions for poetry
that would exclude them.

This question of necessary and sufficient conditions qualifying a work
for entry into a genre is really a central issue for the concept of genre, but

it is often confused with the related but somewhat different question of genre definition. Genre definition may be a futile pursuit because culturally well-established genres with a long history like poetry, as Aristotle's famous essay seems to demonstrate, may be embarrassingly difficult, or even impossible to define in a compact and nontrivial way. But new works are continually being proposed for inclusion in established genres and judgments are constantly being made about the suitability of their candidacy. The history of modern art is filled with accounts of well known critics confronting works that they declare are not "painting" or "music" or "theater" or "dance," only to be answered by others that what they have been confronting is indeed and for certain very good reasons "painting," "music," "theater," or "dance."

These arguments about genre membership have rarely if ever proceeded from definitions of the genre to an examination of the candidate's qualifications. Probably this is so because very few people educated in art feel confident in sweeping definitions of a terrain in which they have experienced as much anxiety and effort as pleasure and conviction, but also because it simply seems the wrong way to go about it.

The negative critic, when not simply outraged, usually proceeds by identifying the absence of some single feature of the new work that he or she regards as an indispensable attribute of all genre members or, alternatively, the presence of a feature that is antithetical to such an attribute. In fact this indispensable attribute is almost inevitably merely a marked feature of all members of some favored subgenre. So for Robert Frost or Allen Tate "formal versification" was the indispensable attribute of poetry, for Stanley Cavell pervasive "compositional choice" the indispensable attribute of music, while for Michael Fried the "literalness" of Minimal Art was antithetical to art, or at least to "modernist" "painting."[3]

The tactic of defenders is to connect some fundamental feature or features of the new work with some feature or features of members of apparently legitimate though not currently dominant subgenres, or with an insufficiently marked feature of a dominant subgenre. This was the point of connecting Whitman's free cadences to the cadenced prose of the King James Bible and the rhapsodic verse of the Hebrew prophets, of connecting Satie's *Gymnopédies* to plainsong and Gregorian chant, earthworks to Stonehenge, or Happenings to collage.

These tactics can be convincing or unconvincing, brilliant or trivial, as the connections are fundamental or inconsequential. What most

convincing arguments of this type have in common is some way of deepening our sense of the tradition of the genre and of art by articulating some hitherto unknown and consequently unforeseen productive line of play that will allow the genre to continue to satisfy our needs. It appears to be this kind of game that keeps a genre alive once it has developed to the point of general recognizability. This seems evident from the fate of opera which, as long as its patrons and performers regard it as a museum art all of whose creators are dead, counts as an extinct species until some composer like Philip Glass with a band of collaborators attempts a new kind of dramatic musical spectacle that restores it to the condition of an endangered species.

So in the case of the George Brecht texts, I believe we saw in them something new that revealed the existence of an insufficiently marked and indispensable poetic tradition. His *TWO SIGNS* joins a line that connects ways of working as diverse as Frances Densmore's translations of Chippewa songs, the Englished versions of Japanese haiku, and a singular poem from Gertrude Stein's *Tender Buttons*.

> The two signs
> - SILENCE
> - NO VACANCY

extricated from two discrete worlds—a recording studio and an apartment house window—come together to gloss John Cage's famous observation that in the supposed total silence of an anechoic chamber you can still hear the sounds of your nervous system and your blood circulating. So SILENCE becomes a place where there is NO VACANCY, as the cup that you empty of water is not truly empty because it's filled with air. The operation of mind invoked here to make sense of this brief text is very close to that required for Issa's haiku

> one man
> one fly
> one big guest room

where a single fly measures the magnitude of the empty guest room, or Buson's

> on the temple bell
> a butterfly
> sleeps[4]

with its two scales of sleep from which both bell and butterfly may wake together, briefly. What is interesting about these works—their conceptual brilliance, which is illuminated by the Brecht poem, seems even more pointed in translation, that strips them of the particular excellences of the Japanese language and verse, and releases into English a new mental poetic power. This power is also invoked by translations of American Indian poetry. I think particularly of Frances Densmore's translations of Chippewa songs.

SONG OF THE BUTTERFLY

In the coming heat
 of the day
 I stood there.

or

MAPLE SUGAR

Maple sugar
 is the only thing
 that satisfies me[5]

which disdain poetically conventional "musical" devices for an intense concentration and a mysterious elegance of tempo and focus that create the image of a purely mental "music" independent of symmetry, repetition and jingling, strangely similar to that singular poem of Gertrude Stein, a poet by no means averse to symmetry, repetition or jingling, *A WHITE HUNTER*:

A WHITE HUNTER

A white hunter is nearly crazy.[6]

This poem goes off like a rocket and leaps out of the semantically fractured text of the rest of *Tender Buttons* with such piercing clarity you can easily forget that you have no idea what it refers to. At the very least there is this image that always comes to me as the all white silhouette of a man in pith helmet and safari clothes projected against the black map of darkest Africa—a silhouette drawn so taut it must surely break and is therefore "nearly crazy," and while such a response is not literary criticism, something of this tense polarity of white and the implied black must be invoked for any reader, stretched to its breaking point at "nearly" and shattered on the word "crazy." If the poem hadn't been written in 1913 one might have to think of it as a deadly image of

Hemingway, for whom it could have served as an epitaph; but since it was written too early for that, I like to think of it as an arrow waiting for its target.

Now as I go over this series of works with family resemblances that group themselves around the George Brecht texts—the Aztec definitions, the Densmore Chippewa songs, Stein's *White Hunter*, I begin to see other poems that come to join them—Ezra Pound's "Papyrus," and "In A Station of the Metro," William Carlos Williams' "Red Wheelbarrow"—and this suggests a whole new set of works that might follow out from them as a set of possible consequences: Jerome Rothenberg's *Sightings*, Robert Kelly's *Lunes*, some of my *Meditations* . . . This list could easily be extended, but I believe this family grouping as I have sketched it out is still too narrowly framed.

Suppose we return to one of Brecht's longer texts, TWO DE-FINITIONS, which reads

- 1. Something intended or supposed to represent or indicate another thing, fact, event, feeling, etc.; a sign. A portent. 2. A characteristic mark or indication; a symbol. 3. Something given or shown as a symbol or guarantee of authority or right; a sign of authenticity, power, good faith, etc. 4. A memorial by which the affection of another is to be kept in mind; a memento, a souvenir. 5. A medium of exchange issued at a nominal or face value in excess of its commodity value. 6. Formerly, in some churches, a piece of metal given beforehand as a warrant or voucher to each person in the congregation who is permitted to partake of the Lord's Supper.

- 2. (a cup and saucer)

These are dictionary entries. The form is familiar. Perhaps they've been modified by subtraction, though the first one seems literal enough. But here they are evidently serving a quite different purpose, because the dictionary is being run in reverse. We habitually go to dictionaries to find definitions of terms we have in hand but with whose usages we are unfamiliar. Here we are given a family of usages that cluster around an unknown term. On their own, these usages seem almost as diverse as the members of a genre. They are queerly related and queerly different—a memorial of affection, a piece of metal, a medium of exchange. Taken all together this definition presents an odd list of actions that you have to think about several times as you work your way up and down the list before you try to guess at the word that unites them—TOKEN—which

then takes on a new life surrounded by all this history when you've finally guessed it.

So this text invokes a family of poems, not so popular now, but with a long history—the riddle—and gives it a new life in contemporary terms, as it turns the dictionary into a possible anthology of riddles by reading its entries in reverse and cropping them of their normal function. But it also calls for family membership with texts of Marcel Duchamp or Joseph Kossuth, though perhaps more faintly when we read the second definition

• (a cup and saucer)

where the possibility of satisfactory solution is denied because there aren't enough clues to tell whether you have the right answer or not; and the impact is mainly made by the rhetorical tactic of an abrupt scale shift from the copious first definition to the sparse and enigmatic second, which gives the work something of a joke structure as it seems to say "you've solved the first one smart guy, try this."

As Brecht's TWO DEFINITIONS opens up a line of connection to riddles and conceptual art, his excerpts from GLOSS FOR AN UN-KNOWN LANGUAGE open in yet other directions. Once again we are dealing with lexicography, but here the lexicon is a selection of translations of presumably problematic words from a text recorded on tablets in some other language. Unlike Armand Schwerner's TABLETS,[7] which may as well have been suggested by this work as by Kramer's Sumerian translations, Brecht's text has none of the impulse toward lyrical though fractured speech, and all of the interest is focussed on the significance of the terms and our need to imagine a possible world in which they could apply. This brings Brecht closer to Wittgenstein than to Schwerner.

Though the conceptions implied by some of these terms are from our point of view decidedly eccentric, they are nevertheless imaginable. In Table 3 we encounter

Line	Character	Image formed by a moving object for the duration
17	9	of one breath.

which suggests a strongly apperceptive and perhaps kinesthesically oriented society with a powerful interest in the measurement of their most fleeting perceptions. Tablet 13 at Line 19, Character 3 yields—"A unit of time derived from the duration of dream events," which is open to at least two crucially different interpretations: this is a society that has found a method of measuring dream events "scientifically" by rapid eye

movement or EEG or some unknown but sophisticated device of technologically advanced civilization; or it is a kind of ritual knowledge such as an Australian aborigine might have had of the "dream time" and sacred happenings within it. In the latter case we know less, because we don't have any idea what the event measuring would be like. Still, it is even possible to speculate on a society that combined both the technological and ritualistic orientation to the dream. In both cases we may have entered into the genre of science fiction.

In Tablet 10 at Line 6, Character 4 we have a unit of conceptual organization, "a cube having its center congruent with that of the observer," in which the observer is embedded as in a kind of three-dimensional Vitruvian space frame that, though apparently odd in its extraordinary precision—having "an edge of length equal to the observer's height"—could be conceived as relevant to the extreme body sensitivity of these people and their strong awareness of proximate objects. This heightened awareness of objects behind as well as in front of the observer appears also in Character 8, Line 31 of Tablet 3, where an observer standing at a shore takes note of both the area of water surface in front of him and the equal area of earth behind him as a single unit. It also indicates, somewhat more obviously, a riparian or littoral culture or at least a culture that attributes some importance to the shore. This is the kind of imaginary anthropology that is invoked by Kafka's *In the Penal Colony* or better-grade science fiction. But of course it is not saddled with a story to tell or even a complete landscape to depict, it merely sets up suggestions of a culture we are invited to conjecturally imagine on the basis of scanty evidence.

Then there are the completely absurd or paradoxical entries, like Line 23 Character 9: "A verb apparently denoting the motion of a static object. (The meaning is not clear.)," which last comment like most of the footnotes of Schwerner's scholar translator, calls as much attention to the comic pathetic plight of the "translator" as the absurdity of the text. Whereas the gloss for Character 2, Line 45 in Tablet 13 evokes a fundamental paradox.

"The independent action of two or more persons"—a man zipping up his pants while his neighbor's wife sues her employer—may be loosely conceived as simultaneous events, in a sense, perhaps as metaphorically connected or as equivalent, or even identical from a certain perspective; but an event isn't an action, which we think of in relation to the idea of an agent. As long as multiple equivalent actions have distinct agents, we

can't imagine how to think of them as a single action if we are to continue to make sense in the language we call English. The idea is, so to speak, ungrammatical. Of course one point of this *GLOSS FOR AN UN-KNOWN LANGUAGE* is to suggest the possibility of another language in which ideas that are "ungrammatical" in our language might be "grammatical," or to allow us to decide whether some ideas that seem logically possible and therefore in our sense grammatical are in fact fundamentally illogical and ungrammatical for any language we can imagine, if this gloss has provided a truly adequate translation. Naturally, it is always possible that the translation may be at fault.

The impulse to this sort of speculation connects GLOSS FOR AN UNKNOWN LANGUAGE to works like Wittgenstein's *Philosophical Investigations* or even to the *Tractatus* and appears to draw them into its orbit: if A is a relative of B, B is a relative of A; and they are both members of the same family. I have on another occasion argued the case for consideration of the *Tractatus* as a poem, but it is not really relevant to the issue here. It may be that the *GLOSS* and the *Tractatus* are constructed out of the same kind of materials but are different kinds of buildings. What I am trying to show is the way the notion of genre operates and has operated as a generative force in the world of radically contemporary art and poetry.

In this context the George Brecht texts are typical in that their candidacy for membership in the genre of poetry appeared to us at the time as both questionable and desirable, as did just about all of the works we found most interesting and powerful—Cage's lectures, the whole range of MacLow's random and partially random texts from the *Asymmetries* to the Presidents and the *Light Poems*, all of Gertrude Stein, the Aztec Definitions, and a great family of texts generated from "primitive" and modern performance and conceptual art works.

This list might suggest, as it probably has suggested to neoconservative critics, that the sole purpose of proposing such works for genre membership—they would probably say "for inclusion in the canon"—is an absolute lack of fit and consequent suitability as instruments of a traditional avant-garde intention to shock. But a questionable fit is unlike either an absolute fit or absolute lack of fit. It is more like an uncertainty about a strangely resembling foreigner presenting himself at a doorway and seeking recognition as a family member, a situation that calls for a kinship search perhaps involving possible affiliations with quite remote ancestors or merely peripheral relatives. This exercise in

kinship analysis has been one of the most fruitful aspects of post-second World War avant-garde art activity, but it has certain surprising historical precedents.

It is well known that Aristotle in the *Poetics*, following Plato and possibly a widespread Greek cultural understanding, accepted imitation (mimesis) as the common feature of all art, of which the *Poetics* served as a full philosophical defense, primarily against Plato's attack in *The Republic*. But what appears to have escaped notice is that in postulating imitation as the defining feature of all art, and imitation through language as the defining feature of poetry, Artistotle was able in the very next passage to propose several radically new candidates for inclusion within the genre of poetry—the mimes of Sophron and Xenarchos and most pointedly the Socratic dialogues—a piece of dialectical judo that allowed him to cast his old teacher as a poet and member of the same class he had exiled from his Republic precisely because of the common commitment to imitation. The comedy of this reversal, which is presented deadpan and somewhat elliptically, could not conceivably have escaped the notice of Aristotle's contemporary audience, who would surely have understood that they were being presented with an elaboration of Plato's own theory with its values reversed, in a version where the notion of reversal (peripety) plays so strong a role. The comic effect must have been greatly enhanced by the fact that the passage in question never once mentions Plato's name.

But if it was rhetorically necessary to sweep the mimes of Sophron and Xenarchos into the net of poetry for Aristotle to catch the Socratic dialogues without revealing that it was Plato himself he had set out to trap, Aristotle had to place himself in the avant garde position of presenting not one but three candidates that must have been considered questionable from the traditional view of the genre. The reason for this was that the mimes and the Platonic dialogues were, according to Aristotle, composed in "bare words" and not in verse, and the traditional conception of poetry was grounded on the historical connection of poetry (the rhythmical verbal art) with music (the art of rhythmically and harmonically ordered tones) and dance (the art of rhythmical body movement) in the family grouping or supergenre of *mousiké*. This was the old cultural understanding supported through the 5th century BC by a performance tradition that regularly associated poetry with music and dance and went along with a widespread belief in their historical unity.

This understanding may have been associated with the notion of

imitation, but could not easily be extended to include unmetrical works that were not apparently aimed toward actual performance, until a truly literary and private literacy that admitted solitary and probably silent reading had become reasonably widespread. According to Eric Havelock such a situation did not come into being until the end of the 5th century,[8] but by Aristotle's time, private literacy was sufficiently widespread to allow for a theory of poetry that was not grounded in performance. This situation is probably reflected in Aristotle's notorious indifference to the actors' performance of tragedy, the importance of which he contemptuously minimizes and compares unfavorably to the art of the costumer. In these circumstances a new understanding could be framed that might admit Aristotle's nonmetrical candidates.

Of the three, Plato's dialogues possess not only the feature of imitation, which was perhaps not so universally accepted as a characteristic attribute of poetry as the Platonic literature would suggest, but they also possess extreme flights of fancy—fantastical figures, metaphors, allegories—that were the surface manifestations of a principle of radical invention, which was widely held to be the property of poetry and probably contributed more to the acceptance of Aristotle's candidates than anything else. For surely it is an interesting question to ask how ready Aristotle's audience would have been to admit as poetry Xenophon's desperately pedestrian Socratic memories, regardless of how thoroughly they exhibit the principle of imitation.

In fact Aristotle's use of the principle of imitation as a defining feature of poetry created more problems for him than it solved, because according to his reading of the principle as a representation of human action he was obligated to exclude from the genre the metrical philosophizing of Empedocles, that had strong traditional claims to membership, and forced to consider admitting history, his resistance to which provides one of the funniest and most problematic passages in the *Poetics*. In the courage of the absurdity with which Aristotle excludes Herodotus, "the father of lies," from the genre of poetry, because he presents an imitation of facts ("what has happened") and therefore a contingent representation instead of the essential representations, fictions or truths, of poetry, Aristotle abruptly shrinks the principle of imitation from a defining feature to a necessary condition and foreshadows one of the symptomatic tactics of a theoretical and programmatic avant-garde.

It is in sharp distinction from this kind of exclusive and theoretical radicalism that the most interesting post-second World War avant garde

undertook its game with genre. Genre was seen as family membership and the basis of inclusion was affiliation with any subgroup with which a new candidate shared a fundamental feature. This often had the fruitful effect of articulating and characterizing possibly for the first time an important branch of the family, which would open up a line of connection between past practice and future possibilities. So for *some/thing*, consideration of George Brecht's poems appeared to connect and open up a tradition of poetry that acts primarily as an instigation of mind to the solicitation of experience.

This articulation is not a definition and would not have served as one if we had stated it in the magazine at the time. It was an opportunity for extension of a practice, that did not even include all of the work that we published and clearly reached out to many works that we had not published or thought to publish, which might well have dissatisfied many of our contributors or even ourselves. Structurally, the result of introducing works like the Brecht texts was very much like a situation described by Wittgenstein in which someone gives the rules of a game and someone else in accordance with the rules makes a move that is legal but was not explicitly foreseen and changes our image of the game. As Wittgenstein points out with droll understatement "it must have been possible not to have foreseen that some quadratic equation would have no real roots."[9]

It seems apparent that there is a large body of otherwise interesting poetry that is not primarily an instigation of mind or is so only secondarily, and there are I am sure many contemporary poets for whom this would hardly seem a sufficient or appropriate function. And even using the texts of Jackson MacLow, who fits well enough within this branch of the family of poetry, and whom we published in all five issues of *some/thing*, we might have come to a different fundamental feature. Something like—radical invention. Following this rather Shklovskian sounding feature would lead us through a somewhat different family grouping that, depending on how we interpreted it, might include only *GLOSS* from the George Brecht texts, while connecting to the works that we printed of Rochelle Owens, Allan Kaprow, Armand Schwerner, Carolee Schneemann, as it led backward to poets like Gertrude Stein, Blaise Cendrars, Vicente Huidobro, Kurt Schwitters, Hans Arp and Tristan Tzara, and Velimir Khlebnikov, or even more interestingly to Aristophanes, Sterne, Diderot, Kierkegaard and G. Spencer Brown.

But this feature too, though it throws light on an illustrious branch of

the family and valuably extends a practice, would hardly suffice as a genre defining property. As many, and perhaps even more, of my contemporaries would be dissatisfied with it, apparently definition is no more useful for the notion of a genre than it is for the notion of a family. Seen from this viewpoint the viability of a genre like the viability of a family is based on survival, and the indispensable property of a surviving family is a continuing ability to take in new members who bring fresh genetic material into the old reservoir. So the viability of a genre may depend fairly heavily on an avant-garde activity that has often been seen as threatening its very existence, but is more accurately seen as opening its present to its past and to its future.

NOTES

1. The attitude reflected in this statement is grounded in long held anarchist/pacifist principles embedded in some combination of Taoist and Buddhist beliefs that MacLow discusses eloquently in the essay "Reflections on the Occasion of the Dance Scope Issue" (74–75).

2. The selections were made from the eleventh book of the *General History of New Spain* (Florentine Codex) translated from the Aztec by Charles E. Dibble and Arthur J. O. Anderson, originally published by the University of Utah. Reprinted in *some/thing*, 1, No. 1: 1–7.

3. Cavell's essay "Music Discomposed" ostensibly positions itself to discuss the condition of crisis he finds in contemporary music, in which the "professionals themselves do not quite know who is and who is not rightly included among their peers, whose work counts and whose does not" but moves to a general consideration of the anxieties produced by the need for the sense of authenticity that he considers "essential to the experience of art," taking "contemporary music as only the clearest case of something common to modernism as a whole" and modernism as only an explicit manifestation of "what has always been true of art." As a consequence his requirement for pervasive compositional choice becomes a necessary feature not only for modern music but all serious music. That this judgment necessarily excludes large bodies of work—aleatoric composition of the Cage variety or procedural composition as in the case of Steve Reich—on the basis of a single indispensable feature, makes it a typical if unusually sophisticated example (Cavell, 180–212). Michael Fried's essay "Art and Objecthood," is an example of a structurally similar argument in relation to modernist art (*Minimal Art*, 116–47).

4. Since I am primarily concerned here with the English speaker's essential reading experience of the haiku and not with any particular translation, I have taken the liberty of presenting my own versions of these famous poems. Other translations, both literal and literary can be found in Henderson, 104, 150.

5. For a selection of the Densmore translations surrounded by numerous other translations dating from the early part of the century and published at the moment of the Imagist movement, see Cronyn. For radically different kinds of English translations that emphasize the phonological structures of the Native American originals and do not belong to the conceptual tradition here being sketched out see the various issues of *Alcheringa*.

6. The asymmetry of this piece as well as its startling brevity make it very atypical. The pieces immediately preceding and following it in *Tender Buttons* are both characterized by marked musical repetitions (Stein, 475).

7. Schwerner, who was a regular contributor to *some/thing*, published Tablets 2 and 3 of his work in the double issue No. 4–5 in 1968. The explosive humor as well as the lyrical tone of Schwerner's work separates it very markedly from the precisionist language of the Brecht Gloss, but they have in common an underlying conception of the fragmentary understanding of the remains of a very alien culture capriciously transmitted through the screen of what must be a very different language and nostalgia for a lost civilization.

8. The older Greek performance tradition is sketched out very neatly by Eric Havelock in Chapter IX of his *Preface to Plato*, and the transformation to a truly literate culture in his 1977 essay in *New Literary History*.

9. The particular passage in Wittgenstein's *Zettel* has considerable application to problems associated with new moves made within a recognized genre.

> 293 "I give the rules of a game. Someone else, in perfect accord with the rules, makes a move the possibility of which I had not foreseen, and which spoils the game, that is, the way I had intended it. I now have to say "I have given bad rules"; I must change my rules or elaborate them.
>
> So then did I have an image of the game in advance? In a certain sense: Yes.
>
> It was surely possible, for example, for me not to have foreseen that some quadratic equation might not have real roots.
>
> The rule leads me to something of which I say, "I had not expected this image, I always imagined a solution like this" (*Zettel*, 54)

It appears that a familiar genre exists in the form of the image that we have of it, and that there is a particular mode of criticism that consists of prescribing rules for the accomplishment of works conforming to it. But the application of even the same rules by people not sharing the same image can lead to surprisingly different outcomes.

WORKS CITED

Antin, David. *Meditations*. Los Angeles: Black Sparrow Press, 1971.

Aristotle. *The Poetics*. London. Trans. W. Hamilton Fyfe. William Heinemann Ltd. and Harvard University Press, 1965.

Battcock, Gregory, ed. *Minimal Art*: A Critical Anthology. New York: E. P. Dutton, 1968.

Cage, John. *Silence*. Middletown, CT: Wesleyan U. Press, 1962.

Cavell, Stanley. *Must We Mean What We Say*. Cambridge, Mass.: Cambridge University Press, 1976.

Cronyn, George, ed. *The Path on the Rainbow*. New York: Boni and Liveright, 1918.

Havelock, Eric. *A Preface to Plato*. Cambridge, Mass.: Harvard Univ. Press. 1963.

———. "The Preliteracy of the Greeks," *New Literary History*, 8, No. 3, (Spring, 1977): 369–391.

Kelly, Robert. *Lunes*. New York: Hawk's Well Press, 1964.

Luckhardt, C. G. *Wittgenstein: Sources and Perspectives*. Ithaca, New York: Cornell University Press, 1979.

MacLow, Jackson. *The Pronouns: A Collection of Forty Dances for the Dancers, 3 February–22 March 1964*. Barrytown, New York: Station Hill Press, 1979.

Pound, Ezra. *Personae: The Collected Shorter Poems of Ezra Pound*. New York: New Directions, 1971.

Rothenberg, Jerome. *Sightings*. New York: Hawk's Well, 1964.

Schwerner, Armand. *Sounds of the River Naranjana & The Tablets I-XXIV*. Barrytown, New York: Station Hill Press, 1983.

some/thing. Eds. David Antin and Jerome Rothenberg, Vols. 1 and 2, Nos. 1–5, New York, 1965–1968.

Stein, Gertrude. *Selected Writings*. New York: Vintage, 1972.

Wittgenstein, Ludwig. *Philosophical Investigations*. Trans. G. E. M. Anscombe. Oxford and New York: Basil Blackwell and Macmillan, 1958.

———. *Tractatus Logico-philosophicus*. Trans. C. K. Ogden. London: Routledge & Kegan Paul, 1983.

———. *Zettel*. Eds. G. E. M. Anscombe and G. H. von Wright. Trans. G. E. M. Anscombe. Berkeley and Los Angeles: University of California Press, 1967.

Young, LaMonte and Jackson MacLow. *An Anthology*. New York: Young and MacLow, 1963.

12

Post-Scriptum–High-Modern

Joan Retallack
University of Maryland

i

It has been said that what addicts the gambler is the degree to which everything acutely matters between the placing of a bet and the outcome. Is this what addiction to art is about? Imagine that commiting oneself to a genre is to lay a bet that certain things will come so sharply, so dangerously into focus within its definitions of space and time, that all else—the disappointments and exhaustions, even the piquancies of daily life—will be effaced. Art, like gambling, can be inimical to dailiness—a diversion full of high risk and dubious reward. Your spouse walks out, forgotton coffee boils over as the last race leaves the gate or a sea of words churns up a white whale. To what end?, one might legitimately query.

It is well known that the novel in its copious nineteenth-century form is in direct competition with families, lovers, honest work and other forms of life greedy for exclusive attention. Philosophers might say, it constructs a parallel, logically possible world. As do all other genres, including certain kinds of poetry, which we might call "closed forms." The bet here has to do with the quality of focus which unequivocal boundaries (the distinct markers of genre) promote—the magnetic promise of a scene both densely provocative and cut off from consequences in the world outside its frame. In a miraculous, reverse trompe l'oeil, the world blanches before its own pale imitation. In poetry this might bring on a full, hundred watt epiphany. With prose we may hope for sustained illumination and absorption, feeding the self-inflicted hunger that good plots bring on.

But not all forms work this way. Some with more permeable boundaries—riddled with gaps, silences, disruptions—present us with a synergistic interaction of reader and text, both similarly vulnerable to perverse and delightful deflections of chance, open to outcomes dictated not only by author's design but by the rich chemistry of a language that

248

is, after all, a form of life. This is clearly a radically different kind of gamble.

<div align="center">ii</div>

Was there once a Jamesian universe like a pale green melon on a silver tray?

(Now it's *Non sequitur ergo sum.*)

We are living in the age of quantum mechanics, which tells us the cosmos is at play.

But, if we define the onset of the modern moment (circa 1620, Bacon's *Novum Organon*) as the replacement of God's will with human will?

Then everything we do, including Bohr's and Heisenberg's and Godel's stories, is an act of recreating our world. It is we and the cosmos who are at play—with one another.

<div align="center">iii</div>

Note on the use of "we" and its compatriots, "us" and "our" while taking a potshot at surrealism, etc.:

> Surrealism is a bourgeois disaffection; that its militants thought it universal is only one of the signs that it is typically bourgeois.
>
> (Susan Sontag, 54)

It used to be that "we" knew who "we" were, or so the story goes. As my cousin likes to say, after spotting a childhood friend on a camel outside Cairo, or in the gift shop at the Louvre, "It's a small middle class world." True of tourism, certainly, but is it true of literature—perhaps a kind of linguistic tourism—as well? In post World War I Europe, scene of the efflorescent Surrealist impulse, it probably was. One might argue that the chance and automatic methods, cut up and collage developed by Dadaists and Surrealists were a self-prescribed antidote to the categorical quality of bourgeois sensibility, a strain of which permeates Sontag's own disaffection with surrealism.

But her statement is instructive, coming out of a relatively recent self-consciousness in the use of the first-person plural to indicate an implicit Western European and American, "universal" consensus. Is it that "we" don't know who "we" are any more or that "we" feel, after the most recent round of cultural critique (sixties ff.) "we" should not presume to know? Or that the confederation of "we"—heretofore mostly Caucasian Old Boy—has been scattered by neo-Marxist and feminist

critique as effectively as were the leagues and alliances of ancient Greece by armed incursion? If twentieth-century modernism, true to its Enlightenment roots, has been about a crisis of the subject, the confused and ego inflated "I," pathetically vulnerable to infection in the Romantic legacy, from which purifying forms of objectivity—abstraction, formalism, minimalism—were to rescue "us," then the idea of postmodernism seems to reflect a crisis of the collectivity (the "we") initiated by those principles to ensure a continuance of the belief in unifying principle itself.

To use the anthropological idea of high and low context cultures (a high context culture being one in which most members share a body of knowledge, values, and beliefs)—as our media saturated mass culture has become increasingly high context, our so called "high culture" has become (in what may or may not be a causal relation) increasingly low context, that is, less certain of what can be assumed about audience. We, whoever "we" are, find ourselves far removed from the cultural small town in which an entire Zeitgeist could be formed out of about 100 German nouns, including "Zeitgeist."

Actually, the intellectual "we" has been breaking up on grounds that have shifted in this century from metaphysics to science to epistemology to philology and semiotics for its self definition. Some of those German nouns, carriers of a philosophical idealist strain going back to Plato, traveled abroad and copulated with linguistic theory—most notably that of Saussure and Whorf. What may define "our" consciousness these days more than anything else is the specter of linguistic and semiotic idealism (Roland Barthes, Jacques Lacan, Jacques Derrida, Jean Baudrillard, the American philosopher Richard Rorty, and common misreadings of Wittgenstein)[1] that has resulted in a round of questions, not to say anxieties, about the justification of the text.

In an age acutely conscious of the role the sign plays in constructing our experience, we, some of us, see our current ontological unease entirely in terms of genre—meta*narrative* rather than meta-psychology or meta-physics or meta-ethics. The contagion of "meta"s over the past few decades has been, in fact, a consequence of our increasing self-consciousness about highly interpreted and historically slippery world views, whose metaphoric structures change as rapidly as the technologies on which we tend to base them. What we appear to be up against these days is a multiplicity of metanarratives grazing one another like restless tectonic plates (to use an old fashioned metaphor from the physical

sciences) floating in an ungrounded medium. This is at least one image the continuing critique of the Enlightenment faith in Reason generates. For a thinker like Jean Baudrillard, immensely influential in the current self-proclaimed "post-modern" art scene, our world is constituted of nothing other than images. This is neo-Platonism with a difference: there is no doctrine of original forms, only a "divine irreference."

The sign of post-modern times has been that new kinds of bets are being laid; some, in their recycling of old forms, perhaps having to do with hedging bets. Modernism continued to stake everything on the Enlightenment promise of redemptive rationalist method—a stringent formalist logic structuring the subjective and irrational material surreal-ism had unleased—even after the catastrophe of the Third Reich threw the connection between cultural and social "enlightenment" into question. Where do "we," whoever "we" are, go from here? If we are truly post-Enlightenment in spirit, that is, if we no longer believe in the possibility of grand unifying principles or cultural progress, then post-modernism cannot function as a critique of modernism in quite the same way that modernism played out a critique of romanticism. We would seem no longer to be in the world of the liberating power of critique.

Have we gone then from a high modernist art for art's sake to deconstruction for its own sake? If this is the case, the post-modern return to earlier images and forms might indeed be, as some critics have claimed, a reactionary nostalgia:

When the real is no longer what it used to be, nostalgia assumes its full meaning. There is a proliferation of myths of origin and signs of reality; of second-hand truth, objectivity and authenticity. There is an escalation of the true, of the lived experience; a resurrection of the figurative where the object and substance have disappeared. And there is a panic-stricken production of the real and the referential, above and parallel to the panic of material production: this is how simulation appears in the phase that concerns us—a strategy of the real, neo-real and hyperreal whose universal double is a strategy of deterrence.

(Jean Baudrillard, 12–13)

(In fear we seek verisimilitude.)

To return to the problem of the first person plural, the "we" that "I" employ hereafter declares itself pro-grammatically uncertain of insidious influences (pre, post, hi, lo, mod . . .) and of its co-conspirators—from

the Latin, *conspirare*, to breathe together, hopefully in a structure permeable to sufficient oxygen.

<div align="center">iv</div>

> It is thus impossible to decide whether an event, account, account of event, or event of accounting took place. . . . All is narrative account and nothing is: . . . and we shall not know whether the relationship between these two propositions—the strange conjunction of the account and the accountless—belongs to the account itself.
>
> <div align="right">(Jacques Derrida, 71)</div>

> This would be the successive phases of the image:
> —it is the reflection of a basic reality
> —it masks and perverts a basic reality
> —it masks the *absence* of a basic reality
> —it bears no relation to any reality whatever: it is its own pure simulacrum.
>
> <div align="right">(Jean Baudrillard, 11)</div>

> Simplifying to the extreme, I define *postmodern* as incredulity toward metanarratives.
>
> <div align="right">(Jean-Francois Lyotard, xxiv)</div>

Is this perhaps another installment in the longest running serial in Western culture, the Fall of Man (sic)? Having slumped from the Golden Age (Hesiod), plummeted from the stars (Pythagoras), degenerated from the unitary rational soul into the affective mess of corporeality (Plato), slouched out of Eden (Moses), lapsed into Humanism (*pace* Desiderius Erasmus), scrambled into mock ruin ("Humpty Dumpty," M. Goose), strayed from rational principle (Bacon–Kant), swaggered/stumbled out of the state of nature (Hobbes/Rousseau), endured alienation and succumbed to greed (Marx), mislaid pre-conscious baggage (Freud), brooked the "revenge of the real" (Lacan) . . . having consoled, redeemed, reconstituted ourselves (Christ/Boethius/Scheherazade/Derrida) with these and other daring narratives, we find ourselves in the midst of a narrative of suspicion toward the role of narrative itself:

> This incredulity is undoubtedly a product of progress in the sciences: but that progress in turn presupposes it. To the obsolescence of the metanarrative apparatus of legitimation corresponds, most notably, the crisis of metaphysi-

cal philosophy and of the university institution which in the past relied on it. The narrative function is losing its functors, its great hero, its great dangers, its great voyages, its great goal. It is being dispersed in clouds of narrative language elements. . . . Thus the society of the future falls less within the province of a Newtonian anthropology (such as structuralism or systems theory) than a pragmatics of language particles. There are many different language games—a heterogeneity of elements. They only give rise to institutions in patches—local determinism.[2] (xxiv)

(The terrible consequence of perspective is the vanishing point.)

This narrative skepticism is not entirely a first. Cratylus who protested to his teacher Heraclitus that you can't step into the same stream even once, much less talk about it, performed the *reductio ad logicum* of pointing. Timon of Athens who thought our dependence on words a bum rap—"Lips, let sour words go by and language end"—would also have advised Scheherazade to hang it up, to let the ruin, the silence, in (Beckett, Wittgenstein, Pound by default, Cage . . .). The template for discarding metanarratives is always handy at that painful or glad moment when the view opens up past the vanishing point of yet another parochial perspective. (In this case the underlying, much ravaged, culprit is logical positivism or naive realism, which assumes an untenable one to one, stable correspondence between signifier and signified.) Now it seems it is not only Humpty Dumpty that must fall but the artfully drawn walls as well. And for the story to pack its punch we must each time say, *this* time Humpty Dumpty *really can't* be put back together again. Except, possibly, in the retelling. "Tomorrow night," we promise the kids, not even thinking that with the fall of narrative momentum, the future may be a thing of the past. We have always exercised that option, haven't we—when the story left us with too much terror, to tell it again? But suppose the story *begins* with things in a fractured condition:

riverrun, past Eve and Adam's. . . . The fall (bababadalgharaghtakamminarronnkonnbronntonnerronntuonnthuntrovarrhounawnskawntoohoohoordenenthurnuk!) of a once wallstrait oldparr is retaled early in bed and later on life down through all christian minstrelsy. The great fall of the offwall entailed at such short notice the pftjschute of Finnegan, erse solid man, that the humptyhillhead of humself prumptly sends an unquiring one well to the west in quest of his tumptytumtoes: and their upturnpikepointandplace is at

the knock out in the park where oranges have been laid to rust upon the green since devlinsfirst loved livvy.

(Finnegans Wake, 3)

And so on to the last page where Humpty Dumpty, who first appeared as a candidate for boiling in *Ulysses*, perhaps even as a shadow on S. P. Buck Mulligan's face on the first page ("oval jowl . . . smile broke . . .") ends this "retaling" of a fall, having popped in as "hemptyempty," "hoompsydoompsy," and other deconstructions along the way, humbly dumbly, only to washup" and retale again "a long the . . . riverrun, past Eve and Adam's . . ." with yet another scenic view of the remarkable phonemic cascade ("bababadalgharagh . . .") plunging through Joyce's im-explosive narrative spiral, taking the King's horses, King's men, and King's English with it.

The narrative line of *Finnegans Wake* is, if there can be such a thing in some non-Euclidian geometry, a closed helix. It is Joyce's attempt in the grand tradition of converts to atheism to outdo the deity by creating, not just a plenum, but a plethora. But what of metanarrative? The meta-narrative in *Ulysses*, highly respectable and therefore highly visible, is the *Odyssey*, a classical legitimation of one day in the life of an Irish lapsed Catholic. The metanarrative in *Finnegans Wake* (Which came first, Eve and Adam or the Egg?) is so fragile, so childlike (Humpty Dumpty you say!?; i.e., a primal bedtime story of the Fall) we barely notice it. But the fall out of meta-narrative is too frightening to contemplate, much less enact to its conclusion, hence the instructions to the reader: keep reading, don't stop, read again and again, over and over, and the scaffold, if not the metaphysical center, from which Finnegan plunges to his death and wake may hold.

The narrative scaffolding of *Finnegans Wake* simultaneously de-constructs and rebuilds itself in each rereading just as Humpty Dump-ty's smithereens *are* put back together in each retelling ("early in bed and later on life down"). The void is there but it can be filled with artifice—reconstituted egg, florid semantics, playful sin-tactics. The only truly terrible consequence of narrative perspective is the vanishing point: all those country lanes, Georgian houses, and simpatico characters falling into the black hole of the period at the end of the nineteenth-century novel. If you avoid the logic of perspective in the narrative line, the ineluctable march toward climax and finish, perhaps you (author, reader) won't disappear.

But . . . to continue our suppositions, suppose we really no longer

believe in stories. Then we might as well relax into the Fall, like vagrant sky-divers and other Icari, explore its formal properties to their logical conclusion—if that's to be how it is, viz, Samuel Beckett's *Cascando*:

> VOICE: —falls . . . again . . . on purpose or not . . . can't see . . . he's down . . . that's what matters . . . face in the sand . . . arms spread . . . bare dunes . . . not a scrub . . . same old coat . . . night too bright . . . say what you like . . . sea louder . . . like thunder . . . manes of foam . . . Woburn . . . his head . . . what's in his head . . . peace . . . peace again . . . in his head . . . no further . . . to go . . . to seek . . . sleep . . . no . . . not yet . . . he gets up . . . knees first . . . hands flat . . . in the sand . . . head sunk . . . then up . . . on his feet . . . huge bulk . . . same old broad-brim . . . jammed down . . . come on . . . he's off again . . . ton weight . . . in the sand . . . knee-deep . . . he goes down . . . sea— (12)

The struggle in *Cascando* is that of a new, revised Scheherazade:

> VOICE (*low, panting*): —story . . . if you could finish it . . . you could rest . . . you could sleep . . . not before . . . oh I know . . . the ones I've finished . . . thousands and one . . . all I ever did . . . in my life . . . with my life . . . saying to myself . . . finish this one . . . it's the right one . . . then rest . . . then sleep . . . no more stories . . . no more words . . . and finished it . . . and not the right one . . . couldn't rest . . . straight away another . . . to begin . . . to finish . . . saying to myself . . . finish this one . . . then rest . . . this time it's the right one . . . this time you have it . . . and finished it . . . and not the right one . . . couldn't rest . . . (9)

This is the fall from the vision of a rationalist epiphany, persistent cultural ambition which combines two dominant metanarratives of recent Western Civ—Christianity and Enlightenment—into the idea of the moment of truth, arrival at the final metanarrative—one species of final solution. This has turned the Middle Eastern Scheherazade act into more than mere divertissement. The Western notion is that you must by your own wits "get it right" *and* complete (a presupposition that led both Pound and Wittgenstein, master fragmentors, to pronounce their life-works failures), whereas in the Scheherazade tale, the telling is enough. For us, the inventors of the Faust legend, the pursuit of truth is tinged with high-stakes danger (in the Medieval church *curiositas* was a mortal sin), conjoined with images of the death and rebirth of the soul—a bit of Platonic mysticism incorporated into the Christian metanarrative via Plotinus. Not until you "get it right" can you die in peace, not until the whole story has been told.

But there is another side to this story of the power of the story. Folklorists say, that when taking oral history from old people you must be careful not to give the impression they have told you everything. You must say, call me when you think of more. Old people who feel they have no more stories to tell tend to die. Beckett, not quite the standard folklorist, hesitates at the finish himself. At the end of the play it's "nearly" right, which gives Woburn an excuse to "cling on":

VOICE} *(together):* —this time . . . it's right . . . finish......
MUSIC}
 no more stories . . . sleep . . . we're there . .
 nearly
 just a few more . . . don't let go . . . Woburn
 . . . he clings on . . . come on . . . come on—

Silence. (18–19)

Beckett, who is obsessed with the micro-athletics of the fall and the concomitant psychological, if not metaphysical, state of being lost (it's hard to find ontological landmarks in this finely sifted rubble), whose characters stumble, drag, scratch, claw themselves from the falling to the fallen rock zone—if they are not too deeply buried to move at all—has been conducting for five decades a tirelessly weary tour of the post-Enlightenment ruin of the academic and aesthetic edifices of Western Civ. Christian and Enlightenment metanarratives have succumbed to cumulative punctures of micro-dot wit, manifest to the reader in the familiar graphics of words . . . more . . . and more susperseded by ellipses longing to be periods. Beckett's fractured narrative flow, interrupted syntactic momentum . . . pauses . . . accumulate mass until the only possible (logical and physical) outcome is silence. Narrative figure and ground shift, with the remaining words casting silence into relief. This is a self-reflexive, textual enactment of the "no more words," "no more stories" uttered by the anonymous Voice that is the locutor in the play—a dire, minimalist strategy following Francis Ponge's rule of textual realism: "In order for a text to expect in any way to render the reality of the concrete world (or the spiritual one) it must first attain reality in its own world, the textual one" (8). The forms of Beckett's, and other high modernists', incredulity exist in relation to a structure of textual credulity (belief in the vitality of the medium) so that

an angle of discourse can be maintained. The playfulness of the medium forms the middle term between believing and doubting.

Cascando, written in 1962, has moved light-dark years from Lucky's manic speech in *Waiting for Godot* of 1949 (and its own phonemic falls—plummeting debris of Babel and other international academies) compulsively, like Joyce, filling the void left by the discrediting of the Christian metanarrative with parody:

> LUCKY: Given the existence as uttered forth in the public works of Puncher and Wattmann of a personal God quaquaquaqua with white beard quaquaquaqua outside time without extension who from the heights of divine apathia divine athambia divine aphasia . . . and considering what is more that as a result of the labors left unfinished crowned by the Acacacademy of Anthropopopometry of Essy-in-Possy of Testew and Cunard it is established beyond all doubt all other doubt than that which clings to the labors of men that as a result of the labors unfinished of Testew and Cunard it is established as hereinafter but not so fast for reasons unknown that as a result of the public works of Puncher and Wattmann it is established beyond all doubt . . . (29)

With this irony, the form of humor Kierkegaard thought responsible for moving us from lower to higher stages of spiritual development—perhaps because we can't stand to dwell in it too long and can no longer return to the object of its cool glare—with this irony Beckett has declared all metanarrational labors inherently futile: that there are no good reasons, that there is only doubt, the great moment of truth will never arrive, and there is nowhere to go, as the famous ending demonstrates:

> VLADIMIR: Well? Shall we go?
> ESTRAGON: Yes, let's go.
> They do not move.
> *Curtain* (61)

There is nowhere to go because narrational perspective has collapsed exhaustedly into itself. The vanishing point is no longer at a temporal distance; it is unavoidably here, now. The future tense has become obsolete just as depth becomes temporarily obsolete in the abstract expressionist painting of the fifties. The continuous present into which Vladimir and Estragon have stumbled and in which much of literary high modernism dwells is the temporal analogue to Jackson Pollock's or Helen Frankenthaler's spatial surface devoid of focal point and depth.

Somehow this remains more unsettling with language than with color and line. Language is supposed to carry us into the future with its syntactic drive. Would there be a future at all without the future tense?, we ask in reverence for the power of language. Vladimir, Estragon, Lucky, Krapp, Winnie (in *Happy Days*); Hamm, Clov, Nell and Nagg (in *Endgame*); the detached mouths and voices of more recent plays . . . all presuppose and indirectly comment on—while fleeing-in-place—the bitter legacy of philosophical and religious metanarratives of hope colliding with, to some extent engendering, the high-tech barbarisms of the 20th century.

But Beckett is neither Cratylus nor Timon from whom even postcards cease to arrive. Neither is he an Isabel Archer, consoled by the botanically garnished ruins of the Roman Empire:

> Isabel took a drive alone that afternoon; she wished to be far away, under the sky, where she could descend from her carriage and tread upon the daisies. She had long before this taken old Rome into her confidence, for in a world of ruins the ruin of her happiness seemed a less unnatural catastrophe. She rested her weariness upon things that had crumbled for centuries and yet still were upright; she dropped her secret sadness into the silence of lonely places, where its very modern quality detached itself and grew objective, so that as she sat in a sun-warmed angle on a winter's day, or stood in a mouldy church to which no one came, she could almost smile at it and think of its smallness. Small it was, in the large Roman record, and her haunting sense of the continuity of the human lot easily carried her from the less to the greater. She had become deeply, tenderly acquainted with Rome: it interfused and moderated her passion.
>
> *(The Portrait of a Lady, 475–76)*

This narrative, written by Henry James in 1881, before either of the "great" wars, sixteen years after the end of an American civil war to "preserve union," is about, if not the Fall (Falls are always *from* unity) then the slippage of metanarrative. *About* it, without incorporating it formally. You will notice the protocol that has become familiar to us moderns—"ruin," "catastrophe," "silence" . . . but woven into finely patterned lawn. If we detach it from the confidence of late 19th-century syntactic propulsion, remove the daisies and substitute ellipses, breach the mono-directional flow with repetition, what happens?

> VOICE: Isabel . . . alone . . . that afternoon . . . *(hesitates)* . . . she wished to be . . . far away . . . under the sky . . . *(Pause)* . . . where she could . . .

descend from her carriage and tread upon the daisies (*brief laugh*) She . . . had
. . . long before this . . . (*hesitates*) . . . taken old Rome . . . into her
confidence . . . (*Laugh. Pause.*) . . . for in a world . . . of ruins . . . the ruin
(*hesitates*) . . . of her happiness . . . seemed . . . (*Long pause.*) . . . a less
unnatural . . . catastrophe . . . (*Sound of nose being blown.*) . . . She . . . She
rested . . . Isabel . . . alone . . . that afternoon . . . (*hesitates*) . . . her
weariness . . . upon things that had crumbled . . . for centuries . . . (*Pause.*)
. . . yet . . . still . . . were upright (*Pause.*) . . . upright (Laughs.) . . .
alone . . . that afternoon . . . she dropped . . . in a world of ruins . . .
the ruin . . . her secret sadness . . . into the silence . . . (*Long Pause.*) . . .
detached itself . . . as she sat . . . in a sun-warmed angle on a winter's day
. . . or stood (*Pause.*) . . . in a mouldy church to which no one came. She
could almost smile at it and think of its smallness . . .(*Sound of nose being
blown.*) . . . Small it was . . . alone . . . that afternoon . . . under the sky
. . . in the ruins . . . and her haunting sense of it . . .the human lot (*brief
laugh*) . . . to which no one came . . . the less . . . the greater . . . She had
become . . . alone . . . a less unnatural catastrophe . . . (*brief laugh*) . . .
alone . . . (*With relish.*) deeply, tenderly! . . . acquainted with Rome . . . it
. . . moderated her passion. . . . moderated. (Silence.)

It's not quite right—still too domesticated, none of Beckett's celtic
pith, rude argot; but with the addition of those elements it could almost
work. This is not to suggest that Samuel Beckett is simply a species of
deconstructed, artfully debased Henry James . . . not quite. It is, of
course, much more complicated than that. But, when Beckett says, the
form must let the ruin in, the ruin he appears to be talking about is not
only a fallen metaphysic, the aftermath—emotional, theoretical and
architectural—of two world wars and the runaway machinations of a
sinister technology . . . but also the dissolution of a prose structure,
linguistic mannerisms, intellectual and social pretensions (starting with
those of Ireland) posited on not only a lost innocence but a disrupted
complacency. His work is part of the modernist project to trim or mock
the linguistic turrets of 19th-century English prose—"whence," "lest,"
"poured forth" . . . and their plush interstices.

In a way, Beckett's discourse, pocked with craters and strewn with
various kinds of linguistic detritus, mimics the scene of a European city
after an aerial bombing, with its bewildered scavengers and vacant lots, a
bit of cornice here, a fragment of molding there—bracketed by dusty
old-world structures. Ruins for Beckett, unlike James, are something
quite contemporary. They have turned him into a wonderfully bizarre,

Western metamorphosis of Scheherazade, endowed with the macro-
athleticism of a Kierkegaard performing over and over a leap, not into
religious faith, but into language in its ceaseless agon with silence.
Sometimes, like Joyce, Beckett shouts the silence down; mostly he lets it
in.

It's a little vaudeville routine (some might name it a Speech Act) called
The Figure-Ground Shift, featuring a pair of tattered, aging stars, (the
Quantum Jump is being performed in the next room) a "mime for two
players," as Beckett calls his acts without words. When Figure and
Ground shift, riffraff (bums and words) shuffle out from the margins and
wander center-page which means suddenly the margin *is* center page;
center page, the margin. Ruins and fragments, it seems, are not acci-
dents or anomalies, but the most reliable constructs of Western Civ.
Post-James, the ruin is not upright (few of the actors manage to be fully
upright!). Post-Eliot, the fragments will not shore up the ruin. The
fragments are the ruin. Ruin is all there is. Fragments, some quite
piquant, are all there are. Silence is no longer skulking on the edges of
paragraphs and stanzas; it has lodged itself in language mid-sentence,
mid-phrase.

<div align="center">v</div>

a dry scratch as a story
rivers left as literature
 P. Inman, *Think of One*

Much of the writing of Joyce and Beckett, Stein and Pound, and those
who have recently emerged under the coy rubric $L = A = N = -$
$G = U = A = G = E$ might be compared to Gödelian number systems—
by their nature subject to a radical incompleteness, self-reflexive on a
meta-level; that is, the level on which the language draws energy and
complexity from its logic (grammar), its history (etymology). This is the
level which allows us to state the paradoxical, to transgress, breach, edge
into the margins of silence, to create a structure, like *Finnegans Wake* or
Cascando or the poetry of Gertrude Stein, which simultaneously affirms
and denies the possibility of its own existence as literature. It does this by
interrupting the trajectory of its discourse with silence, fragmentation,
odd juxtaposition, exploding etymological accretions, ceaseless ques-
tions, "pointless" repetitions. The idea is that a literary work which is
"complete" is like a mathematical proof which doesn't surprise. It is
trivial. It is also in some sense locked into an anachronistic, positivist

world—pre-Gödel, Bohr, Heisenberg, WWs I and II—a world in which the Enlightenment projection of rational epiphany—social, political, and intellectual—seemed less problematic; a world in which 19th-century metanarratives were still largely intact. The Gödelian incompleteness theorem is itself a critique of the inclusive power of metanarrative.

In both cases, literature and mathematics, we must feel confident that incompleteness is the effect of richness, not confusion—a heroic demonstration of unrequitable intellectual need/desire, perhaps an odd form of love. The most minimal aesthetic structures are in their radical incompleteness urgently suggestive, pointing always outside themselves for consummation. To savor Beckett or some of the best Language poets (as well as a very different kind of poet like Oppen) is to participate in a heightened sense of the English language, with all those witty, very fine distinctions its speakers *in medias res* have cared, for centuries, to make. All this, of course, should move the "active reader" along radii poking from the text like spokes of an insistent umbrella into the extra-textual concourse filled with what Wittgenstein called "forms of life."

In his book *After the Great Divide: Modernism, Mass Culture, Postmodernism*, an interesting example of post-modern critical review and polemic, Andreas Huyssen presents a sometimes astute, but almost completely negative picture of the modernist aesthetic. Some of it recalls the tone of modernism's early detractors who could see only what was missing—the well-made plots, the figure, etc.:

—The work is autonomous and totally separate from the realms of mass culture and everyday life.

—It is self-referential, self-conscious, frequently ironic, ambiguous, and rigorously experimental.

—It is the expression of a purely individual consciousness rather than of a Zeitgeist or a collective state of mind.

—Its experimental nature makes it analogous to science, and like science it produces and carries knowledge.

—Modernist literature since Flaubert is a persistent exploration of and encounter with language. Modernist painting since Manet is an equally persistent elaboration of the medium itself: the flatness of the canvas, the structuring of notation, paint and brushwork, the problem of the frame.

—The major premise of the modernist art work is the rejection of all classical systems of representation, the effacement of "content," the erasure of sub-

jectivity and authorial voice, the repudiation of likeness and verisimilitude, the exorcism of any demand for realism of whatever kind.

—Only by fortifying its boundaries, by maintaining its purity and autonomy, and by avoiding any contamination with mass culture and with the signifying systems of everyday life can the art work maintain its adversary stance: adversary to bourgeois culture of everyday life as well as adversary to mass culture and entertainment which are seen as the primary forms of bourgeois cultural articulation. (53–54)

Since the language of both Joyce and Beckett (whom Huyssen identifies earlier as among his targets) draws as deeply, on the vernacular of "ordinary" people, as on high literary language, Huyssen's argument seems not only internally contradictory, but seriously off the mark. The difficulty, I think, is that he fails to distinguish between kinds of "encounters with language," attributing "realism" to only one version of what he calls "content," and raising the apparition of what is impossible—a content-free language. The modernists have in fact substituted one form of content for another. Where there were finely crafted word-pictures of Isabel Archers among the ruins, bathed always in an even Cartesian light of reason, there came the textual stops and starts, benighted rumblings and linguistic infarctions of what Julia Kristeva has called in her *Revolution in Poetic Language* the "subject in process"—as much in evidence in Wittgenstein's *Philosophical Investigations* as *Finnegans Wake* or *Krapp's Last Tape*. That the inventory of objects manipulated by Krapp is much scanter than those in any James afternoon tea, does not mean they are less present, less real, less a part of the world; nor necessarily more.

Hugh Kenner has shown at entertaining length, how packed with the content of Irish life Joyce's language is. Joyce himself claimed the voices of the people of Dublin had written all his books. The distinction that counts in comparing the modernist vision to that of preceding and post-modernist work is not the presence or absence of the world but the angle of the lens which determines what will be included or excluded, in or out of focus.

What the final item in Huyssen's list fits best is at least one branch of the L = A = N = G = U = A = G = E program which has been called by some critics post-modern, but a good deal of which I see as a high modernist post-script (raising the formalist ante) to the project of writers like Beckett and Stein, variously hybridized with strains of Marx,

Lukacs, Gramsci, Adorno. The mistrust of mass culture, seen as a tool of the Capitalist commodity ethic—fetishistic, alienating, pacifying, manipulative—is explicitly articulated by Ron Silliman, one of the Language contingent's most influential theoreticians:

> The function of the commoditized tongue of capitalism is the serialization of the language-user, especially the reader. In its ultimate form, the consumer of a mass market novel such as *Jaws* stares numbly at a "blank" page (the page also of the speed-reader) while a story appears to unfold miraculously of its own free will before his or her eyes. The presence of language appears as recessive as the sub-title of a foreign language film. (127)

And, on the fear of contamination by mass culture and ordinary language structures, Charles Bernstein writes not far removed from the spirit of Francis Bacon's "idols imposed by words":

> Regardless of "what" is being said, use of standard patterns of syntax and exposition effectively rebroadcast, often at a subliminal level, the basic constitutive elements of the social structure—they perpetuate them so that by constant reinforcement we are no longer aware that decisions are being made, our base level is then an already preconditioned world view which this deformed language "repeats to us inexorably" but not *necessarily*. Or else these formations (underscored constantly by all "the media" in the *form* they "communicate" "information" "facts") take over our form of life (see *Invasion of the Body Snatchers* and *Dawn of the Dead* for two recent looks at this) as by posthypnotic suggestion we find ourselves in the grip of—living out—*feeling*—the attitudes programmed into us by the phrases, etc., and their sequencing, that are continually being repeated to us—language control = thought control = reality control: it must be "decentered," "community controlled," taken out of the *service* of the capitalist project. (140)

Huyssen, Silliman, and Bernstein present us with a whopping dose of polemic. What about the poetry itself? In the work of the L = A = N = - G = U = A = G = E poet, P. Inman, a high modernist's high modernist, the dialectic of sound and silence has moved several logical steps beyond Beckett. Gaps have crept in between phonemes, often disrupting semantic units irrevocably. Language is radically decontextualized, but also radically present on the page. Not a word or phoneme is just stringing along for grammatical nicety. Each one seems, paradoxically, both specially chosen and completely arbitrary.

This is the nature of all language, come to think of it. As John Cage has said, "We forget that we must always return to zero in order to pass

from one word to the next" (*For the Birds*, 92). With the usual dense clustering of words pulled seemingly inexorably by the chug of syntactic momentum we give ourselves the illusion of the kind of necessity that reached its apex in steam engines and Hegelian dialectic. The artful indeterminacy of the linguistic field Inman creates invites the reader to slow down and luxuriate in an act of proto-perception:

G: sod droner
 ewe ccretion. digm to result
 all those leaning whitecaps thinks locked in
 niner thought out of leasts
 nain enlarge

H: hair's book meant in rips
 whitewash each further. objects mum drawn to
 matter spelf
 after-image. trenched
 husband contagion

 (from "nimr," 20)

There is nothing but content in this piece; and coextensive with it there is nothing but form. We can see it either way. It has features very much like the classic ambiguous figure—a dangerous business, pushing our trust in the relation between perception and cognition to the edge.[4] As R. L. Gregory writes in *Eye and Brain*,

> Ambiguous figures put our perceptual system at a curious disadvantage; because they give no clue of which bet to make, and so it never settles for one bet. The great advantage of an active system of this kind is that it can often function in the absence of adequate information by postulating alternative realities. But sometimes it makes wrong decisions which may be disastrous. (222)

Now what could this mean in relation to Inman's piece? The greatest danger lies in seeing only a dichotomy: language vs. world, i.e., Inman's language not "reflecting" world. More productive alternative realities might be: a) sharply outlined negative linguistic space, i.e., all that this language cannot hold onto—the prefix that slipped away from "digm," the "a" from "ccretion;" the question of whether "ewe" means sheep, or is somehow detached from "jewel," or "stewed" or "newel" . . .; and, b) the elemental structure of language itself—its odd presence wholly or

partly seen—a stark, luminous frieze bridging and stopping time like partly understood cuneiform fragments. Or, we could say, the alternative realities posed here in figure/ground relief are opacity ("sod droner") vs. transparency ("sod droner"); "sod droner," like the ambiguous kite-cube figure (which can be interpreted either as Necker cube or flat pentagonal surface), spontaneously shifting between transparent semantic depth—with thoughts of earth and monotones—and opaque phonemic surface, much as a partially understood foreign language does. Language is always partially opaque, though we tend to forget this in daily usage unless we are at the boundaries of comprehension.

The sections of "nimr," each of which is a "fractional" mirror image fitting into an overall numerical pattern, function very much like classical ambiguous figures composed entirely of edges—edges which give us contradictory cues about the nature of the "objects mum drawn" they define. (What Clifford Geertz might call a "blurred genre."[5]) It's a complex, humorous realism not dreamed of in the neo-positivist critique of modernism. "Edge," for instance, is a technical term in geography meaning the point beyond which our present store of information is no longer useful. It is, like the ambiguous figure, a possible danger zone. Edges on a country or shore walk are seductive. They draw us on to see what's over the next rise, around the next bend, on the other side of "all those leaning whitecaps." They locate not just paucity of information, but desire, curiosity (intellectual desire)—a heightened response to the world as venture into the unknown which is only possible at the geographic or linguistic edge.

In this kind of experience which leads us to relish the simple presence of linguistic elements, we are engaged on, connected with a primal level, enacting what R. L. Gregory asserts is an ancient response to our world:

> Why should the perceptual system be so active in seeking alternative solutions, as we see it to be in ambiguous situations? Indeed it seems more active, and more intellectually honest in refusing to stick with one of many possible solutions, than is the cerebral cortex as a whole. . . . The perceptual system has been of biological significance for far longer than the calculating intellect. The regions of the cerebral cortex concerned with thought are comparatively juvenile. They are self-opinionated by comparison with the ancient regions of the brain giving survival by seeing. . . . The visual brain has its own logic and preferences, which are not yet understood by us cortically. Some objects look beautiful, others ugly; but we have no idea for all the theories which have been put forward why this should be so. The answer lies a long way back in

the history of the visual part of the brain, and is lost to the new mechanisms which give our intellectual view of the world. (223–24)

Our value systems are, if not invented, then justified by those new intellectual mechanisms which dismiss the palpable experience of "ewe ccretion." as non-sense, or lacking content, when sensible content is all there is. What is at stake here, what we are gambling on, is our most basic connection with our language, and our world. As neuro-physiologists tell us, any stimulus that is constant becomes impercept-ible. Language, which saturates every aspect of being human, is always on the verge of the kind of invisibility that leads to its speaking itself in euphemisms, clichés, and set pieces.

Inman's work is as unsettling and resistent to habitual comprehension as the ambiguous figure and similarly raises questions about the nature of perception. Like Beckett, Inman challenges his reader/audience (his work is also meant to be heard) to consider which is fundamental, presence or absence. As with Beckett we may ultimately decide the answer to this question matters less than the astonished glimpses of pith and humor ("hair's book meant in rips," "matter spelf," "husband contagion") that engage us in their/our worlds. Unlike the ambiguous figure, which is virtually pure form and keeps us on a fascinating but quite abstract level, Inman's constructions have a seductive tangibility. Seduction, always a gamble, always on the edge of loss. It may be the best we can say in our passing affair with this spectacular, tawdry universe— that it, under certain conditions, scintillates before our eyes, invades our startled brains, awakens us to a peculiar interaction which demonstrates our mutual, intricate vitality.

If we value Joyce, the Steins (Gertrude and Wittgen), Beckett, Pound, P. Inman and other literary experimenters—their work—it is because they slide figure and ground toward literary red shift with their expanding sense of genre. Perhaps it's not a matter of addiction at all. Addiction may be the endgame of habit. The bet that is laid in the outline of a playfully expanding genre is that it can dislodge us from habit into the kind of radical humor necessary for catapult acts of the imagination. Perhaps the most generic paradigm of humor—always a matter of extreme conceptual shiftiness—is in fact the ambiguous fig-ure. Are the most vital moments in the uses of genre always a humorous matter, a complicated figure/ground joke—landscape becoming the center of the painting rather than something glimpsed over the shoulder

or under the armpit of the saint or the aristocrat, everyday objects ("ready-mades") becoming art, the servants or the woman or the whale becoming the protagonist, medium becoming content, silence becoming sound. . . .? And is it only the sober genres—scripture, the high-stakes card game, the dead-ahead mystery or thriller—that promote addiction rather than play?

vi

Modernist and high modernist forms, constructed in appropriate terror of the ontological, ecological and political instabilities of the twentieth century, have served to reconnect us with coefficients of what, with the dissolving of the Romantic glue, might have become vacant, lost sensibilities—our love of sound, language, color, texture, the play of ideas . . . and our capacity for the intelligent humor needed to moderate our odd predicament. Along with Gödel, Heisenberg, and Bohr modernist artists have engaged in paradoxical higher-order play that is nothing more or less than the making of those connections which *can* be made—both logically and juxta-positionally—in a post-Newtonian, non-Euclidian, even to some extent post-Einsteinian world.

The special genius of high modernism has been to combine radical elements of stylistic abstraction and logic—the rational vehicles which were to roll Enlightenment to its Western-style nirvana or McDonalds—whichever came first (Adorno would have accurately predicted McDonalds)—with a subversion of the projected outcome of Enlightenment. Another way of putting it is that high modernism simultaneously accommodates disintegrative (fallen) content with integrative logic (consistency, simplicity, elegance . . .) giving us both Fall and anti-Fall in one package—a counterphobic structural paradox which, in order to retain its potency, must be to some extent socially decontextualized. What this means is that Huyssen would be right in his claim of social removal if he restricted it to high modernism; though he is wrong in using this claim as a means of dismissal.

vii

Yet it is difficult not to see the high modernism of, say, some of the L = A = N = G = U = A = G = E poets as a fascinating post-script to a long century of modernist experimentation. The excitement of post-

modernism is that it is in many ways a letter just beginning, a roomy category waiting to be filled. Huyssen considers the sixties in America, under the influence of what he calls the "Duchamp-Cage-Warhol axis," the "prehistory of the postmodern"—an aesthetic U-turn, after a decade dominated by abstract expressionism, toward popular images and culture, particularly in the visual arts—Warhol, Lichtenberg, Rosenquist, Oldenberg, Johns, etc. This was a time when the avant-garde was actively engaged in a critique of modernism—aggressively attending to elements of contemporary life that modernism had systematically excluded from the scope of its art. Since then, Huyssen argues, the postmodern has become post-critical. Here, his view and those of Baudrillard and Lyotard come together:

> The situation in the 1970s seems to be characterized . . . by an ever wider dispersal and dissemination of artistic practices all working out of the ruins of the modernist edifice, raiding it for ideas, plundering its vocabulary and supplementing it with randomly chosen images and motifs from pre-modern and non-modern cultures as well as from contemporary mass culture. Modernist styles have actually not been abolished, but, as one art critic [Edward Lucie-Smith] recently observed, continue "to enjoy a kind of half-life in mass culture," for instance in advertising, record cover design, furniture and household items, science fiction illustration, window displays, etc. Yet another way of putting it would be to say that all modernist and avantgardist techniques, forms and images are now stored for instant recall in the computerized memory banks of our culture. But the same memory also stores all of pre-modernist art as well as the genres, codes, and image worlds of popular cultures and modern mass culture. How precisely these enormously expanded capacities for information storage, processing, and recall have affected artists and their work remains to be analyzed. But one thing seems clear: the great divide that separated high modernism from mass culture and that was codified in the various classical accounts of modernism no longer seems relevant to postmodern artistic or critical sensibilities. (196–97)

The vision of the future of art implied here and more explicitly depicted in Baudrillard seems to be that of a vast, undifferentiated montage created by the reproduction of ready-made, not objects, but images—Plato reinvoked/Duchamp once-removed. Perhaps we are too bewildered by our total submersion to rise to the level of critique. "We live everywhere already in an 'esthetic' hallucination of reality," Baudrillard writes in *Simulations* (147–48). The book ends with this statement:

And so art is everywhere, since artifice is at the very heart of reality. And so art is dead, not only because its critical transcendence is gone, but because reality itself, entirely impregnated by an aesthetic which is inseparable from its own structure, has been confused with its own image. Reality no longer has the time to take on the appearance of reality. It no longer even surpasses fiction: it captures every dream even before it takes on the appearance of a dream . . . The principle of simulation wins out over the reality principle just as over the principle of pleasure. (151–52)

viii

How many variations on philosophical idealism will we run through before the century is out? I long for Jacques Lacan's "revenge of the real." (Did he experience it in the intellectual labyrinth of Paris? Well, you point out, he's dead, isn't he?)

Or for a dose of American pragmatics. John Cage, who has laced his eclectic, inventive American pragmatism with Eastern philosophical pragmatics, has given us a set of instructions which are worth reviewing:

Wherever we are, what we hear is mostly noise. When we ignore it, it disturbs us. When we listen to it, we find it fascinating. The sound of a truck at fifty miles per hour. Static between the stations. Rain. We want to capture and control these sounds, to use them not as sound effects but as musical instruments. . . . If this word "music" is sacred and reserved for eighteenth- and nineteenth-century instruments, we can substitute a more meaningful term: organization of sound. (*Silence*, 3)

ALL YOU CAN DO IS SUDDENLY LISTEN (*Silence*, 46)

You want to know what we're doing?
We're breaking the rules, even our
own rules. And how do we do that?
By leaving plenty of room for X quantities. (*Silence*, 197)

I have for many years accepted, and I still do, the doctrine about Art, occidental and oriental, set forth by Ananda K. Coomaraswamy in his book *The Transformation of Nature in Art*, that the function of Art is to imitate Nature in her manner of operation. Our understanding of "her manner of operation" changes according to advances in the sciences. (*A Year from Monday*, 31)

Cage's contribution to the catalog of twentieth-century figure/ground shifts has been the experience of silence as ambient sound, and that in turn as figure, rather than background "noise" as interruption. In Cage's

view the major focus of a given work of art is properly the world outside
that work, or the discrete work itself only in so far as it is part of the
processes of the world outside it, so that ultimately outside and inside
become one, art and world become indistinguishable. What this means,
given his friend Buckminster Fuller's definition of a structure as nothing
more than an inside and an outside, is that the truly successful aesthetic
structure should disappear entirely from view, foregrounding the
ambient interest of unstructured space or silence.[6] It also means that
Cage is carrying Duchamp's dictum, "the only thing that is not art is
inattention," to its logical fruition. In fact, Cage has been cultivating the
art of paying attention all his life. This seems to be most importantly
what his study of Eastern philosophy (especially Zen Buddhism and
Taoism) has been about—attention, and the essential interconnected-
ness of things. That Cage refers to words as empty (see his *Empty Words*)
and silence as full indicates that from his aesthetic perspective the
figure/ground shift is complete: the dissolution of a false dichotomy.
Where once there was art is now world, and vice-versa; but with all this,
there is no confusion between the two. For Cage the distinction between
intention and indeterminacy remains clear. There is a natural world not
made from the images and intentions of artists and other humans, which
we have the power to affect—positively or adversely. The major connec-
tion Cage sees between a healthy art and its world is an ecological one:

> And nature is not a separation of water from air, or of the sky from the earth,
> etc., but a 'working-together', or a 'playing-together' of those elements.
> That is what we call ecology. Music, as I conceive it, is ecological. You could
> go further and say that *it IS ecology*. (229)

One might wonder if we have arrived finally at Lyotard's scuttled
metanarrative. Cage seems to be creating aesthetic apertures giving on a
world unfettered by interpretation. But of course the world he tinkers
and plays with in his calculated art of leaving things alone, is a product of
at least two metanarratives: American Deweyesque, mystical
pragmatism[7] in which we know the world through active participation
in its processes, and an Eastern tradition of the essential wholesomeness
of things. This is both pre- and post-Enlightenment-modern, since it
does not pose a fallen world to be reclaimed and redeemed by the force of
reason. Neither are there ontological gaps requiring logical fillers and
repair. Cage can allow chance free reign to the extent that he does
precisely because he believes in the essential order of the universe.

Cage's work forms an interesting bridge between the modern and the post modern, both historically and technically. His austere and dedicated belief in systematic procedures is, if anything, high modern and yet he is no purist; he lets the world in (though not unselectively) with its delightful, uncontainable ruckus and relishes the humor in it. His working consciousness and compositional strategies have been influenced by the leading edge of developments in a sophisticated electronic age. He has shared Marshall McCluhan's and Buckminster Fuller's fascination with the technology of media, though not with their mass culture content. In his high culture aesthetic tastes (Satie, Joyce, Stein . . .) Cage has not crossed into the territory of post modernist theoreticians like Baudrillard and Huyssen, both of whom argue convincingly (though not without some questionable assumptions) that a post modern art must come to terms with mass culture.

ix

What then is at stake after all? Are we looking for a way out of our disappointment in the revised Englightenment promise of modernism—that it would nourish us, toughen us as aesthetic creatures, indirectly but importantly connect us with the highest forms of being human in this fallen world? The need to take care of some important items excluded from the modernist agenda becomes more pressing as an accelerating twentieth century draws us around the bend toward a new millennium—or so we hope, in a time when world political stakes continue to escalate alarmingly. Huyssen makes an interesting case for a connection between our nervousness about mass culture and our uneasiness about the feminine, "the problem," as he puts it, of "the persistent gendering as feminine of that which is devalued" (53).

Kristeva's notions of the feminine and the subject in process, Carol Gilligan's distinction between the Enlightenment picture of reason as a primarily masculine logic of justification in contrast to what she identifies as a feminine narrative of relations,[8] the very fact that we are living in a dangerous world with little understanding of these and other persistent dichotomies of gender, of genre[9], of inter and intra-cultural constructs, scientific vs. humanist discourse, "high" vs. popular forms—all this suggests exciting possibilities for the exploration and invention of new aesthetic structures.

X

Modernism let silence in and it disquiets us. What is this silence? For Wittgenstein (like his philosophical progenitor, Kant) it's the mute palpable and ineffable—what "shows itself," "what we cannot speak"; for Beckett it's resignation on the dark side of humor; for Cage it's the chortling of the cosmos. And for "us"? "We" post-moderns have become exquisitely literate in calligraphies of silence and negative space. The spirit of the modern has been bracketed by, habituated to, margins of emptiness: Giacometti's figures under attack by an antagonistic void; Mondrian, Mies Van der Rohe throwing up grids to display the vacant pristine; Joyce and Stein erupting in heroic echolalia to flood out the void. . . We inherit a tradition in response to, flight from, incorporation of a silence which Cage, Baudrillard, contemporary physicists and others plausibly argue doesn't exist. It seems it's time to play out the logic of this interesting new joke.

NOTES

1. As I read both the *Tractatus* and the *Philosophical Investigations*, Wittgenstein always saw language as a "form of life" connected with and contextualized by other forms of life, existing in an extralinguistic world a good deal of which is experienced apart from language. (His idea of silence is quite full.) Relying on the frequently quoted passage, "the limits of my language mean the limits of my world," he is often erroneously cited in arguments for a kind of Whorfian/Derridian textual idealism in which there can be no world apart from the constructs of our language.

2. Note Lyotard's credulity toward the Englightenment metanarrative of "scientific progress" as well as a tendency toward excessive use of the generic metanarrational adjective, "great."

3. See two recently published anthologies for a good sense of the range of their work: *In the American Tree*, edited by Ron Silliman, and *"Language" Poetries*, edited by Douglas Messerli.

4. Interestingly Niels Bohr, inventor of the particle/wave ambiguity, knew and attended the lectures of the Gestalt psychologist, Edgar Rubin, inventor of the famous vase/profile ambiguous figure, during the time when he (Bohr) was developing his quantum mechanical theories.

5. See, for instance, his "Blurred Genres: The Refiguration of Social Thought," Chapter I of *Local Knowledge*.

6. Though Cage disclaims affinity with Wittgenstein, whom he considers too obsessed with rules, I see much common ground, as evidenced, for instance, by the final propositions of the "Tractatus":

6.53

My propositions serve as elucidations in the following way: anyone who understands me eventually recognizes them as nonsensical, when he has used them—as steps—to climb up beyond them. (He must, so to speak, throw away the ladder after he has climbed up it.)

He must transcend these propositions, and then he will see the world aright.

7

What we cannot speak about we must pass over in silence. (151)

The vestigial language of transcendence should not deter us from noticing that for Wittgenstein, as for Cage, the purpose of structure is to let the world "show itself."

7. It has been noted, I think rightly, that John Dewey's *Art as Experience* has a strong Zen flavor.

8. For a detailed discussion of this distinction, see Gilligan's *In a Different Voice*, Chapter 2, "Images of Relationship."

9. Derrida engages in a fascinating discussion of relationships between gender and genre in his essay, "The Law of Genre," cited above.

WORKS CITED

Baudrillard, Jean. *Simulations*. Trans. Paul Foss, Paul Patton, and Phillip Beitchman. New York: Semiotext(e), 1983.

Beckett, Samuel. "Cascando." *Cascando and Other Short Dramatic Pieces*. New York: Grove, 1968. 9–19.

———. *Waiting for Godot*. New York: Grove, 1954.

Bernstein, Charles. "The Dollar Value of Poetry." *The* $L = A = N = G = U = A = G = E$ *Book*. Ed. Bruce Andrews and Charles Bernstein. Carbondale: Southern Illinois UP, 1984. 138–140.

Cage, John. *Empty Words*. Middletown: Wesleyan UP, 1979.

———. *For the Birds*. Boston: Marion Boyars, 1981.

———. *Silence*. 1961. Cambridge: M.I.T., 1969.

———. *A Year from Monday*. Middletown: Wesleyan UP, 1969.

Derrida, Jacques. "The Law of Genre." Trans. Avital Ronell. *Critical Inquiry* 7 (1980): 55–81.

Geertz, Clifford. *Local Knowledge*. New York: Basic Books, 1983.

Gilligan, Carol. *In a Different Voice*. Cambridge: Harvard UP, 1982.

Gregory, R. L. *Eye and Brain*. 3rd ed. New York: McGraw Hill, 1981.

Huyssen, Andreas. *After the Great Divide: Modernism, Mass Culture, Postmodernism*. Bloomington: Indiana UP, 1986.

Inman, P. *Think of One*. Elmwood, Connecticut: Potes & Poets, 1986.

James, Henry. *The Portrait of a Lady*. 1881. New York: Dell, 1961.

Joyce, James. *Finnegans Wake*. 1939. New York: Viking, 1969.

Kristeva, Julia. *Revolution in Poetic Language*. 1974. Trans. Margaret Waller. New York: Columbia UP, 1984.

Lyotard, Jean-Francis. *The Postmodern Condition: A Report on Knowledge*. Trans. Geoff Bennington and Brian Massumi. Minneapolis: U of Minnesota P, 1984.

Messerli, Douglas, ed., *"Language" Poetries*. New York: New Directions, 1987.

Ponge, Francis. *The Power of Language*. Intro. and Trans. Serge Gavronsky. Berkeley: U of California P, 1979.

Silliman, Ron. "Disappearance of the Word, Appearance of the World." *The* $L = A = N = G = U = A = G = E$ *Book*. Ed. Bruce Andrews and Charles Bernstein. Carbondale: Southern Illinois UP, 1984. 121–132.

———. ed., *In the American Tree*. Orono: National Poetry Foundation, 1986.

Sontag, Susan. *On Photography*. New York: Farrar, Straus and Giroux, 1977.

Wittgenstein, Ludwig. *Tractatus Logico-Philosophicus*. Trans. D. F. Pears and B. F. McGuinness. London: Routledge & Kegan Paul, 1961.

Index